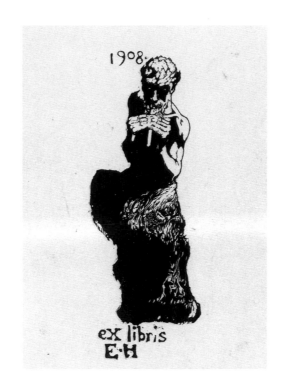

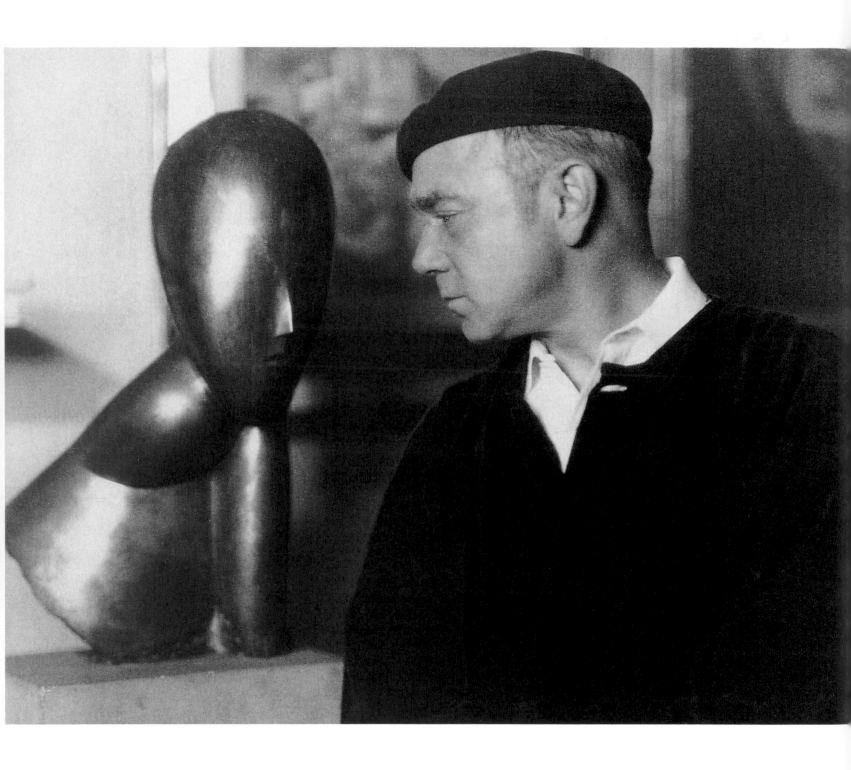

MAD FOR MODERNISM

EARL HORTER AND HIS COLLECTION

INNIS HOWE SHOEMAKER

WITH CHRISTA CLARKE AND WILLIAM WIERZBOWSKI

PHILADELPHIA MUSEUM OF ART

This publication accompanies the exhibition
Mad for Modernism: Earl Horter and His Collection
at the Philadelphia Museum of Art, March 7 to
May 16, 1999

The exhibition was made possible in part by
grants from The Pew Charitable Trusts, The
William Penn Foundation, and the National
Endowment for the Arts, and by a gift from
Charles K. Williams II

This book was also supported by an endowment
fund for scholarly publications established by
grants from CIGNA Foundation and the Andrew
W. Mellon Foundation for the Philadelphia
Museum of Art

Cover/jacket illustration: Pablo Picasso
(1881–1973), *Still Life with Cards, Glasses, and Bottle of
Rum: Vive la [France]*, 1914–15. Oil and sand on
canvas, 21¼ × 25⁹⁄₁₆ inches (54 × 65 cm). Private
collection (plate 46)

Half-title page illustration: Earl Horter
(1880–1940), Bookplate, 1908. Etching, 8 × 6¹⁄₁₆
inches (20.3 × 15.4 cm) sheet. Philadelphia
Museum of Art Archives

Frontispiece and back cover/jacket: William
Shewell Ellis (1876–1931), Earl Horter with
Brancusi's *Muse*, 1929. Gelatin silver print,
7¼ × 9¼ inches (18.4 × 23.5 cm). Private collection

Produced by the Department of Publishing
Philadelphia Museum of Art
Benjamin Franklin Parkway at Twenty-Sixth Street
P.O. Box 7646
Philadelphia, PA 19101-7646

Edited by Jane Watkins, with the assistance of
Kathleen Krattenmaker
Production by William Rudolph

Designed by Greer Allen and Jo Ellen Ackerman
Color separations by Professional Graphics, Inc.,
Rockford, Illinois

Printed and bound in Italy by Amilcare Pizzi,
S.p.A., Milan

Library of Congress Cataloging-in-Publication Data

Shoemaker, Innis H.
 Mad for modernism : Earl Horter and his
collection / Innis Howe Shoemaker ;
with Christa Clarke and William Wierzbowski.
 p. cm.
 Published in conjunction with an exhibition of
the same title held at the Philadelphia Museum of
Art, March 7–May 16, 1999.
 Includes bibliographical references and
indexes.
 ISBN 0-87633-127-4 (alk. paper)
 1. Art, Modern—20th century—Exhibitions
2. Indian art—North America—Exhibitions.
3. Art, Black—Africa, Sub-Saharan—Exhibitions.
4. Horter, Earl, 1880–1940—Art collections—
Exhibitions. 5. Horter, Earl, 1880-1940—
Exhibitions. 6. Art—Private collections—United
States—Exhibitions. I. Clarke, Christa. II.
Wierzbowski, William S., 1951– III. Philadelphia
Museum of Art. IV. Title.
 N6488.5.H67 S36 1999
 707'.4'74811—dc21 98-56052
 CIP

CONTENTS

ACKNOWLEDGMENTS

The idea that the reconstruction of Earl Horter's collection might reveal a lost chapter in the history of collecting modern art came to Anne d'Harnoncourt as a result of research she had done when she was curator of twentieth-century art at this Museum in the 1970s. Among her reasons for encouraging me to launch this project, some twenty years later, must have been her discovery that my memories include a number of anecdotes about Earl Horter told to me by my late mother, Jean Miller Shoemaker, who was a student of Horter's at the Pennsylvania Museum School of Industrial Art in the 1930s. Given Horter's relative obscurity in the annals of modern art history, it has seemed natural that someone with prior knowledge of his career would tell this story. Its evolution, which grew to include the partial reconstruction of Horter's collections of African and Native American art, has been marked by serendipitous good fortune and the enthusiastic support of many old and new friends.

The five years spent piecing together the life and collections of Earl Horter would have been much shortened had we begun about fifteen or twenty years ago, when Horter's widow and other contemporaries were still alive. It was extremely fortuitous that one of my first investigatory telephone calls led directly to two of the four photographs taken of Horter's collection installed in the living room of his Philadelphia house at 2219 Delancey Street. These photographs were then in the possession of Paula Kelly Muller, who has since generously donated them to the Philadelphia Museum of Art (figs. 2 and 4). Without those photographs the identification of some of the most important works of art in Horter's collection would not have been possible. Not until two years later, in Paris, did I come upon the remaining two photographs of the collection in his living room that Horter had sent to Picasso about 1930, which are now in the archives of the Musée National Picasso (figs. 1 and 3).

Students of Earl Horter have been tremendously important in bringing his character into focus. Without exception they impressed upon me the singular impact he had on many young artists in Philadelphia in the 1930s. Foremost among these are William Campbell and Albert Gold, who were able to bring Horter to life through vivid recollections that fondly captured his spirit, demeanor, and classroom methods. Other students and acquaintances who helped to fill in details about Horter's personality and influence are Miriam Brown Fine, Priscilla Grace, John Lear, Molly Lewis (formerly Mrs. Henry Pitz), and Dorothy Morrison MacIntyre.

The keys to this fascinating inquiry have been supplied, above all, by the primary sources. Indispensable information came from many archives and libraries overseen by their devoted keepers, especially Richard Wattenmaker and Judith Throm at the Archives of American Art in Washington, D.C., and Cheryl Leibold, archivist of the Pennsylvania Academy of the Fine Arts, Philadelphia. In Chicago, Diana Haskell of the Newberry Library made available the papers of the Arts Club of Chicago, where Horter's collection was shown in 1934, while Bart H. Ryckbosch and Althea Huber, archivists at the Art Institute of Chicago, provided information related to Horter's contributions to exhibitions at that institution. In New York, Olive Bragazzi, who was in charge of the Pierre Matisse Foundation archives before their transfer to the Pierpont Morgan Library, and Rona Roob, former archivist at the Museum of Modern Art, deserve special thanks. Assistance from Ramona Bannayan in the registrar's office at the Museum of Modern Art, Myrna Davis of the Art Directors Club, and Roberta Waddell at the New York Public Library, who generously granted access to the print room's abundant clipping files, is warmly appreciated. Others who have aided my work include Ellen Cordes, Kevin Glick, and Patricia Willis of the Beinecke Library at Yale University, New Haven, who provided invaluable information from the papers of Alfred Stieglitz; Eugene Gaddis, archivist at the Wadsworth Atheneum, Hartford; Linda Muehlig, associate curator at the Smith College Museum of Art, Northampton, Massachusetts; and Melissa Piper and Lindsay Brown in the Department of Special Collections of the Getty Center for the History of Art and Humanities, Los Angeles, who provided access to the papers of Douglas Cooper. In Paris, Anne Baldassari and Sylvie Fresnault of the archives of the Musée National Picasso have earned my deep gratitude for granting the use of the photographs of Horter's living room. In Geneva, Janet F. Briner, keeper of the Justin K. Thannhauser archives, generously provided provenance information on several works and helped to identify two lost pictures from Horter's collection. Alison Jeffrey of the National Museum of the American Indian, Smithsonian Institution, Washington, D.C., and New York, kindly gave archival assistance to William Wierzbowski; and Virginia-Lee Webb of the Department of the Arts of Africa, Oceania, and the Americas at the Metropolitan Museum of Art, New York, assisted Christa Clarke with research on Horter's collection of African art.

The rich archival holdings of numerous Philadelphia institutions were essential to our research. At the University of Pennsylvania, the papers of Carl Zigrosser and the Philadelphia Art Alliance were made available by Nancy Shawcross, Maggie Kruesi, and John Pollack of the Special Collections Department, Van Pelt–Dietrich Library, and at the University of Pennsylvania Museum of Archaeology and Anthropology, archivists Alessandro Pessati and Charles Klein assisted William Wierzbowski with research on Horter's Native American collection. Bruce Laverty of the Athenaeum of Philadelphia granted access to the papers of Paul Cret. At the archives of the Barnes Foundation, Merion, Pennsylvania, Nicholas King generously provided his assistance, particularly for Christa Clarke's research. Scott Dimond, who catalogued the archives of the Print Center, Philadelphia, was vigilant in watching for information on Horter as he worked. Robert de Sipio of the Office of the Prothonotary, Philadelphia City Hall, helped to trace several legal documents.

Many individuals aided my research by furnishing answers to a variety of questions and generously lending materials in their possession. I am especially indebted to the descendants of R. Sturgis Ingersoll and his sister Anna Warren Ingersoll: Perry Benson, Charles Ingersoll, Robert Ingersoll, and George H. McNeely IV. Earl Horter's grandchildren, Elin Horter Young, Elsa Horter Reddish, and Eric Horter, gave our work their essential support. Ann Corkadel, Janet Maher, and Barry May, the descendants of Horter's wife Elizabeth Lentz Horter, provided invaluable information and research materials. Details about Horter's elusive handyman, Fred Helsengren, were supplied by Venable Herndon and Doris Helsengren Black, while Mercedes Matter, Perry Ottenberg, and Barbara Wolanin enriched my knowledge of Horter's friend Arthur B. Carles. Others of special assistance were Michael Fitzgerald, Philip Jamison, Pepe Karmel, Naomi Sawelson-Gorse, Gail Stavitsky, Robert Storr, and Judith Zilczer. Information about N. W. Ayer and Son was furnished by Maxine Brennan and Warner Shelly; and John Warren and Gloria Braggiotti Etting granted access to the typescript of Emlen

Etting's reminiscences, "Studio in Paris, 1930." Advice on and assistance with research on Horter's Native American collection came from Fred Boschan, Marcy Burns, Edmund Carpenter, Ralph T. Coe, George Horsecapture, Jr., Michael Kan, Richard Pohrt, Sr., Father Peter Powell, David Rasner, Joe Rivera, Carol Russo, Mark St. Pierre, Allen Wardwell, and Deborah Wythe. Special thanks are owed to Katherine Bourguignon, research assistant for the exhibition during the summer of 1997, who zealously tracked down the early provenances of the modern works of art in Horter's collection and located several previously unknown works during the course of her research; I am also grateful for her subsequent work on this project while in Paris.

Loans to the exhibition have received the generous support of many individuals, in particular Gerald D. Bolas and Timothy Riggs of the Ackland Art Museum, The University of North Carolina at Chapel Hill; Douglas Schulz and Cheryl A. Brutvan of the Albright-Knox Art Gallery, Buffalo; James N. Wood, Douglas Druick, and Jeremy Strick of the Art Institute of Chicago; Carol Campbell of Bryn Mawr College, Pennsylvania; Robert Bergman, Diane de Grazia, and Tom Hinson of the Cleveland Museum of Art; Laura Hemmings of the Dixon Ticonderoga Company Collection, Heathrow, Florida; Paul Winkler of the Menil Collection, Houston; Malcolm Rogers, Clifford Ackley, and George T. M. Shackleford of the Museum of Fine Arts, Boston; and Jock Reynolds and Joachim Pissarro of the Yale University Art Gallery, New Haven. At the State Museum of Pennsylvania, Harrisburg, we are grateful to Anita D. Blackaby, Stephen Warfel, and Janet Johnson. In New York, thanks are owed to Thomas Krens, Lisa Dennison, and Mark Rosenthal of the Solomon R. Guggenheim Museum; Glenn Lowry, Kirk Varnedoe, and Cora Rosevear of the Museum of Modern Art; Richard West, Jr., Ann Drumheller, Cecile Ganteame, and Roberta Kirk of the National Museum of the American Indian; and Grete Meilman of Grete Meilman Fine Art. In Philadelphia, we would like to express our appreciation to Daniel Rosenfeld and Sylvia Yount of the Pennsylvania Academy of the Fine Arts; Jeremy A. Sabloff, Lucy Fowler Williams, Xiuqin Zhou, Sylvia Duggan, Lynn Grant, and Brenda Smith of the University of Pennsylvania Museum of Archaeology and Anthropology; and Robert Schwarz of the Schwarz Gallery. In Washington, D.C., we are grateful to James A. Demetrion and Anne-Louise Marquis of the Hirshhorn Museum and Sculpture Garden, and Earl A. Powell III and Jeffrey Weiss of the National Gallery of Art. In Europe, I express profound appreciation to Dr. Angela Schneider of the Staatliche Museen zu Berlin, Nationalgalerie, and to Dr. George W. Költzsch and Dr. Mario-Andreas von Lüttichau at the Museum Folkwang, Essen.

Locating and expediting loans, and photography of the works of art in Horter's collection, involved the assistance of many people, and I would like to express my gratitude to the following individuals: William Acquavella, Emily Braun, Hester Diamond, Wendy Foulke, Meg Perlman, Monika Schmela, and Richard York, and at Sotheby's, New York, John Tancock, Jean Fritts, Susan Kloman, and Anna Swinbourne. William Wierzbowski joins me in appreciation of the work of Ingrid A. Neuman of Berkshire Art Conservation, Williamstown, Massachusetts, who undertook the conservation of the Native American objects from the State Museum of Pennsylvania in Harrisburg.

Members of many departments within the Philadelphia Museum of Art contributed to this project as it unfolded over the past five years. During the research phase, I received countless hours of assistance from Allen Townsend and Lilah Mittelstaedt in the Museum library, as well as from archivist Susan Anderson and archives volunteer Louise Rossmassler. Ann Temkin, The Muriel and Philip Berman Curator of Twentieth-Century Art, generously agreed to the loan of works of art from her department, both directly for the exhibition and in exchange for loans from other sources. In the Department of Prints, Drawings, and Photographs, John Ittmann offered advice on the selection of prints for the exhibition, Matthew S. Witkovsky provided the benefit of his research on Constantin Brancusi, and Gary Hiatt skillfully prepared many of the works for exhibition. I also appreciate the work of several members of the Conservation Department, as well as their enthusiasm for carrying out this project: Nancy Ash, Andrew Lins, Sally Malenka, Suzanne Penn, and Faith Zieske. In the registrar's office, Clarisse Carnell combed through the museum's old loan records, which allowed me to identify several lost works from Horter's collection, and Irene Taurins and Elie-Anne Santine Chevrier made the complicated arrangements for loans to the exhibition appear to be effortless. Suzanne F. Wells, coordinator of Special Exhibitions, used her exceptional powers of organization to keep the exhibition and its budget on track, while Jack Schlechter, installation design coordinator, attacked the challenge of installing so many diverse works of art with remarkable creativity. An array of educational and collaborative programs was ingeniously organized under the direction of Cheryl McClenney-Brooker and Danielle Rice, with the help of Elizabeth Anderson, Sheryl Bar, and Caroline Cassells. Members of the Department of Publishing, especially George Marcus, Sherry Babbitt, Jane Watkins, and Kathleen Krattenmaker, graciously upheld their usual impeccable standards in all aspects of this catalogue; that department was responsible for selecting the gifted designer, Greer Allen, for what proved to be an unusually complex publication. Matthew Pimm, Diane Gottardi, Alison Rooney, William Rudolph, and Maia Wind of the Department of Editorial and Graphic Design contributed to various aspects of the exhibition with their customary flair. The assistance of Conna Clark, manager of Rights and Reproductions, has been much appreciated, as has the expert work of Graydon Wood and Lynn Rosenthal, who photographed many of the works of art illustrated in this catalogue, often under difficult circumstances.

In 1995 a summer intern undertook the summation of one year's worth of my initial research on Earl Horter and in eight weeks produced a chronology that reflected a remarkable grasp of his elusive career and personality. Two years later, after graduating from college, that intern, Greer Pagano, returned to work full time as research assistant for the exhibition. She has been my sympathetic companion on this journey, rapidly blending organizational skills with her intelligent perceptiveness and adding enormous pleasure to the entire undertaking.

Finally, I have benefited immensely from the expertise of my two co-authors, Christa Clarke and William Wierzbowski, who, after some understandable apprehension that the challenge might prove impossible, rose to my call to excavate the deeply buried histories of Earl Horter's collections of African and Native American art and added two more fascinating chapters to this story.

Innis Howe Shoemaker
The Audrey and William H. Helfand Senior Curator of Prints, Drawings, and Photographs

Between 1916, when the successful advertising artist and printmaker Earl Horter moved back to Philadelphia to take up a position with N. W. Ayer and Son, and 1940, the year of his death at the age of sixty, Horter's native city brimmed with cultural changes. Five years before Horter's return, the Philadelphia Orchestra (founded in 1900) hired the brilliant and charismatic Leopold Stokowski; the young conductor introduced startled audiences to the work of Igor Stravinsky, Arnold Schoenberg, and Alban Berg and led the orchestra to experiment boldly with live radio broadcasting in 1929 and early attempts at stereophonic recording in 1932. In the field of architecture, George Howe, whose family had roots in the city, settled in Philadelphia four years before Horter's arrival; together with William Lescaze he designed the PSFS Building, the most ambitious and rigorously International Style skyscraper of its date in the United States. Not only was the exterior of the PSFS Building sleekly modern, but the furniture for its public spaces and offices also was designed by the architects and executed in stainless steel and exotic woods, transforming the entire building into a beautiful, functional machine. Finished in 1932, the PSFS Building was the most celebrated among a group of tall structures updating the city's skyline, including the Market Street National Bank by Verus T. Ritter and Howell Lewis Shay and Ralph Bencker's handsome new tower for N. W. Ayer, which was crowned with sculpture by Horter's friends J. Wallace Kelly and Raphael Sabatini.

Three other architectural landmarks, albeit with more conservative exteriors, helped to set a new stage in the city's culture in the late 1920s. Paul Cret, the French Beaux-Arts architect whose classes at the University of Pennsylvania were to nourish the young Louis Kahn, completed the Barnes Foundation building in a nearby suburb, commissioned by Dr. Albert C. Barnes to house his remarkable holdings of Impressionist, Post-Impressionist, American, and African art, and also designed a smaller structure, the Rodin Museum, for the impressive collection of Rodin sculpture assembled by the movie-theater magnate Jules Mastbaum, which opened to the public in 1929. The new building for the Pennsylvania (soon to be renamed Philadelphia) Museum of Art, rising on the crest of the hill of Fairmount at the end of the recently completed Benjamin Franklin Parkway, had opened a year earlier. Horter's friend the painter Henry McCarter derided it as a cavernous "Greek garage," but its enterprising and forward-looking director Fiske Kimball ensured that modern art, as well as masterpieces of the past, was warmly embraced within its neoclassical walls. The Museum bought its first Picasso (a painting of his Rose period) in 1931, by which time Horter's house on Delancey Street was already crowded with Cubist canvases. There is no doubt that the enthusiastic championing of modernism during the 1920s and 1930s by a circle of artists, architects, musicians, writers, and collectors (Horter and Stokowski notable among them) created the climate that made Philadelphia's venerable institutions surprisingly hospitable to the avant garde.

As Innis Howe Shoemaker, who shines such a bright and penetrating light into the relative obscurity until so recently occupied by Earl Horter and his collection, notes in her essay in this catalogue, before 1930 Horter was one of only a handful of American collectors to be swept off his feet by European modernism in general and Picasso's Analytical Cubism in particular. Aside from Gertrude Stein, who bought her Cubist Picassos in Paris directly from the artist as early as 1909 (when she and Picasso occupied equally radical positions as writer and painter), and John Quinn, whose vast modern collection encompassed several Cubist Picassos as well as a fabulous trove of Brancusi sculpture that Horter and other collectors were to mine after Quinn's death in 1924, the most formidable forerunner in collecting modern art was Walter Arensberg, who bought great Cubist pictures in New York before 1918. Horter's passion for the most complex and difficult compositions (see plates 37 and 38) surely derives in part from his keen artist's eye, which also informed his exceptional ability to communicate the excitement he felt about Cubism and modernism to his friends and students in Philadelphia. The crucial role played by individual artists—whether painters, poets, or (as in the case of Alfred Stieglitz) photographers—in the discovery and acceptance of new art is axiomatic, and it was certainly the case in Philadelphia: the painter William Glackens, for example, was sent to Paris to scout for masterpieces for his classmate Dr. Albert Barnes to buy. It is rare, however, for any artist to be able to pursue his or her own passion for the work of others to the

extent that Horter did. His overwhelming enthusiasm for Native American art of the Great Plains bore perhaps the most ambitious results, as it led him to acquire well over one thousand objects and to dream, at the very end of his life, of creating a museum to house them.

Although Horter's lovingly assembled collections of modern, African, and Native American art began to be dispersed during his lifetime and, as entities, vanished into oblivion after his death, they left vivid memories in the minds of his contemporaries and did much to prepare the way for the enthusiastic embrace of modern art by Philadelphia critics and the museum-going public, so that when the A. E. Gallatin collection galleries opened in the Philadelphia Museum of Art in 1943, followed by those devoted to the Louise and Walter Arensberg collection in 1954, they were very warmly received. The exhibition of Horter's modern collection at the Philadelphia Museum in 1934, well before the Metropolitan Museum in New York or the Museum of Fine Arts in Boston would show such adventurous work, may have been too early for Philadelphians in the grip of the Depression to raise the funds to buy the entire collection as Horter and Kimball both wished, but the exhibition was a signal of strong interest, which later bore spectacular fruit. The Arensbergs' gift of their collection, which the Museum had pursued with great ardor, aptly included a painting by their beloved friend Marcel Duchamp that had belonged to Horter. If Gallatin's exuberant assertion to a reporter in 1943 at the opening of the Museum's new galleries installed with his collection that "the background for appreciation of modern art is more deeply rooted here than anywhere else in America" describes Philadelphia accurately, a substantial share of the credit belongs to Horter.

The creation of this exhibition, *Mad for Modernism: Earl Horter and His Collection,* and its accompanying publication has been a labor of love on the part of Innis Howe Shoemaker, The Audrey and William H. Helfand Senior Curator of Prints, Drawings, and Photographs, who has pursued elusive clues over faint trails with undaunted enthusiasm. That she has succeeded in reuniting Horter's extraordinary collections to a degree beyond what was thought possible is a tribute to her rare combination of fine

detective work, eloquent persuasiveness, and delight in her subject. In her acknowledgments she expresses her thanks to the impressive number of people who helped to bring this project into being; her appreciation is warmly seconded here. We are fortunate that she has been joined in the search not only for Horter's works of art but also for the profoundly personal character of his collections by Christa Clarke and William Wierzbowski, for whose contributions we are deeply grateful. The installation of the exhibition has been intelligently shaped by Jack Schlechter, the Museum's installation designer, and the handsome form of the book was created by Greer Allen, whose designs have graced a number of our publications. Without the willingness of a remarkable array of public institutions and private collectors to join us in reconstructing a vanished treasure by lending wonderful works of art, the exhibition would not have been possible. And without splendid support from both public and private sources, these truly generous loans could not have been brought together and rewoven into a coherent whole. A grant from the National Endowment for the Arts underlines the importance of Earl Horter and his collection within the history of art in the United States, and the invaluable support for the project by The Pew Charitable Trusts and The William Penn Foundation emphasizes the richness of the artistic resources of this region. This book also benefited from an endowment fund for scholarly publications established at this Museum by grants from the CIGNA Foundation and the Andrew W. Mellon Foundation. Last but not least, a most welcome contribution from Charles K. Williams II expresses a shared enthusiasm for the early modern art that Horter loved and a desire to enable the public to enjoy it again sixty-five years after Horter's collection was first shown at this Museum.

Anne d'Harnoncourt
The George D. Widener Director

There is no complete written inventory of Earl Horter's collection of modern art. His habit of not keeping records and the short span of years during which he owned his collection explain why its reconstruction has not been attempted before. Reassembling the contents of Horter's collections involved close scrutiny of several kinds of records, which are occasionally inconsistent with one another. The modern art collection was largely reconstructed from four photographs of his living room at 2219 Delancey Street, Philadelphia, that were taken about 1929–30 (figs. 1–4); from records of the 1934 exhibitions at the Pennsylvania (later Philadelphia) Museum of Art and the Arts Club of Chicago; from photographs in the registrar's files of the Philadelphia Museum of Art; and from records of loans from Horter and his widow Elizabeth Lentz Horter to the Philadelphia Museum of Art.

The plate sections that follow each of the essays constitute checklists of Earl Horter's collections of modern, African, and Native American art. The checklists provide exhibition histories, restricted to those exhibitions that took place during the time period when Earl Horter owned the works. As far as they were able to be reconstructed, the provenance records are complete. For dimensions of works, height precedes width.

The checklist of modern art is divided into European art and American art. Within these categories, works are arranged alphabetically by artists' last names and chronologically thereafter.

Works of art in the plate sections that are in the exhibition *Mad for Modernism: Earl Horter and His Collection* are designated by asterisks.

Two lost prints from Horter's collection are illustrated by impressions from the collection of the Philadelphia Museum of Art (plates 49 and 65). Modern works of art known to have been in Horter's collection for which no images have been found are listed in a separate category on page 131 entitled Missing Works. Unidentifiable works of art that appear in the four photographs of Horter's living room cannot be connected with those on the list of Missing Works.

The few surviving records of Horter's collections of African and Native American works would not permit even partial reconstructions of the contents of these collections; therefore, the checklists of these collections list only those objects in the exhibition.

Works of art by Earl Horter are included as figure illustrations in the essay "Earl Horter: An Artist Collects Modern Art" and the Chronology. Illustrated Works by Earl Horter are indexed on page 189.

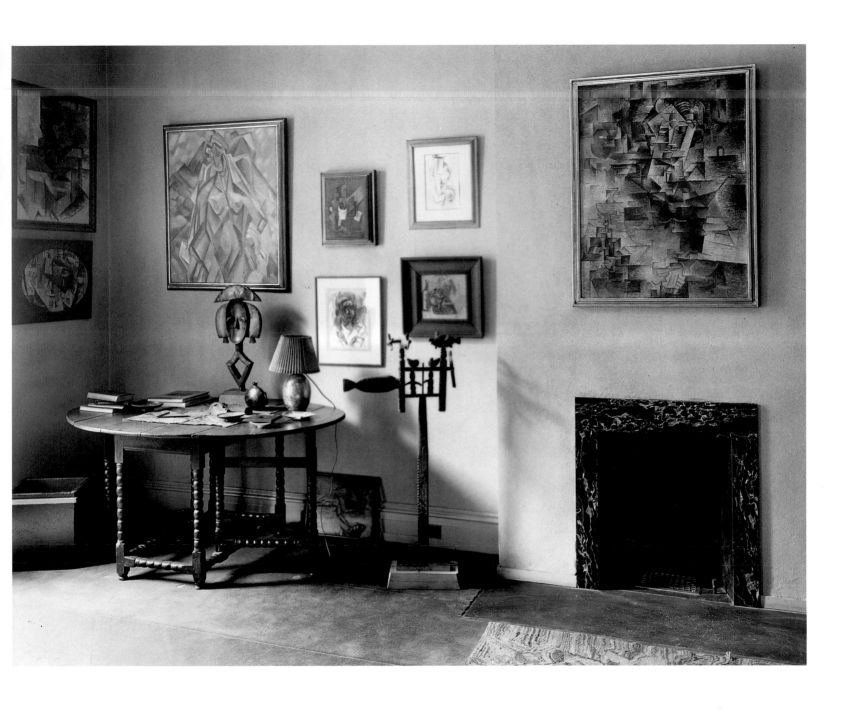

Fig. 1. Earl Horter's living room at 2219 Delancey Street,
Philadelphia, about 1929–30.

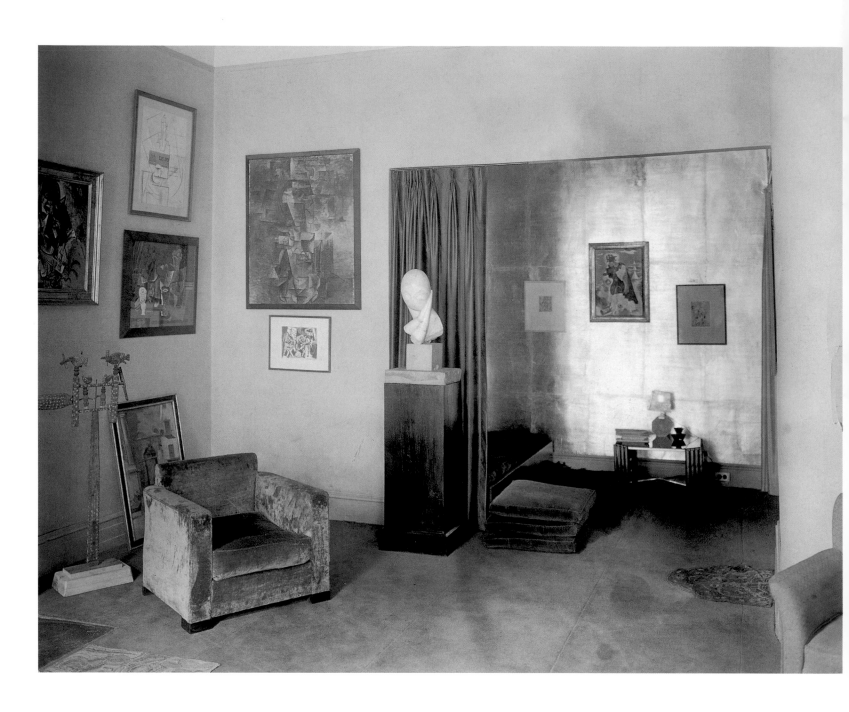

Fig. 2. Earl Horter's living room at 2219 Delancey Street,
Philadelphia, about 1929–30.

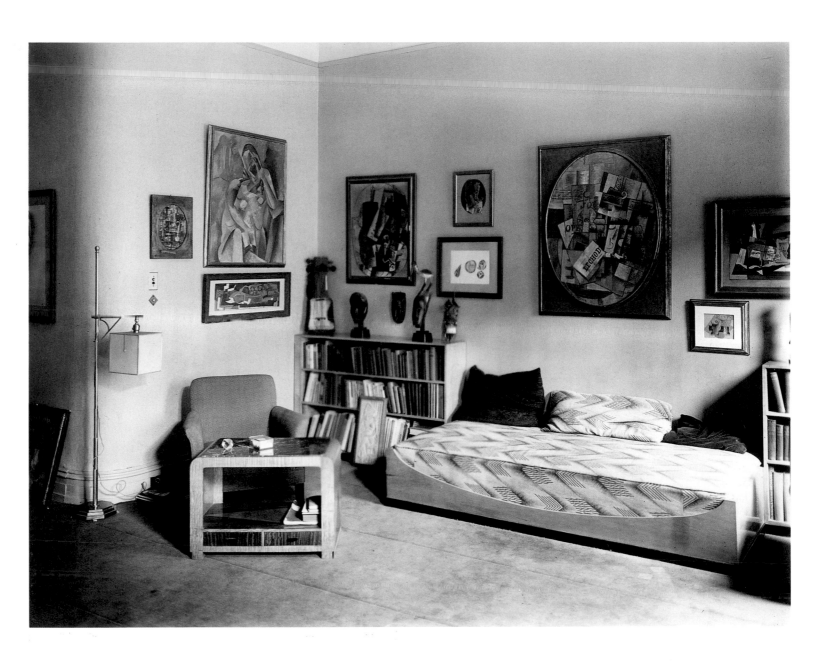

Fig. 3. Earl Horter's living room at 2219 Delancey Street, Philadelphia, about 1929–30.

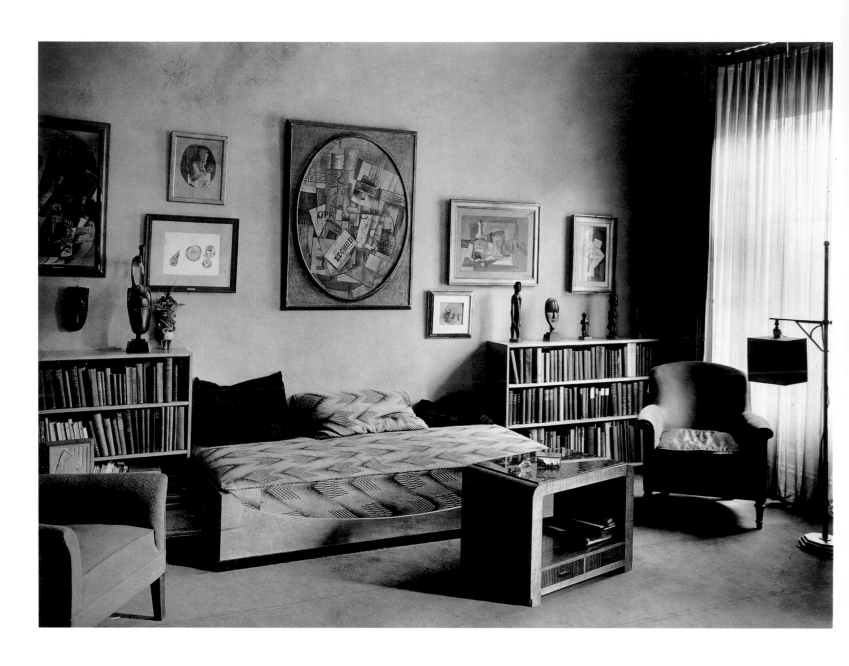

Fig. 4. Earl Horter's living room at 2219 Delancey Street,
Philadelphia, about 1929–30.

EARL HORTER: AN ARTIST COLLECTS MODERN ART

I have a really unique though what would never be a popular collection—but it was [a] collection entirely for my personal taste when I was in a much more opulent state than I am now.[1]

Writing in early 1934 to Alice Roullier, chairman of the exhibition committee of the Arts Club of Chicago, Earl Horter (1880–1940) circumscribed in a single sentence the essential elements that shaped his elusive and short-lived collection of modern art: its intensely personal character and its dependence upon the fluctuations in his finances. Assembled and largely dispersed within a mere decade, the works of modern art from Earl Horter's collection, now scattered throughout the world, are known chiefly through the few provenance records in which Horter's name appears.

The focus of Horter's collection of modern art was narrow and its size relatively small, comprising perhaps eighty paintings, sculptures, prints, and drawings in 1930, the year before he began to break it up. Fairly early in its formation at the beginning of the 1920s, Horter decided to concentrate his collection on Cubism, chiefly upon the work of its founders, Pablo Picasso and Georges Braque, dating for the most part between 1909 and 1914. Along with about thirty Picassos and Braques, two paintings by Juan Gris of 1915 and 1916, a single austere portrait of 1916 by Henri Matisse, Marcel Duchamp's oil study for the *Nude Descending a Staircase, No. 2* (Philadelphia Museum of Art), and four sculptures by Constantin Brancusi made up the core of Horter's collection of European modern art. To these were added a small group of other European artists such as Amedeo Modigliani, Raoul Dufy, André Derain, and Giorgio de Chirico. An equally select group of American modernists included eight spectacular works by Charles Sheeler, two watercolors by John Marin, one Thomas Hart Benton landscape, a Synchromist still life by Stanton MacDonald-Wright, a painting on glass by Joseph Stella, and at least fourteen paintings by Horter's close friend Arthur B. Carles. Other Philadelphia artists represented in addition to Carles were Julian Levi, J. Wallace Kelly, and Franklin Watkins—evidently a carefully chosen lot but one that did not include all his artist friends.

Although focused and selective in his collecting, Horter no doubt would have had a much larger collection if he had had more money. When it came to collecting he was insatiable, as he admitted in 1931 to a reporter: "You know, it's really pretty bad. I may not have 50 cents to my name but I can't resist buying pictures—especially Picasso's—and I'm always owing 50 cents on pictures."[2] Horter's income came entirely from his own work as an advertising artist, and while he was able to amass a great deal of money during the boom years of the 1920s, he was always out of it, as he once put it: "Still scrambling for sheckles [sic] and one step ahead of the sheriff—almost—."[3] Even as early as his first documented acquisitions in 1913, when he made purchases at the *International Exhibition of Modern Art* (the Armory Show), the first note was sounded of a refrain that becomes all too familiar in the records of his acquisitions: his reputation for not paying promptly for all or part of his purchases. On December 23, 1914, twenty-one months after the end of the Armory Show in New York and nineteen months after the exhibition's final closing in Boston on May 19, 1913, one of the exhibition's organizers, Walter Pach, wrote to Elmer MacRae, who was in charge of the financial records of the exhibition: "I would write that man Horter a strong letter. I hear that he makes plenty of money but is very careless about it. We paid for the things he got long ago. I'd tell him that and put it solid."[4] The story of Horter's collection is, in fact, the story of the rise and fall of his finances. It is also the story of an artist who cared little for attending to the records of his possessions, of which there are almost none. The documentation for Horter's collection exists only in scant correspondence kept by others,[5] loan records of the few institutions to which he lent, and four remarkable photographs of his living room at 2219 Delancey Street in Philadelphia that he had taken in about 1929–30 and sent to Picasso when his group of Cubist paintings was still intact (figs. 1–4).

Besides the scarcity of records, the elusive nature of this collection may also be explained by the fact that, unlike many collectors for whom acquiring art was a collaborative or educational enterprise, Horter appears to have followed his own path,

involving few other people in his acquisitions. While he seems to have been acquainted with well-known artists, dealers, and collectors in the art world of New York and Paris in the 1920s, there is no evidence that he had a close friendship with any of them. And while he was generous in sharing his works of art with other enthusiasts, he did not espouse a public mission for the collection, as did his contemporaries Dr. Albert C. Barnes, Arthur Jerome Eddy, Duncan Phillips, Katherine Dreier, or A. E. Gallatin, whose aim it was to expose the public to modern art. Probably Horter's relatively private approach to collecting had something to do with the large amount of his time that was taken up with his dual careers as a practicing artist and a successful businessman in the advertising field; but there was also a distinct single-mindedness in his pursuit of a collection and a lack of interest in pleasing any audience other than himself, which suggest a confidence in his own taste and eye that did not require the advice of others. Horter preferred enjoying his collection by himself or in the company of his Philadelphia artist and collector friends: Arthur B. Carles, Henry McCarter, Samuel S. and Vera White, Franklin Watkins, Anna Warren Ingersoll and her brother R. Sturgis Ingersoll, and other strong supporters of modern art who lived in Philadelphia in the 1920s and 1930s.

Young Draftsman

We still feel the spell of that unpredictable personality. He was full of surprises and took a chuckling pleasure in administering mild conversational shocks. With this went a relish for small deceptions, but he had an instant affection for those who discovered them.[6]

Earl Horter's amiable capriciousness is clearly evident in the various accounts of his early life, which are full of elusive statements and picturesque details, many of them apparently supplied by Horter himself.[7] His deception regarding the year of his birth began as early as 1916, when the catalogue introduction for his first one-man exhibition ambiguously stated that Horter was born "some thirty-four years ago."[8] In fact, he was born in Philadelphia in December of 1880, the earliest of his several purported birthdates, which range as late as

1885. In the 1900 federal census he is listed as a nineteen-year-old landscape artist living with his grandmother and his widowed mother and several other relatives at 617 Chelten Avenue in the Germantown section of Philadelphia; his parents were Jeannette Blumner Horter and Jacob Horter, whose occupation is unknown (figs. 5 and 6).[9]

Horter was small, active, and eager— constantly at work, whether in the advertising business or creating his own art, assiduously studying the work of others and reading widely, and in later life collecting modern art, buying cars and houses, teaching, writing, and organizing exhibitions. Horter's physical demeanor was always remarked upon with humorous affection, for while he was grubby and unkempt, famous for wearing the same suit for years and favoring eccentric hats, he had undeniable charisma that won over men as well as women. Indeed, women were one of his weaknesses. While he lived in New York during the first two decades of the twentieth century he married the first of four wives, Elin Magnusson (fig. 7), a young woman of Swedish descent, who in 1909 bore his only child, Donald. Horter's disinterest in long-term domestic relationships is clear from letters he wrote to Carl Zigrosser and Arthur B. Carles, two close friends in whom he confided at different periods of his life: his wives and mistresses are scarcely mentioned and his son not at all. His long, detailed letters about art, books, and travel are more revealing for their frankly expressed loneliness, disclosing with great honesty that few people meant as much to him as the male confidants with whom he could share what really mattered to him. Despite his inner isolation, Horter's public persona radiated infectious charm, often recalled with great fondness by his colleagues and students. Well-placed flattery was also part of his bag of tricks, and he used it to placate Alfred Stieglitz, impatient for Horter's decision on whether or not to purchase a John Marin watercolor, and to successfully maintain good relations with the irascible Dr. Albert Barnes.

Most of what is known about Horter's artistic background and training comes from newspaper interviews and articles by his friends and colleagues, often written many

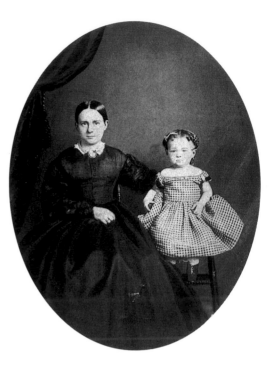

Fig. 5. Earl Horter and his mother, Jeannette Blumner Horter, about 1883.

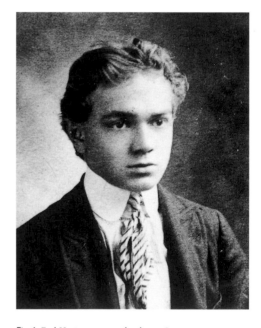

Fig. 6. Earl Horter as a youth, about 1895.

Fig. 7. A later photograph of Horter's first wife, Elin Magnusson Horter, to whom he was married from 1909 to 1927.

years after the fact. Each account contains some variation on a single theme: that Earl Horter was a prodigious draftsman who was largely self-taught. In one account he claimed to have learned to draw from a tramp who painted pictures on cigar-box lids; in another "he scraped acquaintance with a disreputable old fellow who, between drinks, took the boy on long nature hikes and taught him to draw." There is also the story of an older brother, employed by the International Correspondence School, who set up a series of drawing demonstrations in a shop window, talking to audiences as his younger brother pretended to "draw free-hand" while sitting in the window. To accomplish this the young artist had previously made lightly traced pencil sketches on each sheet of paper, then supposedly executed the drawings on the spot as though without any guidance.[10] Horter's capacity to astonish with his draftsmanship and his powers of concentration when drawing before an audience stayed with him throughout his life; many of his students remember Horter's singular method of teaching by demonstration.

Whatever the nature of his initial training, sources indicate that at an early age Horter was employed by an engraver to produce delicate lettering and decorative tracery on stock certificates. About 1903 he was lured from a job lettering price tickets at the John Wanamaker store in Philadelphia to the newly organized advertising firm of Calkins and Holden in New York City. Horter was hired at an auspicious moment in the history of advertising. Recommended to Earnest Elmo Calkins by the illustrator Walter Fawcett, Horter and Fawcett became the first art department at Calkins and Holden, which had opened on January 1, 1902, in the St. James Building on 26th Street.[11] As conceived by the thirty-four-year-old Calkins, the company heralded a revolution in advertising by approaching it as a combination of art and good design. Calkins prided himself on being the first to recognize that "when the first collar was shown on a man's neck instead of lying by itself against a background of nothing, it was revolutionary."[12]

At Calkins and Holden, Horter was a draftsman for one of the company's best-known advertisements, Sunny Jim, a cartoon character who appeared with before-and-after

jingles advertising Force cereal (fig. 8). Calkins described the origins of Sunny Jim: "We were forced to use two artists, Sewell Collins . . . because of the humor he could inject into a sketch—and Earl Horter, to supply the clean sharp line that Collins' work lacked. . . . Soon the whole English-speaking world had added Sunny Jim to its gallery of portraits."[13] Calkins repeatedly expressed admiration for the fine delicacy of Horter's work, as well as his seriousness, and "the naïve pride" with which he submitted his sketches.[14]

It is impossible to separate Horter's advertising drawings of the 1910s from the drawings and etchings he made as an independent artist. The close and many-faceted relationship that has been observed between the fields of printmaking and illustration in America in the first half of the twentieth century extended to the growing field of advertising, which employed many of the same artists, subjects, styles, and techniques as those of printmaking and illustration.[15] Not surprisingly, this overlap occurred at the moment when the field of business began to recognize the commercial value of art, and the aesthetic quality of advertising improved.[16] Horter's work provides a clear example of the interrelationship between these fields.

The subject matter of Horter's independent work in the 1910s consisted mostly of unpopulated architectural and city views. In the same way, the images in his commercial work predominantly used architectural monuments as backdrops, as in a 1913 series of etched advertisements for Packard automobiles (fig. 9). In one important commission, Horter collaborated with two older artists, Jerome Myers and the Philadelphian Joseph Pennell, to produce illustrations of sweeping architectural vistas, precise renderings of individual buildings, and vignettes of New York City life in *Glimpses of New York: An Illustrated Handbook of the City*, which was published in two editions in 1911 and 1912 by the New York Edison Company, for many years an important client of Calkins and Holden (fig. 10). On January 2, 1916, another series of Horter's drawings for the New York Edison Company portraying the changing face of the New York cityscape was published in the rotogravure

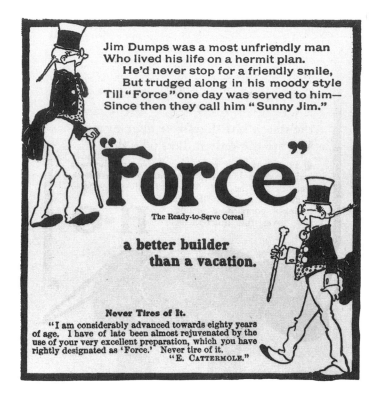

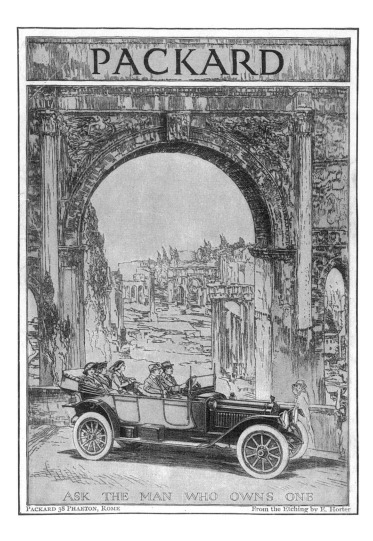

Fig. 8. Sunny Jim, the character in advertisements for Force cereal, drawn by Sewell Collins and Earl Horter for the advertising firm of Calkins and Holden, New York.

Fig. 9. Earl Horter's etching advertising the Packard automobile, about 1913.

section of *The Sun*. Although some of the Edison drawings belonged to the Edison Company, others in this piece were credited to Frederick Keppel and Company, the gallery on 43 East 39th Street, New York, that had recently begun representing his work, an indication of how interchangeable the two facets of Horter's work had become.

Two impressions dated 1908 of a rough, scratchy etching of workers at a construction site bear the inscription "first etching," thereby documenting the beginning of Horter's career as an etcher (fig. 11). His boss, Earnest Elmo Calkins, wrote admiringly of Horter's "persistent study in night art school" that led to his importance later as a printmaker.[17] Horter is said to have taken etching classes with George Senseney, who taught at the Art Student's League, as well as in the studio of Troy Kinney, an etcher of theatrical nudes whose influence on Horter was probably purely technical;[18] but his real lessons seem to have been learned from his own diligent study of the etchings of his contemporaries and immediate predecessors such as James Abbott

McNeill Whistler, Joseph Pennell, James McBey, and Charles Meryon, whose work was shown at Frederick Keppel and Company. Horter's admiration of Whistler was not unusual, for the latter's influence on early twentieth-century American printmakers was unrivaled. The eclectic nature of Horter's training as an etcher was also typical of a New York artist prior to World War I, for there was little opportunity to learn the technique in a formal way, and most printmakers were either self-taught or learned informally from other artists.[19]

New York Etcher

Exhibition records fill the gaps in the history of Horter's progress as an artist in the 1910s. Between 1908 and 1910 he showed his advertising work in the annual *Exhibition of Advertising Art* at the National Arts Club, but by 1914 he had achieved prominence as an independent artist, at which time he was listed as an exhibitor as well as secretary and juror for the first exhibition of the New York Society of Etchers at the galleries of the Berlin Photographic Company. Founded

in 1913, the year of the groundbreaking Armory Show, the society proclaimed in the exhibition brochure that "the fine showing of original graphic art at the Armory last year was a factor in stimulating the enthusiasm of our members to organization."[20] The Society of Etchers exhibition included the work of sixty-three artists selected from three-hundred-and-fifty entries. Except for a few names such as Joseph Pennell and Mahonri Young, most of those artists have disappeared into obscurity. Reviewers of the Society of Etchers exhibition expressed disappointment in the artists' lack of originality: "At first view [the exhibition] . . . lacks variety. . . . The dictum of Whistler seems to hang over the show. Is nothing legitimate beyond the Whistler range?" Another commented: "The prints . . . are not startling in originality, but they show genuine care for the medium, and in many instances a quiet initiative and expressiveness. . . . There is the work of Mr. Horter, for example; one would go far to find a more sincere vision."[21]

Two years later the character of the New York Society of Etchers exhibition had changed. Their 1916 exhibition included a

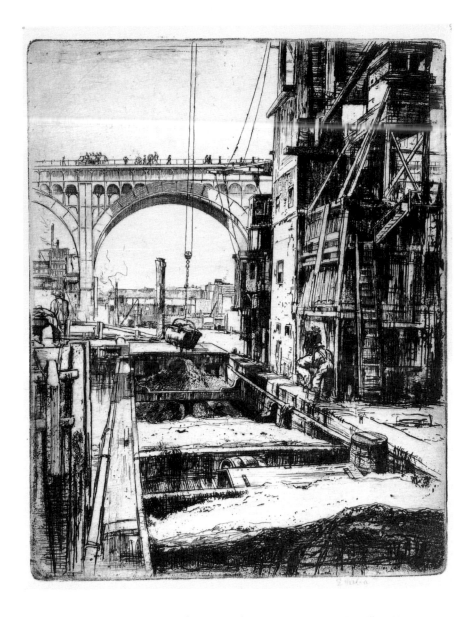

Fig. 10. Earl Horter, *Coal Pockets and Viaduct, New York*, c. 1911, etching, 9 ⁷/₈ x 7 ¹/₂ inches (25.1 x 19 cm) plate. Philadelphia Museum of Art. Gift of Mrs. Alexander Lieberman in memory of her husband, 1944-70-19. The etching was published in two editions of *Glimpses of New York: An Illustrated Handbook of the City* (New York: New York Edison Company, 1911 and 1912).

Fig. 11. Inscribed "first etching," Earl Horter, *Workers at a Construction Site*, 1908, etching, 5 ⁵/₈ x 5 ⁷/₈ (14.3 x 14.9 cm) plate. Private collection.

group of artists very different than those who had appeared in the earlier show. The introduction to the catalogue was written by the young Carl Zigrosser (fig. 12), since 1912 the research librarian for the New York gallery of Frederick Keppel and Company, which represented prints of all schools, including some contemporary artists.[22] It is unclear whether Zigrosser, dubbed by one critic as the etchers' "prophet,"[23] had a hand in the selection of artists. Only twelve artists from the 1914 exhibition reappeared, Horter among them (he was vice-president of the Society of Etchers). While the shadow of Whistler had not receded entirely, the thirty-three artists shown in 1916 not only were more distinguished but also represented a wider variety of styles and a less traditional approach to the medium.

The change that had taken place in the brief interval between these two exhibitions of the New York Society of Etchers was symptomatic of what has been characterized as a new wave of printmaking. In about 1915–16, printmakers finally broke from the tradition of Whistler and a new group of artists began

making prints for the first time.[24] John Taylor Arms, who took up etching in 1915, Martin Lewis, and Childe Hassam were among those whose prints were included in the 1916 New York Society of Etchers exhibition, as were John Marin's. Marin's were the most strikingly different, representing a complete departure from the prints in the traditional Whistlerian vein that he had made before 1913. The reviewers responded enthusiastically to the new spirit and particularly to Marin's abbreviated style, which suggested more by describing less:

One of the merits of the present exhibition is the absence of long-drawn-out detail. The etching is in the class with the short story and the one-act play, and unless it realizes this it becomes a bore. To show an appetite for all the facts available is the surest way for an etcher to invite disaster with the modern public, none too patient with multiplicity even where that is in place.[25]

Just a month before the Society of Etchers 1916 exhibition, Carl Zigrosser had organized a one-man show of thirty etchings and thirty-three drawings by Horter at the Frederick Keppel gallery. While many of the works were views of New York (fig. 13), others had been done in Europe and elsewhere in the United States; the exhibition included work dating back to about 1913.[26] Horter's views of New York were especially admired in reviews of the Keppel exhibition:

Horter's is not Pennell's or Hassam's New York. It is individual, yet achieved with a kind of quietness characteristic of work done in the older cities where men do not feel bound to discover artistic features. The etcher takes it for granted that we all have seen New York. He waves no flags in our faces, blows no bugles.[27]

Horter's work remained closer in style to the older tradition of such artists as Joseph Pennell than to that of Marin or Jules Pascin, even though he was surely well aware of their more progressive work.

The Armory Show

I've always been a collector.[28]

Horter's obsession with collecting began much earlier than the 1920s, the decade when he began to acquire in earnest major works of modern art. Biographical sketches and inventories of his possessions confirm that his interests were wide ranging, extending to such diverse fields as folk art, wrought iron, ancient glass, and Native American artifacts. Horter also had a print collection of unknown but apparently considerable size and was said to have given much of it away before he began collecting modern art. Only scattered traces of Horter's print collection are known, but there is evidence from many different sources that it was conservative in taste, ranging from the work of his early hero Whistler to William Nicholson's color woodcuts, Donald Shaw MacLaughlan's etchings, a set of Goya's *Caprichos*, and Japanese prints.[29]

Prints seem to have been the medium through which Horter began to collect modern art. At the New York Armory Show of 1913 he purchased for $112 thirteen lithographs by Édouard Vuillard, which must be *Paysages et Intérieurs* ("Landscapes and Interiors"; Paris, 1899), a series of twelve color lithographs plus a title page, published by Ambroise Vollard.[30] Of the five purchasers of Vuillard prints at the Armory Show, Horter was the only one who acquired the entire set. Although today his purchase may seem conservative, at the time of the Armory Show, Post-Impressionist artists such as Vuillard were considered, even by the most knowledgeable American viewers, to be part and parcel of the progressive school of European modernism. American collectors of modern art, such as John Quinn and Katherine Dreier, were acquiring Matisse and the Post-Impressionists, and they had not yet begun to pursue the Cubists. Three of the other buyers of Vuillard lithographs from the Armory Show, in fact, became well known as collectors of modern art: Arthur Jerome Eddy, Lillie P. Bliss, and Walter Arensberg (who purchased one of the Vuillards but later returned it).[31]

Horter may also have begun to collect modern works of art other than prints while he lived in New York. Tantalizing evidence that he purchased a painting or a drawing at the Armory Show appears in a letter from Walt Kuhn to Horter after the close of the exhibition in New York, thanking him for lending to the Chicago and Boston venues the "picture you bought while the exhibition

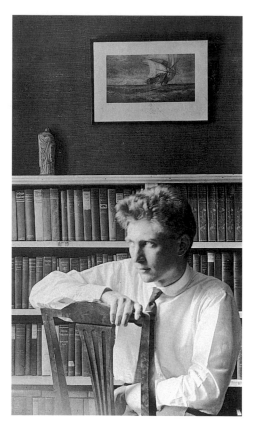

Fig. 12. Carl Zigrosser in 1916.

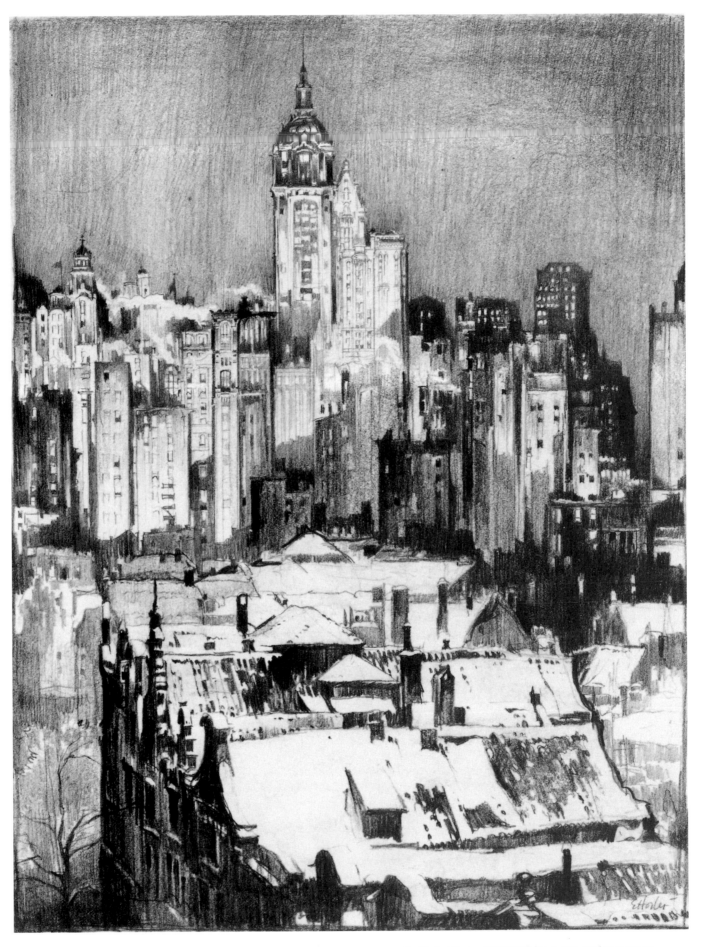

Fig. 13. Earl Horter, *Manhattan Skyline*, c. 1916, graphite on paper, 11 ⅜ x 8 ¾ inches (29 x 22.3 cm). Philadelphia Museum of Art. Gift of an anonymous donor, 1953-64-8. This drawing was shown in his one-man exhibition at Frederick Keppel and Company, New York, in 1916.

was going on in the 69th Regiment Armory"; this "picture" is not documented elsewhere.[32] Another mention, years later, of an early purchase of a painting seems somewhat dubious. In 1930 Paul Lewis wrote about Horter's acquisition of a Matisse when he lived in New York in the 1910s: "With his first accumulation he went down to a Fifth Avenue gallery and bought a painting by Matisse, which is one of three now in his possession."[33] Probably this account contains some grain of truth, although it is certain that Horter did not own three Matisse paintings in 1930, and he probably never owned more than one: *Italian Woman* of 1915 (pl. 21), which he bought on April 9, 1926, from the estate of John Quinn.

Horter's Armory Show purchases are not only the first evidence of his interest in modern art, but they are also the only documented acquisitions he made during his early years in New York City. There is no evidence to show that Horter made purchases in the period that preceded by nearly ten years the city's brief rise and fall as the new, dynamic capital of the international avant-garde, which occurred between the Armory Show of 1913 and the United States' entry into World War I in 1917, but it seems reasonable to pursue further what occasions Horter may have had to do so.

Before the Armory Show, opportunities to purchase modern art in New York were limited. In 1905–6 Alfred Stieglitz's Little Galleries of the Photo-Secession at 291 Fifth Avenue (called "291") opened, concentrating first upon photography and, in 1908, expanding to include works of art in all mediums. Before 1913 the series of exhibitions at Alfred Stieglitz's 291 would have afforded Horter the opportunity to know and perhaps acquire the work of Matisse (in 1908, 1910, and 1912), Toulouse-Lautrec (in 1911), Cézanne (in 1910 and 1911), Picasso (in 1911), and American modernists such as John Marin, Max Weber, Alfred Maurer, Arthur B. Carles, and others who had their first one-man exhibitions there. A letter to Stieglitz from Horter in 1926 mentions his prior knowledge of 291 but does not give the impression that he had made any purchases: "Thanks to you and the early days of 291— my joy in art has led to a deep feeling and I believe a real appreciation of great

Moderns."[34] In addition to Stieglitz's gallery there were also adventurous exhibitions, mainly of American art, at galleries such as the Montross, Macbeth, and the Berlin Photographic Company. Horter could also have learned about developments in European modernism through books and magazines available in New York before the Armory Show, as well as from the many American artists and collectors who traveled to Paris between 1908 and 1914.[35] Although his own library contained many books on modern art that date from this period, when he acquired them is not indicated. The subjects of some of Horter's etchings show that he went to Europe at least once before World War I, but nothing in his work, his collection, or his later correspondence suggests that the experience initiated his collecting of modern art.

What evidence there is suggests that the Armory Show did not make Horter an instant convert to modernism, as it had Arthur Jerome Eddy, John Quinn, and Walter Arensberg. Nor was he ever a part of the vibrant, international group of avant-garde artists who gathered at the Arensbergs' soirees or the salons of Mabel Dodge between 1914 and 1917. Yet there is no reason to believe that Horter ignored the spate of galleries that exhibited modern art after the Armory Show, including the Montross Gallery, where he probably bought the catalogue of a Matisse exhibition held there between January 20 and February 27, 1915.[36]

Another suggestion about the nature of Horter's interests in the years following the Armory Show is found in Carl Zigrosser's introduction to his one-man exhibition of etchings and drawings held at the Frederick Keppel gallery in 1916, where he characterized Horter as a New Yorker so fully involved in the life of the city that he could scarcely have remained oblivious to the exciting developments taking place in modern art during those years—particularly given his ardor for collecting:

He lives intensely in all directions; he drinks in everything that is picturesque and exciting in the great city. He delights in the intricacies of modern engineering and industry, he finds time to enjoy poetry, he loves fine books both in cover and content,

he is a follower of the sports, he knows the spell of the electric light and the restaurant and the theatre, he is a passionate art collector, he does not disdain to acknowledge the romance of vast business enterprise—with a certain Americanness of spirit he takes eager possession of all that comes upon his path.[37]

By the time Horter left New York in 1916 he had lived in the capital of the avant-garde during its heroic early years but seems to have remained on its periphery. Nonetheless, as his friend Zigrosser put it, "the pulse of New York beats in his blood."[38] Not only had he explored in his etchings the city's buildings, its picturesque corners, and many of its changing aspects, but he also had become an established figure in the print-making world of New York, represented by one of its principal galleries, and a founding member of its etching societies who was acknowledged favorably by the press. When Horter began working for the Philadelphia advertising firm of N. W. Ayer and Son on January 19, 1917,[39] he apparently regarded the move to Philadelphia as temporary. But he never returned to live in the city that had so strongly shaped the style and subject matter of the independent and commercial work he would produce well into the 1920s.

Letters to Carl Zigrosser

Here's to you from a very quaint old grown up village.[40]

Horter's own remarkably candid words provide an account of his life and thoughts during his first years in Philadelphia in more than a dozen letters he wrote to Carl Zigrosser.[41] The letters show that besides exhibiting Horter's work at Keppel's, Zigrosser was significant as a friend and a confidant as well as a counselor about his art, particularly during his lonely first months in Philadelphia. Still using the stationery from his New York residence at 11 East 36th Street, in what seems to be the first of his letters to Zigrosser, Horter expressed confidence that his "sojourn" in Philadelphia would be a success, but he was embittered by the slow pace of the city and the dullness of its inhabitants. One would never guess from his railings against Philadelphia that he had spent the greater part of his youth there:

Fig. 14. Earl Horter, *Ancient Greece* (the Theater of Herodes Atticus, Athens), 1921, graphite on paper, 18 x 15 inches (20.2 x 28.1 cm). Dixon Ticonderoga Company Collection. One of many drawings Horter made with the Eldorado pencil for the Joseph Dixon Crucible Company.

I am shaking off the nervous responsiveness of New York—but only gradually—the pulse of this town beats as of one on a deathbed. . . . The people here are terrible. . . . There is hardly an artistic quiver here and the sodden masses of stupid creatures that plod daily to and fro to houses as inartistic as themselves—concern me not at all. They even are not picturesque—I spend my days at work and play—am saving money to spend in Europe—and at night come home and study and play the piano.[42]

Despite his rancor and loneliness, Horter threw himself into his job. Beginning as a sketch artist when he joined N. W. Ayer in 1917, Horter rose quickly to become an art director, which gave him the authority to assign work for Ayer's clients to artists of his choice. According to his friend and pupil Albert Gold, Horter would frequently assign the work to himself because, unlike most art directors, he was able to produce the finished art work:

[An art director] would commission the artwork from some artist . . . whose reputation and past performances guarantee success with the client's needs. . . . He never did the finish, almost ever. The only one who did the finish when he wanted to was Earl Horter because his skill was a kind of universal skill.[43]

The year 1919 was the fiftieth anniversary of N. W. Ayer's founding, and the company experienced a boom. The volume of business increased by more than seven million dollars and profits passed the half-million dollar mark.[44] At that time, Horter wrote to Zigrosser of working day and night and complained of too many long hours on the job. The most important Ayer client he was working for was the Joseph Dixon Crucible Company. From 1919 through the mid-1920s Horter made about fifty-five pencil drawings advertising Dixon's Eldorado pencil, the "Master Drawing Pencil," which (unlike

Dixon's common-use Ticonderoga pencil) was marketed to artists, draftsmen, and architects. Since the 1870s Dixon had used pencil drawings to advertise its pencils, letting the product speak for itself.[45]

For Horter, the Dixon commission was not unlike one he had completed for the New York Edison Company several years before, as there were almost no restrictions on subject matter. He was to travel around the world to draw, with the Eldorado pencil, virtually anything that appealed to him (fig. 14). His advertisements appeared mostly in magazines for artists and architects, such as *American Artist*, *Pencil Points* (now *Progressive Architecture*), and *Printers' Ink Monthly*.[46] The texts accompanying his Eldorado drawings often included his name so that the reader "followed" the artist on his travels around the world, as in one advertisement: "Writing from Europe, Earl Horter tells us with what

keen delight he rediscovered this ancient doorway. . . ." Occasionally an advertisement would include Horter's personal endorsement of the product; he virtually became "the Eldorado Artist."[47]

Horter saw the advantage in the freedom allowed him by the Dixon commission: he was able to reuse some of his earlier work in the Dixon drawings, even as he made etching plates after some of them. One of his letters to Carl Zigrosser suggests this overlap: "Am doing things in a way that best goes with the stuff I do for a living." One of his methods was to recycle images from his earlier work in his advertisements. For example, his 1913 etching *Ye Olde Curiosity Shop, Nantucket* (fig. 15) provided the basis for an Eldorado drawing of 1920 (fig. 16). He cropped the earlier image slightly, removed figures, and altered several details such as the shop front's lettered plaques, where on a secret, playful note he placed the names of his N. W. Ayer colleagues: F. Watkins for Franklin Watkins, who had joined N. W. Ayer in 1918; [J. W.] Riggs, which surely stands for Robert Riggs, who started working at N. W. Ayer at the same time as Horter in 1917; and Macom, for an N. W. Ayer artist who was known by his colleagues as the "Pantograph King."[48] In another instance of artistic economy, Horter used a single drawing for commissions from Dixon and the Atlantic Refining Company. Further license with the Dixon Eldorado commission can be deduced from the story his friends told of his practice of making many of the Eldorado drawings after returning from his travels from postcards he had collected.

The Eldorado pencil drawings brought Horter considerable recognition on several fronts. He developed a technique of using a hard pencil on dull-coated paper, which resulted in pencil drawings that had the appearance of etchings. This technique was a godsend, for although the effect of a sharp, etched line was preferable for use in commercial work, the etching technique itself was impractical because, in the increasingly rapid pace of advertising, it was too complex and time consuming.[49] Horter also achieved a reputation for his ability to work successfully in a variety of styles, although while he was an art director at N. W. Ayer there was a noticeable lack of

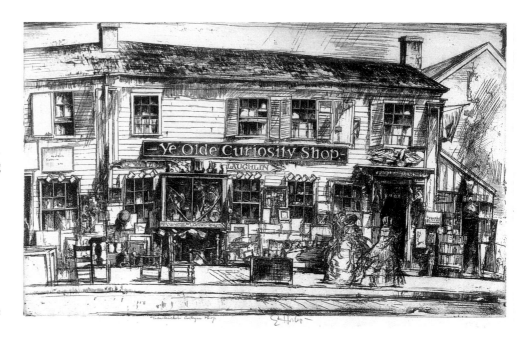

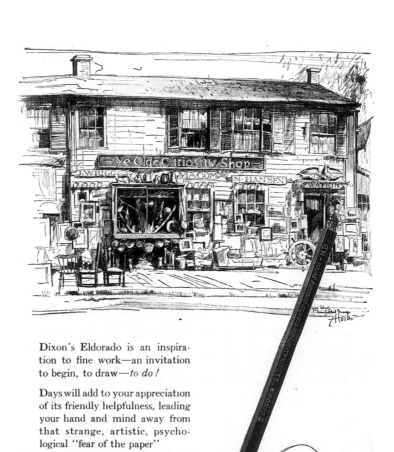

Fig. 15. Earl Horter, *Ye Olde Curiosity Shop, Nantucket,* 1913, etching, 9⅞ x 15¼ inches (25.1 x 38.8 cm) plate. Philadelphia Museum of Art. Gift of Mrs. Alexander Lieberman in memory of her husband, 1944-70-15.

Fig. 16. Advertisement for Dixon Eldorado pencils with Horter's drawing *Ye Olde Curiosity Shop,* 1924.

variety in the kinds of clients for which he worked. When he gained the authority to assign his own work in the early 1920s, Horter seems to have chosen to work for industrial clients: companies producing slate, oil, steel, and automobiles predominated. For these clients he drew buildings and machinery, which, as in his own work, took precedence over people.

Success in business nonetheless produced a quandary for Horter, and he was assailed by doubts about his dual careers in art and advertising, which were the more difficult to resolve because of his ability to make money in the advertising business. In letters written during and just after World War I, he presented his dilemma to Carl Zigrosser with great earnestness:

I am etching a little Carl—but here I would ask your indulgence and advice—I'm really in a position at present to give a lot of time to Etching—BUT—I also have great opportunities to make quite a bit of money, that is of course for an artist. I think with careful planning I can have saved perhaps $10,000 within another year— or less—It seems to me that this would go a long way toward fulfilling my desires and hopes as an etcher and help me well along the acrid highway of the etcher and a much more sensible thing than combining a little etching and a little commercial now. . . . it seems to me if I could give five years straight to it would give me so much more than a continual compromise of being artist and business man at the same time. . . . but it's War— eternally war all around me—Why shouldn't I use my tumultuous days now to lining my coffers with gold and squander it a little later when things are more peaceful—Counsel me please—.[50]

A letter follows suggesting Zigrosser had responded that as long as the war continued Horter should (in his own words) call "an artistic truce." This response naturally engendered even greater self-doubt, and Horter bravely posed the question that was really bothering him:

One thing only I would ask—do you feel I will be able to do fine work some day? works that [are] better than the vast middle class etcher I abominate— Sometimes I think way in me I have a vision that will in its ultimate development yeald [sic] much in my work—I know I love only the best and coupled with an intense fire of desire and unceasing labours ought not this carry me far—I hate mediocrity would ask you for a frank opinion—a helpful one—.[51]

We will never know Zigrosser's answer to this question. However, clues in ensuing correspondence indicate that by 1920, soon after Zigrosser moved to head the print department of the Weyhe Gallery in New York, his interest in Horter's work was on the wane. Zigrosser did include one of Horter's earlier New York etchings, *The Dark Tower* (fig. 17), in the portfolio *Twelve Prints by Contemporary American Artists*, financed by the Weyhe Gallery and published for the gallery's opening in November 1919, but letters suggest that Horter initially had submitted a Philadelphia subject for the portfolio, which Zigrosser was not pleased with: "Am sending under separate cover a proof. It is one of the Philadelphia subjects and I think would be a good one for the Folio." In another letter Horter wrote:

Peters tells me you did not like the prints we made for you as samples—I thought they were good but we can follow the print sent just as well—I am working on some other subjects—and think you will be interested in them. I have a new plate on the one we had originally for the folio—a much better plate.[52]

The *Twelve Artists* portfolio was not, in any case, a success. Zigrosser later lamented that he had not exercised enough editorial judgment, feeling that some of the artists "represented a compromise with the prevailing taste." He further regretted not having included the work of Arthur B. Davies, George Bellows, and Julian Alden Weir.[53] In 1919 Horter's art was in a transitional state; Zigrosser's decision to include one of his earlier etchings in the portfolio suggests that Horter may have been one of the artists Zigrosser regretted having included. Moreover, while Horter and Zigrosser maintained their friendship off and on after 1920, and Horter was an active client of the Weyhe Gallery, his own work never was represented by Weyhe.[54]

As time went on, Horter's letters to Zigrosser show that his attitude toward Philadelphia became more positive. He wrote that he had found a delightful studio apartment near the museum, bordering on a park; and, in another letter, that "there are wonderful things to etch . . . and plenty to do." He added that he had found "a fine old printer—who is willing to be taught and having heard of me in advance thinks much

more of me than I do of myself." This printer was almost certainly Gustav Peters mentioned in another letter, who was one of two brothers in charge of an old family printing firm in Philadelphia. Known after 1904 as Peters Brothers, they printed etchings for such artists as John Sloan and Joseph Pennell.[55] Clearly Horter was working hard at etching: "I do hope to have ten plates this year—in fact sure to have them ready—good ones too."[56]

The Zigrosser correspondence also vividly documents the evolution of Horter's taste during his first years in Philadelphia. For example, the apparent lack of conflict between his taste for the traditional and the modern surfaces in a letter of about 1918 in which he expressed interest in Muirhead Bone's etchings even as he thanked Zigrosser for sending him Robert Coady's *The Soil* (fig. 58), a monthly magazine published only between December 1916 and July 1917 that advocated modernism, popular art, and "primitive art" while poking fun at the avant-garde:

Thanks for the SOIL—I have been in touch with it and have a complete set. I'm for it. It shocks me too on one page and gives me a new thrill on the next. It's kind of hard to analyze and is free indeed. By the way—getting away from the Soil—if you see any opportunity to have any [Muirhead] Bone etchings photographed I will send a check to cover all I can get.

By the time Zigrosser began to work at the Weyhe Gallery in 1919, however, Horter's taste had moved decisively toward the moderns, for he ordered books from Weyhe on Kandinsky and Gaudier Brzeska and wrote, "Be sure to send over anything new on my favorites— Matisse, Picasso, Braque, Kandinsky, Derain, Davies." His growing interest in modern art was also reflected in his increasing boredom with Whistler and Pennell:

Will Whistler ever be new or will the demands of the changes in the world demand something radically different? . . . Joe Pennell is rather tiresome at times. No one knows anything anymore but Pennell and only Whistler ever did a good etching [in Pennell's opinion]. . . . I liked his industrial stuff at the Academy till I examined them—then I hated him for not really loving the precious things of Art—He just snaps the spirit of the scene—and there you are, Another Pennell.[57]

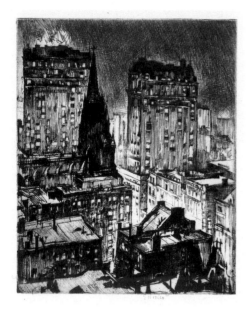

Fig. 17. Earl Horter, *The Dark Tower*, c. 1916, etching, 6⅛ x 4⅞ inches (15.6 x 12.4 cm) plate. Philadelphia Museum of Art. Gift of an anonymous donor, 1942-79-2. Selected by Carl Zigrosser for the portfolio *Twelve Prints by Contemporary American Artists*, 1919.

Fig. 18. Alfred Stieglitz's portrait of Arthur B. Carles in 1923.

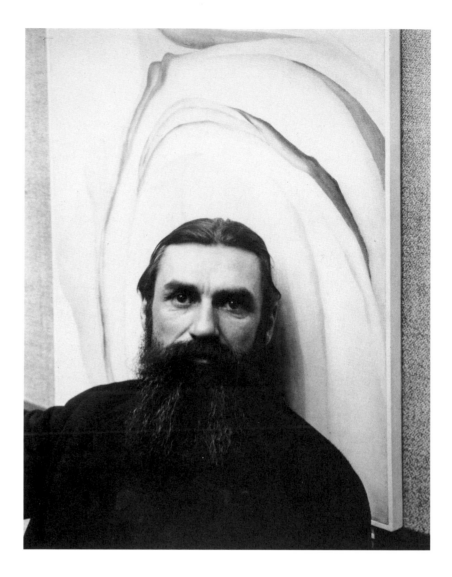

Philadelphia Modernists

A statement made in 1931 by Horter to a reporter reveals how his taste for modern art developed:

Years ago . . . I was an ardent etching fan. . . . But that was before I met any of the Academy people. About twelve years ago I met Henry McCarter and Arthur Carles—men who know art, modern and classic. They influenced me in the direction of the moderns and since then nothing has looked the same to me.[58]

Horter's conversion to modernism began within his first two years in Philadelphia under the influence of a circle of artists at the Pennsylvania Academy of the Fine Arts. During his years in New York, Horter had not been at the center of the avant-garde, but he quickly became a vital part of this group of Philadelphia modernists, whom he met through Franklin Watkins, then a young painter who shared an office with him at N. W. Ayer. Fourteen years younger than Horter, Watkins had just completed five years of study at the Pennsylvania Academy and was working at N. W. Ayer to support

himself as an artist. As Watkins told it: "We were just working away at these ghastly things and had hardly spoken to each other for three or four days. One day Horter turned to me and asked, 'Did you ever hear of a guy named Cézanne?' And that was the beginning of our friendship."[59]

After World War I the vitality of the New York avant-garde had declined: exiled European artists returned home; the Arensbergs departed for California. However, the spirit of modernism thrived among a group of artists and collectors in Philadelphia during the early 1920s. Many years later Franklin Watkins described their excitement:

We were a small group. The impact of what's still called modern art had hit us all and we were all going through this stage of thrilling discovery all the time. Carles was a leader in that. . . . Stokowski was here—he was conductor of the orchestra at that time, and he brought Stravinsky to town; I remember a party for Stravinsky. We all went to that. And there was an awfully good architect named George Howe . . . he built the Philadelphia Savings Fund Building. George Howe and Horter, Stokowski, Leopold Seyffert were in on it. We used to see one another quite a bit; had parties at one another's places and that sort of thing. We were isolated from New York. I mean we looked down on New York painters very much at that time. They were still painting what we called the Dark Brown School.[60]

Music led the way in Philadelphia's modern movement, as the flamboyant young conductor of the Philadelphia Orchestra, Leopold Stokowski,[61] introduced staid and sometimes recalcitrant audiences to the work of contemporary composers. The painter Arthur B. Carles, a close friend of Stokowski, and his older colleague Henry McCarter were the leading artist components of the group, joined by Carroll S. Tyson, Jr., Hugh Breckenridge, Leopold Seyffert, Adolphe Borie, Raphael Sabatini, and others. The architects in the circle were, respectively, the designer of the spectacular PSFS building, George Howe, and Paul Cret, professor of architecture at the University of Pennsylvania, who designed the house and foundation building for Dr. Albert Barnes.

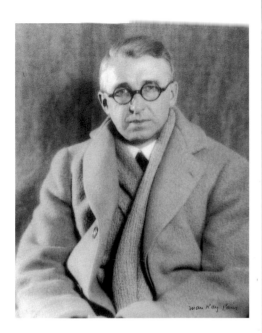

Fig. 19. Man Ray's portrait of Samuel S. White, 3rd, in the 1920s.

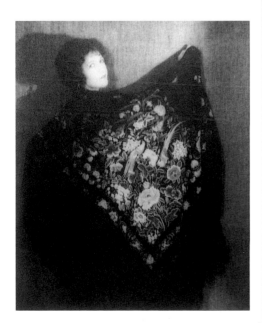

Fig. 20. Man Ray's portrait of Vera White in 1924.

Henry McCarter and Arthur B. Carles were members of the faculty of the otherwise tradition-bound Pennsylvania Academy. After studying at the academy with Thomas Eakins, McCarter had spent time in Paris, where he worked informally with Henri de Toulouse-Lautrec; his spirited experimentation with brilliant color and light, coupled with his verbal gifts, made him a popular teacher.[62]

It was Watkins's former teacher Arthur B. Carles (fig. 18) who made the most profound impact on the Philadelphia art world and more significantly upon Horter's life and art.[63] Horter quickly became part of Carles's inner circle, probably his closest confidant, talking late into the night about modern art, lending him money and buying his pictures, and inviting him to his seaside house on Long Beach Island, New Jersey. Carles had a dramatic demeanor. Tall, bearded, with piercing eyes and an exaggerated perception of his every experience, he described his constant searching for new stimulation as "livingness." Horter had doubtless known Carles's work for a number of years, for Stieglitz gave Carles a one-man exhibition at 291 in 1912, and he was included in the Armory Show. During his five years in Paris between 1907 and 1912, Carles met Gertrude Stein, visited the art galleries, and deeply admired the brilliant colors of Matisse's palette, which affected his own work. After joining the faculty in 1917, Carles, with McCarter, was responsible for blowing the fresh air of French modernism into the staid classrooms of the academy.

Philadelphia art collectors flocked around McCarter and Carles, and many collections of modern art built by Philadelphians in the 1920s began as a result of their enthusiastic encouragement.[64] They consisted of members of affluent old Philadelphia families, such as Carroll S. Tyson, Jr. (also an artist), and R. Sturgis Ingersoll, and well-to-do businessmen like Samuel S. White, 3rd, Alexander Lieberman, Bernard Davis, and the attorney Maurice Speiser, not to mention the advertising man Earl Horter. Omnipresent but not part of the group was Dr. Albert Barnes, the most avid collector of them all. The collectors' approaches varied. Tyson and Horter, as artists from differing backgrounds and financial resources, had

collections similar in their concentration upon spectacular examples of a few favorites. For Horter it was Picasso and Braque; for Tyson it was Cézanne and Renoir. The attorney R. Sturgis Ingersoll, from a prominent Philadelphia family and a close friend of McCarter's, kept his wide-ranging collection in his houses in the city and his large country house at Penllyn. Ingersoll's tastes were considered to be radical for his time, and he was responsible for a number of the museum's early acquisitions of modern art, such as Picasso's *Woman with Loaves*, which he persuaded his father to buy for the Pennsylvania (later Philadelphia) Museum in 1931. Ingersoll's own collection included, for the most part, paintings and sculptures by French and Philadelphia artists: Rousseau, Matisse, Derain, Soutine, and Picasso; and Watkins, Carles, McCarter, and Horter.

Other collectors attempted to cover a wide spectrum of modernism. Carles's influence was strongly felt in the Speiser, White, and Lieberman collections, each of which included some of Carles's favorites: Matisse, Jules Pascin, Moïse Kisling, and Utrillo. Maurice Speiser, who was the attorney for Carles and Stokowski as well as a friend of Brancusi, installed his collection of mainly French and Russian as well as Philadelphia artists' work in a modern townhouse at 2003 Delancey Place designed in 1933 by George Howe. Alexander Lieberman, a realtor in Elkins Park, collected French and American moderns, including many prints, and watercolors by Marin, Demuth, and Joseph Stella, as well as a group of African sculptures. Heir to a dental equipment business, Samuel S. White, 3rd, and his artist wife, Vera (figs. 19 and 20), traveled widely, collecting paintings, sculpture, pottery, textiles, and works on paper from many periods and parts of the world. Among the moderns their favorites were Matisse, Braque, Picasso, Rouault, Utrillo, and the Americans Demuth, Marin, and Carles. The Brancusi *Danaïde* (pl. 2), which they bought from Horter's collection, graced the newel post of their suburban house in Ardmore, Pennsylvania. The Whites were friends of Horter's, and their names appear often in his correspondence with Carles, where he sometimes made fun of their pretensions. Nonetheless, they saw a lot of each other

and enjoyed sharing their collections. The Philadelphia artist Emlen Etting paints a vivid portrait of the Whites, mixing humor with admiration for their collection, which sheds light on Horter's attitude toward them:

Sam White's family had made a fortune manufacturing dental equipment and he had inherited the business. His wife, Vera, was pretty, opened her eyes wide on the world, and painted pretty floral subjects. Early on in their marriage, they had decided to go into ART, so they went to Europe and, in time, astutely acquired a distinguished array of works by outstanding artists. The small suburban house itself was unimpressive, and the first thing I noticed in the hall was a list of numbered outgoing calls Vera kept next to the telephone to make sure the Bell Company was not cheating on the monthly bill. Over this, incredibly, hung a glowing Matisse—Seated Nude. We were ushered into a large studio type room filled with Oriental artifacts, Korean scrolls, sculpture by Carl Milles, Despiau, Brancusi and, on a pedestal, a small bronze by Rodin: The Athlete. Sam White himself had posed for this in his boxing days, Vera informed us—a fact at this point hard to imagine. Crowded together were well chosen works by Rouault, John Marin, Picasso, Demuth, Marcoussis, and an excellent portrait of his wife by Cézanne—not to mention several of our hostess's floral fantasies. As we moved about admiringly, a Brahms Symphony flowed relentlessly into the room through a loudspeaker concealed behind a tapestry.[65]

The Russian-Jewish immigrant Bernard Davis housed an immense collection from twelve countries specializing in post-1925 Russian and French artists, including George Anenkoff, Jean Souverbie, André Favory, Marc Chagall, the Italian Futurist Gino Severini, and many others, in a gallery adjacent to his textile business in the Frankford section of Philadelphia. Called La France Art Institute after Davis's La France Textile Mills, the gallery was open to the public, while at Davis's house at 1914 Rittenhouse Square more modern works were displayed in theatrical settings. As one visitor described the Davis collection:

None of the old school of modernism has been included. Fauvism, Cubism, and (with the one exception of Marcoussis) Abstraction have all been eliminated. Picasso, Matisse, Braque, and Derain have already become old masters and here provide only a background for the present school of younger painters.[66]

With the exception of Horter, few Philadelphia collectors focused on acquiring abstract art specifically and none shared his passion for early Cubism. In general, brightly colored landscapes, still lifes, and nudes were preferred. While Carles may have been the initial inspiration for Horter's collecting of modern art—and his influence can doubtless be felt in some of the individual works in his collection—the austere Cubist core of the Horter collection was the true reflection of Horter's own taste.

In 1920 Carles, along with Carroll Tyson and academy alumnus William H. Yarrow, organized the *Exhibition of Paintings and Drawings by Representative Modern Masters* at the Pennsylvania Academy of the Fine Arts, to which Horter lent six lithographs by Vuillard (undoubtedly from the set he had purchased at the Armory Show) and a Toulouse-Lautrec.[67] Horter also offered, in a letter to Carles, to lend other prints from his collection "at a moment's notice," stating that he had five Toulouse-Lautrec prints (one in color), a Mary Cassatt, a Maurice Denis, and two by Käthe Kollwitz.[68] Most of the loans to the 1920 exhibition came from the New York dealers Alfred Stieglitz and Marius de Zayas and collectors such as Walter Arensberg and Lillie P. Bliss. A few others in addition to Horter were Philadelphians, such as relatives of Mary Cassatt, who lent over forty of her works, and Tyson, who lent two Daumiers, a Whistler, and a Monet. The *Representative Modern Masters* exhibition was intended to provide an introduction to modern painting. In his catalogue introduction, Leopold Stokowski exhorted Philadelphians to accept Cézanne, Picasso, and Matisse as they had learned to appreciate the music of Debussy, Strauss, Scriabin, Stravinsky, and Schoenberg. Carles installed the exhibition didactically, as a chronological survey presenting modernism as part of a continuum that extended from Courbet, Whistler, and the Impressionists through the Post-Impressionists, to contemporary Europeans such as Picasso, Braque, and Picabia, and the American Synchromist painter Stanton MacDonald-Wright.[69]

In the following year William Yarrow formed a selection committee made up of New York and Philadelphia artists to organize a second exhibition at the academy.

This time concentrating upon a wide spectrum of styles of contemporary American art, the 1921 *Exhibition of Paintings and Drawings Showing the Later Tendencies in Art* was based upon the model of the *Forum Exhibition of Modern American Painters* that had been held in New York in 1916.[70] It was from the academy exhibition that Horter made his first documented and identifiable purchase of a modern painting: Joseph Stella's *Water Lilies* (pl. 85), a small painting on glass, for which he paid $80.[71] Stella's six submissions to the exhibition covered a range of his diverse styles, which included delicate silverpoint drawings, the brilliantly colored, naturalistic *Water Lilies*, and his large and bombastic painting of 1913, *Battle of Lights, Coney Island, Mardi Gras* (Yale University Art Gallery, New Haven, Connecticut). Horter's acquisition of the *Water Lilies* was not especially adventurous, given the Cubist paintings he would soon purchase, but may be typical of the beginnings of his collection, when he seems to have concentrated upon paintings by American artists. It is not surprising that among his early purchases, besides the Stella, were paintings by his friend Arthur Carles; seven paintings are listed in one of Carles's notebooks as being in Horter's home at 1826 Spruce Street, where he lived between 1920 and 1923.[72]

Not only did Horter collect Carles's paintings but his art also began to show the influence of Carles's style, even though he would continue to make and exhibit more traditional etchings for several years. When they met in 1918, Carles had been concentrating for the previous five years or so almost solely upon painting the nude; Horter's introduction of the nude into his vocabulary of nearly exclusively architectural subjects was due to Carles's influence. For a time Horter took classes from Carles and, as he wrote, "I can't tell you how much your work and the classes have helped my own outlook."[73] Horter's initial nude subjects were mostly etchings and pencil drawings, but by 1923 he had done a nude in brilliant watercolor, which was acquired in that year by the Art Institute of Chicago (fig. 21). Watercolor was not a new medium for Horter; he had included three watercolors in the 1912 edition of the Edison Company's *Glimpses of New York* and had probably used watercolor in other advertising commis-

Fig. 21. Earl Horter, *Nude*, c. 1923, watercolor on paper,
14¼ x 15 9/16 inches (37.5 x 39.5 cm) The Art Institute of
Chicago. The Brown Bigelow Purchase Prize, 1923.336.

Fig. 22. Anna Warren Ingersoll in the 1920s.

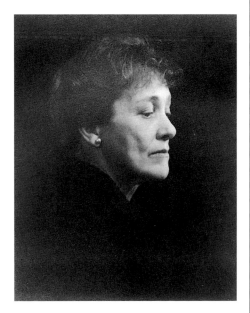

sions. However, the influence of Carles's far
more dramatic and painterly nudes is
reflected in the open, reclining pose of
Horter's model and the brilliance of the
color and its free application in the back-
ground behind the rather skimpy and unpre-
possessing figure.

The 31 Exhibition

The event that in every way embodied the
spirit of the Philadelphia artists at the begin-
ning of the 1920s was an exhibition called the
31. Led by Carles and McCarter, Horter and
other Philadelphia modernist artists formed a
committee early in 1923 to organize this
exhibition, which was held from April 3 to 14.
Fortunately, a great deal is known about the
organization of the *31* exhibition from the
diary of Anna Warren Ingersoll (fig. 22), sister
of R. Sturgis Ingersoll and an artist-member
of the group, who engagingly recounted the
committee's daily activities, which were
sometimes disorganized and occasionally
exasperating but full of lively meals, discus-
sions, and above all, fun.

The *31* took its name from a 1917 exhibition
of thirty-one artists at the James McClees
Gallery, which had been generally recog-
nized since the first decade of the century
for its avant-garde exhibitions. The second *31*
exhibition also included thirty-one artists
but not all the same ones.[74] In 1923 the orga-
nizing committee consisted solely of artists:
Henry McCarter, Arthur B. Carles, Franklin
Watkins, Earl Horter, Anna Ingersoll, and
another former academy student, Christine
Chambers. The artist committee was
responsible for every aspect of the exhibi-
tion, which included selecting the partici-
pating artists, finding an exhibition space,
and furnishing and installing it.

It seems that the committee's first meeting
took place only six weeks before the open-
ing. As Anna Ingersoll wrote on February
27: "Met 31 exhibition committee at Horter's
for tea consisting of Christine [Chambers],
Carles, Watty [Franklin Watkins], Horter,
and me. McCarter being absent. It will be
fun."[75] A week later she wrote that she had
persuaded the owner of an empty new
building at 1607 Walnut Street to lend the
entire second floor for the exhibition. It had

no heat and no electric light or water but had large windows and skylights. The artists whitewashed the walls and furnished the space with donations from local furniture companies. The logistics were not always easy, and Anna Ingersoll describes a sofa stuck in the stairwell that eventually had to be hauled up by the elevator operator with block and tackle. Other aggravations were personal: McCarter driving Anna Ingersoll "insane" and Carles reported to declare gloomily on March 27, "If we don't do something about the show there won't be any." Carles and McCarter probably hung the show, with the other members of the committee drifting in and out, and on April 2, when it was nearly done, Carles, Watkins, Raphael Sabatini (known as Rafe), Julian Levi, and Anna Ingersoll went to a French restaurant "where we could have cocktails and where for a few minutes we seemed to be in Paris."

The opening tea was on April 3 with about two hundred guests in attendance; Dr. Albert Barnes arrived on the following day and Leopold Stokowski on April 5. With satisfaction, Anna Ingersoll wrote on April 3: "The room with spring air, white walls, nice furniture, rugs, and people was lovely and later with candles. Some of the pictures create much conversation especially a single breasted nude of Watty's [Franklin Watkins]." According to one reporter, the installation must have been planned as a protest against "the entire established order of current picture display,"[76] an allusion to the then-unusual use of white walls, strip frames, and the generally comfortable atmosphere, all of which was proclaimed a great success. The press, however, was not completely enthusiastic about the art: "The spectator must proceed . . . with an entirely open mind. . . . If one find[s] subject and composition frequently bewildering among The 31, there will surely be few who will not take a sort of primitive delight in the extraordinarily vivid color combinations."[77] Of special note were the nudes that had numbers as titles. These belonged to members of the artist committee who, wanting to vary the titles of so many nudes, named their pictures after the street numbers of their houses or studios.[78] Carles waxed ecstatic about the exhibition, and his remarks to the press characterize the attitude of the

Philadelphia modernists toward the Pennsylvania Academy:

Don't you think it is the best hung show you ever saw? And don't you think these are the most talented students that came out of the Academy? You see one kind of student goes up the Delaware River and the other kind goes to Paris. This is the Paris kind and most of them don't get into the Academy. . . . I think it is a lot more interesting than the dead wood that is admitted.[79]

Horter and Charles Demuth were paired in more than one favorable review, apparently because the formal structure of their work was more clearly understood than was that of some of the others. Unfortunately, none of Horter's eight exhibited works, which included five or six drawings and one watercolor, can be identified, but two reviews provide clues about his style of the moment:

Both Horter and Demuth . . . are wrenching order from the chaos which bewilders some of their colleagues. . . . Horter also sees beauty, but he reacts to a pleasing contour of line and mass, which in itself creates a pleasurable reaction. There may be strange drawings of the nude form, or of flowers, but they possess a fluid rhythm.[80]

And in another: "There is the occasional piquant use of a geometric motif."[81]

Anna Ingersoll's diary entry for April 13, at the closing of the 31 exhibition, characterized the diverse composition of the Philadelphians who had supported the exhibition and the artists who had organized it with a cooperative spirit they never again were able to duplicate:

This p.m. had a select tea of all the patrons of the show . . . some 100 people and many droppers in— The Rich quartette played the Ravel. . . . And Leopold [Stokowski] talked on modern art and the 31. . . . Afterwards exhibitors, drunk & sober (not very drunk!) sat in the light of many candles & told each other how marvellous they were & how epochmaking the show until finally Chris, Sara, Carles, Mac and I started for the French restaurant but lost Carles on the way—A peaceful two-hour dinner.

Horter's life was extremely full during the months following the 31 show. At nearly the same time, the Brown-Robertson Gallery in

New York held a retrospective of his etchings and drypoints, which included some new work as well as a range of prints from the past ten years. The works in the exhibition epitomized Horter's chameleonlike nature as an artist. Rather than showing the modernist nudes and flower pieces he exhibited with the 31, he seems to have returned to the style and subjects of his earlier etchings in the new work he showed at the Brown-Robertson Gallery. One reviewer praised Horter's incredible command of detail in one of his new plates, *The Old Barkentine* (fig. 23): "All the intricacies [are] so accurate as to pass muster with a seaman, a quality which deserves mention since there are artists who do not seem to feel that this kind of fidelity is inessential."[82] Overall response to the exhibition was positive and respectful, one reviewer noting Horter's longstanding importance in the world of traditional printmaking: "Mr. Horter, who has been etching for ten years or more, is one of those most clearly responsible for the etching renaissance in America."[83]

Even as Horter was moving so easily between two opposing trends in his art, his social life was thriving. A letter from the painter Helen Seyffert to Carles complained of hearing no news from Horter in six months: "Mac [McCarter] wrote me and asked if I knew whether Horter had a girl . . . and by God I think old Bill *must* be again in the throes of love."[84] Other letters received by Carles mention Horter's seaside cottage in Barnegat, New Jersey, as a popular retreat in the summer of 1923; his new "girl" must have been in residence, for Carles's daughter Mercedes wrote somewhat plaintively to her father in August, "Will your accepting [Horter's] hospitality make it necessary for you to chaperone his friend for the last week of August?"[85]

Horter's new love was probably the young painter from Detroit, Sophie Victor, who was a student at the academy between 1922 and 1924.[86] Her affair with Horter coincided with his second European trip for the Dixon Eldorado pencil commission, on which she accompanied him in the autumn and winter of 1923–24. By this time Horter was working as a freelance artist for N. W. Ayer and Son, for on October 5, 1923, just before his depar-

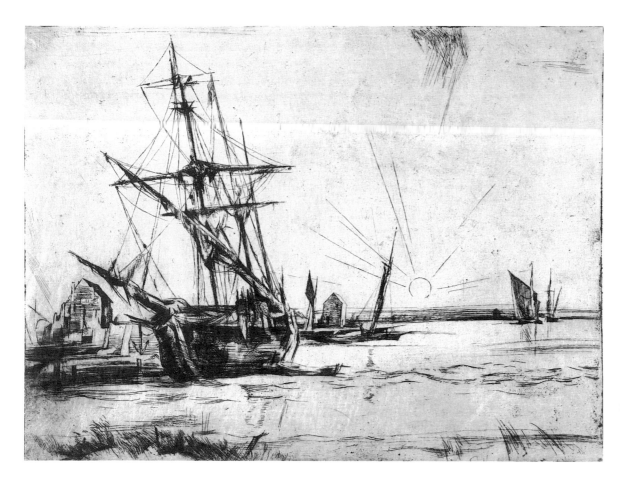

ture for Europe, he left N. W. Ayer's regular staff. The reasons are unknown, but it seems significant that both he and Franklin Watkins left N. W. Ayer at the time of a major turnover in the company's management after the death of its president, Francis Wayland Ayer.[87]

The Eldorado Pencil Artist

Departing aboard the *Paris* on November 24, 1923,[88] Horter and Sophie went first to France, where he continued his work for N. W. Ayer as "the Eldorado pencil artist." Since some of these Eldorado drawings are precisely dated, it is possible to follow Horter on his travels: in November he drew Amiens and Moulin; in December he was in Tivoli; and in January, in Grasse. In southern Italy in February, when he and Sophie were exhibiting paintings *in absentia*, each for the first time, in the 1924 *Annual Exhibition of Painting and Sculpture* at the Pennsylvania Academy,[89] they encountered Anna Ingersoll in the Hôtel de Londres in La Cava. As her diary records for February 7, 1924, she was delighted to see them, for they apparently offered a refreshing diversion from her more staid traveling companions. She spent

the evening looking at their pictures and observed, "What a change this talk was!" Two days later, she wrote that one of her companions, a Miss Coles, "reproached me for not introducing Horter and Sophie—and I thought I had shown such tact!" In later years when Anna Ingersoll added notes to her diary entries, she wrote about her meeting with Horter and Sophie in La Cava: "I had broken my neck *avoiding* introducing 'The Horters' to the family. . . . Miss Coles said it had been her only chance to ever meet people openly living in sin."[90]

During his travels Horter wrote to Carles, describing in one long letter his vivid impressions, which distracted him from work:

Well—here we are on the Riviera—not so damn good but better than Phillie—We don't like it here much—it's swell sort of and lots of Goddam English—are leaving for Italy tomorrow. . . . Fell in with a guy who runs a limousine around Nice all winter for swells—who was coming down here about the same day we decided to leave Paris flat and in company with his nice French wife we started through the god-damdest finest country ever. Beautiful villages and country for two or three days—quaint hotels to stop at—some with piss pots and some without—Gee they were funny as hell but always marvellous good

food. . . . We left Grenoble and for three days came through the French Alps . . . Jesus it was great but sure looked dangerous—saw the same road we left sometimes hours back thousands of feet below our feet. . . . [I work] a little but the result rotten as this town is not IT yet and guess till I get to Sicily I will still feel transient—Plenty to do—but can't settle my excited mind—too much to take in—all wonderful—Guess this trip will prove I'm no artist—but I will not try to force anything even if I don't bring home a brush stroke. . . . I miss you a lot a hell of a lot and unless you get over in the Spring I probably won't stay so long.[91]

By the time they reached southern Italy and Spain in February and March, Horter seems to have succeeded in working, and the trip proved to be significant for his development of a Cubist-inspired style. The six watercolors he later submitted to the academy's watercolor exhibition included four Spanish and one Italian subject, and his two paintings in the academy's 1925 *Annual Exhibition of Painting and Sculpture* depicted Toledo and Sorrento. Abandoning the modernist nudes and flowers he had shown in the *31* exhibition, Horter now applied the new style to the architectural subjects he had favored in his earlier etchings, as seen in a sketchbook he purchased in Palma de Mallorca (fig. 24). Cézanne was the inspiration for the blues

and greens of his watercolor *Toledo* (fig. 25), but his watercolor technique was emphatically his own: working over a very slight pencil sketch, he applied the colors in large, wet, cleanly articulated blocks, leaving large areas of paper blank for the whites.[92] In Horter's painting *Toledo I* (fig. 26), shown at the academy in 1925, he drew upon another source: Georges Braque's 1908 paintings of L'Estaque in which cliffs and aqueducts are piled up in precipitous blocks over the entire surface of the composition.

About 1925 there was a perceptible lull in the enthusiasm that had propelled Philadelphia's group of modernists in the earlier 1920s. The reasons are unclear, but Carles had been the leader of the group, and his dismissal in 1925 from the academy's faculty, amid much student protest, and his recurring health problems and related alcoholism must have had something to do with it.[93] None of Carles's paintings were included in the academy's 1925 annual exhibition of painting, in which Horter and Sophie both exhibited, and from 1926 through 1929 neither Horter, Watkins, nor Carles showed in the academy exhibitions; whether their absence was a protest against Carles's dismissal is a provocative but unanswered question. However, there is no doubt that the spirit that had united the artist committee of the 31 had dispersed. Enthusiasm had petered out after a less successful exhibition in 1924, during which arguments broke out among the committee members, particularly between Carles and

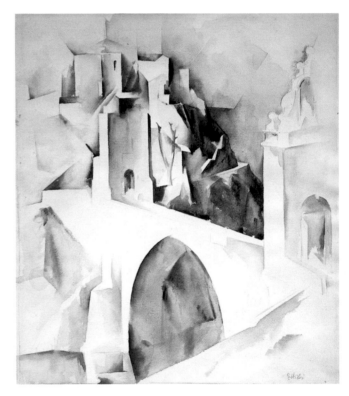

Fig. 24. Earl Horter's sketchbook purchased in Palma de Mallorca in 1924. Private collection.

Fig. 25. Earl Horter, *Toledo*, 1924, watercolor over black crayon on paper, 16 ¹¹⁄₁₆ x 15 ¼ inches (42.4 x 38.9 cm). Philadelphia Museum of Art. The Samuel S. White, 3ʳᵈ, and Vera White Collection, 1967-30-42.

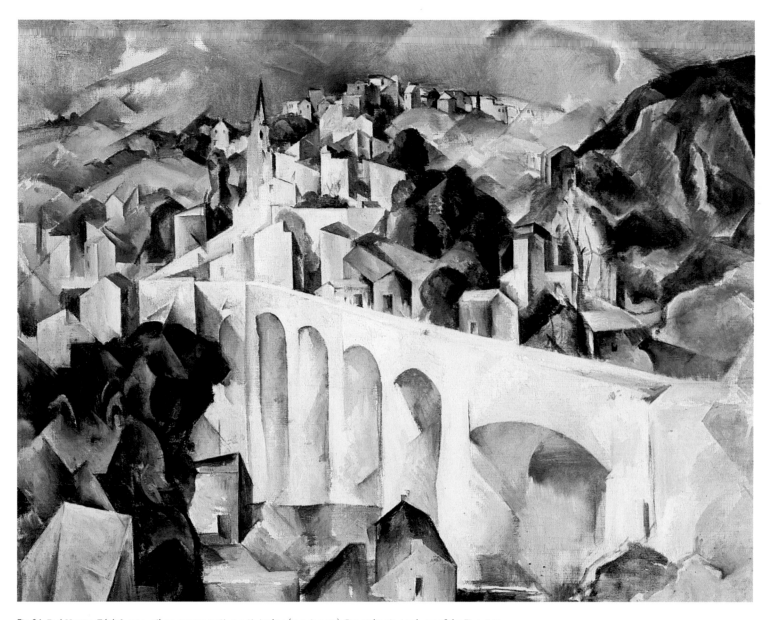

Fig. 26. Earl Horter, *Toledo I*, 1924, oil on canvas, 20¹/₁₆ x 24¹/₁₆ inches (51 x 61.2 cm). Pennsylvania Academy of the Fine Arts. Philadelphia. John Lambert Fund.

McCarter, and on January 27, 1925, Anna Ingersoll wrote in her diary, "Horter tells Chris better no 31 this year."[94]

Nonetheless, during this period Carles, Horter, and their artist friends spent time together in a series of classes offered by Dr. Albert Barnes and his assistant, Dr. Thomas Munro, at the Barnes Foundation in Merion, Pennsylvania. The classes began in February of 1925 and continued with varying degrees of regularity through the 1927–28 season; Anna Ingersoll's diaries again provide a running commentary, reporting on February 8,

1925, that Barnes "had invited what proved to be all the 31 [committee]—and Sophie." The class encountered Barnes's ire when some of them went out on the balcony to smoke, but they were allowed to continue and accompanied Dr. Munro to the Metropolitan Museum in New York on February 25 and, on the following day, visited Philadelphia's University Museum to look at Chinese art and African sculpture. Carles's younger sister Sara, who was also a painter, defended Barnes against the criticism of some of the others such as Anna Ingersoll, who remained skeptical: "[Sara]

puts him in a much nicer light. . . . Must keep notes on lectures. Some of it is surprisingly interesting—He is brutal to the Florentines—picked out a filthy repainted Botticelli to abuse!" (February 24); and later (February 26): "Trying to really study Barnes' book—without complete conviction."

Horter, like Sara Carles, had appreciated the classes, and in May he wrote his thanks to Barnes, no doubt sincerely, but with an uncharacteristically dramatic fervor that flattered the recipient:

Yours is the greatest—most comprehensive work in Art education and appreciation that has ever existed in the World and if the work seems at times like shooting a barrage out into the night—with its consequent discouragements—do not entertain them. . . . I hope you will believe in the few of us who believe in your work as it stands and help you in small ways on the outside—fighting the lesser battles and tempering those who would be antagonistic. Please accept our gratitude—now in words—later I hope in the Art of Painting itself.[95]

Barnes's reply was grateful but tempered with his bitterness about the lack of comprehension of the rest of Philadelphia's artists:

Thank you for your kind and appreciative letter which is doubly valuable because you were one of the very few artists who showed by your work of the past season that you realize how useful the Foundation can be made to painters. The rest . . . seem to have missed the point—they believe that merely looking at pictures is all that is necessary; they ignore the fact that until they know what to look for, they will never emerge from the sloppy kind of idle reverie that keeps them from realizing their own talents. . . . So I am going to work other and more promising fields and let the painters go their own way. We mean business and they don't.[96]

Only two exhibitions, which were held in the 1927–28 season, again united the work of some of the Philadelphia modernists. The first was the *Exhibition of Paintings by Seven Philadelphia Painters*, organized by the Wildenstein Gallery in New York in October and repeated at several sites in the Midwest. Adolphe Borie, Arthur B. Carles, Hugh Breckenridge, Earl Horter, Henry McCarter, Carroll Tyson, and Franklin Watkins showed their work to a somewhat mixed response by New York critics, who were unanimous in their surprise that the Philadelphia artists were less conservative than they had expected. Watkins, who had never before exhibited in New York, elicited the greatest interest; the critic Henry McBride characterized his work as that of a young man with an "un-Philadelphian style" who had not yet found himself. He labeled Horter as "distinctly the cubist."[97] Five of the eleven works Horter submitted had been done three years earlier during his trip to Europe. However, his magnificent pencil drawing *City Hall: Philadelphia* (fig. 27), which

did not attract the critic's notice, signaled a new departure. His sources of inspiration had expanded to include Robert Delaunay's disjointed Futurist spires, which Horter adapted to his dynamic rendering of Philadelphia's elaborate Second Empire tower; it would not be long before he added other modernist styles to his repertoire.

Later that winter the same group, along with others, participated in an exhibition of modern painting and sculpture by Philadelphia artists that opened in February at Philadelphia's McClees Gallery. This exhibition met with a decidedly less than enthusiastic response and was labeled by a reviewer as disappointing, derivative, and lacking in the liveliness of the 31 exhibition of 1923. Horter, who had submitted only one painting, *Senlis*, which was probably done during his 1924 European trip, received moderate praise for "one of the able bits of landscape"; the same reviewer said what the artists themselves, for various reasons, seemed to be experiencing: "So far as one may determine from the present exhibition, the years have not brought any particular advance."[98]

Although Horter exhibited his work less frequently between 1925 and 1930, his advertising career was booming and his reputation in that field continued to grow. In 1927 he proudly stated:

I do a great deal of work for New York now. Almost every new building that goes up in New York, I make full page illustrations of it. I just finished the French Building, the new Savoy Plaza Building, the New York Life Building . . .[99]

He was freelancing for several different agencies, and each year between 1926 and 1931 his work was included in the annual exhibition of the Art Directors Club in New York, with his drawings submitted by eight different advertising agencies; in 1928 he served on the club's exhibition committee. Although the fast pace of the advertising business and the brief lifespan of advertisements often obscure the importance of an advertising artist's reputation, it is worth recognizing that by the late 1920s Horter had reached the pinnacle of the profession. In 1930 an article in the journal *Advertising Arts* proclaimed: "There is no doubt that Horter has contributed markedly to the

respect with which artists regard the advertising business."[100]

Horter's advertisements were no longer predominantly pencil drawings; he frequently produced work in watercolor or gouache. One of his most important works in color was commissioned in 1927 for Steinway and Sons, a client of N. W. Ayer: a splendid color evocation of George Gershwin's *Rhapsody in Blue* (fig. 28), which had premiered at Carnegie Hall in 1924. According to a former N. W. Ayer executive, Warner Shelly, who as a young man in the mid-1920s was associated with the Steinway account, the idea to make a painting of *Rhapsody in Blue* originated from the desire of N. W. Ayer's head art director, Vaughan Flannery, to persuade Steinway executives to commission modern paintings for the company's large collection of artists' portraits and works inspired by musical compositions. Initially, the Mexican artist Miguel Covarrubias had received the commission for *Rhapsody in Blue*, but Flannery rejected his painting even before showing it to Steinway because it included cavorting dancers with trays of alcoholic drinks, unacceptable images during Prohibition, especially for the conservative Baptist image of N. W. Ayer. Flannery then gave the commission to Horter;[101] the timing was perfect for him, coinciding with his interest in Futurism. A pianist himself, Horter intuitively grasped the spirit of Gershwin's newest creation and based his rendition of it upon the Futurist Gino Severini's 1912 composition *Dynamic Hieroglyphic of the Bal Tabarin* (fig. 29).

Steinway did not keep Horter's painting for the collection but used it for advertisements in 1927 (fig. 30), and N. W. Ayer submitted it to the annual exhibition of the Art Directors Club in the following year. While the dynamism of Horter's interpretation of the Gershwin composition may have been too radical a first step toward modernism for Steinway executives, it is one of Horter's masterpieces: the composition of vibrating broken planes reveals fragments of skyscrapers,

Opposite:
Fig. 27. Earl Horter, *City Hall, Philadelphia*, c. 1927, graphite on paper, 19½ x 14 inches (49.5 x 35.6 cm). Philadelphia Museum of Art. Purchased with the Haney Foundation Fund, 1972-25-1.

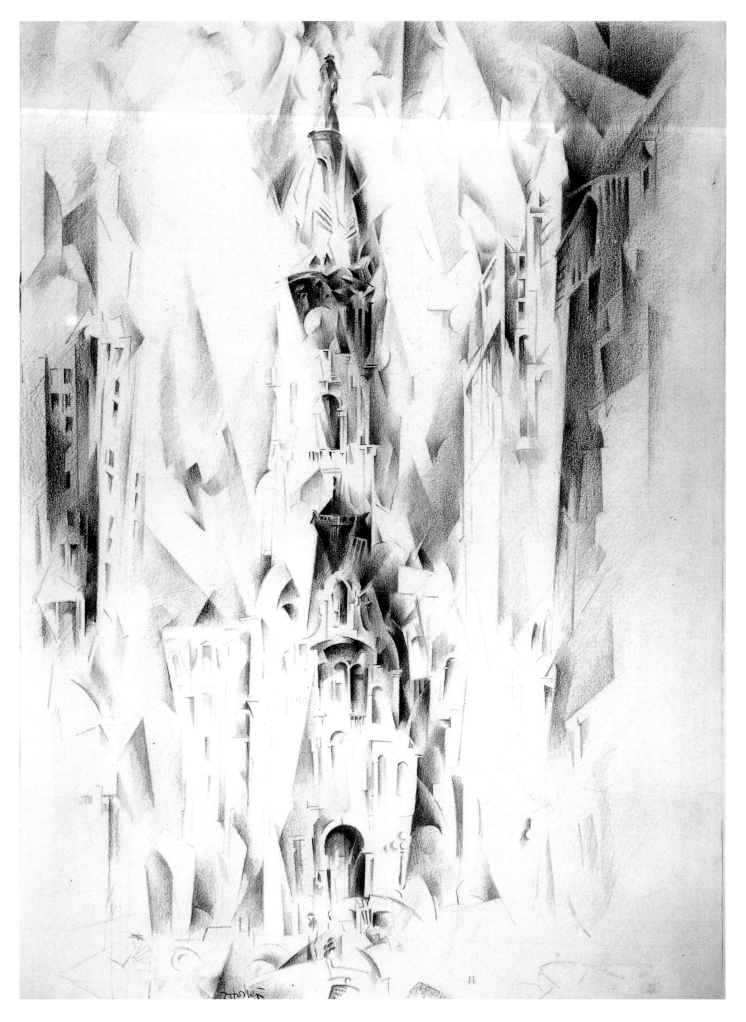

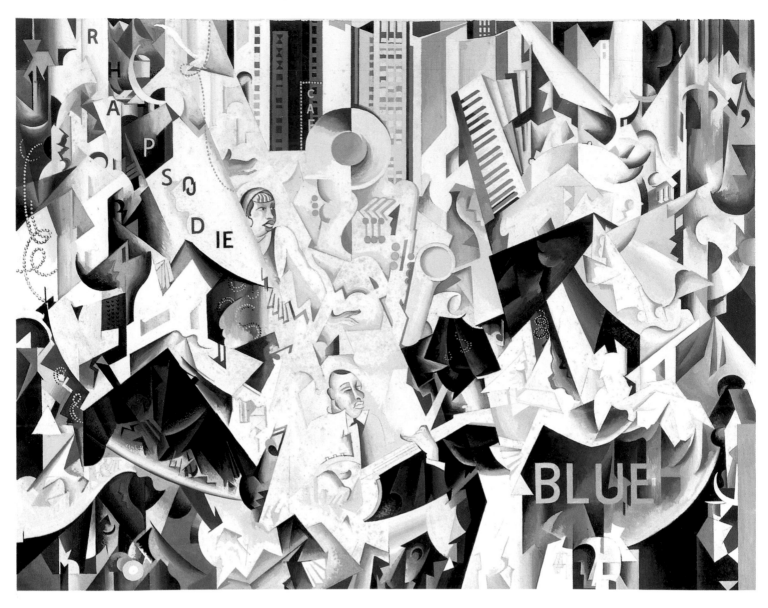

Fig. 28. Earl Horter, *Rhapsody in Blue*, 1927, watercolor and graphite on board, 21⁷⁄₁₆ x 27½ inches (54.4 x 69.8 cm). Private collection..

musical instruments, dancers, and musicians, interwoven with beaded curlicues, musical notes, and fans. According to an N. W. Ayer colleague, Paul Lewis, Horter's *Rhapsody in Blue* was the advertising work of which he was, justifiably, most proud: "This he considers the choicest bit of clover in which an advertising artist has ever been permitted to romp."[102]

"A Feast of Picassos"

He had an eye; he had taste. Today, thirty years after his death, a painting recognized as from his collection is earmarked as close to perfect of its kind. He kept open house, and he and his collection had immense influence in Philadelphia's appreciation of twentieth-century art.[103]

As Horter's own work began to embrace Cubism in the early 1920s, so also did his acquisitions. An early purchase, bolder and more significant than the Joseph Stella painting he had bought at the Pennsylvania Academy in 1921, was Charles Sheeler's *Pertaining to Yachts and Yachting*, 1922 (pl. 82), which was shown in January 1923 in the exhibition of contemporary art at the Montross Gallery in New York. Horter must have purchased the painting directly from the Montross show, for a few months later he was listed as its owner in the brochure of the 31 exhibition when it was exhibited in April 1923.[104] *Pertaining to Yachts and Yachting*, and *Church Street El* (pl. 78), which Horter would also acquire, were paintings that Sheeler himself described as of seminal importance in his development: "In these paintings I sought to reduce natural forms to the border-line of

abstraction, retaining only those forms which I believed to be indispensable to the design of the picture."[105] Horter's acquisition of an important Sheeler painting demonstrates in a powerful way the heights to which his aspirations as a collector had risen by 1923. He was thinking big and buying key works of art— works that probably also held great value for him as an artist; the carefully conceived method that Sheeler described for his *Yachts* was no doubt useful to Horter as he applied his own studious, analytical method to the development of his Cubist style.

Horter's growing taste for abstraction led to another acquisition in 1923, a Synchromist painting by Stanton MacDonald-Wright, which he purchased from the Philadelphia collector Samuel S. White, 3rd, evidently not long before he went to Europe in

Fig. 29. Gino Severini, *Dynamic Hieroglyphic of the Bal Tabarin*, 1912, oil on canvas, 63⅝ x 61½ inches (161.6 x 156.2 cm). The Museum of Modern Art, New York. Acquired through the Lillie P. Bliss Bequest, 1949.

Fig. 30. Earl Horter's *Rhapsody in Blue*, 1927, in an advertisement for Steinway pianos.

November of 1923. He wrote to Arthur B. Carles from the Riviera in early 1924: "Sam seems to have regretted selling me the MacDonald Wright—I only paid him half . . . so I hope he won't try and get it back while I'm away—If he does I wish you would tell Jim Gamble under no conditions to let it get out of the house—or anything else."[106] The MacDonald-Wright, which was entitled *Still Life Synchromy*, 1917, appears in the lists of Horter's collection compiled when it was shown in February 1934 at the Pennsylvania (later Philadelphia) Museum of Art and again that year at the Arts Club of Chicago, but nothing more is known of this painting.

The first contemporaneous mention of Horter's owning the work of Picasso or Braque, which would become his collection's

major focus, appears in Anna Warren Ingersoll's diary entry for February 10, 1923, when she wrote about seeing paintings by Picasso, Braque, and Carles during a visit to Horter's, but she did not elaborate further. In 1965 the artist Leon Kelly wrote a tantalizing story of having bought two small Picassos from Horter "because they did not fit in with his desire to make his collection entirely related to cubisme."[107] It is not known what those non-Cubist Picassos were or when Horter acquired them, which he could have done even as early as his years in New York. However, it is clear that his focus upon Cubism had begun by 1923, which suggests that the works to which Kelly referred would have been acquired before then.

Where Horter made his earliest purchases of work by Picasso and Braque is also

unknown. Although their work could be found in New York, it is possible that Horter made acquisitions during his 1921 trip to Europe for Dixon Eldorado pencils. It is tempting to think that he may have made some of his early purchases on that trip in the company of Arthur B. Carles, who was also in France during 1921.[108] There were an unusual number of opportunities to find Cubist pictures by Braque and Picasso in postwar Paris in 1921—and at reasonable prices. In just May and June of 1921 one could visit a Picasso exhibition at Paul Rosenberg's gallery and a Braque and Gris exhibition at Léonce Rosenberg's Galerie de l'Effort Moderne, as well as the sale of the collection of Wilhelm Uhde on May 31 and the first of the spectacular series of sales of the dealer Daniel-Henry Kahnweiler's stock on June 13–14.[109]

Although many of the works by Braque, Picasso, and André Derain in Horter's collection were at one time part of Kahnweiler's stock, and other works of Braque and Juan Gris seem to have come from Léonce Rosenberg, no firm evidence has been found to document any purchases by Horter in Paris in 1921.

Little is known about the evolution of Horter's taste as he formed his collection of Cubist pictures. However, there are a few indications that he may have initially preferred Picasso's Synthetic Cubist works, with their more varied colors and complex painterly textures, before he developed a passion for collecting the earlier, austere Analytical Cubist paintings he acquired in the second half of the 1920s. Certainly his early purchases of paintings by Carles and MacDonald-Wright in 1922–23 suggest his current taste for colorful abstractions. In early 1924 Horter wrote to Carles of a Picasso he had reserved in Paris: "I left a deposit on a Picasso which represents an early period when he used clay and sand to build up his pictures before he painted over them."[110] It is possible that this refers to Picasso's *Still Life with Cards, Glasses, and Bottle of Rum: Vive la [France]*, 1914 (pl. 46), a Synthetic Cubist painting in oil and sand on canvas with bright colors, exceptional among the Picassos in Horter's collection. Another suggestion of Horter's early taste for Synthetic Cubism is the acquisition of Picasso's 1919 *Still Life with Bottle of Port (Oporto)* (pl. 47), which Horter may have bought in 1923 from the Whitney Studio Galleries in New York, where it was part of an exhibition of recent work by Picasso, felicitously installed by Marius de Zayas with African masks: "No such opportunity to study the recent work of Picasso, under conditions so sympathetic, has been offered before," raved the reviewer in the May 1923 issue of *The Arts*, where the *Still Life with Bottle of Port* was reproduced.[111]

Horter's reputation as a collector grew as the decade of the 1920s progressed and his advertising commissions flourished, yet there are tremendous gaps in our knowledge of the network of sources and contacts he surely had. Transplanted Philadelphia artist George Biddle, who lived in Paris between 1923 and 1926, described the small-ness of the Paris art world at the time Horter made his buying trips:

The gray mist-laden winters in Montparnasse had an undeniable, urbane and cosmopolitan charm. Wrapped in one's overcoat and woolen muffler, one's feet by an open charcoal brazier, one sat the evening through in front of the Dôme or Rotonde, sipping one's porto à l'eau, gossiping in four or five languages; smugly aware that this was the intellectual, the artistic hub of the civilized universe. Sooner or later one met them all, or nearly all of them, these genial, bourgeois, unshaved members of the world's Who's Who in art, who had blazed a path from Paris to Moscow, from Tokio [sic] to Dr. Albert Barnes's mausoleum in Merion.[112]

That Horter was part of this international group is known from several sources. The Chicago collector Elizabeth (Bobsy) Goodspeed (later Elizabeth Goodspeed Chapman) wrote of Horter: "He never was a dealer. He was a painter living and working in Paris during the '20s, and was a friend of all the great artists of that time."[113] Dr. Albert Barnes inscribed a copy of the small catalogue of a 1926 de Chirico exhibition at Paul Guillaume's gallery to which he had written the introduction: "To Earl Horter from Albert C. Barnes, in memory of the Cinzanos absorbed together at the Cafe du Dom, 30 May 1927 Paris."[114] Writing many years afterward, Leon Kelly attempted to recall the sources and circumstances of Horter's collecting:

While I was in Europe during the period of 1924–30 Horter always came to see me. Some Paris dealers would send things over to the studio so that he would be able to see them. Kislings, Pascins, etc. He would usually make his buying tours and if at all possible try to purchase from the artists directly for whom he always had a desire for closer relations. . . . The sources of acquisitions by collector Earl Horter were as far as I can recall from conversation Paul Guillaume, Paris, Jeanne Boucher [sic], Paris, Hotel Drouot sales, and particularly the sale of the John Quinn Coll[ection] in Paris. Being an artist himself I know he was always anxious to contact the artists directly.[115]

One of the shadowy figures whose name crops up in a number of circumstances in relation to Horter's collecting was the French painter and Paris correspondent for *The Arts*, Jacques Mauny, who was responsible for introducing A. E. Gallatin to the Paris art world in the mid-1920s.[116] Mauny was a painter whose bizarre quasi-surrealistic paintings of everyday life possessed a charm that was not lost on collectors such as Horter and Gallatin, who wrote a small monograph on his work in 1928. Mauny made his first two trips to the United States in 1925 and 1927 and became friends with a number of American collectors. Horter and Mauny knew each other by the fall of 1927, when the latter wrote to Gallatin that "[Horter] is anxious to buy all the sculptures by Picasso"; and a month later, referring to one of his own paintings that Horter had bought: "I am very much disgusted with H . . . he never sent me the $500 which he promised to send for the first of Oct. Moreover he never answers my letters . . . when I consider I spent one month on the replica of the White Oxen [pl. 25] I am hurt."[117] Yet, despite their differences, Horter and Mauny were clearly friends, and Horter owned at least seven of Mauny's works. Moreover, Mauny visited Horter in Philadelphia, where he made the acquaintance of the collector R. Sturgis Ingersoll (whom Mauny introduced to a number of French artists in 1929), and Ingersoll also acquired Mauny's work.[118] Given their relationship during these years, there is little doubt that the following letter from Mauny to Picasso of May 31, 1928, refers to Horter:

The American painter I told you about is in Paris for nine days; he is one of the few American collectors who truly understands things and he deeply loves your work (he already has seven beautiful Picassos). I beg your kindness to give us a few minutes, he would like so much to see you. He wants to buy an important work very much. I will telephone you tomorrow morning for your answer.[119]

If this visit indeed took place in 1928 and Horter bought "an important work," it may have been the *Nude*, 1909 (pl. 31), of which Horter would tell Douglas Cooper, the collector to whom he sold it in 1937, "Picasso sold it to me direct."[120] Only one other Picasso painting is purported to have been purchased by Horter from the artist, the small *Heure*, c. 1914 (pl. 45), which he may also have bought on the same visit. In any case, a year or two later Horter sent Picasso four photographs of his collection installed in his Philadelphia living room (see figs. 1–4).[121]

In the mid-1920s Horter's collecting gathered the greatest momentum, and it was then that his preference for the most "difficult" Cubist works of Picasso and Braque emerged—works from the years of their collaboration in 1909 to 1914. And because Horter's taste ran counter to that of most postwar collectors, who preferred the more accessible subjects and styles of the artists' later work,[122] he was no doubt able to acquire works for his collection at comparatively modest prices. At an auction at the Hôtel Drouot, Paris, of "Tableaux modernes" from the collection of Georges Aubry on December 12, 1925, he bought a splendid *trompe l'oeil* collage of 1912–13 by Braque (pl. 7) and a 1912 chalk drawing by Picasso (pl. 42).[123] Early in 1926 Horter wrote to Alfred Stieglitz:

The only balm to my soul over my impoverished pocketbook is the fact that I spent 5,000 last year on paintings mostly Picasso. . . . I expect owing to limited means I will have to limit myself to a few Artists—Picasso, Braque and Marin—I have no Matisse except sculpture—but I hope to be a real Marin patron soon, as soon as I get just a few crooks out of my affairs—I have ten Picassos why not ten Marins.[124]

Horter's use of flattery mixed with self-pity was shameless when it came to buying more pictures. This letter to Stieglitz concerned a reserve he was trying to maintain for too long on a Marin watercolor, when Stieglitz had another customer. In addition to suggesting "why not ten Marins," he was also dangling before Stieglitz the prospect of buying "that wonderful piece of Negro sculpture," and he concluded with a postscript in the same letter: "Will come in in a week or ten days and take my Marin no. 1 away."

Leon Kelly believed Horter's "urge toward collecting paintings came from his relationship with Arthur Carles mainly and what they had seen in the Armory Show of the works of the outstanding modern painters. Horter was fired with the desire to make a collection on this pattern."[125] If taken literally, this interpretation is greatly exaggerated, for Horter certainly could not have intended to emulate the sprawling exhibition of 1913 that surveyed the modernist tendencies in contemporary and historical

art, primarily emphasizing the work of American artists. On the other hand, Kelly's reminiscence assumes new meaning when read in the light of Horter's initial purchases from the sales of the vast collection of John Quinn in 1926, which went straight to the heart of the Armory Show's most controversial works of art. His first purchase was *Mademoiselle Pogany I* (pl. 1), the Armory Show's Brancusi marble infamously called a "hardboiled egg balanced on a cube of sugar."[126] About six weeks later he acquired Duchamp's *Nude Descending a Staircase, No. 1* (pl. 16), the first and smaller version of the painting that had stirred up the greatest furor at the Armory Show in 1913 (by this time the *Nude, No. 2* belonged to Walter Arensberg). Horter showed off his new acquisition of the Duchamp, as recounted by Kelly, who by chance witnessed its arrival in Philadelphia:

One night I was in Philadelphia and walking along Spruce Street with Arthur Carles. It was quite late and suddenly a taxi stopped at the curb. Horter was in the cab and with him a large painting wrapped up. He got out . . . unwrapped the paper to proudly display the painting he had just brought from NY. It was the Duchamp—Nude Descending the Staircase.[127]

Of the Philadelphia collectors who rushed to take advantage of the private sales of John Quinn's collection, Horter made the largest number of acquisitions; he bought eight works from the various Quinn sales during the course of 1926, at least six of them at private sales held by the dealer Joseph Brummer prior to the auctions that took place later in Paris and New York.[128] Although four of Horter's acquisitions from the Quinn sales were by artists already represented among his holdings (Sheeler, Braque, and two by Picasso), his first three purchases from the Quinn collection added new artists to his own collection. Following *Mademoiselle Pogany I* and *Nude Descending a Staircase*, he acquired his first Matisse: *Italian Woman*, 1915 (pl. 21), as austere in color as a Cubist Picasso.

By the end of 1926 Horter would possess three, and possibly four, Brancusi sculptures.[129] After acquiring the marble *Mademoiselle Pogany I*, Horter bought Quinn's bronze *Muse*, 1917 (pl. 3), and later in the year, the wild-cherry-wood *Cock*, 1924 (pl. 4),

which he purchased from the Brancusi exhibition that had been installed by Duchamp at the Brummer Gallery.[130] He seems to have admired Brancusi's work several years before 1926, as indicated by a pencil drawing of Brancusi sculptures that he probably made at the time of the 1922 exhibition *Contemporary French Art* at the Sculptor's Gallery in New York (fig. 31). The drawing, which belonged to Carles, shows a bronze *Mademoiselle Pogany II* and the marble *Mademoiselle Pogany I*, along with an inscription in Horter's hand referring to the marble *Muse* in the collection of Arthur B. Davies. Since the 1922 exhibition at the Sculptor's Gallery was the only time those three works were shown together, Horter may have made the small, folded sketch for Carles to take to the exhibition to refer to for some reason.

Soon after the Quinn sales, on May 21, 1926, Anna Warren Ingersoll wrote of a visit to Horter's, where she saw his new purchases: "Then to Horter's—such a feast of Picassos etc. as he has and a marvellous Matisse—for which I would give everything else! Also Negro sculpture. . . . we sat around while he worked. Oh and two new Brancusis—a marvellous white lady's head."[131]

The years between 1926 and 1928 were the boom years of Horter's collecting. While early in 1926 he had told Alfred Stieglitz that he owned ten Picassos, by November 1927 he wrote to Dr. Albert Barnes that he had twenty. Using the careful yet slightly ironic tone he assumed in his dealings with Barnes, Horter invited him to visit his collection: "My modest collection is growing as my finances don't—wish you would look 'em over sometime—an evening spent here with 20 Picassos etc. would not be entirely wasted."[132]

Horter may have projected a low-key and self-deprecating attitude toward his collection of modern art, but the care with which he furnished the rooms where he installed it and the photographs he had taken of it show that the collection was a source of enormous pride. William Shewell Ellis's formal photographic portrait of Horter in 1929, posed in a smock and French beret next to Brancusi's *Muse* (frontispiece) tells all: portrayed as the Artist Contemplating the Muse, with head in profile and hands

crossed, displaying long fingers, of which he was surely proud, he is well groomed and shaved, serious but not pompous. Whether or not any humor was intended in this portrait (which somehow seems doubtful), it in every way manages to belie the familiar description of Horter as "stocky, with short arms and legs, a round, serious face, somewhat filthy clothes, [and] unwashed hands and face."[133]

As his wealth accumulated, Horter did not hesitate to spend it, and by 1927 he had deeply committed himself financially not only to an important collection of modern art but also to a new house and a new wife. His romance with Sophie Victor was over by 1925,[134] and in 1927 he married Elizabeth Reynolds Sadler, who graduated that year from the University of Pennsylvania's School of Education and later served as an assistant docent at the University Museum.[135] During their brief marriage, which lasted only until 1930, they purchased a townhouse at 2219 Delancey Street, which he renovated and filled with his burgeoning collections. His friend Paul Cret, the architect of Barnes's house and foundation building, designed a large studio on the top floor (fig. 32).[136] An article in the *Evening Public Ledger* describes the impressive studio and how Horter preferred to do his own work in another, smaller space on a lower floor of the house:

He was working in a little room, cluttered with many things. One wall was covered with a startling display of American Indian adornments. . . . One wall was taken up with the windows, and the other two supported dozens of paintings and sketches of the author. But this is only one room in the house—the one in which Mr. Horter works. Upstairs, under the roof is the official "studio" where Mr. Horter does not work. . . . This is a very elegant studio with excellent lighting both from the sun and electricity, which is sprinkled through corrugated glass. The walls are pale blue, except the two sections which are a deeper blue for contrast and relief. The woodwork is smooth maple and the design of the entire room is simple and impressive. So impressive, in fact, that Mr. Horter has not yet gotten used to it.[137]

The drawing room on the first floor and the living room on the second floor housed Horter's collection of modern art; the dining room was "unexpectedly early American, with a relief offered in a collec-

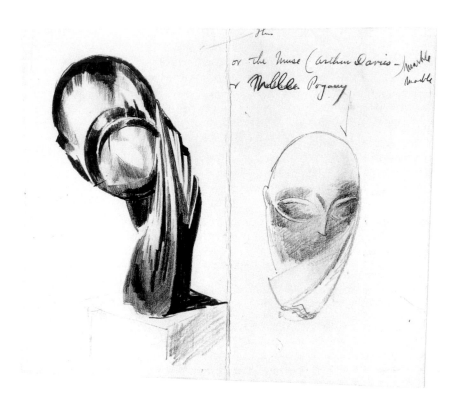

Fig. 31. Earl Horter, Sketch of Brancusi sculptures, 1922, graphite on paper, 6 15/16 x 7 7/8 inches (17.6 x 20.1 cm). Collection of Dr. and Mrs. Perry Ottenberg.

tion of ancient glassware of all countries." Horter's granddaughter, Elin Horter Young, recalls visiting 2219 Delancey Street annually during February vacations: "The house was full of Indian and African artifacts. . . . Horter's studio was on the top floor and I was allowed in the area only by invitation. There was a circular stairway and a grand piano on the first floor so you could look down and see him playing."[138]

The rooms shown in the four photographs of 2219 Delancey Street are those on the second floor (figs. 1–4):

The drawing room, which one enters from the street, houses the more striking art pieces. Sculpture by Brancus[i], paintings by Matisse and Picasso and others form a permanent Reception Committee, which escorts the guests up the modernistic stairway into the living room on the second floor, where more "moderns" live. . . . Here a forbidding parade of Negro sculpture surprises the uninitiate[d].[139]

The colors of the living room were black, gray, and silver, with a "mouse colored" carpet over which were laid smaller

oriental, hooked, or fur rugs. Japanese tea paper covered the walls of the small room behind Brancusi's *Mademoiselle Pogany I* (pl. 1), and the curtain separating the rooms was a neutral violet. The *Portrait of Daniel-Henry Kahnweiler* (pl. 38), Picasso's Cubist masterpiece, hung over a false fireplace, flanked on each side by a pair of folk-art whirligigs. On the wall opposite the fireplace, Braque's *Still Life with Glass and Newspaper* (*Le Gueridon*) (pl. 8) was hung over a long backless daybed covered with a geometric-patterned fabric, purchased from the New York decorator Rena Rosenthal, from whom he also acquired the onyx-topped coffee table and the cigarette holder on it. Horter himself designed the small crystal paperweight on the coffee table, and he designed the bookshelves, which were built by his houseman, Fred Helsengren.[140] Pieces of African sculpture and a kachina doll were placed on the bookshelves and table. The mixed installation of modern, African, and folk art in Horter's house was not unlike the Arensbergs' furnishing of their New York apartment in the teens, but his use of a

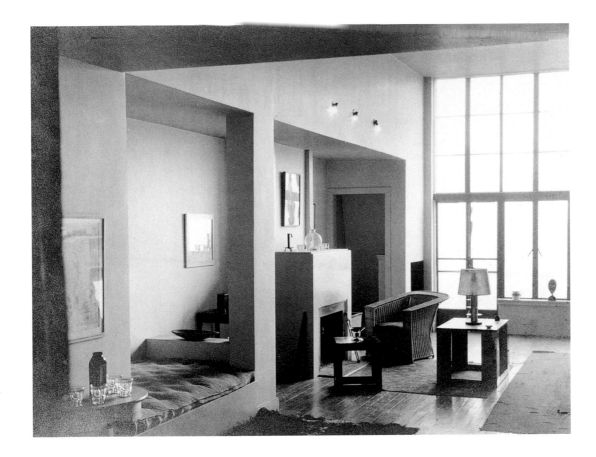

Fig. 32. Earl Horter's studio on the top floor of 2219 Delancey Street, Philadelphia, designed by Paul Cret, 1929.

Fig. 33. Helen Lloyd Horter (later Helen Kelly) at Rockport, Massachusetts, summer 1935.

streamlined modern design for the studio and some of the furnishings in the living room displayed a more adventurous taste favored by other Philadelphia collectors of modern art, such as Maurice Speiser, who installed his collection just two blocks from Horter's in a townhouse renovated by the architect George Howe, or Bernard Davis, who furnished in the Art-Deco style the rooms where he installed his modern pictures in his Rittenhouse Square house.

Surprisingly, not pictured in any photograph are Horter's pictures by American artists: the eight Sheelers, two Marins, the Thomas Hart Benton, the Carleses, and others, which must have been elsewhere in the house. His installation did not please everyone, despite general admiration. Emlen Etting wrote of visiting Horter in 1929, when he was in the midst of the renovation. Etting had a particular dislike of crowded installations and criticized Horter's presentation of his collection:

His entire house up to the studio was in process of being done over modern, with a lot of built in furni- *ture of his own design. Banquettes were built in pale pine, also bookcases. One small room was all silver, with tricky lamps. What I didn't like was the way the pictures were crowded together and badly lit.*[14]

While there are not many reports of visitors to Horter's collection from outside the Philadelphia area, documentation from various sources indicates that it was well known, if not necessarily seen in situ, to such New Yorkers as Alfred Stieglitz, Carl Zigrosser, and Alfred H. Barr, Jr., director of the Museum of Modern Art, as well as to A. Everett Austin, Jr., director of the Wadsworth Atheneum in Hartford; the architectural historian Henry-Russell Hitchcock; dealers Marie Harriman, Sidney Janis, Galka Scheyer, and Paul Rosenberg; artists such as Picasso, Braque, and Duchamp; and collectors A. E. Gallatin, Frank Crowninshield, and Douglas Cooper. When Gallatin wrote his preface to the 1940 revised catalogue of his Museum of Living Art, he praised Horter's collection: "In the U.S.A. many excellent groups of Twentieth Century paintings have been formed, notably the superbly chosen collections of

Mr. Arensberg and Mr. Horter."[142] The most heartfelt tribute to Horter's collection came from R. Sturgis Ingersoll in a lecture at the Print Club of Philadelphia in 1930:

Earl Horter in his house on Delancey Street, sits and thinks and works, surrounded by his amazing collection of abstract paintings. In Paris, Berlin, New York, by amateurs and collectors, Earl Horter is known as having the finest collection of abstract paintings, particularly Picasso, under one roof.[143]

"We turn the page."

In the autumn of 1930 Horter wrote to Arthur B. Carles announcing his recent marriage to one of Carles's students, Helen Lloyd: "I had to give Bett the gate. . . . she proved a complete flop—We turn the page—I am married to Helen Lloyd—no stranger to you—married two months now and happy as hell. Sails a boat better than I do—paints well and will paint better soon."[144] Helen Sharpless Lloyd, Horter's third wife, whom he married in August, was a beautiful young painter thirteen years his junior (fig. 33). Despite tremendous financial instability, the years of their marriage seem to have been among Horter's happiest. Also perpetually present at 2219 Delancey Street was the mysterious Fred Helsengren (fig. 84), who was Horter's "concierge" and jack-of-all-trades. Described as a thin man with a bushy beard, who wore overalls and owned two dogs, Fred was responsible for keeping the house in order, driving, stretching canvases and making frames, and reading Western thrillers to Horter as he worked: "Fred was his reader and he would read right through the night if Horter worked," says a former student, William Campbell. A quasi-dependent person with a violent temper—he was known to have thrown an ax at his son—Fred outlasted all of Horter's wives; indeed Fred has been called "Horter's real wife," for the two of them seem to have needed each other, in entirely different ways, to keep going through their lives.[145]

Grand times in the 1930s were spent at Horter's house in Harvey Cedars, at the New Jersey seashore. Horter drove a Pierce Arrow car with retractable headlights and had a sailboat that he, Helen, and his friends would sail: "Harvey Cedars was full of summertime drunks. Everyone drank a lot; with the Pinto brothers they would go out to Sandy Island and get drunk, or get drunk and go sailing," recalls a former resident.[146] Through a painter friend, Sarah Langley Mendenhall, Helen became interested in astrology and numerology, and in 1934 she convinced Horter to add an *e* to the end of his first name because that made the numbers work out right. In the 1935 annual exhibition of paintings at the Pennsylvania Academy and from then on, Horter spelled his first name Earle.[147]

Horter vividly summarized the state of the Philadelphia art crowd around 1930 in a letter to Carles, who had been in France since April 1929 with his own new wife, Caroline Robinson, and their baby daughter. Carles stayed abroad until 1931, but Caroline returned in the summer of 1930 to Philadelphia, where Horter wrote that he saw her and the baby often. He commented upon the breaking up of the old group of friends but seemed to welcome his isolation:

Life does not yeald [sic] up many friends that mean anything and with the changes that have come over me lately—very few people cut any figure—I've taken stock of people the past two years and they're punks mostly. . . . Gee old friend I want you back since I can't reside in France—There is only one Carles and no one else will do—I have no other friend—There's many a night that would be perfect if you were here to sit with a coffee grinder between us—etc. etc. I have canned all the alleged friends of the past cleaned House—and then some—keeping Life simple. . . . There seems to be little interest in pictures—all the old crowd are sort of split up.[148]

Indeed, with "the old crowd" dispersed, Horter worked with more independence than when he had been part of a group with a common dedication to promoting modernism. Because of the Depression, advertising commissions were few and far between, and as the 1930s began he became involved in a wide variety of new projects, such as writing, organizing, and lending to exhibitions—activities that stemmed from his now more widely known reputation as an artist and a collector. In June 1930 he joined a group of twenty-five subscribers to purchase Carles's painting *The Marseillaise* for the new Pennsylvania (later Philadelphia) Museum of Art on Fairmount, while farther afield he was a lender and catalogue author for the exhibition *Contemporary Paintings of the Modern School* at Helen's alma mater, Smith College. Within a year he also wrote introductions to two privately published books: *Picasso, Matisse, Derain, Modigliani* and *Pencil Drawing*, a didactic book using his own drawings to illustrate the text (fig. 34).[149] And in 1932 his reputation as a collector of Native American artifacts led to his membership on the Philadelphia general committee for the *Exposition of Indian Tribal Arts*, an exhibition held at the Philadelphia Art Alliance.

In addition to being an artist and a collector, Horter was an eloquent writer about art. Without any mission to convert or to enlighten wider audiences than his reader, his writings show a penetrating understanding that must have been the result of hours of reading, thinking, and looking at many kinds of art. It was this lucid, unpretentious, reflective spirit, inviting others to share his own enjoyment, that characterized Horter's attitude toward collecting:

Modern Art is as much part of the Great Tradition as is the Parthenon—a culmination of the panorama of Art from the beginning—not really new, but extremely conscious of itself and its continuous borrowings and reflections from that panorama. Nature as we see it objectively is not always reflected in its results, but the essence, the symbol of objectivity is most certainly achieved in the work of the great Moderns. They paint what they think about what they see and not just what they are looking at. This is confusing to many who insist on Art being representative. Music through the sense of hearing is nonobjective. The organization of sounds, rhythms, instruments—with different textures—all combine in a clearly ordered result of beauty. Why not colors, forms, rhythms in painting? Modern Art does not replace the old order but is another door to another room in that Great House of all Art. The great Tradition of Giotto, Michelangelo, Titian, Botticelli, Ingres, Delacroix goes on in Cézanne, Manet, Picasso, Matisse, Seurat, Miro—if one has the enthusiasm to investigate.[150]

Horter's own art also gained new momentum in the 1930s, probably as a result of the dearth of advertising jobs and also, perhaps, the inspiration of a new painter-wife. In 1930 Horter entered the Pennsylvania Academy's watercolor exhibition for the first time in five years. No longer working in the Futurist style of his earlier *Rhapsody in Blue*

Fig. 34. Earl Horter, *Gerona*, 1924, graphite on paper, 11 3/4 x 10 7/8 inches (29.9 x 27.7 cm). Pennsylvania Academy of the Fine Arts, Philadelphia. Donated to the Leo Asbell Fund by Mrs. Ruth Beer. This drawing was used as an illustration in Horter's book *Pencil Drawing*.

Fig. 35. Earl Horter, *Coal No. 1*, c. 1930, watercolor, ink, and graphite on paper, 20 5/8 x 17 1/4 inches (52.4 x 43.8 cm). Philadelphia Museum of Art. Gift of Mrs. Earl Horter, 1972-265-1.

and *City Hall: Philadelphia*, he showed the "mechanistic" watercolors, which he described in a letter to Carles: "I am painting water colors—sort of mechanistic Industry—like America—aluminum tanks, coal pockets, stacks, power houses, etc."[151] In *Coal No. 1* (fig. 35) from that exhibition, his subject and style recall the Precisionism of Charles Sheeler's contemporaneous paintings and watercolors, but it was Charles Demuth's technique that he used for obtaining textural effects by sprinkling salt onto the wet paper, which he then brushed away when the paper dried.[152] Horter's use of the salt technique is especially evident in the sky of *Coal No. 1*; he repeated it in the dappled areas of his Precisionist masterpiece of the following year, *The Chrysler Building Under Construction* (fig. 36).

Perhaps it was his interest in creating texture and tone, combined with his mastery of watercolor washes, that brought about Horter's experimentation with making aquatints around 1932. While he had never entirely abandoned printmaking, he had produced few new etching plates since his exhibition at the Brown-Robertson Gallery in 1923. No doubt the return to printmaking was also inspired by the courses in printmaking he began to teach in the late 1920s at Philadelphia's Graphic Sketch Club (now the Samuel S. Fleisher Art Memorial).[153] He soon became known for his mastery of

aquatint, a method of etching used to create broad areas of tone, often in imitation of wash drawings. So superb was his control of the medium that he was able to produce aquatints without any bitten lines, practically making a watercolor with the acid. Just as he had been admired for the precision and delicacy of his etching line in the 1910s, in the aquatints of the 1930s Horter achieved a reputation for his ability to produce uninterrupted tonal effects, seen in such works as *The Kitchen* (fig. 37), which was illustrated in B. F. Morrow's handbook *The Art of Aquatint*,[154] and in *Light and Shadow* (fig. 38), which won the Charles M. Lea prize at the Print Club of Philadelphia's *First National Salon of Etchings, Lithographs, and Block Prints* in 1932.

At the same time, Horter also made watercolors in a Pointillist style. Seurat is often suggested as the obvious inspiration for these, but Horter's "Pointillism" was distinctly unscientific, unlike Seurat's. Rather, the granular ground of his aquatints and his method of sprinkling sand on his watercolors to create texture probably influenced his development of this new dotted style (figs. 39 and 40). He made only a few "Pointillist" works, some of them in the summers of 1932–35 in Rockport and Gloucester, Massachusetts, where a number of Philadelphia artists were working, including Yarnall Abbott, president of the Rockport Art Association, Hugh Breckenridge, who ran the Breckenridge School of Art in East Gloucester, and occasionally Arthur B. Carles, visiting his daughter Mercedes, a student of the painter Hans Hofmann.[155] Horter's "Pointillist" watercolors are quiet, delicate works of great charm, much less assertive than the Futurist and Precisionist watercolors. During these years, when he was painting as well as making watercolors and prints, Horter passed rapidly and even simultaneously through many styles (see figs. 41 and 42), as demonstrated in his one-man exhibition of realist, Pointillist, and Cubist nudes held at the Crillon Galleries in Philadelphia in March of 1933 as well as in an exhibition of his aquatints at the Print Club in October of that year.[156]

At this time Horter was also rapidly absorbing a wide range of images as sources for his art. Georges Braque remained an important

Fig. 37. Earl Horter, *The Kitchen, New Orleans*, c. 1933, aquatint, 12⅜ x 10½ inches (31.4 x 26.7 cm) plate. Philadelphia Museum of Art. Gift of Mr. and Mrs. Arthur Peck, 1956-30-60.

Fig. 38. Earl Horter, *Light and Shadow*, 1932, aquatint, 10 x 11½ inches (25.3 x 29.2 cm) plate. Philadelphia Museum of Art. Print Club Permanent Collection, 1948-47-24.

Opposite:
Fig. 36. Earl Horter, *The Chrysler Building Under Construction*, 1931, ink and watercolor on paper, 20¼ x 14¾ inches (51.4 x 37.5 cm). Whitney Museum of American Art, New York. Purchase, with funds from Mrs. William A. Marsteller, 78.17.

Fig. 39. Earl Horter, *The Beach at Bass Rocks*, 1932, watercolor over graphite on paper, 15 ½ x 19 ¾ inches (39.4 x 50.2 cm). Private collection.

Fig. 40. Earl Horter, *Newcastle, Delaware*, c. 1932, watercolor on paper, 12 x 19 inches (30.5 x 49.5 cm). Collection of Charles K. Williams II.

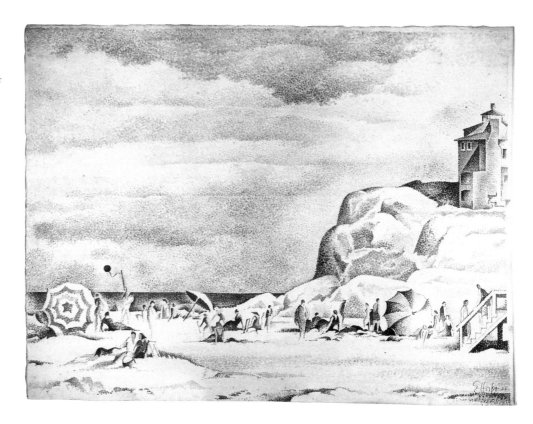

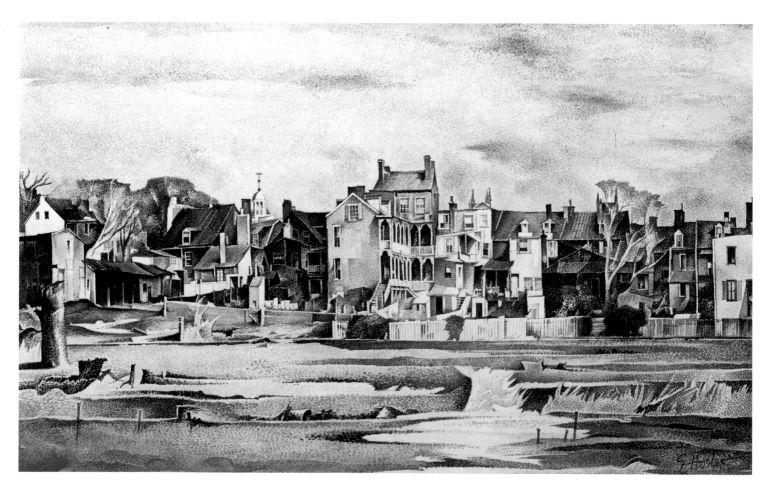

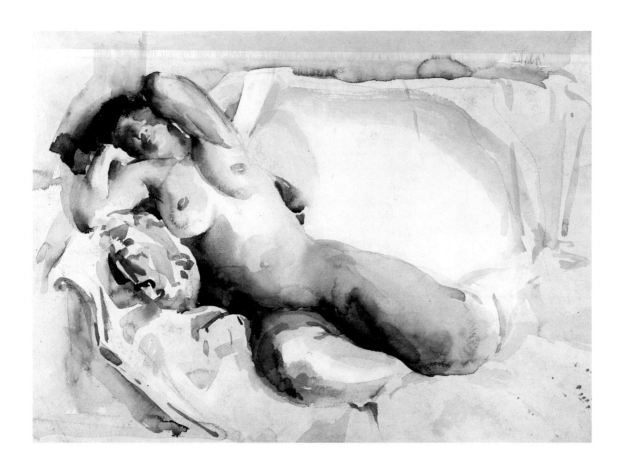

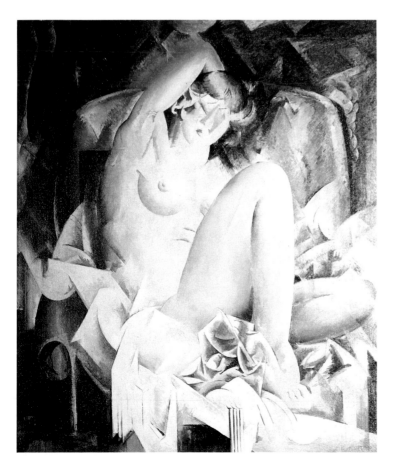

Fig. 41. Earl Horter, *Nude*, c. 1931, watercolor on paper, 12½ x 17 inches (31.8 x 43.2 cm). Collection of Jane and Philip Jamison.

Fig. 42. Earl Horter, *Seated Nude*, 1930–35, oil on canvas, 24 x 20 inches (61 x 50.8 cm). Private collection, New Jersey.

influence, as he had been for Horter's Cubist watercolors of 1924 done in Spain. In the mid-1930s, however, Horter consulted a nearly contemporaneous series of Braque's seascapes, which show blocklike shacks and rock formations and tilted sailboats perched on dotted sandy beaches (fig. 43). Horter's seascapes, produced in Gloucester and Rockport, closely mimic Braque's paintings. As his sheets of studies for them show, he developed his seascapes first in painstaking pencil studies that reveal how deeply he sought to penetrate Braque's method (figs. 44 and 45). A student of Horter's, William Campbell, recalls watching Horter one day at Rockport in 1935 as he studied reproductions of Braque's work in an issue of *Vanity Fair*: "He spent the whole day with that thing under his arm and whenever he had time he would look at this Braque."[157]

The relationship between Horter's art and the works of art in his collection is worth exploring. While he was an ardent student of the work of other artists, his sources extended much farther afield than the walls of his own house. The eclectic and derivative nature of his own work tempt one to conclude that he collected modern art primarily for study purposes, but that supposition misses the point of his genuine passion for the work of great artists, with which he sought to surround himself. Horter never made any pretense that he thought himself a great artist, as he wrote to Carl Zigrosser:

I work so hard—and when I'm done I look at the work of some great master—he seems so universal like a wonderful thunderstorm—or like looking over the edge of Vesuvius and I the little firecracker that goes off with a hiss—thank God I can detect greatness here and there and worship it.[158]

Still, Horter's work was sometimes inspired by the styles of the works of art in his collection, as may be seen in countless sheets of pencil studies of Cubist compositions. Only rarely are these sketches copies of specific works, as in his pencil drawing (fig. 50) after Picasso's *L'Arlesienne* from his collection (pl. 40). Usually, he created his own Cubist compositions, such as the small oval painting (fig. 51) that very loosely resembles Braque's *Still Life, Second Study*, 1914 (pl. 11). Horter's collection was only one of many sources for the wide range of styles in which he worked. Even as

he copied motifs from paintings by Braque that were later than those in his collection, he also made Precisionist watercolors in a style that was influenced not by the Sheelers he owned, but by Sheeler's later works. The contents of Horter's library also reveal that he used books and magazines to study reproductions of the work of many artists; he seems to have consulted them even more than his collection as sources of inspiration for his own work. An interesting point that emerges from the reminiscences of his former students is that while Horter often shared his books and files with them, he rarely used his collection in teaching.[159]

"He was a whiz. He was just sensational."

While financial difficulties plagued Horter as the 1930s progressed, his teaching gave him immense pleasure.[160] "Dealing with these young people is what keeps me going," he told those who asked why he kept at it.[161] Although he had never done any teaching until he started at the Graphic Sketch Club in the late 1920s, by all accounts he was a "natural." Horter taught at the Pennsylvania Museum School of Industrial Art between 1933 and 1939, beginning as an instructor in "Pictorial Expression." After the retirement of the redoubtable illustrator Thornton Oakley in 1936,[162] he joined the Department of Illustration, headed by Henry Pitz. As a teacher Horter made a lasting impression on his students, particularly with his superlative ability to demonstrate his methods before an audience and to motivate his students, who adored him (fig. 48). Albert Gold, a student of Horter's at the Museum School, describes the practical knowledge students received from Horter's classroom methods:

He was a very unusual teacher in that he demonstrated everything. . . . Demonstration came naturally to Horter because he did not have a formal art education. . . . What he would do would be to take a little drawing or a little photograph and use that as the basis for his composition. It was invaluable to the student. It was the one class I had where the instructor actually showed [the student] what to do, how to think.[163]

Bernard Shackman, another student, exclaimed, "If he liked you, you were IT,"[164]

and, indeed, Horter spent a lot of time with his students in and out of the classroom. In the summer of 1935 he rented a large house in Rockport, Massachusetts, where, along with Helen and his houseman Fred Helsengren, he took about twenty students for a summer course in painting (figs. 46 and 47). Most of the students lived in the house, where the group ate together in the large dining room, and classes were held outdoors unless it rained. According to Helen's daughter, her mother thought that Horter was a taskmaster but an amiable one, getting the students out to work early in the morning and replying to their complaints, "Just think how much the president of the United States has already accomplished by eight o'clock this morning!"[165]

Right after the summer in Rockport in 1935, Horter began teaching at the newly founded Stella Elkins Tyler School of Fine Arts. Along with Franklin Watkins, Furman Fink, and Raphael Sabatini, Horter was hired by the sculptor Boris Blai to join the first faculty of the Tyler School, where he taught watercolor and printmaking. Blai was proud of the curriculum of the new school, which he described as an attempt to "produce a real American art in a unique and progressive way. . . . A study of past periods and styles will be forgotten in the beginning and as a substitute there will be active practice in all possible art media, by all students."[166] The sculptor Joseph Greenberg, one of the first Tyler students, confirmed that advanced students were given a great deal of freedom:

It wasn't like the Academy which thought that everything in those days had to be very traditional and academic. The insistence was on technique, on polishing your skills, seeing, and putting down. But then, we were urged to do our own thing.[167]

Greenberg also vividly characterized Horter's appearance and his special talent for motivating students to try anything:

He was a tiny little fellow. He had a ridiculous complexion. He was sort of olive-green, and he wore unusual clothes. . . . But he had . . . a charisma, charm about him that was sensational. This was all pervasive. . . . He was a marvelous teacher. Almost as soon as I got to art school, it was announced that

Fig. 44. Earl Horter, *Sailboat*, c. 1935, oil on canvas, 8½ x 10¾ inches (21.7 x 27.3 cm). Private collection.

Fig. 43. Georges Braque, *Cabin and Sailboat*, 1928, oil on canvas, 14¹⁵/₁₆ x 18⅛ inches (38 x 46 cm). Location unknown.

Fig. 45. Earl Horter, Sketch for *Sailboat*, c. 1935, graphite on paper, 9¹/₁₆ x 11 inches (23 x 29.2 cm). Private collection.

Fig. 46. Earl Horter in Rockport, Massachusetts, summer 1935.

Fig. 47. Horter with Helen Horter and his students in Rockport, Massachusetts, summer, 1935.

Mr. Horter was going to give us an introduction to watercolor. All art students who haven't gotten into it are terrified of watercolor. . . . This little man stood in front of us and did magic things so easily with watercolors, and got us so enthusiastic, that we were immediately splashing washes and doing all kinds of wonderful things that he told us in this period of two or three hours. . . . And then, we got into etching and engraving and lithography and all that—all of which he taught.[168]

Through this period Horter also had many private students whom he taught in his studio on Delancey Street and later in a studio in Germantown. His students included a diverse cast of characters; while his friends complained that Horter was wasting his time on so many students, he appeared to enjoy all of them. Philadelphia artist John Lear tells of a group of public-school art teachers who met at Horter's each Saturday morning for a workshop/teaching session: "He was almost like a guru to them." In contrast, there were affluent private students like Vera White, who with her husband Sam shared Horter's passion for collecting modern art.[169] Another group

consisted of about a dozen of Horter's buddies, whom he taught to make prints one winter. To "The Gang," as they called themselves, Horter was known as "Bill" (fig. 49). According to their own account, the group got started almost as a dare:

Many came along simply for a crazy good time—for all had, in common, a mild insanity in varying degrees. And Bill shared it. . . . [He] pulled out his whole bag of tricks, demonstrating line etching, aquatint, sand paper, soft ground, dry point and so on. And, in turn, The Gang taught Bill at least one new wrinkle, how to get sharper lines and finer in straight aquatint than gummy shellac made possible.[170]

"Money Jams"

I have had reverses and being an Artist? ha ha—I am interested in spending my remaining years in Work and not collecting.[171]

By 1930 Horter's grand years of collecting were over. The renovation of 2219 Delancey Street had absorbed much of his money even as the Depression loomed and his

advertising commissions diminished. The photographs of the rooms installed with his prize possessions (figs. 1–4) are a poignant record of a collection that he would reluctantly begin to sell off, piece by piece, within a year or two. In the autumn of 1930 Horter wrote dejectedly to Arthur B. Carles in France:

I have no new pictures to speak of—Have been busted constantly—and by all appearances will keep that way. . . . Wish we could see a bunch of Picassos or Braques together—but Hell what's the use in wishing—I keep in touch with their work through repros: Cahiers d'Art etc.—Before you come home I will send you some money to get me photos of recent Braques and Picassos at Rosenbergs.[172]

Although he could no longer buy new pictures, during the 1930s Horter actively lent works of art from his collection. While he helped to organize an exhibition at Smith College and provided seven loans in 1930, he also lent two paintings by Jacques Mauny to the artist's New York exhibition at De Hauke and Company, and he lent to the Brancusi exhibition organized in 1933 by

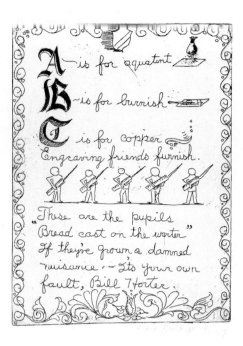

Duchamp at the Brummer Gallery, New York.[173] The *Henri Matisse Retrospective Exhibition* (1931), *African Negro Art* (1935), and *Charles Sheeler: Paintings, Drawings, and Photographs* (1939) at the new Museum of Modern Art in New York all included loans from Horter. Late in 1933 he was asked, on the recommendation of the Paris dealer Paul Rosenberg, to lend to the first museum exhibition of Picasso's work at the Wadsworth Atheneum in Hartford, Connecticut, but he was unable to cooperate as he was already committed to showing most of his collection at the Pennsylvania (later Philadelphia) Museum of Art.[174]

This Philadelphia exhibition, entitled *The Collection of Earl Horter* and held from February 17 to March 13, 1934, was one of a series focused upon the several private collections of modern art then in Philadelphia. These were shown in the museum's new Gallery of Modern Art that had opened in December 1932. With little of its own to show before the arrival of the collections of A. E. Gallatin in 1943 and Walter and Louise Arensberg in 1950, the museum organized four exhibitions of work by contemporary American artists for the gallery's first season, followed by the series of exhibitions of local collections. The fourth exhibition in the series, *The Collection of Earl Horter* included nearly eighty works of art: forty-three paintings, eighteen watercolors and drawings, and fifteen sculptures, including nine pieces of African sculpture. Reviews in the Philadelphia papers were positive but generally plodding in their insistence upon interpreting the collection, albeit favorably, as a didactic exercise, probably to explain the collection's narrow focus: "The current show is the first obviously chosen from the standpoint of the painter and gathered as source material from which to draw suggestions for self-development."[175] The *Christian Science Monitor* of Boston took a slightly more critical stance: "So absorbed was Mr. Horter in the work of Braque and Picasso that he acquired a gallery full of their abstractions. For the general public, however, there is a persistent note of monotony. . . . The one Matisse in the collection is a bold distortion of a woman in which that painter's usual brilliant charm of decorative detail is wholly lacking."[176]

A month after the Philadelphia show, an exhibition of sixty-one paintings and works of art on paper from Horter's collection was shown at the Arts Club of Chicago. *Modern Paintings from the Collection of Mr. Earl Horter of Philadelphia* was accompanied by the only published checklist of the collection. Chicago's *Sunday Tribune* for April 15, 1934, contained a review by Eleanor Jewett that could just as well have appeared twenty-one years earlier when the Armory Show shocked the art world. Proclaiming the French modernists in Horter's collection as "tired men, disillusioned men, men to whom novelty was a refuge from the impatience of living," Jewett said of Picasso: "There is no craft in his painting; it is merely a release for his ego."[177] Matisse's *Italian Woman* was "a ghastly creation," though Braque was "a great deal more wholesome than Pascin." The Americans fared better, particularly Arthur B. Carles, praised for his vigorous color, and Charles Sheeler, "clever and gay and cold as a dip in the sea in November." It was precisely this kind of "philistinism" that had driven Barnes to sequester his collection in Merion

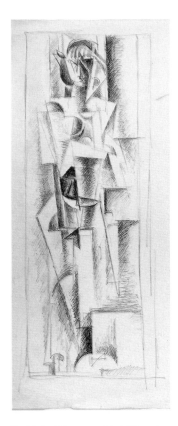

Fig. 50. Earl Horter, untitled *(Woman)*, c. 1935, graphite on paper, 16⅞ x 13½ inches (42.9 x 35.3 cm). Private collection.

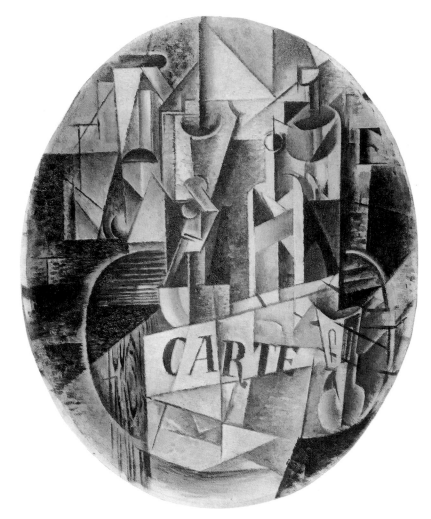

Fig. 51. Earl Horter, untitled *(CARTE)*, c. 1935, oil on canvas board, 15¼ x 12¼ inches (38.7 x 31.2 cm). Private collection.

after it was shown at the Pennsylvania Academy of the Fine Arts in 1923, and it is perhaps telling to see how much more accepting of modern art the Philadelphia critics had become by 1934. One also wonders what Earl Horter thought of Jewett's review of his collection. His approach to collecting art for his own enjoyment and his subsequent lack of interest in pleasing or educating the public suggest that, if he saw it, the review probably did not make much difference to him.

When a representative for the New York dealer Marie Harriman made a tour of Philadelphia private and public collections in May 1932, she reported on her visit to Horter's:

Horter's collection is more interesting to us as a source of pictures for different loan exhibitions which we may want to arrange than that of a possible client. Horter is completely broke. His collection of Picasso and Braque of the cubistic period is simply extraordinary. He also has a very beautiful green and

red abstraction of Picasso's from about 1913 and a good many pictures by other artists.[178]

Not only was Horter broke, but he had also begun to sell a few pieces from his collection. The green and red Picasso mentioned by Harriman's representative was the *Still Life with Cards, Glasses, and Bottle of Rum: Vive la [France]* (pl. 46), which would be sold to Sidney Janis (then Janowitz) by 1934 through the dealer Pierre Matisse. It was not the first work to be sold, for by May 15, 1931, ownership of Picasso's *Portrait of Braque* (pl. 34) had passed to Horter's friend Frank Crowninshield, the editor of *Vanity Fair*, who proclaimed it to be "the first important cubist portrait—a picture of the greatest cubist by the second greatest cubist."[179]

Thus the collection was no longer fully intact even before it was exhibited at the Pennsylvania Museum of Art, and, indeed, a letter of 1930 from Jacques Mauny to Leon Kelly mentions that Horter was offering to

sell his collection for $100,000, payable over ten years.[180] Another early indication that Horter was thinking of selling his collection appeared on February 6, 1931, when Henri Marceau, curator of paintings at the museum, replied to Horter's request to help him find an appraiser for it.[181] Marceau suggested R. Sturgis Ingersoll, who did not take on the responsibility. The appraisal seems to have been done, perhaps at Ingersoll's suggestion, by the New York dealer Pierre Matisse, and during 1932 Horter offered at least four works for sale through Matisse's gallery, including the *Italian Woman* by the dealer's father, Henri Matisse.[182] For some reason, Horter had his attorney, Eugene John Lewis, handle all contacts with the gallery, which complicated the dealer's transactions. Matisse complained in a letter that Horter had tied his hands by requesting that no deal be made unless Lewis gave his approval. Sales did not progress well, for only one work sold, and in May 1933 the unsold works were returned to Horter.

Because the Pennsylvania Museum of Art had raised the funds from a private donor, Mrs. Rodolphe Meyer de Schauensee, to purchase Brancusi's *Mademoiselle Pogany I* from him for $2,000 in 1933, after it was shown at the museum's inaugural exhibition in 1928,[183] Horter became hopeful of selling the museum his whole collection. When the Wadsworth Atheneum in Hartford had asked to borrow two or three of Horter's Picassos for exhibition, he had replied, "Ordinarily I could spare one or two things but as I am trying to sell my entire collection of modern works to the museum you can readily see how important it is to have it intact."[184] Even in his early correspondence concerning the Arts Club of Chicago exhibition, Horter was still hopeful that he would not have to "dip into my collection of paintings."[185] But by the time of the Chicago exhibition in April 1934, it must have become clear to him that the Pennsylvania Museum would not buy his collection, for he wrote to Alice Roullier at the Arts Club: "I hope you can sell at least three pictures as whoever gets them will never be able to do better than in this time of need." Nonetheless, before the exhibition had closed in Chicago he had already found buyers for two of the paintings, and he wrote to Alice Roullier that they were no longer available: "I sold to a friend here the picture by Charles Sheeler—*Pertaining to Yachts and Yachting*—so please eliminate it as an available picture—also the Duchamp *Nude Descending Staircase* is nearly sold—so must hold it for at least a week." In a subsequent letter he reiterated: "Do not sell the Duchamp *Nude Descending Staircase*—I have given a party a chance to buy it—and I am waiting to hear."

No wonder the sale of the Duchamp was taking time. Not including Horter, at least six people were involved in the sale of *Nude Descending a Staircase, No. 1*, including Duchamp himself, who eventually was successful in procuring it for Walter Arensberg.[186] Horter asked a friend of his, Arthur Edwin Bye, a Philadelphia painting restorer, to act as his agent in the sale of the painting. John Davis Hatch, Jr., assistant director of the Isabella Stewart Gardiner Museum in Boston expressed interest in buying the painting from Bye,[187] but he decided that Bye's price was too high; in the course of his dealings with Bye, Hatch discovered that Bye was also receiving bids from Duchamp to buy the picture, and

Hatch withdrew. Suspecting that Duchamp was acting on behalf of their mutual friends Louise and Walter Arensberg, Hatch contacted them. Louise Arensberg then told Hatch of the problems they had been having with the California dealer Galka Scheyer, who had offered them the same painting without revealing the owner. Apparently Scheyer's efforts to procure the painting for the Arensbergs fell through when Horter refused to sell it to Scheyer for less than he wanted for it. Frustrated by Scheyer and having forced the dealer to admit that Horter was the painting's owner, the Arensbergs asked Duchamp to approach Horter directly, and the deal was concluded for an unknown sum.

Another account of the sale of the *Nude, No. 1* appears in Sidney Janis's unpublished autobiography. It is difficult to assess how this story fits in with the others:

[Janis and Arensberg] . . . both knew that Earl Horter . . . owned the original smaller and less abstract version [of the Nude*]. Walter [Arensberg] was also aware that I had ready access to Horter by virtue of having previously pried loose from him a fine 1914 Picasso for my own collection, and so in 1935 he asked me to see if I could obtain the first version of the* Nude. *I approached Horter at a moment when he was behind on his alimony payments to at least two ex-wives, and he named a price of $2,500 for the painting. I badly wanted it for myself but could not risk Walter's ire; my request that he defer to me was in vain, and he lost no time in buying it.*[188]

Five pictures, including his cherished Picasso *Portrait of Daniel-Henry Kahnweiler* (pl. 38)—in his words "the finest Cubistic Picture in existence," were sold from the Arts Club of Chicago exhibition in 1934, which made the largest impact to date upon Horter's holdings.[189]

In December 1934, after the exhibition of his collection in Philadelphia and Chicago, Horter proposed to his friend R. Sturgis Ingersoll that he would lend the Pennsylvania Museum any works of art from his collection that the museum would like to borrow. Ingersoll, who was a museum trustee, the museum's director Fiske Kimball, and Henri Marceau, the assistant director, were delighted. Marceau visited Horter and drew up a list of twenty-six pictures, which were delivered to the museum on February 14, 1935.[190] Shortly

thereafter, Marceau wrote to Horter asking whether he would care to quote prices on the pictures: "It occurred to me that if we had a price list available we might be able from time to time to dispose of a picture for you." Perceiving the folly in this suggestion, Kimball sent Marceau a memorandum: "Change signals: Don't press Horter for a price list. I am told it might give him more impulse to sell off the things in his collection—& thus be unfavorable to his continuing to lend it to us."[191]

What was Horter's motive in lending a large portion of his collection to the museum, when this must have nearly depleted the walls of his living room, considering what he had already sold? There are no clues in the correspondence, but the museum certainly provided a convenient venue to make the collection available not only to the museum's audience but also to potential buyers. It appears to have been Horter's wont to remove himself personally from the sale of works from his collection whenever possible by using his attorney or an agent or by selling works of art from an exhibition.[192]

The first sale of a painting from the group of works lent to the museum in 1935 was Henri Matisse's *Italian Woman*, which Pierre Matisse had evidently had his eye on since Horter had offered it for sale at Matisse's gallery in New York in 1932. The Pierre Matisse Gallery acquired it by February 14, 1936, and sold it almost immediately to Mrs. L. M. Maitland of Beverly Hills, California, for $3,000.[193] Following this sale, Horter and his attorney, Eugene John Lewis, opened a new series of negotiations with Pierre Matisse, who then visited the collection at the museum in Philadelphia. He was especially eager to acquire a Braque for one of his clients, but Lewis reported that "the only picture of the group, at this time, that [Horter] is inclined to sell is a large Picasso," which was *Woman with a Book* (pl. 30).[194] The details surrounding the sale of that painting reveal the desperation of Horter's circumstances; apparently he offered it not only to Pierre Matisse but also to the young Australian-born collector Douglas Cooper, for $1,500. Cooper did not purchase it, and Horter immediately sold the painting to Pierre Matisse for only about $650.[195]

Horter did sell three other pictures to Douglas Cooper, who visited the museum in

Philadelphia in 1936 and later bought the Picasso collage *Still Life with Bottle, Cup, and Newspaper* (pl. 41), the large green Picasso *Nude*, 1909 (pl. 31), and Horter's largest Braque, *Still Life with Glass and Newspaper* (*Le Gueridon*) (pl. 8).[196] Ruefully, Horter wrote to Henri Marceau asking that the museum release the Braque: "I want it sent collect as the price wasn't too great and I feel he got a good picture—I guess I'll stop selling out of my depleted collection—but I do get into Money Jams."[197]

There was little left to sell.[198] Even before Cooper bought three pictures, Horter had already sold a large group of works of art, still on loan to the museum, for $5,000 to a widowed Philadelphia art teacher, Elizabeth Lentz Keim. Despite a legally drawn agreement of sale, what took place in this transaction is nearly impossible to decipher, as Horter subsequently disposed of seventeen of the works listed in the document, including some that were given to Helen Horter following their divorce in February 1937.[199] It would seem that Mrs. Keim, a student of Horter's in Rockport the previous summer, was kindhearted as well as shrewd in the terms of her purchase; the sale seems to have been more of a loan with the art offered as collateral, for Horter was permitted to purchase back the works of art within eighteen months for $5,000 with 6-percent interest. Museum records show that Mrs. Keim did not take possession of the works of art at the time of the sale; perhaps she agreed to buy $5,000 worth of unspecified objects on the list, leaving Horter free to dispose of the remainder, but there is nothing in the bill of sale to suggest that this was the case.

Given his situation, it is not surprising that in July of 1937 Horter collapsed with a heart attack in New York, as recounted in a letter of August 4 from Arthur B. Carles to Carroll Tyson:

I went right over and found him with a nurse in a hotel room not even allowed to feed himself. There he still is not allowed to be moved. He had a heart attack, but the doctors say he will be O.K. if he stays still. He seemed cheerful, and seems able, and expects to drive up your way when he can. Met his son who seems like a regular fellow. He sees him every day.[200]

Horter seems to have been able to go on with his life that autumn, when he returned to teach at the Tyler School of Art. Still, his troubles were far from over, for the Home Owner's Loan Corporation foreclosed on 2219 Delancey Street in November. In the catalogue of the academy's annual painting exhibition in January of 1938, Horter's residence is listed as 158 Maplewood Avenue, Germantown. His fortunes took a decidedly better turn three months later, however, when he nominally reacquired part of his collection of modern and African art by marrying its new owner, Elizabeth Lentz Keim. Soon afterward they bought a large and beautiful old house, Beech Knoll, at Stenton and Hillcrest Avenues in Chestnut Hill, where they installed some of the remaining collection along with Horter's increasingly large group of Native American artifacts.

Elizabeth Lentz Horter (fig. 52) brought greater calm and stability to Horter's life. In addition to being an artist, she was also an astute businesswoman. It is said that he liked to joke that "she has some part of every nickel she ever had," but this was kindly meant, for this marriage seems to have suited the decidedly more serene life he was happy to be leading. In her diary for May 17, 1938, about a month after the marriage, Anna Ingersoll observed that "H[orter] is married again . . . and talked most peacefully and middleagedly about it.[201] Horter's new wife Betty, as she was called, showed her work in the academy annuals, and she was proud and supportive of Horter's work. He seems to have continued all of his activities without abatement, except that he made fewer prints.

Horter's work in the last years of the 1930s consisted principally of paintings and watercolors, which generally alternated between realistic landscapes and splendid, complex still-life abstractions (figs. 53 and 55). For the latter compositions he again drew upon a series of Braque's recent paintings—this time Braque's still lifes. Imitating but not copying their compositional arrangements or their individual forms, he repeated his method of making scores of detailed preparatory drawings, as he had for his earlier Braque-inspired seascapes (fig. 54). His colleague and friend Henry Pitz described those drawings and their purpose:

The preparatory drawings, the sheets of tracing paper covered with stages of gradual clarifications, are lessons in the use of directed effort. They show the reduction of fumbling to a minimum. They also reveal how in the concentrated pursuit of one goal, equal opportunities open out on either side of the path. The final designs are little gems of graphic joinery.[202]

In the late 1930s Horter avidly acquired Native American artifacts, and his collection had reached more than a thousand pieces by 1940. He had collected this material most of his life, but after the sale of his modern art collection, he pursued Native American artifacts with greater vigor and even thought of starting a museum, as his student William Campbell recalled:

I don't know that he had any real plans for it but he heard that there was some big estate up in Bucks County that was going up for auction. Somebody said, why don't you get that and use it as a museum for your collection? So . . . pretty much on the spur of the moment Fred raced him up there and he got there just in time for the auction to be over. I understand that he was really crushed by this.[203]

Another major focus of Horter's efforts in the late 1930s was the Philadelphia Art

Fig. 52. Elizabeth Lentz Horter about 1935.

Fig. 54. Earl Horter, Sheet of studies, c. 1935, graphite on paper, 14 x 17 inches (35.5 x 42.76 cm). The Schwarz Gallery, Philadelphia.

Alliance, an organization dedicated to promoting the interests of art. The Art Alliance was enjoying a period of renewed strength and purpose under the directorship of the painter Yarnall Abbott, who sought "the best and the strongest" in the alliance's committees, exhibitions, and performances. The record of exhibitions organized during Abbott's short tenure, which lasted only two years before his early death, is astonishing, and Horter was involved in many of the exhibitions. He served on the committee and was a lender to *African Art and Its Modern Derivatives* in January 1936, and in May, he and Abbott arranged the first one-man exhibition of the young Andrew Wyeth's watercolors. In 1937 Horter, working with program chairman Henry Pitz, was in charge of the Art Alliance's Committee for Watercolor, Drawing, and Illustration, during which time he organized *Contemporary Drawing* (1937), *William Ferguson Watercolors* (1938), and *Pop Hart Watercolors* (1939).[204]

A Passion for Picasso

On New Year's Eve 1929, Philadelphia artist Emlen Etting recorded in his diary:

Lunched with George Howe, Mo Speiser, and Earl Horter. . . . The conversation was interesting, leading up to a eulogy of Picasso, an obsession of Horter's.[205]

Alfred Barr's great and long-awaited exhibition *Picasso: Forty Years of His Art* at the Museum of Modern Art in New York closed in January of 1940, just two months before Horter died. He had once owned four of the paintings in the exhibition, but not one of them remained in his possession.[206] In early March his old friend Jacques Mauny wrote to R. Sturgis Ingersoll: "Kindly give me Horter's address. I would like to ask him what he thought of the Picasso exhibition."[207]

Horter was at the Art Alliance at a dinner the night before he died on March 29, 1940. Following the party, where he was said to be

in good spirits, he went home and worked on a flower painting, which was still drying on the easel when he died the next morning. In keeping with a pact he and his friends had made with each other to create a death mask of the first one of them who died, a death mask was made of Horter, which was later given by his widow to the Philadelphia Museum of Art (fig. 57). No one was more depressed by Horter's death than Arthur B. Carles, already in fragile condition, who never recovered from the early loss of his closest friend. He wrote to Elizabeth Horter that he could not bring himself to attend the large memorial exhibition that was held at the Art Alliance the following November: "I just couldn't do it. I just couldn't stand the proof that there had been the violent break."[208]

In May, Jacques Mauny again wrote R. Sturgis Ingersoll: "Poor Horter. . . . On his grave these words: He admired Picasso. He lived

Fig. 55. Earl Horter, *Organization No. 2*, 1939, watercolor on paper, 19¼ x 17¾ inches (49.2 x 45.1 cm). Private collection.

Navojoa

. . . treasures for almost nothing

Low roundtrip fares to **Mexico City** permit you to go one way on the National Railways of Mexico, one way on Southern Pacific's **West Coast Route**, see **Guaymas, Mazatlan, Guadalajara** and many another interesting place. Stop over at Southern Pacific's magnificent new **Hotel Playa de Cortés** (Guaymas) for a bit of sun-bathing, swimming or deep-sea fishing.

If you are thinking of going to Mexico this winter, you will find no better time than now. Fiesta season is beginning. The sun shines warmly in clean, blue skies.

For a new rotogravure folder describing the West Coast Route to Mexico City, write **O. P. Bartlett**, Dept. Ti-113, ~~Michigan Boulevard, Chicago.~~

mural made headlines last week (see above), his greatest rival in the field of modern art, Pablo Picasso, was honored by three shows at once. When both of them were young rebels in Paris, it was Painter Matisse who coined the name "Cubist"

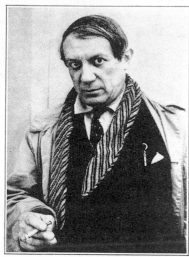

Courtesy Valentine Gallery

PABLO PICASSO

Lurking in Paris, he carried New York.

for the angular painting of his rival. At the Museum of Living Art ~~present~~

the comfort standards. for low fa and *Manh.* $116. Third ~~dent Harding~~ is $129, Thi.

A Sailing Cobb, Pl

Also "Ameri and Liverp to Londo

Fig. 56. News clipping with photograph of Picasso carried by Horter in his billfold at the time of his death.

Fig. 57. Death mask of Earl Horter.

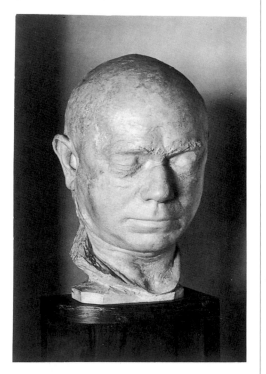

to see his great one man's show and I wanted to know what he thought of it."[209] Sadly, there are no reports of what Horter thought of the exhibition, but the touching proof of his enduring admiration for Picasso was found in the billfold he carried at the time of his death: along with two playing cards showing the king of diamonds, snapshots of his wife, and a driver's license, was a photograph of a debonair Picasso torn from an old magazine (fig. 56).

The *Earl Horter Memorial Exhibition* at the Philadelphia Art Alliance included more than two hundred of his works, ranging from early etchings to advertising work, preparatory sketches, and later works in a variety of styles and mediums. His friend R. Sturgis Ingersoll captured the essence of Horter's irrepressible delight in works of art in the graceful tribute he wrote for the memorial catalogue:

We can see those busy hands at work, hear that eager voice, and watch that dynamic figure enter a room, with that unforgettable smile give greetings, and then turn to a painting on the wall and with a twist of his head beckon you to come and share it with him.[210]

Notes

1. Horter to Roullier, undated, Arts Club of Chicago papers, Newberry Library, Chicago (hereafter NL).

2. "Hobby Hunter Runs into Artist Who Thrills in Works of Others," *Evening Public Ledger* (Philadelphia), July 3, 1931.

3. Horter to Carles, undated, Arthur B. Carles papers, Archives of American Art, Washington, D.C. (hereafter AAA). ·

4. Pach to MacRae, December 23, 1914, Elmer MacRae papers, Hirshhorn Museum and Sculpture Garden, Smithsonian Institution, Washington, D.C.

5. Horter confirmed this in testimony he delivered at the time of his divorce from his first wife: "I never keep any letters. I have so many clippings connected with my work that I don't even keep business correspondence, and when it is terminated, I throw it all away." Earl B. Horter v. Elin Horter, February 3, 1927, Court of Common Pleas, No. 4, for the County of Philadelphia, March Term 1927, No. 255, p. 83 (hereafter EBH v. EH, 1927).

6. Henry C. Pitz, "Earl Horter: The Man and His Work," *American Artist* (New York), vol. 20, no. 4 (April 1956), p. 20.

7. Pitz, "Earl Horter," 1956, pp. 20–26, 66.

8. *Catalogue of an Exhibition of Etchings and Drawings by Earl Horter*, introduction by Carl Zigrosser (New York: Frederick Keppel and Company, 1916), n.p. (hereafter cited as Zigrosser, Keppel and Company, 1916).

9. Twelfth Census of the United States, Schedule No. 1—Population, State of Pennsylvania, Philadelphia County, City of Philadelphia, 22nd Ward, June 6, 1900. On his marriage license application of April 18, 1938, for his marriage to Elizabeth Lentz Keim, Horter listed the names of his parents (Commonwealth of Pennsylvania, County of Philadelphia, license no. 689361). Jacob was a common Horter family name; it appears in multiple entries in the *Philadelphia City Directory* between 1875 and 1880. In 1931 Horter told a reporter that his father also had been a collector ("Hobby Hunter," 1931). In 1895 a Jacob Wise Horter, M.D., of Philadelphia offered to donate a collection of archaeological specimens to the University Museum, which the museum subsequently rejected (University of Pennsylvania Museum Archives, Philadelphia, Office of the Director, Stewart Culin—Horter Collection). While it is likely that Dr. Horter was a relative, it is certain that he was not Earl Horter's father, since the latter is known to have died in 1900 and Dr. Horter was still alive in 1901. Whether Earl Horter may have known this collector of archaeological materials in his youth, however, is a tantalizing question.

10. For stories about Horter's training, see Julian E. Levi, "Earl Horter," *Living American Art Bulletin* (New York), July 1939, p. 4; Dorothy Grafly, "Horter's Built Up $20,000 Income: His Story More Colorful Than His Work," *Philadelphia Record*, April 21, 1940; and Pitz, "Earl Horter," 1956, p. 20.

11. Earnest Elmo Calkins, "And Hearing Not—" *Annals of an Adman* (New York: Charles Scribner's Sons, 1946), p. 206.

12. Earnest Elmo Calkins, "Art as a Means to an End," *Advertising Arts* (New York) January 8, 1930, section 2, p. 18.

13. Calkins, "And Hearing Not—" 1946, p. 218.

14. Calkins, "And Hearing Not—", 1946, p. 206.

15. See Richard S. Field, "Introduction to a Study of American Prints, 1900–1950," in *American Prints, 1900–1950* (New Haven: Yale University Art Gallery, 1983), pp. 14–21.

16. See Michele H. Bogart, *Advertising, Artists, and the Borders of Art* (Chicago and London: The University of Chicago Press, 1995), pp. 207–12.

17. Calkins, "And Hearing Not—," 1946, p. 206.

18. George Senseney is mentioned by Carl Zigrosser, in Keppel and Company, 1916, n.p. On Senseney and the Art Student's League, see Reba White Williams, "The Weyhe Gallery Between the Wars, 1919–1940" (Ph.D. diss., City University of New York, 1996), p. 24. Julian Levi mentions Horter's study in the studio of Troy Kinney in "Earl Horter," 1939, p. 4.

19. Reba White Williams, "Prints in the United States, 1900–1918," *Print Quarterly*, vol. 14, no. 2 (June 1997), p. 168.

20. Berlin Photographic Company, New York, *New York Society of Etchers: First Annual Exhibition at the Galleries of the Berlin Photographic Company*, January 6–31, 1914. In 1914 he was also represented by three etchings in the *Exhibition of Works by American Etchers* at the Art Institute of Chicago. Five of his etchings were shown in the 1914 *Annual Exhibition of the Association of American Etchers*, which traveled around the country, and were reproduced in the *Year Book of American Etching 1914*, introduction by Forbes Watson (New York: John Lane Company, 1914), n.p. In 1915 the Brown-Robertson Gallery submitted four of Horter's etchings to the *Panama-Pacific International Exposition* in San Francisco, for which he won a silver medal.

21. "Jottings from the Galleries," *American Art News*, January 17, 1914; "The New York Society of Etchers," *New York Times*, January 11, 1914, magazine section.

22. Montross Gallery, New York, *Exhibition· New York Society of Etchers*, October 31–November 18, 1916; see also Carl Zigrosser, *My Own Shall Come to Me: A Personal Memoir and Picture Chronology* (Haarlem: Casa Laura, 1971), p. 52.

23. Robert J. Cole, "Studio and Gallery," *Evening Sun* (New York), undated clipping, Philadelphia Museum of Art Archives (hereafter PMAA). Frederick Keppel and Company issued a popular series of catalogues for its exhibitions in the 1910s, which Zigrosser often wrote; he became known as a strong proponent of contemporary printmakers.

24. Field, *American Prints*, 1983, p. 19.

25. "Exhibition of New York Society of Etchers," *New York Times*, October 29, 1916, magazine section.

26. Zigrosser, Keppel and Company, 1916. Horter's working methods defy the arrangement of his work in chronological order: he habitually worked on many plates at the same time and almost never dated his work; he made plates of much earlier drawings and also assigned different titles to the same print, and he constantly reused his earlier work in new, modified versions.

27. Robert J. Cole, "Studio and Gallery," *Evening Sun* (New York), October 12, 1916.

28. "Hobby Hunter," 1931.

29. "Yet he had already acquired and given away a notable collection of prints," recorded Grafly, 1940. Horter's acquisition of a wide-ranging print collection is also confirmed by the artist Jacob Landau, a student of Horter's, to whom he gave his set of Goya's *Caprichos*. Also documented are the gift of Nicholson woodcuts from Mrs. Horter to the Philadelphia Museum of Art; Horter's loan of Japanese prints to the Philadelphia Art Alliance in 1937; and his letters mentioning owning prints by Whistler and MacLaughlan.

30. Elmer MacRae papers, Hirshhorn Museum and Sculpture Garden, Smithsonian Institution, Washington, D.C., "Artists' Ledgers." See Milton W. Brown, *The Story of the Armory Show*, 2nd ed. (New York: Abbeville Press, 1988), p. 323, which lists "Thirteen sold for $112 to E. Horter, March 9, 1913," indicating only that Horter purchased thirteen prints by Vuillard, lent by Ambroise Vollard. The numerical correspondence between the thirteen prints and the Vuillard suite *Paysages et Intérieurs* was suggested by John Ittmann, Curator of Prints, Philadelphia Museum of Art.

31. Brown, *Armory Show*, 1988, p. 323.

32. Kuhn to Horter, May 28, 1913, Walt Kuhn papers, AAA.

33. Paul Lewis, "Earl Horter: An Artist's Artist," *Advertising Arts* (New York), January 8, 1930, section 2, p. 65.

34. Horter to Stieglitz, [January 18, 1926], Alfred Stieglitz papers, Yale Collection of American Literature, New Haven, Connecticut (hereafter YCAL). In 1908 Stieglitz held an exhibition of prints by the conservative landscape etcher Donald Shaw MacLaughlan, at which Horter may have purchased the two MacLaughlan prints that he tried to sell in 1934 (Horter to Alice Roullier, undated, Arts Club of Chicago papers, NL).

35. See Carol Arnold Nathanson, "The American Response, in 1900–1913, to the French Modern Art Movements after Impressionism" (Ph.D. diss., The Johns Hopkins University, 1972), pp. 237–83.

36. The catalogue *Henri Matisse Retrospective Exhibition* from the Montross Gallery appears on a list of books from Horter's library compiled during the 1970s by Barbara Sevy, Librarian at the Philadelphia Museum of Art, when Mrs. Horter offered to donate books to the museum.

37. Zigrosser, Keppel and Company, 1916, n.p.

38. Zigrosser, Keppel and Company, 1916, n.p.

39. For the date of Horter's employment, see "Earl Horter" research file for the exhibition *Philadelphia: Three Centuries of American Art*, April 11–October 10, 1976, Department of Twentieth-Century Art, Philadelphia Museum of Art (hereafter PMA). In his testimony for his divorce from Elin Horter, Horter said that he moved to Philadelphia in 1916 to begin working for N. W. Ayer (EBH v. EH, 1927, p. 6).

40. Horter to Zigrosser, undated, Carl Zigrosser papers, Special Collections Department, Van Pelt–Dietrich Library, University of Pennsylvania, Philadelphia (hereafter UPP).

41. The fifteen letters from Horter to Zigrosser are undated. One bears a postmark of September 29, 1920; another, datable to around 1933, includes the address where Horter resided between 1928 and 1937. All the other letters are dated on the basis of their contents. Most of the letters may be dated between late 1916 and 1919. Some were clearly written during World War I; others may be dated shortly before or after the birth on September 11, 1917, of Zigrosser's daughter, Carola;

several refer to Horter's contribution to the portfolio *Twelve Prints by Contemporary American Artists*, which Zigrosser organized for publication by the Weyhe Gallery in November 1919. Carl Zigrosser papers, UPP.

42. Horter to Zigrosser, n.d., Carl Zigrosser papers, UPP.

43. Author's interview with Albert Gold, June 25, 1997, transcript, PMAA (hereafter, Gold interview, 1997).

44. Ralph M. Hower, *The History of an Advertising Agency: N. W. Ayer and Son at Work, 1869–1949*, rev. ed. (Cambridge, Massachusetts: Harvard University Press, 1949), p. 109.

45. Jersey City Museum, New Jersey, *Pencil Points: Selections from the Dixon Ticonderoga Company Collection*, organized by Francine Corcione, August 31–November 12, 1994, pp. 14, 17.

46. *Pencil Points*, 1994, p. 17.

47. The advertisements are collected in the N. W. Ayer scrapbooks, Archives Center, National Museum of American History, Washington D.C.; see also "An Interesting Correspondence with the Eldorado Pencil Artist," *Graphite* (Jersey City, New Jersey), vol. 26, no. 5 (September–October 1924), p. 1.

48. Interview with Franklin Watkins by Paul Cummings, 1971, transcript, Franklin Watkins papers, AAA (hereafter Watkins–Cummings interview, 1971).

49. Albert E. Haase, "Pencil Drawings Which Give Effect of Etchings," *Printers' Ink Monthly*, vol. 1, no. 6 (May 1920), pp. 41–42.

50. Horter to Zigrosser, Carl Zigrosser papers, UPP.

51. Horter to Zigrosser, Carl Zigrosser papers, UPP.

52. Horter to Zigrosser, Carl Zigrosser papers, UPP.

53. Carl Zigrosser, *A World of Art and Museums* (Philadelphia: The Art Alliance Press; and London: Associated University Presses, 1975), pp. 40–41.

54. The letter from Horter to Zigrosser that is datable to around 1933 (see note 41) contains Horter's offer to send a group of his recent aquatints and watercolors of nudes to Zigrosser, but there is no indication that this took place. Zigrosser's diaries twice mention his seeing Horter in Philadelphia in the 1930s, and there is an entry recording Zigrosser's regret at Horter's death, but they never again shared the friendship they enjoyed during and just after Horter's sojourn in New York.

55. On Peters Brothers, see Peter Morse, *John Sloan's Prints* (New Haven and London: Yale University Press, 1969), pp. 4–5.

56. Horter to Zigrosser, Carl Zigrosser papers, UPP.

57. Horter to Zigrosser, Carl Zigrosser papers, UPP.

58. "Hobby Hunter," 1931.

59. Watkins–Cummings interview, 1971.

60. Watkins–Cummings interview, 1971. While Watkins made these comments in response to a question about Philadelphia in the 1930s, his answer clearly refers to events that took place in the 1920s. Watkins's statement and other evidence presented in this essay pertaining to the Philadelphia art world in the 1920s stand in contradiction to the theory of Wilford Wildes Scott presented in "The Artistic Vanguard in Philadelphia, 1905–1920" (Ph.D. diss., University of Delaware, 1983), pp. 227–36, where the 1920s modernist movement in Philadelphia is portrayed as a small-scale revival of a more vital pre-war

artistic vanguard; that earlier group had included not only Carles, McCarter, and Breckenridge, but also the artists Lyman Säyen and Morton Schamberg, both of whom died in 1918, and Charles Sheeler, who moved to New York in 1919. The collectors of modern art such as Horter, Maurice Speiser, and Samuel S. White, 3rd, are presented by Scott as the remaining supporters of the avant-garde in Philadelphia after the war rather than as the lively and adventurous proponents of the avant-garde that they were.

61. See Oliver Daniel, *Stokowski: A Counterpoint of View* (New York: Dodd, Mead & Company, 1982), especially chapter 21.

62. See R. Sturgis Ingersoll, *Henry McCarter* (Cambridge, Massachusetts: The Riverside Press, 1944).

63. See Barbara A. Wolanin, *Arthur B. Carles (1882–1952): Painting with Color* (Philadelphia: Pennsylvania Academy of the Fine Arts, 1983); and letters in the Arthur B. Carles papers, AAA.

64. A revealing summary of the contents of Philadelphia collections in May 1932 appears in a report prepared by a representative of the Marie Harriman Gallery (Walt Kuhn papers, Marie Harriman Gallery correspondence, AAA). A more informal description of some of the same collections, entitled "Studio in Paris, 1930," was written by Emlen Etting (Emlen Etting papers, AAA). A brief, descriptive tribute to Philadelphia collectors by R. Sturgis Ingersoll was given in a speech delivered at the Print Club of Philadelphia, November 14, 1930 (A. E. Gallatin papers, New-York Historical Society). Individual studies of the Philadelphia collections under discussion that provide more information than checklists are the following: John Rewald, "The Collection of Carroll S. Tyson, Jr., Philadelphia, U.S.A.," *Philadelphia Museum of Art Bulletin*, vol. 59, no. 280 (Winter 1964); "The Samuel S. White, 3rd, and Vera White Collection," *Philadelphia Museum of Art Bulletin*, vol. 63, nos. 296–97 (January–March/April–June 1968); and Richard J. Wattenmaker, "Dr. Albert C. Barnes and the Barnes Foundation," in *Great French Paintings from the Barnes Foundation* (New York: Alfred A. Knopf, 1995), pp. 3–27.

65. Etting, "Studio in Paris, 1930," Emlen Etting papers, AAA.

66. C. H. Bonte, "In Gallery and Studio," *Philadelphia Inquirer*, March 18, 1934.

67. *Exhibition of Paintings and Drawings by Representative Modern Masters* (Philadelphia: Pennsylvania Academy of the Fine Arts, 1920), no. 105 and nos. 244–49.

68. Horter to Carles, undated, Arthur B. Carles papers, AAA.

69. See Sylvia Yount, "Rocking the Cradle of Liberty: Philadelphia's Adventures in Modernism," in *To Be Modern: American Encounters with Cézanne and Company* (Philadelphia: Museum of American Art of the Pennsylvania Academy of the Fine Arts, 1996), pp. 16–18.

70. *Exhibition of Paintings and Drawings Showing the Later Tendencies in Art* (Philadelphia: Pennsylvania Academy of the Fine Arts, 1921); see also Yount, "Rocking the Cradle," 1996, pp. 18–21.

71. Sales Record Book, 1900–1959, Archives of the Pennsylvania Academy of the Fine Arts, Philadelphia.

72. Notebook entry, with the heading "1826 Spruce—Earl Horter," undated, Arthur B. Carles papers, AAA. Paintings listed are *Tulips*; *Small Head*; Two small

[illegible]; 1 medium *Bouquet*; 1 20x24 [illegible]; and *Color comp—No. 2—Large Flowers*.

73. Horter to Carles, undated, Arthur B. Carles papers, AAA.

74. The artists in the 31 exhibition held in 1923 were George Biddle, Delphine Bradt, Hugh Breckenridge, Arthur B. Carles, Sara Carles, Christine Chambers, Jean Knox Chambers, William Cochran, Charles Demuth, Elizabeth Dercum, Paul Froelich, Charles Gardner, Weeks Hall, Earl Horter, Anna Ingersoll, Thomas Jones, Alice Riddle Kindler, Julian Levi, Mary Lowell Lloyd, Henry McCarter, Lisa Moncure, Katharine Munoz, William Nell, Carl Newman, Josephine Page, Raphael Sabatini, Charles Sheeler, Helen Sortwell, Dorothy Stewart, Franklin Watkins, and J. Wallace Kelly.

75. Diary for 1923, entry for February 27, Anna Warren Ingersoll papers, AAA. Subsequent quotations from the 1923 diary are cited with specific dates within the text.

76. Dorothy Grafly, "Protest Exhibition By 'The 31' Is Opened," *The North American* (Philadelphia), April 4, 1923.

77. C. H. Bonte, "Sensing of Soul Not Substance," *Philadelphia Inquirer*, April 8, 1923.

78. Horter, for example, showed one of these numbered nudes, which was entitled *1826* for his residence at 1826 Spruce Street.

79. Quoted in Edith W. Powell, "What Our Artists and Musicians Are Doing," *Evening Public Ledger* (Philadelphia), April 18, 1923.

80. Grafly, "Protest Exhibition," 1923.

81. Powell, "What Our Artists," 1923.

82. "Horter Etchings Have Varied Appeal," *Art News*, vol. 21 (May 5, 1923), p. 2.

83. "Notes and Activities in the World of Art," *New York Herald*, May 6, 1923.

84. Seyffert to Carles, May 20, 1923, Arthur B. Carles papers, AAA.

85. Mercedes Carles to Arthur Carles, August 7, 1923, Arthur B. Carles papers, AAA.

86. See her biography in the archives of the Pennsylvania Academy of the Fine Arts, Philadelphia: Sophie Victor, later Sophie Victor Greene (1906–1989), studied at the Pennsylvania Academy of the Fine Arts between 1922 and 1924. On the advice of her teacher Earl Horter she went to Paris in 1924, where she quickly became part of the artistic circle of Dada and Surrealist artists in Montparnasse. Among her friends were the American photographers Berenice Abbott and Man Ray, artists such as Ossip Zadkine and Braque, and writers as diverse as Hemingway and Aragon. She also met the young documentary photographer Stephen Greene, whom she eventually married, and, except for the years of World War II, the couple spent the rest of their lives in Paris.

87. On the date of Horter's departure, see "Earl Horter" research file for the exhibition *Philadelphia: Three Centuries of American Art*, April 11–October 10, 1976, Department of Twentieth-Century Art, PMA; on the changes at N. W. Ayer, see Hower, *History of an Advertising Agency*, 1949, p. 123.

88. Henry McCarter to Helen Seyffert, October 14, 1923, courtesy of Robert S. Ingersoll III.

89. The Pennsylvania Academy exhibition was held from February 3 to March 23, 1924. In the catalogue

Horter's address is listed as 4920 Parkside Av[enue], where he had lived before 1920; this was Arthur B. Carles's studio address in 1924.

90. Diary for 1924, entries for February 7, 9, and 10, Anna Warren Ingersoll papers, AAA.

91. Horter to Carles, undated, Arthur B. Carles papers, AAA.

92. See Sue Welsh Reed and Carol Troyen, *Awash in Color: Homer, Sargent, and the Great American Watercolor* (Boston: Museum of Fine Arts in association with Bulfinch Press, 1993), p. lv.

93. Wolanin, *Arthur B. Carles*, 1983, p. 84.

94. Diary for 1925, Anna Warren Ingersoll papers, AAA. Subsequent quotations from the 1925 diary are cited with specific dates within the text.

95. Horter to Barnes, undated, Barnes Foundation Archives, Merion, Pennsylvania.

96. Barnes to Horter, May 22, 1925, Barnes Foundation Archives, Merion, Pennsylvania.

97. Henry McBride, "Visitors Suspected of Attempt to Stampede Early Art Season," *Evening Sun* (New York), October 29, 1927.

98. C. H. Bonte, "Modernist Show in Philadelphia," *Philadelphia Inquirer*, February 26, 1928. The location of Horter's painting *Senlis* is unknown.

99. Statement in EBH v. EH, 1927, pp. 63–64.

100. Lewis, "Earl Horter," 1930, pp. 66–67.

101. Author's conversation with Warner Shelly, March 1, 1996.

102. Lewis, "Earl Horter," 1930, p. 66. Response to Horter's *Rhapsody in Blue* was not all positive. Nathaniel Pousette-Dart, reviewer of the *Seventh Annual Exhibition of the Art Directors Club*, wrote that the work was "not wholly successful, because it leans toward invention, rather than toward creation. Although it was evidently intended to be a dynamic interpretation, it is in reality somewhat static. . . . However, it is a fine gesture toward freedom in advertising" (*Art Center Bulletin* [New York], vol. 6, no. 8 [May 1928], p. 134).

103. R. Sturgis Ingersoll, *Recollections of a Philadelphian at Eighty* (Philadelphia: National Publishing Company, 1971), p. 91.

104. The painting was reproduced in *The Arts*, vol. 3, no. 1 (January 1923), p. 56, with a credit to the Montross Gallery January exhibition; it was also mentioned in a review, "Seven Artists at the Montross," *American Art News*, vol. 21, no. 16 (January 27, 1923), p. 2. After Horter lent it to the *31* exhibition, the painting was shown again in 1923 in the same room with one of Horter's Cubist nudes, in the *Spring Salon* exhibition at the Galleries of the American Art Association, New York, May 21–June 9, 1923, which included "Negro art, ship models, Indian and Persian pottery, Chinese and Persian paintings, Gothic sculptures, the pictures of Cézanne, and even machinery among paintings by modern Americans . . . to reveal the unity of purpose uniting them all" ("Salons of America Give Varied Show," *The Art News* [New York], vol. 21, no. 33 [May 26, 1923], p. 1).

105. Unpublished manuscript written by Sheeler for Harcourt Brace, undated, Charles Sheeler papers, AAA. There is no doubt that Horter and Charles Sheeler knew each other, but there is almost no firm evidence of when they met or how close they were. Only a 1924 Christmas card from Sheeler to Horter, a dedication to

Horter on a 1924 Sheeler lithograph, and one 1930 letter from Horter to Sheeler remain to document their friendship; there is also a remark in a 1927 letter from Walt Kuhn to his wife: "Earl Horter knows everybody in Phila and now that he probably sees less of Sheeler . . ." (Walt Kuhn papers, AAA). A 1986 catalogue entry provides tantalizing information, but without documentation, that "at one time Horter shared a studio in Philadelphia with Sheeler, and his family owned Sheeler's work" (Hirschl and Adler Galleries, Inc., New York, *Modern Times: Aspects of American Art, 1907–1956* [New York: Hirschl and Adler Galleries, Inc., 1986], p. 62). Both artists came from Philadelphia, but while Horter was in New York, Sheeler was studying at the Pennsylvania Academy and pursuing his career as a painter and photographer in Philadelphia; Horter moved back to Philadelphia in 1916, and Sheeler moved to New York in 1919, and the overlap is the most likely time of their friendship. Sheeler began to work for N. W. Ayer in 1927, while Horter was working as a freelance artist for Ayer. Horter was a great admirer of Sheeler and owned nine works by him, which date between 1916 and 1924; however, there is evidence of his buying only one of them directly from Sheeler.

106. Horter to Carles, undated, Arthur B. Carles papers, AAA. For *Still Life Synchromy*, see M6 under Missing Works, p. 131.

107. Leon Kelly, recollection of Earl Horter, April 23, 1965, typescript, courtesy of Paula Kelly Muller (hereafter cited as Kelly, recollection, 1965).

108. The itinerary of Horter's 1921 trip is pieced together from the dates on some of his drawings for the Dixon Eldorado pencil commission. Carles left Philadelphia on July 9, 1921; he lived in Edward Steichen's house in Voulangis and visited Paris frequently; he returned to Philadelphia in February 1922 (Wolanin, *Arthur B. Carles*, 1983, p. 150).

109. Michael C. Fitzgerald, *Making Modernism: Picasso and the Creation of the Market for Twentieth-Century Art* (New York: Farrar, Straus and Giroux, 1995), pp. 116–18; see also Malcolm Gee, *Dealers, Critics, and Collectors of Modern Painting: Aspects of the Parisian Art Market Between 1910 and 1930* (New York and London: Garland, 1981), especially pp. 242–43.

110. Horter's mention of another Picasso in this letter does not describe any known painting in his collection: "Saw the one you liked so well of an abstract head, sort of flat umber dark grey green background etc. Sure was a beaut—could buy it for 800—but hardly feel I can make the grade—but may fall at the last moment" (Horter to Carles, undated, Arthur B. Carles papers, AAA).

111. "Picasso at the Whitney Galleries," *The Arts* (New York), vol. 3, no. 5 (May 1923), pp. 364–65, reproduced p. 323, with a credit to the Whitney Studio Galleries. While Justin K. Thannhauser (inventory book, Justin K. Thannhauser Archives, Geneva, Switzerland), one of the later owners of the painting, had tentatively suggested that Horter probably acquired it from Léonce Rosenberg, more likely it was with Paul Rosenberg. There was a "Nature morte: Bouteille de porto" listed as no. 12 in the catalogue for *Exposition Picasso* at the Galeries Paul Rosenberg, Paris, in May–June 1921. It is not known whether Horter

acquired the painting from Paul Rosenberg and lent it to the Whitney Galleries in 1923 or whether he purchased it from the Whitney exhibition.

112. George Biddle, *An American Artist's Story* (Boston: Little, Brown and Company, 1939), p. 208.

113. Mrs. Gilbert W. Chapman to Courtney O'Donnell, October 27, 1975, curatorial file, Art Institute of Chicago.

114. Inscribed catalogue *Exposition d'oeuvres de Giorgio de Chirico*, Galerie Paul Guillaume, June 4–12, 1926, introduction by Dr. Albert C. Barnes, Earl Horter papers, PMAA.

115. Kelly, recollection, 1965.

116. For Jacques Mauny, see Christian Derouet, "*Vue de New York* par Jacques Mauny," *Revue du Louvre et des Musées de France*, vol. 37, no. 4 (1987), pp. 297–300.

117. Mauny to Gallatin, November 13, 1927, and December 12, 1927, A. E. Gallatin papers, New-York Historical Society.

118. Ingersoll, *Recollections*, 1971, p. 58 and pp. 86–87.

119. Mauny to Picasso, May 31, 1928, "Scripteurs illustres, 1928–31," Archives of the Musée National Picasso, Paris (author's translation).

120. Horter to Cooper, undated, Douglas Cooper papers, The Getty Research Institute for the History of Art and the Humanities, Los Angeles.

121. The four photographs are in the archives of the Musée National Picasso, Paris (see figs. 1–4). They may be dated to about 1929–30, after Horter purchased the Delancey Street house on September 10, 1928; by May 15, 1931, he had sold Picasso's *Portrait of Braque* (pl. 34), which appears in one of the photographs.

122. See Malcolm Gee, "The Avant-Garde, Order and the Art Market, 1916–23," *Art History*, vol. 2, no. 1 (March 1979), p. 102.

123. Hôtel Drouot, Paris, "Tableaux modernes: Aquarelles, gouaches, pastels, et dessins," December 12, 1925, lots 9 and 121, both reproduced. Gee, *Dealers, Critics, and Collectors*, 1981, p. 280, states that the works in the auction were from the collection of Georges Aubry.

124. Horter to Stieglitz, January 18, 1926, Alfred Stieglitz papers, YCAL.

125. Kelly, recollection, 1965.

126. See Brown, *Armory Show*, 1988, p. 139.

127. Kelly, recollection, 1965.

128. Statement of Account, Estate of John Quinn, National Bank of Commerce in New York, formerly Thomas F. Conroy, San Mateo, California; photocopy of original document courtesy of Judith Zilczer, Hirshhorn Museum and Sculpture Garden, Smithsonian Institution, Washington, D.C. The document records the dates of sale and prices of six of Horter's purchases from the private sales held prior to the auctions of Quinn's collection: Brancusi, *Mademoiselle Pogany I* ($1,200) on February 15, 1926; Duchamp, *Nude Descending a Staircase, No. 1* ($300) on March 22; Matisse, *Italian Woman* ($2,327) on April 9; Braque, unidentified ($50) on April 13; Brancusi, *Muse* ($750) on April 23; and Sheeler, unidentified ($270) on June 14. Other Philadelphia collectors and institutions were also buyers: R. Sturgis Ingersoll (Rouault and Metzinger on January 28); Samuel S. White, 3rd (Braque on March 2 and Pascin on April 14); Raymond Pitcairn (Cézanne and Egyptian art on March 4); and the University

Museum, University of Pennsylvania (18 "African Negro" carvings on June 1). The two Quinn works in Horter's collection that he did not buy from the private sales, because they are not listed on the Statement of Account, are two Picassos, *Nude Figure* (pl. 35) and *L'Arlesienne* (pl. 40); see Pierre Daix and Joan Rosselet, *Picasso: The Cubist Years, 1907–1916: A Catalogue Raisonné of the Paintings and Related Works* (Boston: New York Graphic Society, 1979), p. 256, no. 349 and p. 284, no. 496, respectively.

129. It is not known when Horter acquired his fourth Brancusi, the *Danaïde*, 1913.

130. Ann Temkin, "Brancusi and His American Collectors," in *Constantin Brancusi, 1876–1957* (Philadelphia: Philadelphia Museum of Art, 1995), p. 59 and n. 80.

131. Diary for 1926, Anna Warren Ingersoll papers, AAA.

132. Horter to Barnes, undated, Barnes Foundation Archives, Merion, Pennsylvania. The letter can be dated by Barnes's letter to Horter of November 14, 1927, to which this is a reply.

133. Ingersoll, *Recollections*, 1971, p. 90.

134. Anna Ingersoll called on Sophie Victor with Paul Cret's wife, Marguerite, on February 20, 1925, and wrote in her diary: "Horter is sending her around to be rid of her. . . . And she is fond of him—and lonely."

135. Horter had divorced his estranged wife, Elin Horter, on February 3, 1927. Information on Elizabeth Reynolds Sadler was provided by the Alumni Office of the University of Pennsylvania and the Archives of the University Museum, University of Pennsylvania.

136. Cret's drawings for the fourth floor of 2219 Delancey Street are with the Paul Cret papers, Athenaeum of Philadelphia.

137. "Hobby Hunter," 1931.

138. Letter to the author from Elin Horter Young, February 26, 1997, PMAA.

139. "Hobby Hunter," 1931.

140. The description of the furnishings shown in the photographs is from notes on the reverse of two of the photographs, which were written in May 1972 by Horter's former wife Helen Lloyd Horter (later Helen Kelly), PMA.

141. Emlen Etting, diary, entry for November 2, 1929, transcript, courtesy of John F. Warren.

142. A. E. Gallatin, "The Plan of the Museum of Living Art," in A. E. Gallatin, *Museum of Living Art: A. E. Gallatin Collection* (New York: New York University, 1940), n.p.

143. R. Sturgis Ingersoll, speech given at the Print Club of Philadelphia, November 14, 1930, A. E. Gallatin papers, New-York Historical Society.

144. Horter to Carles, undated, Arthur B. Carles papers, AAA. The letter can be dated to autumn 1930 by the events described in it, such as the divorce from Elizabeth and the marriage to Helen.

145. Author's interview with William Campbell, February 6, 1995; author's conversation October 18, 1996, with Venable Herndon, whose mother resided with Fred's son, Jim Helsengren.

146. Herndon, 1996.

147. Author's interview with Paula Kelly Muller, daughter of Helen Lloyd [Horter] Kelly and Leon Kelly, October 8, 1995.

148. Horter to Carles, undated, Arthur B. Carles papers, AAA.

149. Earl Horter, *Picasso, Matisse, Derain, Modigliani* (Philadelphia: H. C. Perleberg, 1930); Earl Horter, *Pencil Drawing* (Philadelphia: H. C. Perleberg, 1931). Many of the drawings in *Pencil Drawing* were earlier works to which Horter added didactic texts. The drawing of *Gerona*, for example, was made during Horter's trip to Europe in 1923–24. Christa Clarke has pointed out that Horter's texts may show some influence of the writings of Dr. Albert Barnes.

150. Quoted in Samuel S. White, 3rd, "Earl Horter," *The Art Alliance Bulletin*, November 1940, n.p.

151. Horter to Carles, undated, Albert B. Carles papers, AAA.

152. Albert Gold, "Earl Horter: Pioneer of Modernism," *Step-by-Step Graphics*, July/August 1991, p. 117.

153. Horter is mentioned as a staff member in a clipping from an unidentified newspaper article, "Founder Realizes Dream in Graphic Sketch Club's Aim," 1929(?), Samuel S. Fleisher Art Memorial papers, AAA.

154. B. F. Morrow, *The Art of Aquatint* (New York: G. P. Putnam's Sons, 1935), opposite p. 110.

155. Horter's visits to the Gloucester area are confirmed by the dates and subjects of several of his "Pointillist" watercolors. See also a letter addressed to Carles in Gloucester, with the closing, "With my best to you and Bill and Horter," Carroll Tyson to Carles, August 19, 1934, Arthur B. Carles papers, AAA.

156. Crillon Galleries, Philadelphia, *Earl Horter: Studies of Nudes*, March 15–28, 1933. See also "Series of Nudes Shown by Horter," *Public Ledger* (Philadelphia), March 19, 1933. The Print Club exhibition was held between October 1 and November 4, 1933, according to an invitation in the Print Center Archives, Pennsylvania Historical Society, Philadelphia.

157. Campbell interview, 1995.

158. Horter to Zigrosser; see note 41.

159. Interviews with Horter's students reveal very little knowledge, and nearly no firsthand knowledge, of his collection, even on the part of students who studied with him in the studio in his house. One student, Joseph Greenberg, reported: "One of the things I look back on with great joy was the fact that Horter would bring in beautiful art books all the time. He just seemed to have an endless source of very rare books" (Interview with Joseph J. Greenberg by Cynthia Veloric, March 19, 1991, AAA).

160. Greenberg–Veloric interview, 1991.

161. Campbell interview, 1995.

162. The illustrator Thornton Oakley taught at the Philadelphia Museum School of Industrial Art between 1914 to 1919 and 1921 to 1936. Described as a "bull in a china shop," he was also revered as a stern but effective teacher. On the wall of his classroom hung "the rules of art," handed down to him by his teacher Howard Pyle, which he expected his pupils to follow (Campbell interview, 1995). See Brandywine River Museum, Chadds Ford, Pennsylvania, *Thornton Oakley*, by Gene E. Harris, January 22–March 20, 1983.

163. Gold interview, 1997.

164. Author's conversation with Bernard Shackman, October 5, 1995.

165. Campbell interview, 1995; Paula Kelly Muller interview, 1995.

166. Quoted in "Blai's Method," *The Art Digest*, October 15, 1935.

167. Greenberg–Veloric interview, 1991.

168. Greenberg–Veloric interview, 1991.

169. Author's interview with John Lear, January 31, 1995.

170. Philadelphia Sketch Club Gallery, *Being an Exhibition of the Work of Earl Horter's Gang . . . This Show Is One Way of Saying "Thank You, Bill" . . . We Hope He Will Understand*, December 2–14, 1940, n.p.

171. Horter to Alice Roullier, undated, Arts Club of Chicago papers, NL.

172. Horter to Carles, undated, Arthur B. Carles papers, AAA.

173. Correspondence between Duchamp and Brancusi on November 9 and 13, 1933, concerning the Brummer exhibition mentions Horter in reference to loans to the exhibition, but his name does not appear as a lender in the exhibition brochure. See Doïna Lemny, "Archives," in *La Collection: L'Atelier Brancusi* (Paris: Centre Georges Pompidou, 1997), p. 199.

174. A. Everett Austin to Horter, December 18, 1933; Henry-Russell Hitchcock to Horter, January 16, 1934; Horter to Hitchcock, undated, Wadsworth Atheneum Archives, Hartford, Connecticut. The Pennsylvania Museum of Art became the Philadelphia Museum of Art in 1938.

175. "Painter Viewpoint in Horter Art: Cubism Traced in Europe and America," *Public Ledger* (Philadelphia), February 18, 1934.

176. Dorothy Grafly, "The Horter Collection," *Christian Science Monitor* (Boston), February 24, 1934.

177. Eleanor Jewett, "Art Exhibits Range from Old Masters at Johnson Galleries to Earl Horter's Collection of Moderns," *Chicago Sunday Tribune*, April 15, 1934.

178. Walt Kuhn papers, Marie Harriman Gallery correspondence, AAA; see note 64.

179. Crowninshield to Jerry Abbott (curator, Museum of Modern Art, New York), Alfred Barr papers, The Museum of Modern Art Archives, New York.

180. Mauny to Kelly, October 4, 1930, courtesy of Paula Kelly Muller.

181. Marceau to Horter, February 6, 1931, Marceau file, PMAA.

182. The 1932–33 correspondence between Pierre Matisse and Horter or his attorney, Eugene John Lewis, does not present a coherent picture of what took place. Correspondence dated between April 26, 1932, and October 11, 1933, specifically mentions four works: a Picasso "grey 'Abstraction'"; a Picasso "Green Still Life" (probably *Vive La [France]*); the Matisse *Italian Woman*; and Brancusi's *Mademoiselle Pogany I*. It is clear that the Brancusi was never sent to New York. The Matisse seems to have traveled back and forth to New York more than once; on February 8, 1933, it was in Philadelphia, when Lewis wrote to Pierre Matisse that Mr. [Chester] Dale was expected to come there to see it. On May 8, 1933, Lewis wrote to Pierre Matisse: "We have taken back all the pictures to Philadelphia with the exception of the 'Mattise' [Lewis's spelling and quotation marks], which we have left at Mr. Janowitz' place" (Pierre Matisse Gallery papers, Pierpont Morgan Library, New York, hereafter PML). It is this author's theory that the "Mattise" is confused with the Picasso

Vive la [France], which was sold to Sidney Janis (then Janowitz) by early 1934, at which time Janis lent it to the exhibition *Pablo Picasso* at the Wadsworth Atheneum, Hartford, Connecticut (February 6–March 1, 1934, no. 27).

183. Kimball to Horter, April 28, 1933, PMAA.

184. Horter to Hitchcock, undated, Wadsworth Atheneum Archives, Hartford, Connecticut.

185. For this and subsequent correspondence regarding the Arts Club show, see Horter to Alice Roullier, undated, Arts Club of Chicago Archives, NL.

186. On the provenance of the *Nude Descending a Staircase, No. 1*, see Naomi Sawelson-Gorse, "Hollywood Conversations: Duchamp and the Arensbergs," in *West Coast Duchamp*, ed. Bonnie Clearwater (Miami Beach, Florida: Grassfield Press, 1991), p. 41, n. 6.

187. There are two different versions of how Hatch learned of the availability of *Nude Descending a Staircase, No. 1*: first, that in late February of 1934 he heard through a friend that Bye had the painting for sale (Hatch to Arensberg, April 17, 1934, John Davis Hatch, Jr., papers, AAA); second, that he saw it for sale in a New York gallery in 1934 before it was shown in Chicago (see Gorse-Sawelson, "Hollywood Conversations," 1991, p. 41, n. 6). The former story must be the correct one, as the *Nude, No. 1* was not in New York but was being exhibited at the Pennsylvania Museum of Art in February, prior to the show in Chicago.

188. Sidney Janis, memoirs, entry for March–April 1986, typescript, pp. 182–83, courtesy of Carroll Janis.

189. Horter's handwritten notation on the checklist he sent to the Arts Club of Chicago (Arts Club of Chicago papers, NL). Elizabeth Goodspeed (Mrs. Charles B. Goodspeed, later Mrs. Gilbert W. Chapman) was the shrewd purchaser of the *Portrait of Daniel-Henry Kahnweiler* (pl. 38), as well as of the Picasso *Portrait of a Woman* (pl. 37), the Braque collage (pl. 7), and the small Gris still life (pl. 19). Another, unknown buyer acquired a Modigliani drawing (location unknown). At the same time as the Arts Club exhibition, Horter lent Modigliani's *Nude (Caryatid)* (see M10 under Missing Works), John Marin's watercolor *Landscape in Maine* (pl. 73), and four of his own watercolors to the Art Institute of Chicago's *Thirteenth International Watercolors, Drawings, and Monotypes* exhibition. He sold the Marin to the Art Institute, while his own watercolor *Chinatown at Night* won the Watson F. Blair Award and was also acquired for the institute's collection (for correspondence and records regarding this exhibition, see Horter to Henry Clifford, PMAA; PMA Registrar's records; and Horter to Robert B. Harshe, undated, Art Institute of Chicago Archives).

190. Ingersoll to Horter, December 7, 1934, and Marceau to Horter, February 14, 1934, Marceau file, PMAA.

191. Marceau to Horter, February 19, 1935, and Kimball to Marceau, March 19, 1935, Marceau file, PMAA.

192. Other explanations might include Horter's desire to save the cost of insuring the collection, or possibly a need to keep the collection out of the way of creditors who plagued him at the time.

193. Matisse to Ruth Maitland, February 14, 1936, and March 23, 1936, Pierre Matisse Gallery Archives, PML.

The amount of [illegible] was not much more than the $2,327 Horter had paid for the painting ten years earlier and far less than the $5,500 he had asked for it in 1932.

194. Lewis to Matisse, April 19, 1936, Pierre Matisse Gallery Archives, PML.

195. Horter wrote to Douglas Cooper: "The large Picasso negroid figure [*Woman with a Book*] is in my belief the best cubistic picture—I know of except the Kahnweiler portrait which I have never forgiven myself for having sold. I have always missed it. I refused Pierre Matisse $1200 for it before he left for Paris 1 month ago—He is mad at me for not selling it to him but I just decided against it. I know I'll regret it later—but I will sell it for $1500 only because I want this Indian Collection" (Horter to Cooper, undated, Douglas Cooper papers, The Getty Research Institute for the History of Art and the Humanities, Los Angeles). It is unclear whether Horter received $650 or $600 for the Picasso *Woman with a Book* (called "Figure Seated" in the correspondence). On November 12, 1937, Horter's attorney signed a receipt from the Pierre Matisse Gallery for $350. Noted in ink on the bottom of the receipt is the date "Dec. 18, 1937," and "Received balance of $300. for above picture," signed by Lewis. However, there is also a typed receipt for $600 annotated as "full payment" by the gallery on December 18, 1937, and also signed by Lewis (Pierre Matisse Gallery Archives, PML).

196. Horter wrote: "Sorry I did not see you when in Phila—I'm always interested in abstract painting—and in meeting anyone that is collecting same—I once had a marvellous col. but the depression took some of the best ones away from me" (Horter to Cooper, undated, Douglas Cooper papers, The Getty Research Institute for the History of Art and the Humanities, Los Angeles). On Cooper's purchases from Horter's collection, see Dorothy M. Kosinski, *Picasso, Braque, Gris, Léger: Douglas Cooper Collecting Cubism* (Houston: Museum of Fine Arts, 1990), pp. 17, 22.

197. Horter to Marceau, undated, Registrar's files, PMAA. Other than the Pennsylvania Museum's purchase of Brancusi's *Mademoiselle Pogany I* in 1933, there is no evidence that additional works from Horter's collection were ever under discussion for purchase by the museum, though Kimball hoped to discourage Horter from selling. It was not that the museum lacked funds; rather, its priorities lay elsewhere. During the same years when Horter was in his most desperate financial straits and was apparently willing to bargain on the prices of the remaining works in his collection, the museum purchased two great Cézannes: in 1936 the *Mont Sainte-Victoire* for the George W. Elkins Collection and in 1937 *The Large Bathers*, with the W. P. Wilstach Fund.

198. Horter sold other works from the collection to Philadelphia collector friends: the Brancusi *Muse* (pl. 3) was purchased in 1936 by the artist Ray F. Spreter, who had seen and admired the sculpture with Horter at the Quinn estate sale ten years earlier; his small Braque *Still Life with Fruit* (pl. 12) was bought by Anna Warren Ingersoll in 1937; and the Brancusi *Danaïde* (pl. 2) was acquired at an unknown date by Samuel and Vera White.

199. Bill of sale, Earl Horter of Philadelphia,

Pennsylvania, to Elizabeth Lentz Keim, of South Langhorne (Penndel), Pennsylvania, June 23, 1936, papers of Elizabeth Lentz Horter, private collection. Seventeen items are marked "sold"; they seem to correspond to the works sold to Pierre Matisse and Douglas Cooper, and those given to Helen Horter. See Helen Lloyd Horter v. Earl Horter, February 23, 1937, Court of Common Pleas, No. 5, for the County of Philadelphia, June Term 1936, No. 2522. The property settlement, which included ten pictures, some American Indian artifacts, the house in Harvey Cedars, New Jersey, and other household items may be partially reconstructed from lists written by Helen Lloyd Horter, courtesy of Paula Kelly Muller.

200. Carles to Tyson, August 4, 1937, Arthur B. Carles papers, AAA.

201. Diary for 1938, Anna Warren Ingersoll papers, AAA.

202. Pitz, "Earl Horter," 1956, p. 26.

203. Campbell interview, 1995.

204. Exhibition records in the papers of the Philadelphia Art Alliance, Special Collections Department, Van Pelt-Dietrich Library, University of Pennsylvania, Philadelphia.

205. Emlen Etting, diary, entry for December 31, 1929, typescript, courtesy of John F. Warren.

206. The paintings exhibited were *Portrait of Braque*, *Woman with a Book* (called "Woman in a Landscape"), *Portrait of Daniel-Henry Kahnweiler*, and *Vive la [France]* (pls. 34, 30, 38, and 46, respectively).

207. Mauny to Ingersoll, March 4, 1940, PMAA.

208. Carles to Elizabeth Lentz Horter, Earl Horter papers, PMAA.

209. Mauny to Ingersoll, May 9, 1940, PMAA.

210. R. Sturgis Ingersoll, "Earle Horter, 1880–1940," introduction to the brochure *E. Horter* accompanying the *Earl Horter Memorial Exhibition* at the Philadelphia Art Alliance, November 8–30, 1940.

PLATE 1
Constantin Brancusi
(French, born Romania, 1876–1957)
Mademoiselle Pogany I, 1912
White marble, 17 1/2 x 8 1/4 x 12 3/8 inches
(44.5 x 20.9 x 31.5 cm),
base 6 inches (15.2 cm)

Philadelphia Museum of Art.
Gift of Mrs. Rodolphe Meyer de
Schauensee, 1933-24-1

PROVENANCE: Little Galleries of
the Photo-Secession, New York, 1914;
John Quinn, New York, 1914; estate
of John Quinn, 1924 to 1926; Earl Horter,
Philadelphia, February 15, 1926, to April
28, 1933; purchased by the Philadelphia
Museum of Art with funds contributed
by Mrs. Rodolphe Meyer de Schauensee,
April 28, 1933.

EXHIBITIONS: Pennsylvania
(later Philadelphia) Museum of Art,
Philadelphia, *Inaugural Exhibition of the
New Museum of Art, Fairmount: European
and American Sections,* March 1928;
Pennsylvania (later Philadelphia)
Museum of Art, Philadelphia, *The Earl
Horter Collection,* February 17–March 13, 1934
(hereafter cited as Philadelphia, 1934).

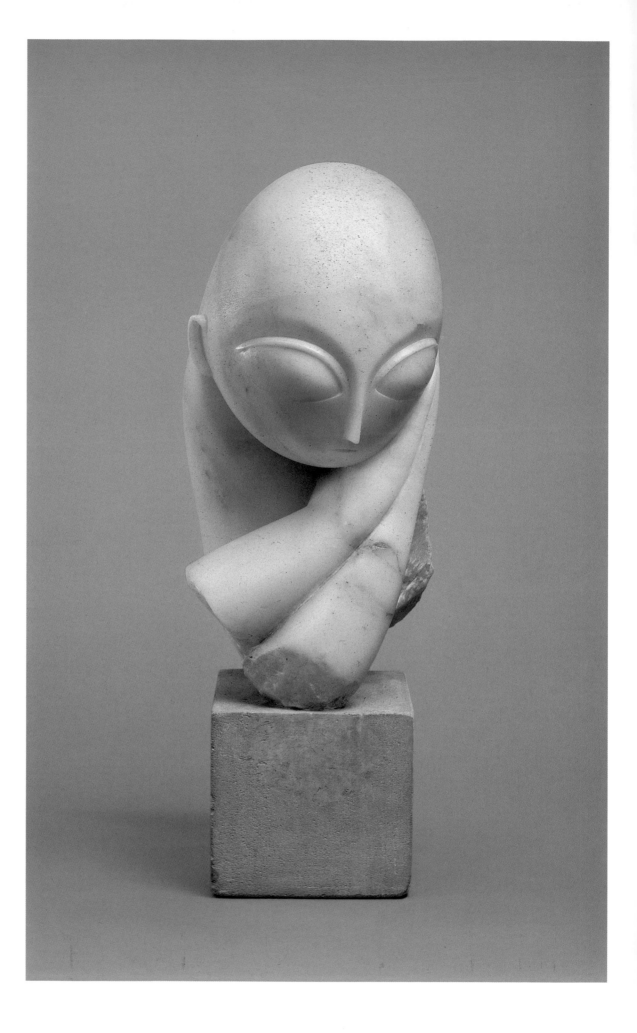

PLATE 2
Constantin Brancusi
Danaïde, 1913
Partly polished bronze (patina on hair),
10³/₄ x 8¹/₄ x 7 inches (27.3 x 21 x 17.8 cm),
base 5¹/₈ inches (13 cm)

Philadelphia Museum of Art. The Samuel S.
White, 3rd, and Vera White Collection,
1967-30-6

PROVENANCE: Earl Horter, Philadelphia;
Samuel S. White, 3rd, and Vera White,
Ardmore, Pennsylvania, to 1967; Philadelphia
Museum of Art, 1967.

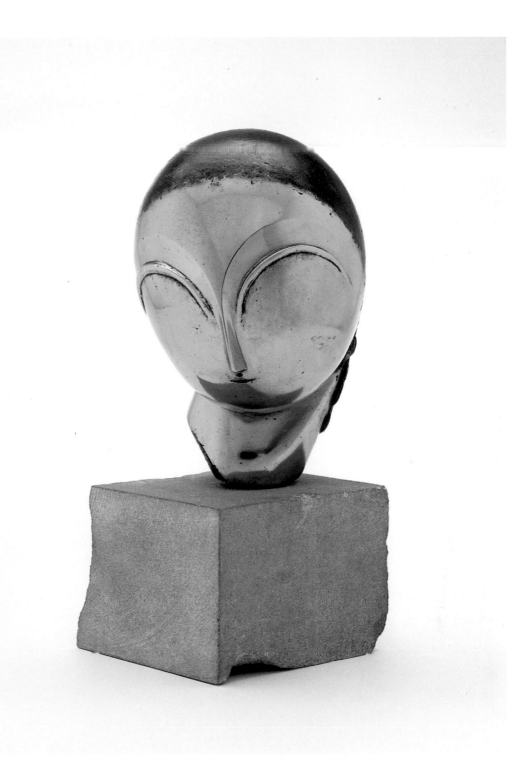

PLATE 3
Constantin Brancusi
Muse, 1917
Polished bronze, 19³/₁₆ x 10¹/₂ x 9⁵/₈
inches (48.8 x 26.7 x 24.4 cm),
base 10 inches (25.4 cm)

The Museum of Fine Arts, Houston.
Museum purchase with funds provided
by Mrs. Herman Brown
and Mrs. William Stamps Farish

PROVENANCE: Acquired from the artist
by John Quinn, New York, 1918; estate
of John Quinn, 1924 to 1926; Earl Horter,
Philadelphia, April 23, 1926, to 1936;
Ray F. Spreter, Gladwyne, Pennsylvania,
1936 to 1962; The Museum of Fine Arts,
Houston, 1962.

EXHIBITION: Pennsylvania (later
Philadelphia) Museum of Art,
Philadelphia, *Living Artists: An Exhibition
of Contemporary Painting and Sculpture*,
November 20, 1931–January 1, 1932.

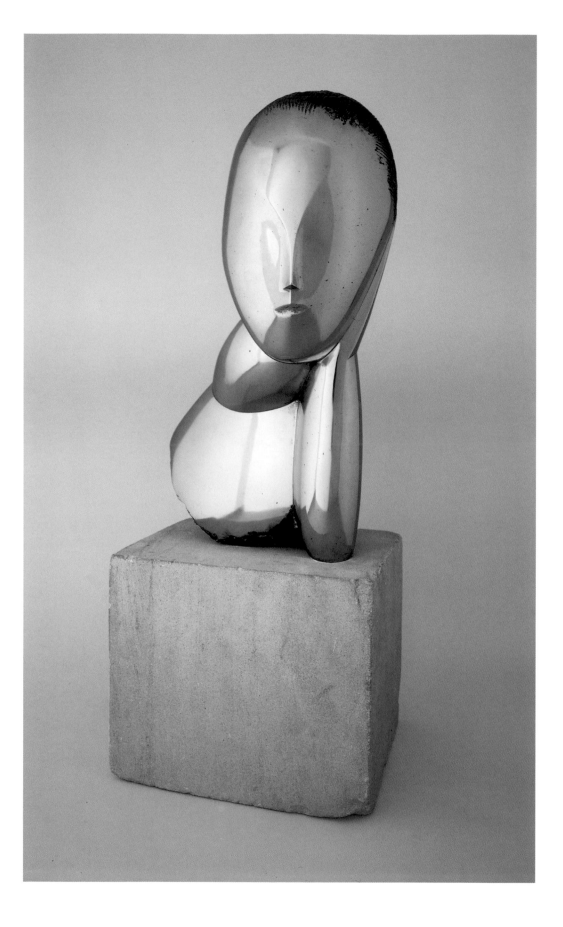

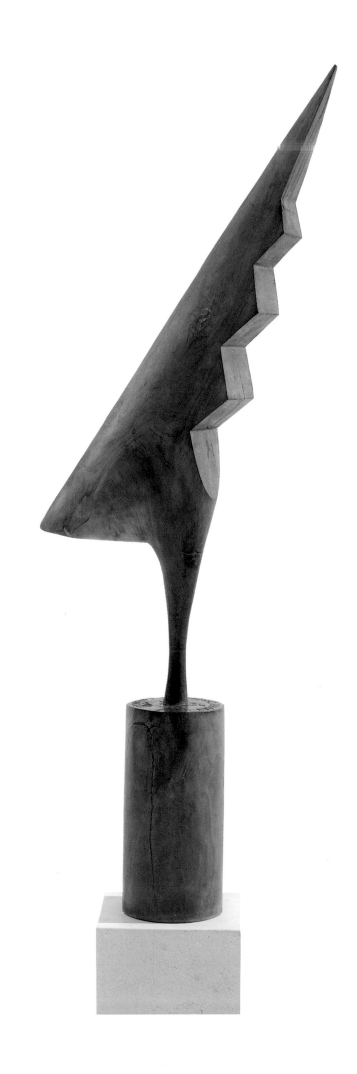

PLATE 4
Constantin Brancusi
**Cock,* 1924
Wild cherry, 47⅝ x 18¼ x 5¾ inches
(121 x 46.3 x 14.6 cm)

The Museum of Modern Art, New York.
Gift of LeRay W. Berdeau, 1959

PROVENANCE: Brummer Gallery, New York;
Earl Horter, Philadelphia, 1926 to 1934(?);
LeRay W. Berdeau, New York, to 1959;
The Museum of Modern Art, New York, 1959.

EXHIBITION: Brummer Gallery, New York,
Brancusi, November 17, 1933–January 13, 1934,
no. 48.

PLATE 5
Georges Braque
(French, 1882–1963)
Glasses and Bottles, 1912
Oil on canvas, 29 x 21 inches (73 x 54 cm)

Collection of Mrs. Robert B. Eichholz

PROVENANCE: Galerie Kahnweiler, Paris;
Earl Horter, Philadelphia; Jacques Seligmann
and Company, New York; Robert B. Eichholz,
Washington, D.C., October 20, 1944.

EXHIBITIONS: Philadelphia, 1934; The Arts Club
of Chicago, *Modern Paintings from the Collection
of Mr. Earl Horter of Philadelphia,* April 3–26, 1934
(hereafter cited as Chicago, 1934).

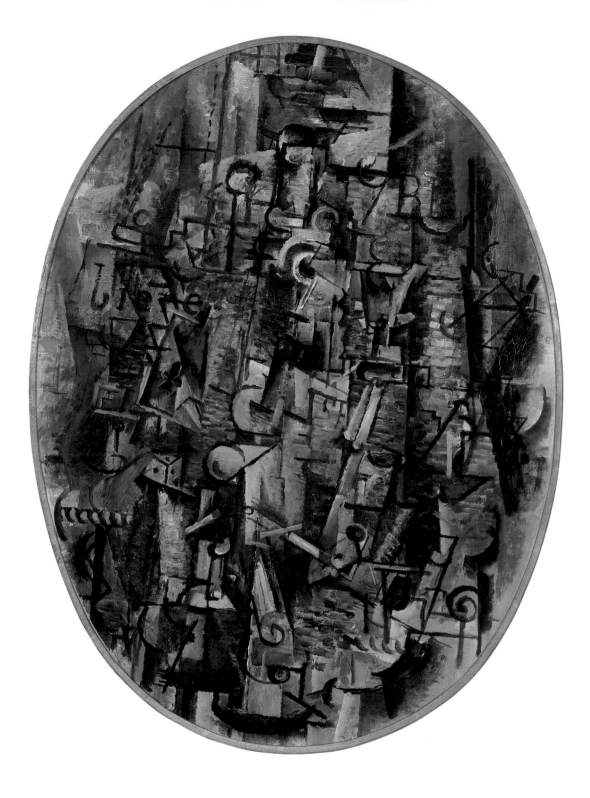

PLATE 6

Georges Braque
Glass, Bottle, Playing Card, BAR, 1912
Oil on canvas, 11¾ x 9½ inches (30 x 24 cm)

Private collection

PROVENANCE: Galerie Kahnweiler, Paris (inv. no. 996, photograph no. 1041); Hôtel Drouot, Paris, "Tableaux modernes Collection du Tableau Vendus", June 13, 1921, lot 27; Van Leer, Paris; Earl Horter, Philadelphia, by 1929/30; Elizabeth Lentz Keim, South Langhorne (Penndel), Pennsylvania (later Elizabeth Lentz Horter), June 25, 1936; Harold Diamond, New York; Allan Stone Gallery, New York; Sotheby's, New York, "Impressionist and Modern Paintings, Drawings, and Sculpture," May 13, 1992, lot 74; Galerie Rosengart, Lucerne.

EXHIBITIONS: Philadelphia, 1934; Chicago, 1934.

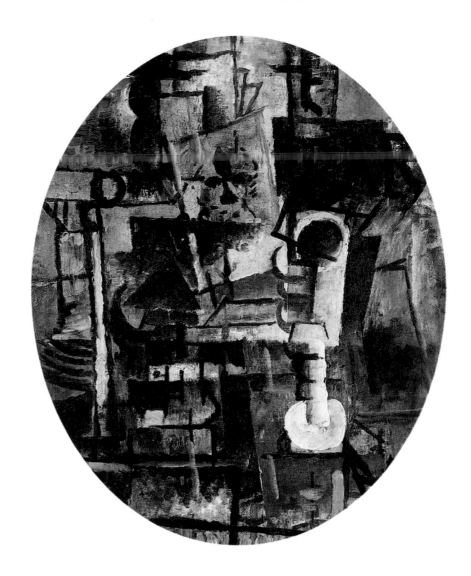

PLATE 7
Georges Braque
Untitled (Still Life), 1912/13
Collage composed of charcoal,
graphite, oil paint, and watercolor
on a variety of paper elements,
mounted on board, 13³/₄ x 10⁷/₈ inches
(35 x 27.7 cm)

The Art Institute of Chicago. Gift
of Mrs. Gilbert W. Chapman

PROVENANCE: Galerie Kahnweiler,
Paris (inv. no. 2244, photograph no. 1206);
Hôtel Drouot, Paris, "Tableaux modernes:
Aquarelles, gouaches, pastels, et dessins,"
December 12, 1925, lot 9; Earl Horter,
Philadelphia, December 12, 1925, to
May 9, 1934; Mrs. Charles B. Goodspeed,
Chicago (later Mrs. Gilbert W. Chapman,
New York), May 9, 1934, to 1947; The Art
Institute of Chicago, 1947.

EXHIBITIONS: Philadelphia, 1934;
Chicago, 1934, no. 11 (as "Still Life").

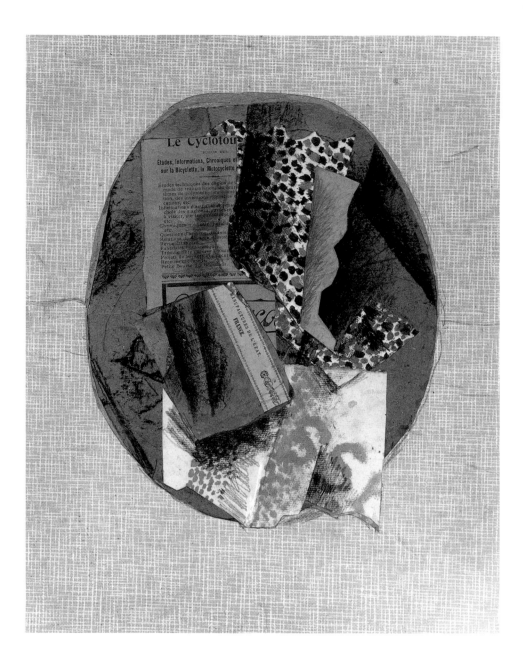

PLATE 8

Georges Braque
*Still Life with Glass and Newspaper
(Le Gueridon),* 1913
Black chalk, charcoal, and oil on canvas,
38¼ x 28⁹⁄₁₆ inches (97.2 x 72.5 cm)

Staatliche Museen zu Berlin, Nationalgalerie.
On permanent loan from the Berggruen
Collection

PROVENANCE: Galerie Kahnweiler, Paris
(inv. no. 1468, photograph no. 1152); Hôtel
Drouot, Paris, "Tableaux modernes: Collection
Henry Kahnweiler," July 4, 1922, lot 40;
André Breton, Paris; Mackenzie Sholto, London;
Douglas Sholto, London; Earl Horter,
Philadelphia, by 1929/30; Douglas Cooper,
London, July 29, 1937, to 1969; Acquavella
Galleries, New York, 1969 to 1970; private
collection, Italy, 1970 to 1980; Heinz Berggruen,
Geneva, 1981; Staatliche Museen zu Berlin,
Nationalgalerie, on permanent loan from the
Berggruen Collection.

EXHIBITIONS: Philadelphia, 1934; Chicago,
1934, no. 7 (as "Large Abstraction [oval]");
The Philadelphia Art Alliance, *African Art and Its
Modern Derivatives,* January 6–31, 1936.

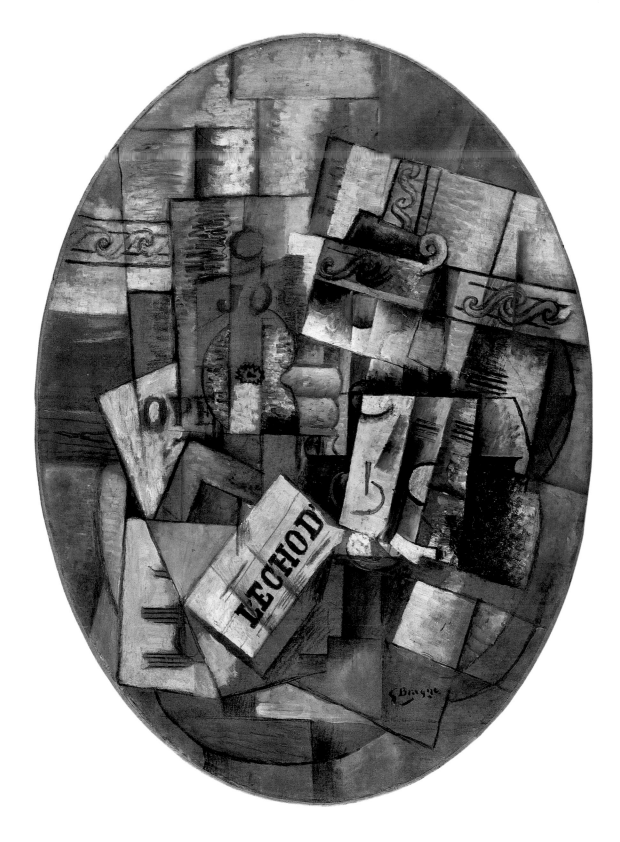

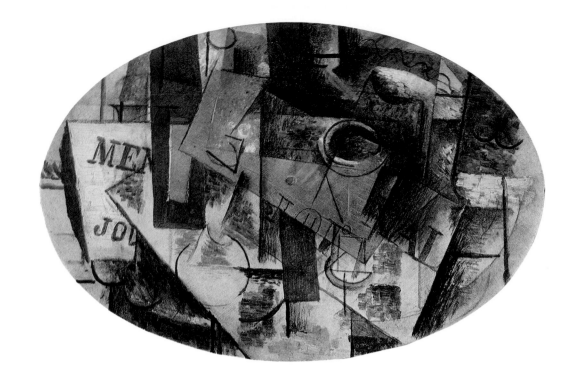

PLATE 9

Georges Braque
Bottle and Glass, 1913
Oil on canvas, 15 x 21¾ inches (38 x 55 cm)

Location unknown

PROVENANCE: Galerie Kahnweiler, Paris; Earl
Horter, Philadelphia, by 1929/30; Elizabeth Lentz
Keim, South Langhorne (Penndel), Pennsylvania
(later Elizabeth Lentz Horter), June 25, 1936;
Justin K. Thannhauser, New York and Bern,
by the early 1960s; Sotheby's, London,
"Impressionist and Modern Paintings, Drawings,
and Sculpture," July 4–5, 1962, lot 247.

EXHIBITIONS: Philadelphia, 1934; Chicago,
1934, no. 6 or no. 10; Memorial Art Gallery
of the University of Rochester, New York,
*The Art of the African Negro with Related Modern
Paintings*, April 1936.

PLATE 10

Georges Braque
**Violin*, 1913
Oil on canvas, 13¾ x 9½ inches (35 x 24 cm)

Private collection

PROVENANCE: Galerie Kahnweiler, Paris
(photograph no. 1110); Earl Horter, Philadelphia;
Elizabeth Lentz Horter, Philadelphia, 1940;
Galerie Sami Tarica, Paris, by the early 1970s;
Alfred Schmela, Düsseldorf.

EXHIBITIONS: Philadelphia, 1934; Chicago,
1934, no. 3.

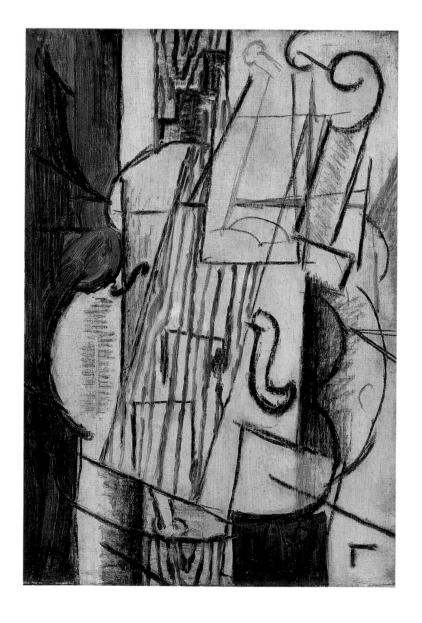

PLATE 11
Georges Braque
**Still Life: Second Study,* 1914
Oil on canvas, 28⅞ x 21¼ inches
(73.3 x 54 cm)

Private collection

PROVENANCE: Galerie Kahnweiler,
Paris; Galerie de l'Effort Moderne, Paris
(photograph no. 14-N-151); John Quinn,
New York (?); Earl Horter, Philadelphia,
by 1929/30; Helen Lloyd Horter (later
Helen Kelly, Harvey Cedars, New Jersey),
1937 to 1950s; Robert Elkon;
Nelson A. Rockefeller, New York;
George S. Coumantaros, Athens; present
owner, 1986.

EXHIBITIONS: Philadelphia, 1934;
Chicago, 1934.

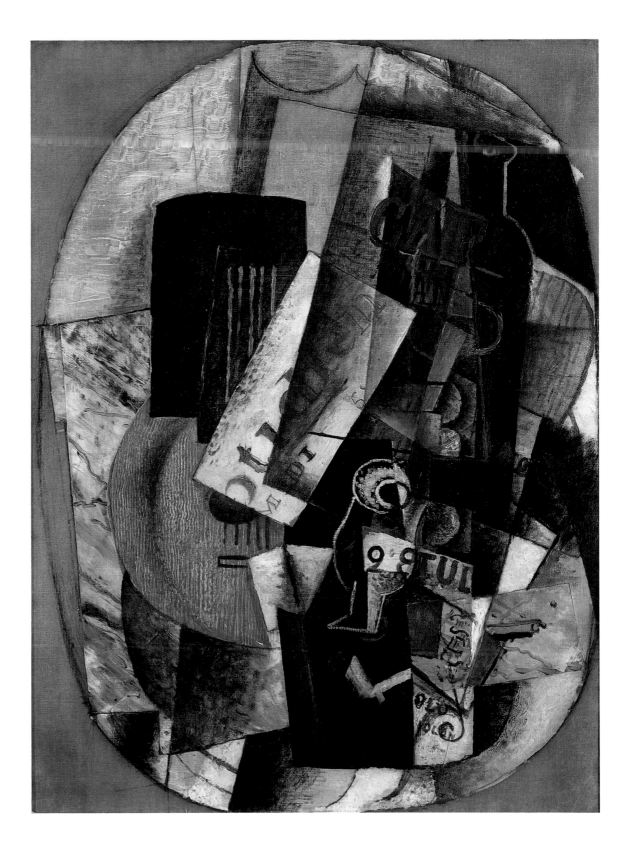

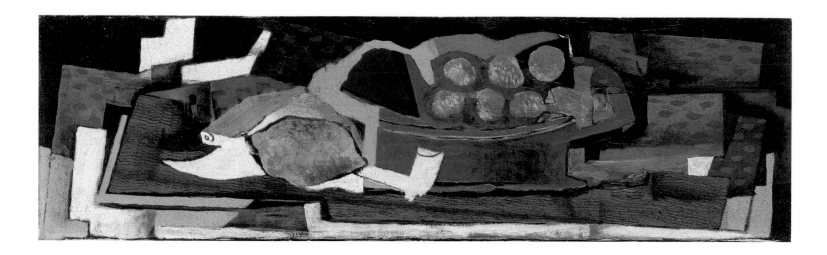

PLATE 12
Georges Braque
**Still Life with Fruit (Still Life: Grapes,
Lemons, and Pipe)*, c. 1926
Oil and sand on canvas, 7³/₄ x 25 ½ inches
(19.7 x 64.8 cm)

Philadelphia Museum of Art. Gift of
Miss Anna Warren Ingersoll, 1964-108-1

PROVENANCE: Galerie Simon, Paris; Earl Horter,
Philadelphia, by 1929/30; Anna Warren Ingersoll,
Philadelphia, March 30, 1937, to June 18, 1964;
Philadelphia Museum of Art, 1964.

EXHIBITIONS: Smith College Museum of Art,
Northampton, Massachusetts, *Contemporary
Paintings of the Modern School*, May 29–June 18, 1930,
no. 4; Philadelphia, 1934; Chicago, 1934, no. 6 or
no. 10; Memorial Art Gallery of the University of
Rochester, New York, *The Art of the African Negro
with Related Modern Paintings*, April 1936.

PLATE 13

Giorgio de Chirico
(Italian, born Greece, 1888–1978)
The Invincible Cohort, 1928
Oil on canvas, 52½ x 35 inches
(131 x 89 cm)

Private collection

PROVENANCE: Léonce Rosenberg, Paris;
Valentine Gallery, New York, 1928; Earl
Horter, Philadelphia, in 1928; Elizabeth
Lentz Keim, South Langhorne (Penndel),
Pennsylvania (later Elizabeth Lentz Horter),
June 25, 1936; transferred to Eugene John
Lewis (Mrs. Horter's attorney),
Philadelphia, by July 29, 1940; Galleria
d'Arte Moderna, Florence; private
collection, Milan, 1970s; Christie's,
London, "Twentieth-Century Art (Evening
Sale)," December 10, 1998, lot 512.

EXHIBITIONS: Valentine Gallery, New
York, *Recent Paintings by Giorgio de Chirico*,
December 31, 1928–January 26, 1929;
Philadelphia, 1934; Chicago, 1934, no. 20;
Nebraska Art Association, Lincoln, *Forty-
Eighth Annual Exhibition of Painting*, March
6–April 3, 1938.

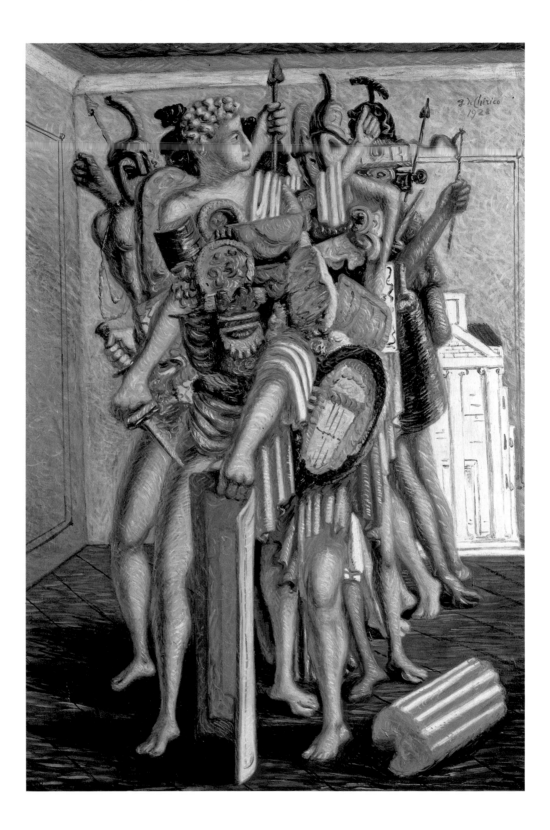

PLATE 16

Marcel Duchamp
(American, born France, 1887–1968)
Nude Descending a Staircase, No. 1,
1911
Oil on cardboard on panel,
37 3/4 x 23 3/4 inches (95.9 x 60.3 cm)

Philadelphia Museum of Art.
The Louise and Walter Arensberg
Collection, 1950-134-58

PROVENANCE: John Quinn through
Walter Pach, 1915; estate of John Quinn,
1924 to 1926; Earl Horter, Philadelphia,
March 22, 1926, to 1934; Louise and Walter
Arensberg, Hollywood, California, through
Marcel Duchamp, 1934 to 1950; Philadelphia
Museum of Art, 1950.

EXHIBITIONS: Philadelphia, 1934; Chicago,
1934, no. 23.

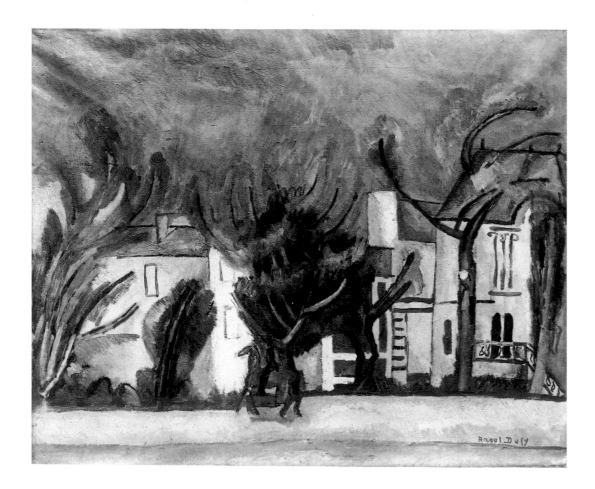

PLATE 17
Raoul Dufy
(French, 1877–1953)
The Avenue du Bois de Boulogne, 1909
Oil on canvas, 21¼ x 25¾ inches
(54 x 65.5 cm)

Location unknown

PROVENANCE: Earl Horter, Philadelphia;
Elizabeth Lentz Keim, South Langhorne
(Penndel), Pennsylvania (later Elizabeth Lentz
Horter), June 25, 1936; Pierre Matisse Gallery,
New York, May 6, 1950; Jacob Rosenberg, New
York, January 16, 1951; Peter and Elizabeth Rubel,
New York, by 1957.

EXHIBITIONS: Philadelphia, 1934; Chicago, 1934,
no. 22 (as "Landscape").

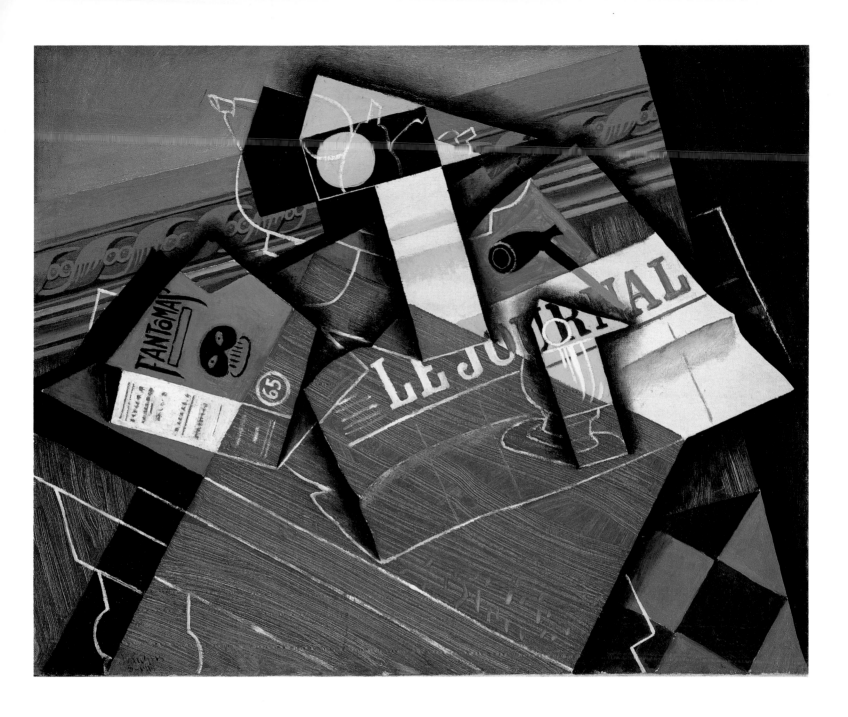

PLATE 18
Juan Gris
(Spanish, 1887–1927)
Pipe and Newspaper (Fantômas), 1915
Oil on canvas, 23⅝ x 28⅜ inches (60 x 72 cm)

National Gallery of Art, Washington, D.C.
Chester Dale Fund, 1976

PROVENANCE: Léonce Rosenberg, Paris
(photograph no. 14-N-970, stock no. 5326);
Earl Horter, Philadelphia; Elizabeth Lentz Keim,
South Langhorne (Penndel), Pennsylvania
(later Elizabeth Lentz Horter), June 25, 1936;
Galerie Berggruen, Paris, by 1958 to 1966; Horst
Pavel, Bad Homburg, Germany; Galerie Nathan,
Zurich, by 1974 to 1976; National Gallery of Art,
Washington, D.C., 1976.

EXHIBITIONS: Marie Harriman Gallery,
New York, *Juan Gris,* February 1932, no. 6;
Philadelphia, 1934; The Arts Club of Chicago,
Retrospective Exhibition of Juan Gris, January 3–27,
1939, no. 14 (as "Nature Morte").

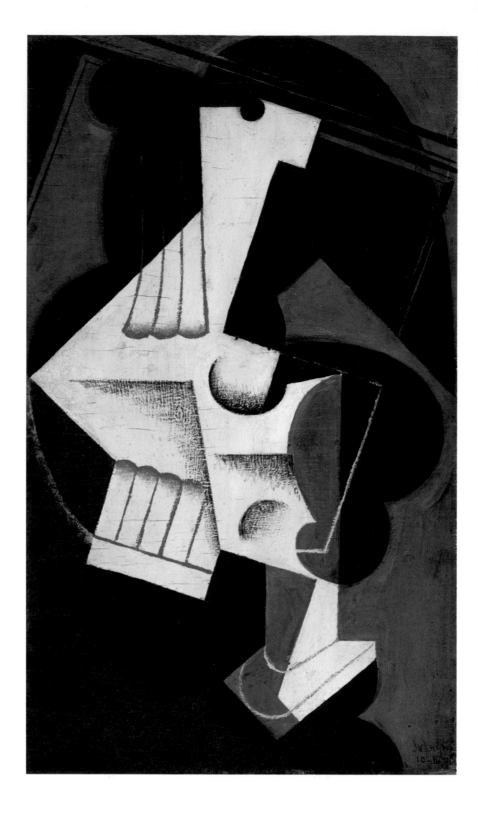

Henri Matisse
(French, 1869–1954)
Standing Nude, Arms Raised, 1906
Bronze, height 10¼ inches (26 cm)

Location unknown

PROVENANCE: Earl Horter, Philadelphia, by
January 18, 1926; Elizabeth Lentz Horter,
Philadelphia, 1940 to 1985; estate of Elizabeth
Lentz Horter, 1985; Sotheby's, New York,
"Impressionist and Modern Paintings and
Sculpture, Part II," November 14, 1985, lot 216a.

EXHIBITION: Philadelphia, 1934.

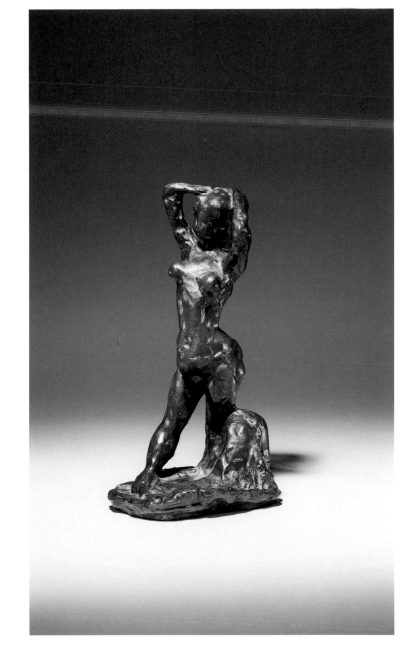

Henri Matisse
Reclining Nude with Legs Crossed, 1929
Etching, 4 x 5¾ inches (10.2 x 14.6 cm) plate

Location unknown

PROVENANCE: Earl Horter, Philadelphia;
Elizabeth Lentz Horter, Philadelphia, 1940 to
1985; estate of Elizabeth Lentz Horter, 1985;
Sotheby's, New York, "Old Master, Nineteenth-
and Twentieth-Century, and Contemporary
Prints," May 15–16, 1986, lot 357.

EXHIBITIONS: Philadelphia, 1934; Chicago,
1934.

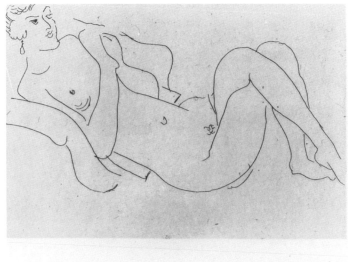

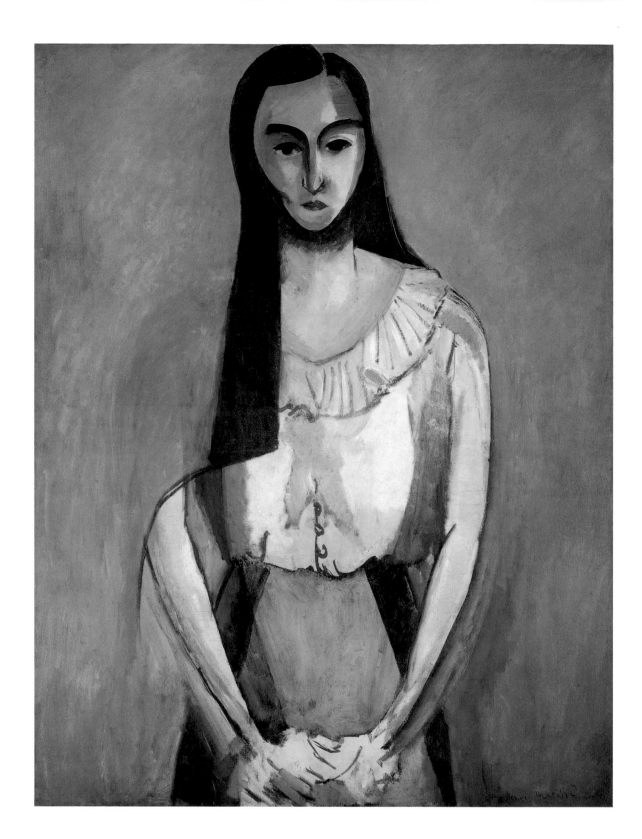

PLATE 21

Henri Matisse
Italian Woman, 1916
Oil on canvas, 45 $^{15}/_{16}$ x 35 $^{1}/_{4}$ inches
(116.7 x 89.5 cm)

Solomon R. Guggenheim Museum,
New York. By exchange, 1982

PROVENANCE: Acquired from Marius de
Zayas by John Quinn, New York, 1919;
estate of John Quinn, 1924 to 1926; Earl
Horter, Philadelphia, April 9, 1926, to 1936;
Pierre Matisse Gallery, New York,
by February 14, 1936; Dr. L. M. and Mrs.
Maitland, Beverly Hills, California,
by March 23, 1936; Nelson A. Rockefeller,
New York, by 1960; gift to the Museum
of Modern Art, New York, 1977, to 1982;
Solomon R. Guggenheim Museum, 1982.

EXHIBITIONS: The Museum of Modern
Art, New York, *Henri Matisse Retrospective
Exhibition*, November 3–December 6, 1931,
no. 29; Philadelphia, 1934; Chicago, 1934,
no. 29.

Jacques Mauny
(French, 1893–1962)
Naples, 1921

Location unknown

PROVENANCE: Earl Horter, Philadelphia;
Elizabeth Lentz Keim, South Langhorne
(Penndel), Pennsylvania (later Elizabeth Lentz
Horter), June 25, 1936; David David Gallery,
Philadelphia, May 7, 1971.

EXHIBITION: Philadelphia, 1934.

Jacques Mauny
Scene in Palermo, 1925
Oil on canvas

Location unknown

PROVENANCE: Earl Horter, Philadelphia, by
1929/30; Elizabeth Lentz Keim, South Langhorne
(Penndel), Pennsylvania (later Elizabeth Lentz
Horter), June 25, 1936; David David Gallery,
Philadelphia, May 7, 1971.

EXHIBITIONS: De Hauke and Company, New
York, *First Exhibition in America of Paintings and
Gouaches by Jacques Mauny,* January 6–25, 1930, no.
14 or no. 15; Smith College Museum of Art,
Northampton, Massachusetts, *Contemporary
Paintings of the Modern School,* May 29–June 18, 1930,
no. 6; Pennsylvania (later Philadelphia) Museum
of Art, Philadelphia, *Living Artists: An Exhibition of
Contemporary Painting and Sculpture,* November 20,
1931–January 1, 1932; Philadelphia, 1934; Chicago,
1934, no. 31 (as "Palermo").

PLATE 25

Jacques Mauny
White Oxen
(replica of his painting in the Carnegie
Museum of Art, Pittsburgh), c. 1927
Oil on canvas

Location unknown

PROVENANCE: Earl Horter, Philadelphia, 1927.

EXHIBITIONS: Philadelphia, 1934; Chicago,
1934, no. 30.

PLATE 26

Jacques Mauny
Scene Between the Walls

Location unknown

PROVENANCE: Earl Horter, Philadelphia.

PLATE 27

Jacques Mauny
Palermo
Oil on canvas, 13 x 13 inches (33 x 33 cm)

Private collection

PROVENANCE: Earl Horter, Philadelphia;
Elizabeth Lentz Keim, South Langhorne
(Penndel), Pennsylvania (later Elizabeth Lentz
Horter), June 25, 1936.

Pablo Picasso
(Spanish, 1881–1973)
**Woman with a Book*, 1909
Oil on canvas, 36 ¼ x 28 ¾ inches
(92 x 73 cm)

Private collection

PROVENANCE: Earl Horter, Philadelphia,
by 1929/30; Pierre Matisse Gallery,
New York, 1937; Walter P. Chrysler, Jr.,
New York, 1937; Lee Ault, New York; Perls
Gallery, New York; Mrs. Robert F. Windfohr,
Fort Worth, Texas (later Mrs. Charles D.
Tandy), May 1951; Anne Burnett Tandy,
Fort Worth; private collection; Acquavella
Galleries, New York.

EXHIBITIONS: Possibly Smith College
Museum of Art, Northampton,
Massachusetts, *Contemporary Paintings of the
Modern School*, May 29–June 18, 1930, no. 1
(as "Figure"); Philadelphia, 1934; Chicago,
1931, no. 45 (as "Abstract Form Negro
Period"); The Philadelphia Art Alliance,
African Art and Its Modern Derivatives,
January 6–31, 1936.

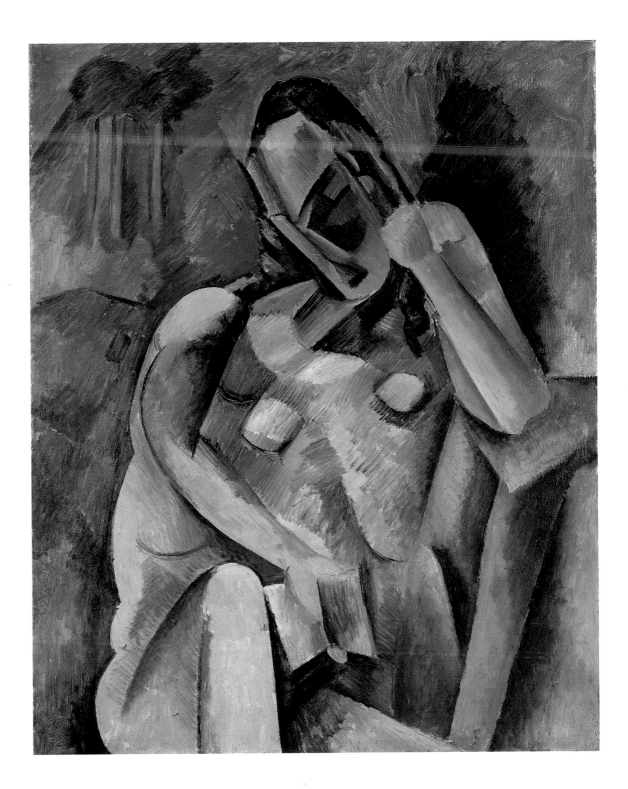

PLATE 31
Pablo Picasso
Nude, 1909
Oil on canvas, 35¼ x 28½ inches
(90 x 72.4 cm)

Private collection

PROVENANCE: Acquired from the artist
by Earl Horter, Philadelphia, by 1929/30;
Douglas Cooper, London, 1937 to 1939;
Stanley Barbee, Los Angeles; Paul
Rosenberg and Company, New York;
Mr. and Mrs. Morton G. Neumann,
Chicago; Sotheby's, New York, "Twenty-
Seven Works from the Neumann Family
Collection," November 17, 1998, lot 112.

EXHIBITIONS: Philadelphia, 1934;
Chicago, 1934.

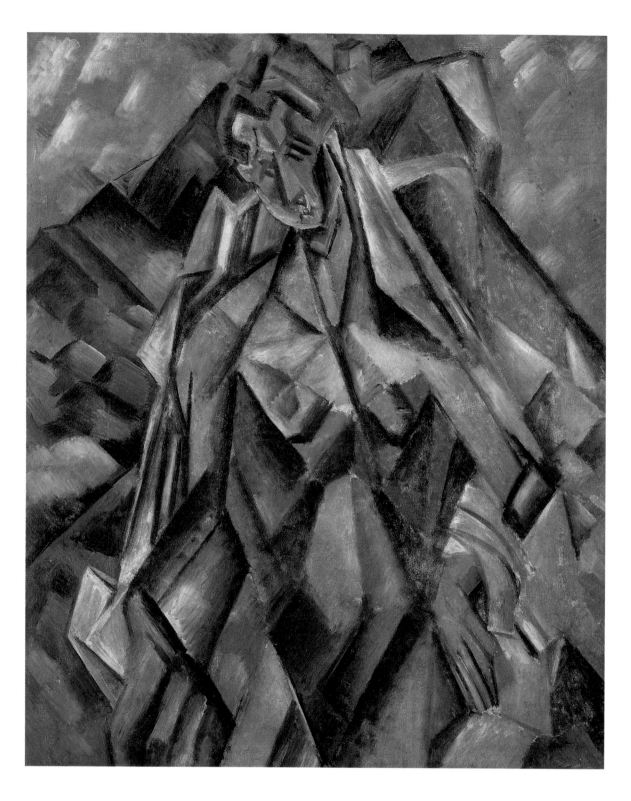

PLATE 32
Pablo Picasso
Study of Fruit, c. 1909
Watercolor on paper, 9⅝ x 12⅜ inches
(24.2 x 31.5 cm)

Location unknown

PROVENANCE: Earl Horter, Philadelphia,
by 1929/30; Helen Lloyd Horter (later Helen
Kelly, Harvey Cedars, New Jersey), 1937;
Julien Levy, New York, by March 28, 1946;
Sotheby's, New York, "Paintings, Drawings,
and Sculpture from the Julien Levy
Collection," November 4–5, 1981, lot 20.

EXHIBITIONS: Philadelphia, 1934; Chicago,
1934, no. 50 (as "Fruit [watercolor]").

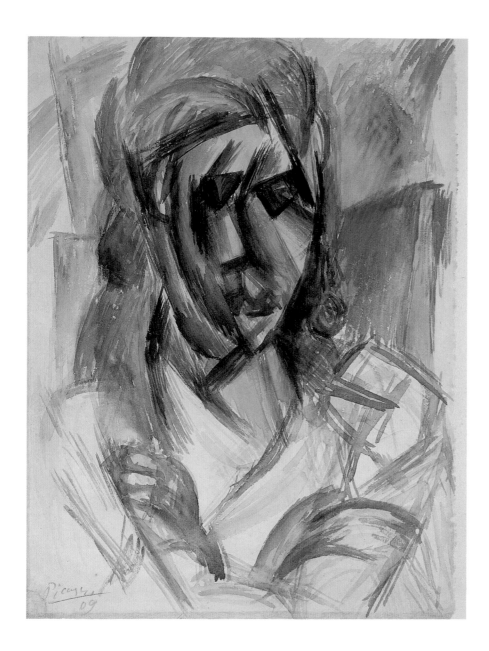

PLATE 33
Pablo Picasso
Head of a Woman, 1909–10
Watercolor and gouache on paper,
12⅛ x 9¼ inches (31 x 23 cm)

The Art Institute of Chicago. Gift of Mr.
and Mrs. Roy J. Friedman

PROVENANCE: Earl Horter, Philadelphia, by
1929/30; Mr. and Mrs. Roy J. Friedman, Chicago,
to 1964; The Art Institute of Chicago, 1964.

EXHIBITIONS: Philadelphia, 1934; Chicago,
1934, no. 47 (as "Watercolor Negro Period").

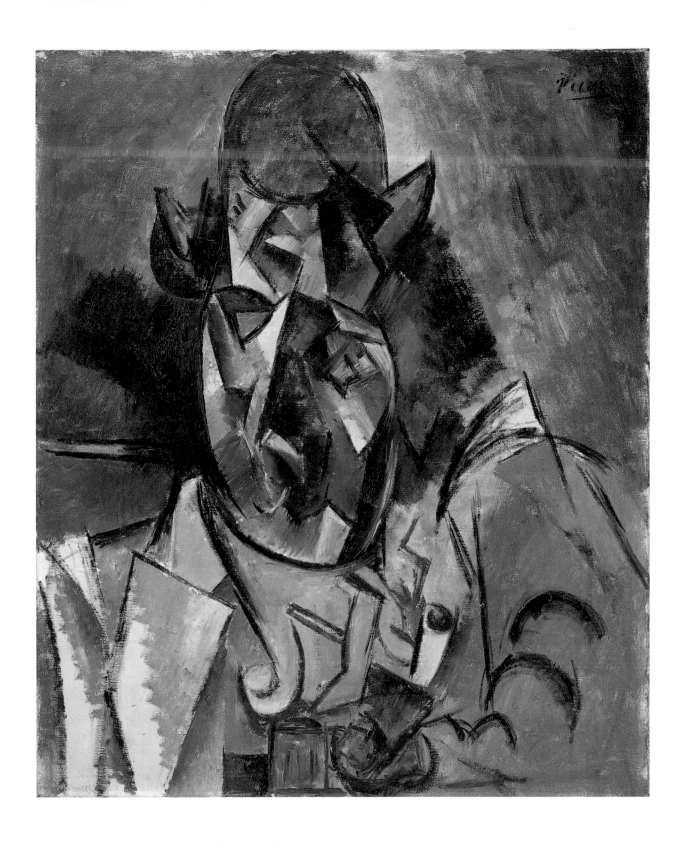

PLATE 34

Pablo Picasso

Portrait of Braque, 1909–10

Oil on canvas, 24 x 19⅝ inches
(61 x 50 cm)

Staatliche Museen zu Berlin, Nationalgalerie.
On permanent loan from the Berggruen Collection

PROVENANCE: Earl Horter, Philadelphia, by 1929/30;
Frank Crowninshield, New York, by May 15, 1931; Parke-Bernet,
New York, "Paintings, Sculptures, Drawings, and Lithographs
by Modern French Artists," October 19–20, 1943, lot 200;
Edward A. Bragaline, New York; E. V. Thaw, New York, to 1985;
Heinz Berggruen, Geneva; Staatliche Museen zu Berlin,
Nationalgalerie, on permanent loan from the Berggruen
Collection.

PLATE 35
Pablo Picasso
**Nude Figure*, 1909–10
Oil on canvas, 38½ x 30 inches
(97.8 x 76.2 cm)

Albright-Knox Art Gallery, Buffalo,
New York. General Purchase Funds, 1954

PROVENANCE: Ambroise Vollard, Paris;
John Quinn, New York, through Carroll
Galleries, New York; estate of John Quinn,
1924 to 1926; Earl Horter, Philadelphia;
Elizabeth Lentz Keim, South Langhorne
(Penndel), Pennsylvania (later Elizabeth
Lentz Horter), June 25, 1936, to December
10, 1941; Pierre Matisse Gallery, New York,
December 10, 1941, to 1954; Albright-Knox
Art Gallery, 1954.

EXHIBITIONS: Philadelphia, 1934;
Chicago, 1934; The Philadelphia Art
Alliance, *African Art and Its Modern Derivatives*,
January 6–31, 1936; Memorial Art Gallery
of the University of Rochester, New York,
*The Art of the African Negro with Related Modern
Paintings*, April 1936; Nebraska Art
Association, Lincoln, *Forty-Eighth Annual
Exhibition of Painting*, March 6–April 3, 1938.

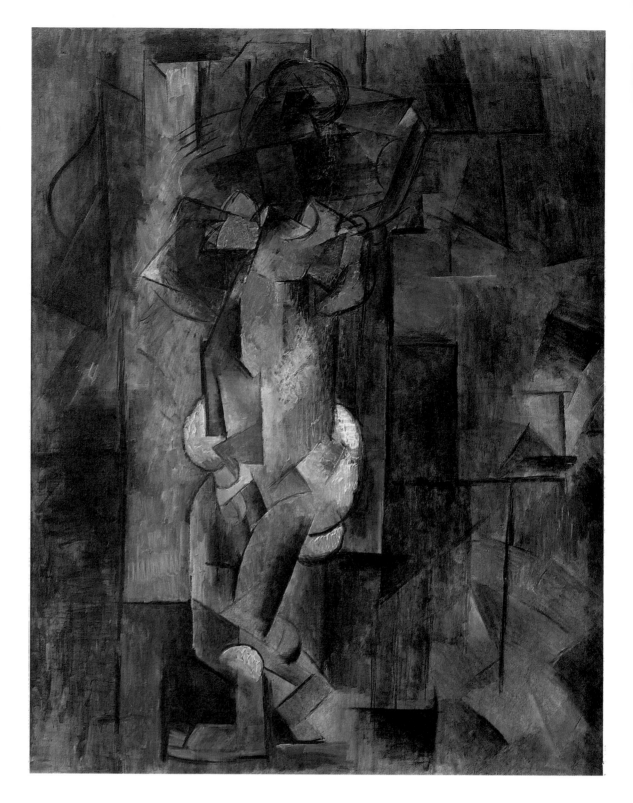

PLATE 36

Pablo Picasso
The Rower, 1910
Oil on canvas, 28 3/8 x 23 1/2 inches
(72.1 x 59.7 cm)

The Museum of Fine Arts, Houston.
Museum purchase with funds provided
by Oveta Culp Hobby, Isaac and Agnes
Cullen Arnold, Charles E. Marsh,
Mrs. William Stamps Farish, the Robert
Lee Blaffer Memorial Collection, Gift
of Sarah Campbell Blaffer by exchange,
and the Brown Foundation Accessions
Endowment Fund

PROVENANCE: Ambroise Vollard, Paris;
Modern Gallery, New York (?); Earl Horter,
Philadelphia, by 1929/30; Elizabeth Lentz
Keim, South Langhorne (Penndel),
Pennsylvania (later Elizabeth Lentz
Horter), June 25, 1936; Pierre Matisse
Gallery, New York, by March 10, 1942;
Mr. and Mrs. Ralph F. Colin, New York,
November 15, 1943; private collection,
New York; E. V. Thaw, New York,
to February 25, 1981; The Museum of Fine
Arts, Houston, 1981.

EXHIBITIONS: Philadelphia, 1934;
Chicago, 1934; Memorial Art Gallery
of the University of Rochester, New York,
*The Art of the African Negro with Related Modern
Paintings,* April 1936.

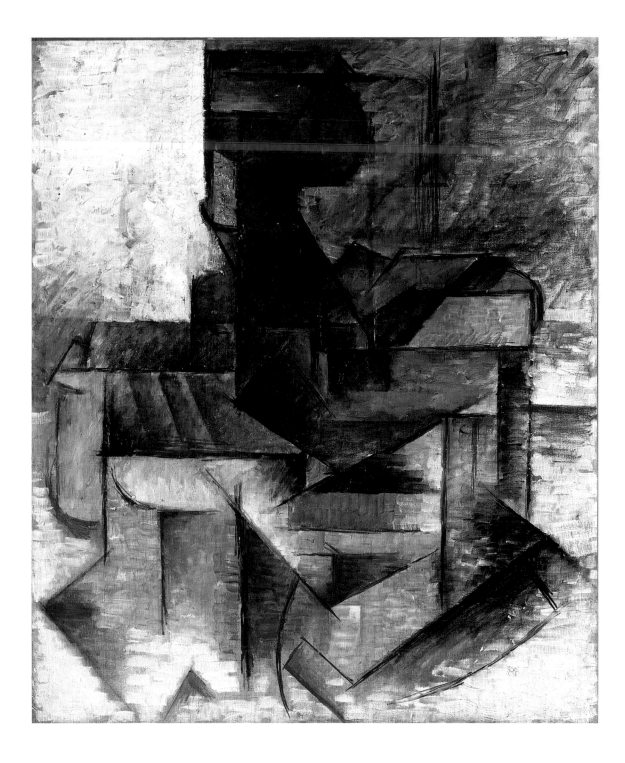

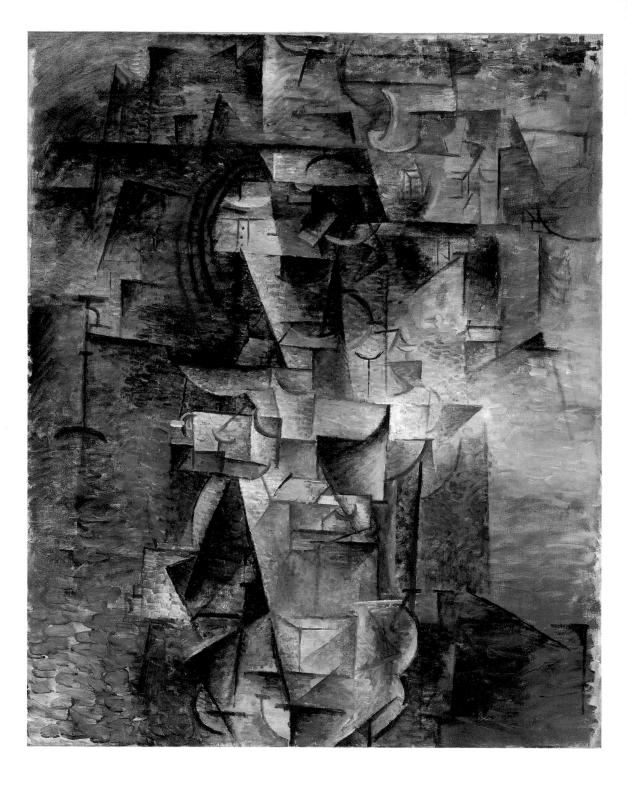

Pablo Picasso
Portrait of Daniel-Henry Kahnweiler,
1910
Oil on canvas, 39⅝ x 28⅝ inches
(100.6 x 72.8 cm)

The Art Institute of Chicago. Gift
of Mr. Gilbert W. Chapman in memory
of Charles B. Goodspeed

PROVENANCE: Daniel-Henry Kahnweiler,
Paris; Hôtel Drouot, Paris, "Collection
Henry Kahnweiler: Tableaux, sculptures,
et ceramique modernes," June 13–14, 1921,
lot 84; Isaac Grünewald, Stockholm
and Paris, 1921; Earl Horter, Philadelphia,
by 1929/30 to 1934; Mrs. Charles B.
Goodspeed, Chicago (later Mrs. Gilbert W.
Chapman, New York), by May 14, 1934,
to 1948; The Art Institute of Chicago, 1948.

EXHIBITIONS: Philadelphia, 1934;
Chicago, 1934, no. 53.

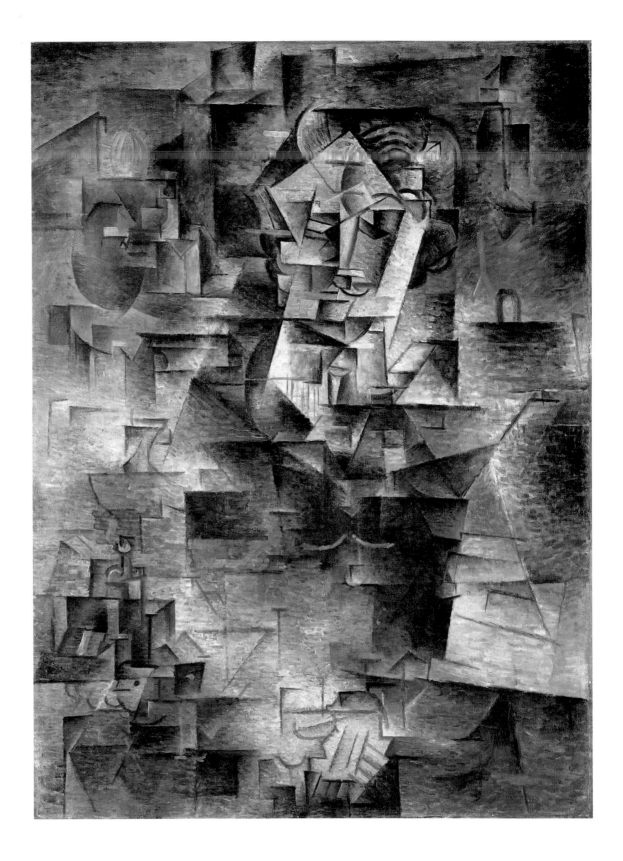

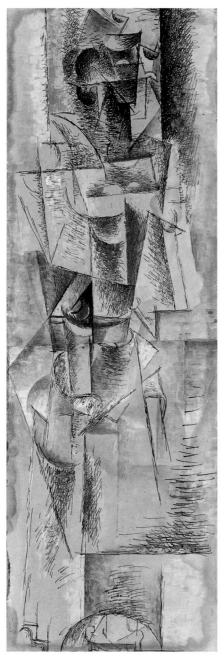

PLATE 39

Pablo Picasso
Mademoiselle Léonie, 1910
Plate 1 from Max Jacob, *Saint Matorel*
(Paris: Daniel-Henry Kahnweiler, 1911)
Edition 79/106
Etching, 10 1/2 x 7 7/8 inches
(26.7 x 20 cm) sheet, 7 3/4 x 5 1/2 inches
(19.8 x 14.1 cm) plate

Philadelphia Museum of Art. Gift of Mrs.
Earl Horter, 1975-275-1

PROVENANCE: Earl Horter, Philadelphia;
Elizabeth Lentz Horter, Philadelphia, 1940
to 1975; Philadelphia Museum of Art, 1975.

PLATE 40

Pablo Picasso
Girl from Arles (L'Arlesienne), 1912
Gouache and ink on paper mounted
on canvas, 26 x 9 inches (66 x 22.8 cm)

The Menil Collection, Houston

PROVENANCE: Galerie Kahnweiler, Paris;
Léonce Rosenberg, Paris; John Quinn, New York;
Earl Horter, Philadelphia; Helen Lloyd Horter
(later Helen Kelly, Harvey Cedars, New Jersey),
1937 to 1955; The Menil Collection, 1955.

EXHIBITIONS: Possibly Smith College Museum
of Art, Northampton, Massachusetts, *Contemporary
Paintings of the Modern School*, May 29–June 18, 1930,
no. 1; Philadelphia, 1934; Chicago, 1934, no. 42
(as "Arlesienne").

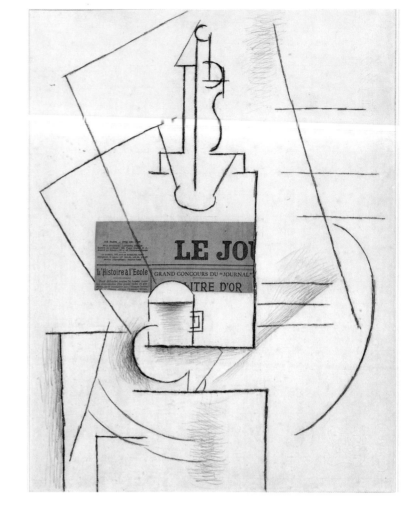

PLATE 41

Pablo Picasso
Still Life with Bottle, Cup, and Newspaper, 1912
Collage composed of pasted paper, charcoal, and graphite on paper, 24 x 18½ inches (63 x 48 cm)

Museum Folkwang, Essen

PROVENANCE: Earl Horter, Philadelphia, by 1929/30; Douglas Cooper, London, 1937; Galerie Berggruen, Paris; Walter Feilchenfeldt, Zurich, 1958 to 1961; Museum Folkwang, Essen, 1961.

EXHIBITIONS: Philadelphia, 1934; Chicago, 1934.

PLATE 42

Pablo Picasso
The Violin, 1912
Chalk on paper, 12 x 17¹¹/₁₆ inches (30.5 x 19.5 cm)

Private collection

PROVENANCE: Galerie Kahnweiler, Paris (inv. no. 1036); Hôtel Drouot, Paris, "Tableaux modernes: Aquarelles, gouaches, pastels, et dessins," December 12, 1925, lot 121; Earl Horter, Philadelphia; Justin K. Thannhauser, New York and Bern, to 1976; Mme Justin K. Thannhauser, Bern.

EXHIBITIONS: Philadelphia, 1934; Chicago, 1934, no. 43.

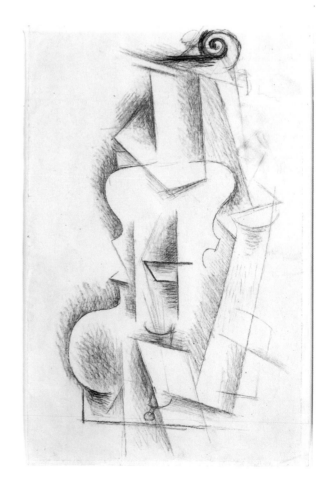

PLATE 43
Pablo Picasso
*Dice, Wineglass, Bottle of Bass,
Ace of Clubs, and Visiting Card, 1914
Oil on canvas, 13½ x 9⅛ inches
(34.3 x 23.8 cm)

Collection of Hester Diamond

PROVENANCE: Galerie Kahnweiler
(photograph no. 344); Earl Horter,
Philadelphia, by 1929/30; Elizabeth Lentz
Keim, South Langhorne (Penndel),
Pennsylvania (later Elizabeth Lentz Horter),
June 25, 1936; Harold Diamond, New York.

EXHIBITIONS: Philadelphia, 1934; Chicago,
1934, no. 52 (as "Still Life—Dice and Glass").

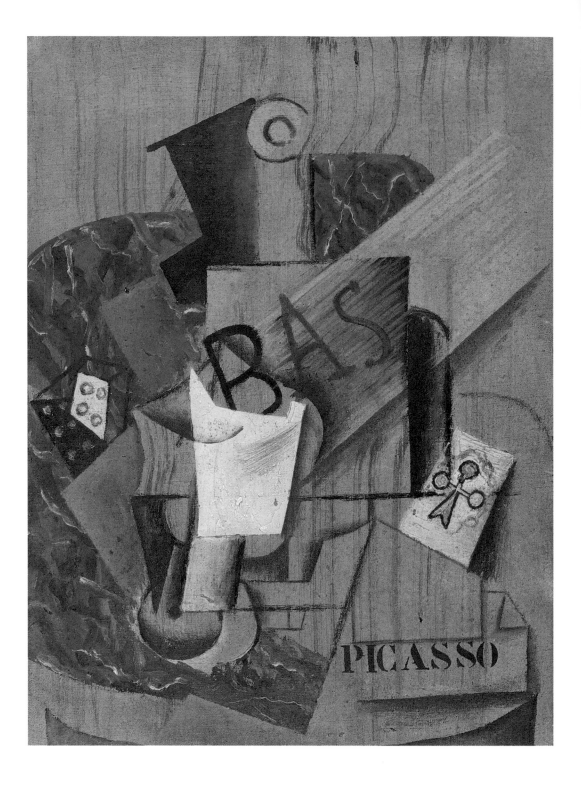

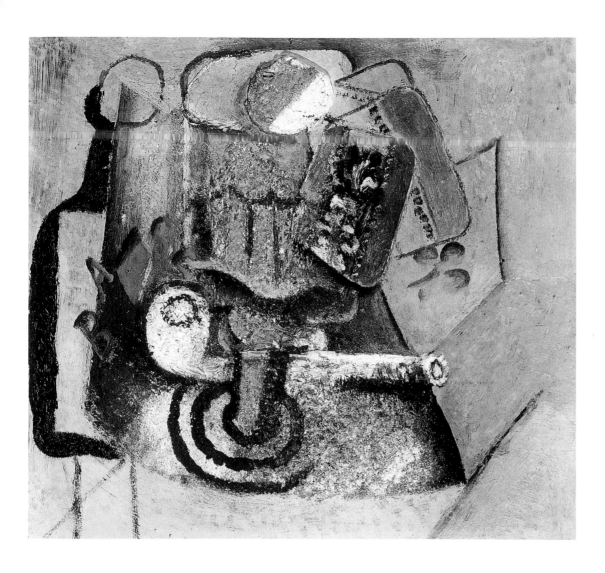

PLATE 44

Pablo Picasso
Bottle of Bass, Glass, and Pipe, 1914
Oil and sawdust on canvas, 9½ x 10¼ inches
(24.1 x 26 cm)

Private collection

PROVENANCE: Galerie Kahnweiler, Paris
(photograph no. 375); Earl Horter, Philadelphia,
by 1929/30; Elizabeth Lentz Horter, Philadelphia,
1940; Harold Diamond, New York; Allan Stone
Gallery, New York; Sotheby's, New York,
"Impressionist and Modern Paintings, Drawings,
and Sculpture, Part I," May 13, 1992, lot 71.

EXHIBITIONS: Philadelphia, 1934; Chicago,
1934, no. 51 (as "Still Life [Blue Period]").

PLATE 45

Pablo Picasso
**Heure,* c. 1914
Oil and sand on board, 5⅞ x 6¾ inches
(15 x 17.2 cm)

Private collection

PROVENANCE: Acquired from the artist by Earl
Horter, Philadelphia, by 1929/30; Elizabeth Lentz
Horter, Philadelphia, 1940 to 1985; estate of
Elizabeth Lentz Horter, 1985; Sotheby's, New
York, "Impressionist and Modern Paintings and
Sculpture, Part II," November 14, 1985, lot 247a.

EXHIBITIONS: Philadelphia, 1934; Chicago, 1934.

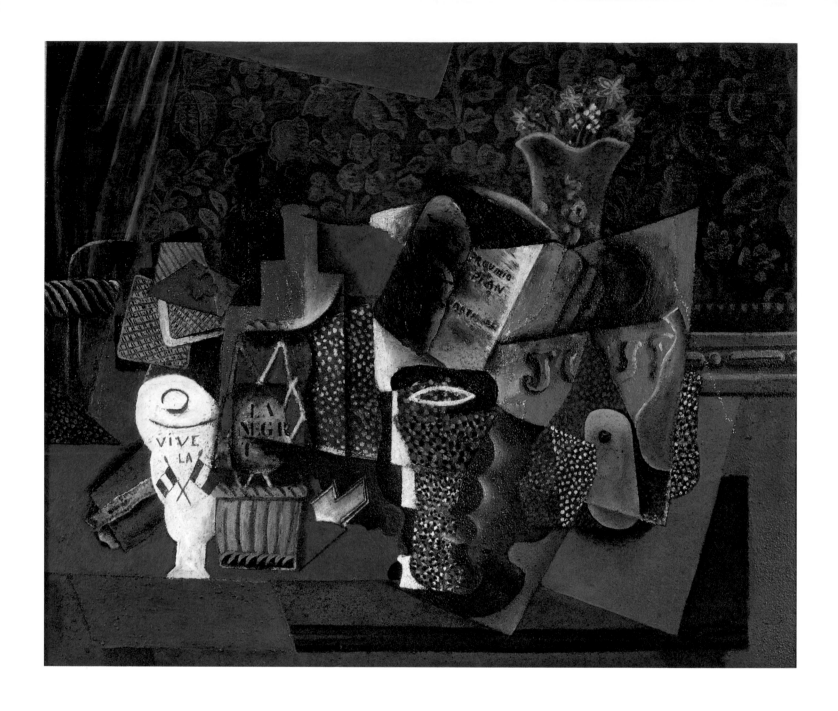

PLATE 46

Pablo Picasso
*Still Life with Cards, Glasses, and Bottle of
Rum: Vive la [France], 1914–15
Oil and sand on canvas, 21¼ x 25⁹⁄₁₆ inches
(54 x 65 cm)

Private collection

PROVENANCE: Léonce Rosenberg, Paris
(photograph no. 14-N-120); Earl Horter,
Philadelphia, by 1929/30; Sidney Janowitz
(later Janis), New York, by 1934; Mr. and Mrs.
Leigh B. Block, Chicago, by 1957.

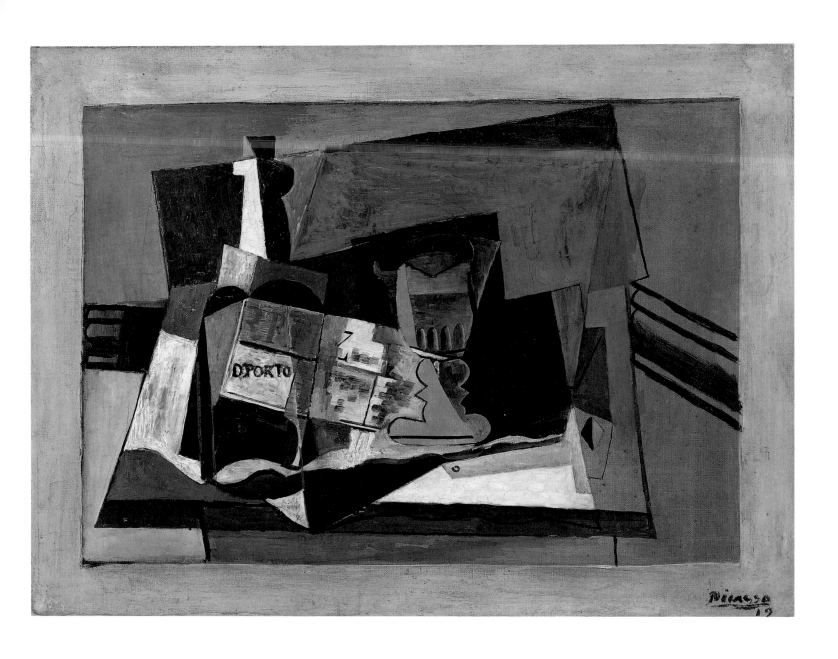

PLATE 47
Pablo Picasso
Still Life with Bottle of Port (Oporto), 1919
Oil on canvas, 18⅛ x 24 inches (46 x 61 cm)

Dallas Museum of Art. Museum League Purchase Fund, The Cecil and Ida Green Foundation, Edward W. and Evelyn Potter Rose, The Pollock Foundation, Mary Noe Lamont and Bill Lamont, Mr. and Mrs. Thomas O. Hicks, Howard E. Rachofsky, an anonymous donor, Mrs. Charlene Marsh in honor of Tom F. Marsh, Gayle and Paul Stoffet, Mr. and Mrs. George A. Shuff, Dr. Joanne Stroud Bilby, Mr. and Mrs. Barron L. Kidd, Natalie H. (Schatzie) and George T. Lee, Mr. and Mrs. Jeremy L. Halbreich, Dr. and Mrs. Bryan Williams, and Mr. and Mrs. William E. Rose

PROVENANCE: Probably with Paul Rosenberg, Paris, 1921; Whitney Studio Galleries, 1923; Earl Horter, Philadelphia, by 1929/30; Elizabeth Lentz Keim, South Langhorne (Penndel), Pennsylvania (later Elizabeth Lentz Horter), June 25, 1936; Justin K. Thannhauser, New York and Bern, by the early 1960s to 1976; Mme Justin K. Thannhauser, Bern; Silva Casa Foundation, Bern; Dallas Museum of Art, 1998.

EXHIBITIONS: Galeries Paul Rosenberg, Paris, *Exposition Picasso*, May–June 1921; The Whitney Studio Galleries, New York, *Recent Paintings by Pablo Picasso and Negro Sculpture*, May 1923; Philadelphia, 1934; Chicago, 1934, no. 46 (as "Still Life—Bottle and Glass"); Nebraska Art Association, Lincoln, *Forty-Eighth Annual Exhibition of Painting*, March 6–April 3, 1938.

PLATE 48
Pablo Picasso
**Two Women,* 1920
Watercolor and gouache with black crayon
on paper, 10 ⁹/₁₆ x 7 ⅞ inches (26.6 x 20 cm)

Collection of Hilary Dixon Lewis

PROVENANCE: Earl Horter, Philadelphia;
Helen Lloyd Horter (later Helen Kelly,
Harvey Cedars, New Jersey), 1937; Eugene John
Lewis, Philadelphia, by November 29, 1956;
Margaret Lewis, Philadelphia, to 1997.

EXHIBITIONS: Philadelphia, 1934; Chicago, 1934,
no. 48 (as "2 Figures watercolor").

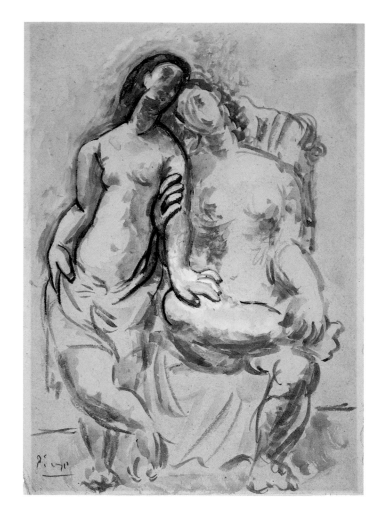

PLATE 49

Pablo Picasso

**Interior Scene*, 1926

Lithograph, 8¾ x 11 inches
(22.2 x 27.9 cm) image

Location unknown

PROVENANCE: Earl Horter, Philadelphia,
by 1929/30.

Illustrated by an impression from the collection
of the Philadelphia Museum of Art.

PLATE 50

Pablo Picasso

Three Nudes, 1927

Etching, 16¼ x 11¾ inches
(41.5 x 29.8 cm) plate

Location unknown

PROVENANCE: Earl Horter, Philadelphia;
Elizabeth Lentz Keim, South Langhorne
(Penndel), Pennsylvania (later Elizabeth Lentz
Horter), June 25, 1936, to 1985; estate of
Elizabeth Lentz Horter, 1985; Sotheby's, New
York, "Nineteenth- and Twentieth-Century and
Contemporary Prints," November 15–16, 1985,
lot 467.

EXHIBITIONS: Philadelphia, 1934; Chicago,
1934, no. 39 (as "Three Graces").

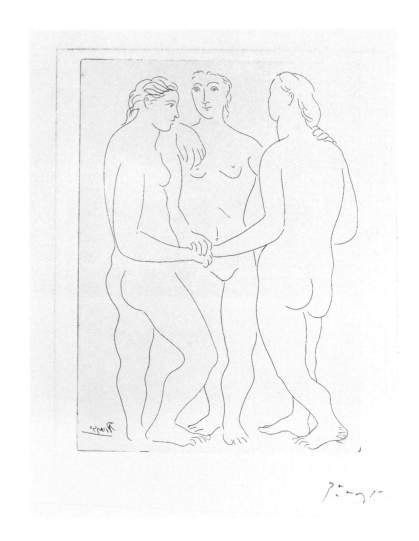

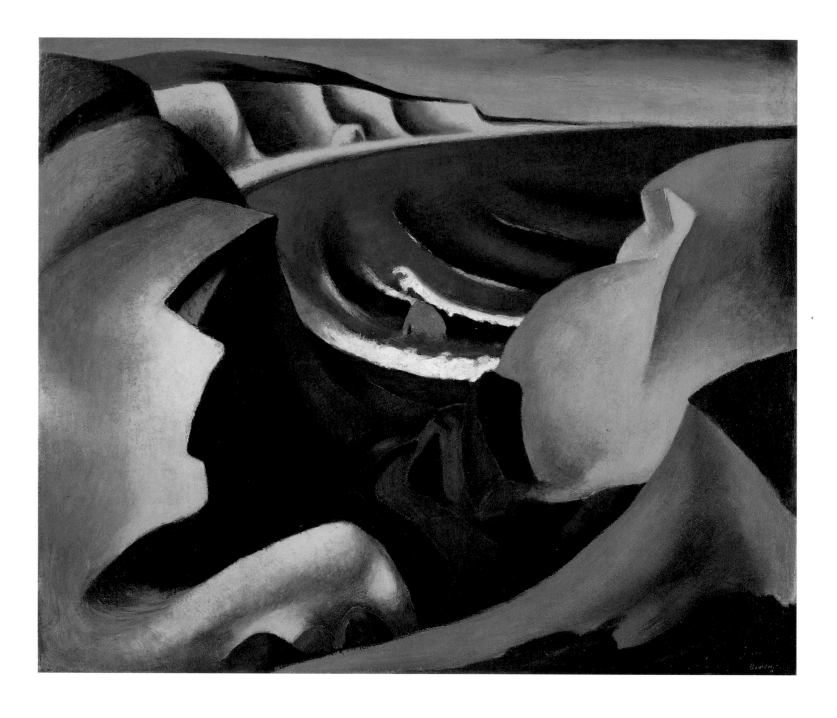

PLATE 51

Thomas Hart Benton
(American, 1889–1975)
The Cliffs, 1921
Oil on canvas, 29 x 34⅝ inches
(78.7 x 87.8 cm)

Hirshhorn Museum and Sculpture Garden,
Smithsonian Institution, Washington, D.C.
Gift of Joseph H. Hirshhorn, 1966

PROVENANCE: Earl Horter, Philadelphia; Elizabeth
Lentz Keim, South Langhorne (Penndel), Pennsylvania
(later Elizabeth Lentz Horter), June 25, 1936; Zabriskie
Gallery, New York, to March 18, 1964; Joseph H. Hirshhorn,
New York, March 18, 1964, to May 17, 1966; Hirshhorn
Museum and Sculpture Garden, 1966.

EXHIBITIONS: Philadelphia, 1934; Chicago,
1934, no. 1 (as "Landscape, Martha's Vineyard").

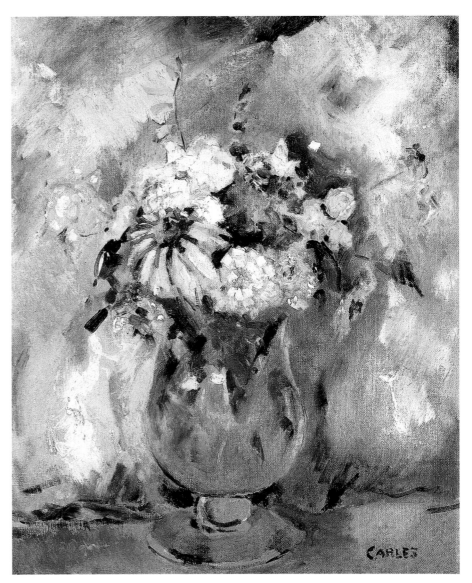

PLATE 54
Arthur B. Carles
Seated Nude, 1915–20
Oil on canvas, 23⅞ x 24⅞ inches
(60.5 x 63.1 cm)

Hirshhorn Museum and Sculpture
Garden, Smithsonian Institution,
Washington, D.C. Gift of Joseph H.
Hirshhorn, 1966

PROVENANCE: Earl Horter, Philadelphia;
Elizabeth Lentz Horter, Philadelphia, 1940;
Zabriskie Gallery, New York, to March 18,
1961; Joseph H. Hirshhorn, New York,
March 18, 1961, to May 17, 1966; Hirshhorn
Museum and Sculpture Garden, 1966.

PLATE 55
Arthur B. Carles
Nude, 1917
Inscribed: *To my friend Horter from Carles,
Xmas, 1930*
Oil on canvas, 25⅛ x 24¼ inches
(63.8 x 61.6 cm)

Private collection

PROVENANCE: Earl Horter, Philadelphia;
Elizabeth Lentz Keim, South Langhorne
(Penndel), Pennsylvania (later Elizabeth
Lentz Horter), June 25, 1936, to 1985; estate
of Elizabeth Lentz Horter, 1985.

EXHIBITIONS: Philadelphia, 1934;
Chicago, 1934, no. 14.

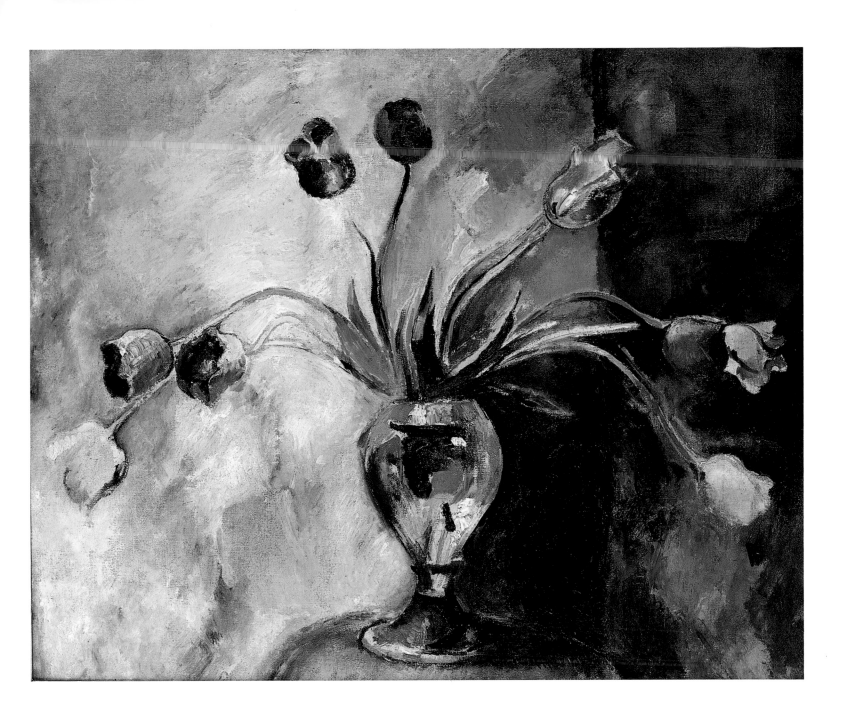

PLATE 56
Arthur B. Carles
Tulips in a Vase, 1918
Oil on canvas, 33¼ x 27½ inches
(84.5 x 69.9 cm)

Private collection

PROVENANCE: Earl Horter, Philadelphia, c. 1920;
Elizabeth Lentz Keim, South Langhorne (Penndel),
Pennsylvania (later Elizabeth Lentz Horter),
June 25, 1936, to 1985; estate of Elizabeth Lentz
Horter, 1985.

EXHIBITIONS: The Pennsylvania Academy of the
Fine Arts, Philadelphia, *The One-Hundred and Sixteenth
Annual Exhibition,* February 6–March 27, 1921, no. 357;
Montross Gallery, New York, *Paintings by Arthur B. Carles,*
December 2–23, 1922, no. 24; Philadelphia, 1934;
Chicago, 1934, no. 13 (as "Tulips").

PLATE 57
Arthur B. Carles
Nude in a Landscape, 1921
Oil on panel, 16⅛ x 12⅞ inches
(40.9 x 32.5 cm)

Location unknown

PROVENANCE: Earl Horter, Philadelphia;
Elizabeth Lentz Horter, Philadelphia, 1940;
Zabriskie Gallery, New York, to December
23, 1958; Joseph H. Hirshhorn, New York,
December 23, 1958, to May 17, 1966;
Christie's, New York, "Important American
Paintings, Drawings, and Sculpture of the
Eighteenth, Nineteenth, and Twentieth
Centuries," December 1, 1989, lot 248.

EXHIBITION: Marie Harriman Gallery,
New York, *Paintings by Arthur B. Carles*,
January–February 1936, no. 2.

PLATE 58
Arthur B. Carles
Landscape, 1921
Oil on wood panel, 12⅞ x 16⅛ inches
(32.7 x 40.9 cm)

Hirshhorn Museum and Sculpture
Garden, Smithsonian Institution,
Washington, D.C. Gift of Joseph H.
Hirshhorn, 1966

PROVENANCE: Earl Horter, Philadelphia;
Elizabeth Lentz Horter, Philadelphia, 1940;
Zabriskie Gallery, New York, to December
23, 1958; Joseph H. Hirshhorn, New York,
December 23, 1958, to May 17, 1966;
Hirshhorn Museum and Sculpture
Garden, 1966.

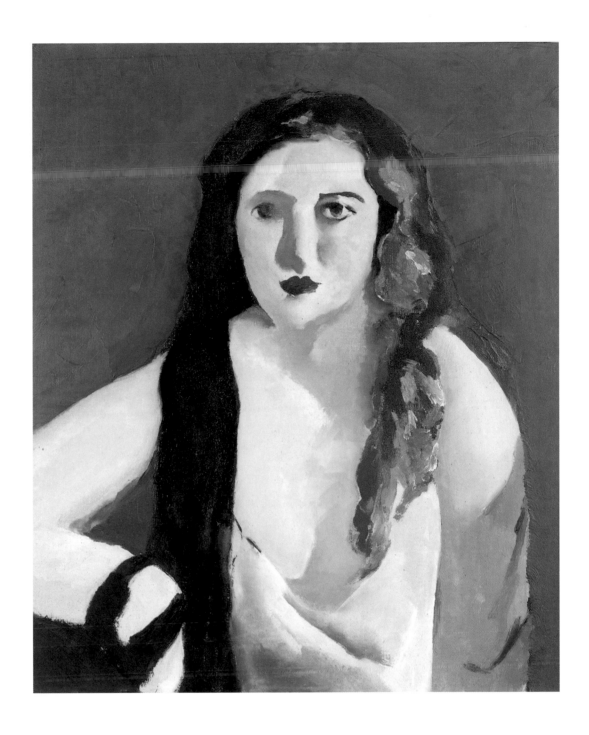

PLATE 59
Arthur B. Carles
*Girl with Red Hair (Angele), 1922
Oil on canvas, 18 x 15 inches
(45.7 x 38.1 cm)

Private collection, New Jersey

PROVENANCE: Earl Horter, Philadelphia;
Elizabeth Lentz Keim, South Langhorne
(Penndel), Pennsylvania (later Elizabeth Lentz
Horter), June 25, 1936, to 1985; estate of
Elizabeth Lentz Horter, 1985; Richard York
Gallery, New York.

EXHIBITIONS: Montross Gallery, New York, *Paintings
by Arthur B. Carles*, December 2–23, 1922, no. 9; The
Pennsylvania Academy of the Fine Arts, Philadelphia,
The One-Hundred and Eighteenth Annual Exhibition, February
4–March 25, 1923, no. 72; Smith College Museum of Art,
Northampton, Massachusetts, *Contemporary Paintings of the
Modern School*, May 29–June 18, 1930, no. 9; Philadelphia,
1934; Chicago, 1934, no. 15 (as "Red Headed Girl");
Palace of Fine and Decorative Arts, San Francisco, *Golden
Gate International Exposition*, February 1–December 2, 1939,
no. 65.

Arthur B. Carles
Composition of Flowers, 1922
Oil on canvas, 49⅛ x 36⅛ inches
(125.4 x 92.4 cm)

Philadelphia Museum of Art.
Gift of Mrs. Earl Horter, 1950-40-1

PROVENANCE: Earl Horter, Philadelphia;
Elizabeth Lentz Keim, South Langhorne
(Penndel), Pennsylvania (later Elizabeth
Lentz Horter), June 25, 1936, to 1950;
Philadelphia Museum of Art, 1950.

EXHIBITIONS: The Pennsylvania Academy
of the Fine Arts, Philadelphia, *The One-
Hundred and Nineteenth Annual Exhibition,*
February 3–March 23, 1924, no. 310;
Carnegie Institute, Pittsburgh, *Twenty-Third
Annual Exhibition,* April 24–June 15, 1924,
no. 92; The Corcoran Gallery of Art,
Washington, D.C., *Eleventh Exhibition
of Contemporary American Oil Paintings,* October
28–December 9, 1928, no. 54; Philadelphia,
1934; Chicago, 1934, no. 12 (as "Flowers");
The Art Institute of Chicago, *A Century
of Progress: Exhibition of Paintings and Sculpture,*
June 1–November 1, 1934, no. 554.

PLATE 61

Arthur B. Carles
Still Life with Flowered Cloth, 1922
Oil on canvas, 32¼ x 36¼ inches
(81.9 x 92 cm)

Private collection

PROVENANCE: Earl Horter, Philadelphia,
Elizabeth Lentz Keim, South Langhorne
(Penndel), Pennsylvania (later Elizabeth
Lentz Horter), June 25, 1936, to 1985; estate
of Elizabeth Lentz Horter, 1985.

PLATE 62

Arthur B. Carles
Portrait of Helen Seyffert, c. 1925
Oil on canvas, 30 x 25 inches
(76.2 x 63.5 cm)

Private collection

PROVENANCE: Earl Horter, Philadelphia;
Helen Lloyd Horter (later Helen Kelly,
Harvey Cedars, New Jersey), 1937; Paul
Gratz, Audubon, New Jersey; Sotheby's,
New York, "American Paintings, Drawings,
and Sculpture," September 21, 1994, lot 173.

EXHIBITIONS: Philadelphia, 1934;
Chicago, 1934, no. 19.

PLATE 63
Arthur B. Carles
Reclining Nude
Oil on canvas, 23¾ x 20 inches
(60.3 x 50.8 cm)

Private collection

PROVENANCE: Earl Horter, Philadelphia;
Elizabeth Lentz Horter, Philadelphia, 1940;
Freeman Fine Arts of Philadelphia, "Spring
Gallery Auction," April 17–19, 1997, lot 893.

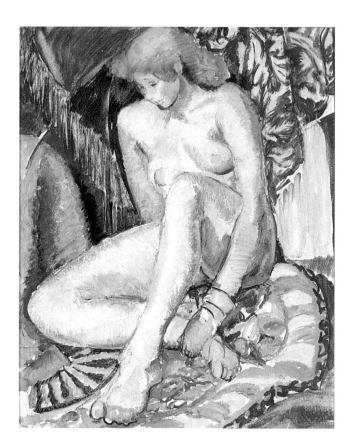

PLATE 64
Arthur B. Carles
Seated Nude
Oil on canvas board, 20 x 16 inches
(50.8 x 40.6 cm)

Private collection

PROVENANCE: Earl Horter, Philadelphia; Baum
Gallery, Sellersville, Pennsylvania; private
collection, early 1980s; Sotheby's, New York,
"American Paintings, Drawings, and Sculpture,"
September 14, 1995, lot 238.

PLATE 65

Arthur B. Davies
(American, 1862–1928)
Angled Beauty (Autumn), 1918
Soft-ground etching and aquatint,
7 15/16 x 11 7/8 inches (20.2 x 30.1 cm) plate

Location unknown

PROVENANCE: Earl Horter, Philadelphia;
Elizabeth Lentz Horter, Philadelphia, 1940
to 1985; estate of Elizabeth Lentz Horter,
1985; Conrad Graeber, Baltimore.

Illustrated by an impression in the
collection of the Philadelphia Museum
of Art.

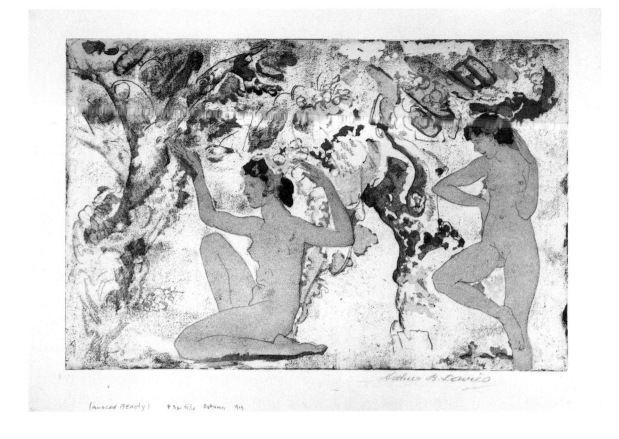

PLATE 66

Arthur B. Davies
Kingdom of the Sun, 1919
Soft-ground etching with drypoint
and aquatint, 8 7/8 x 5 7/8 inches
(22.6 x 14.9 cm) plate

Private collection

PROVENANCE: Earl Horter, Philadelphia;
Elizabeth Lentz Horter, Philadelphia, 1940
to 1985; estate of Elizabeth Lentz Horter,
1985.

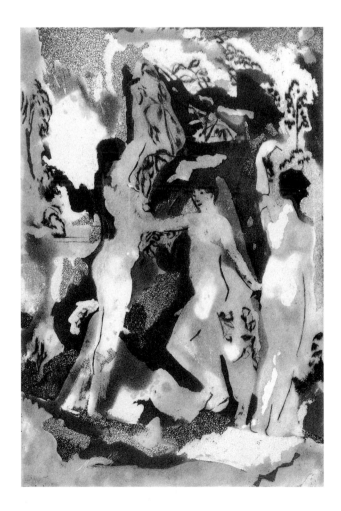

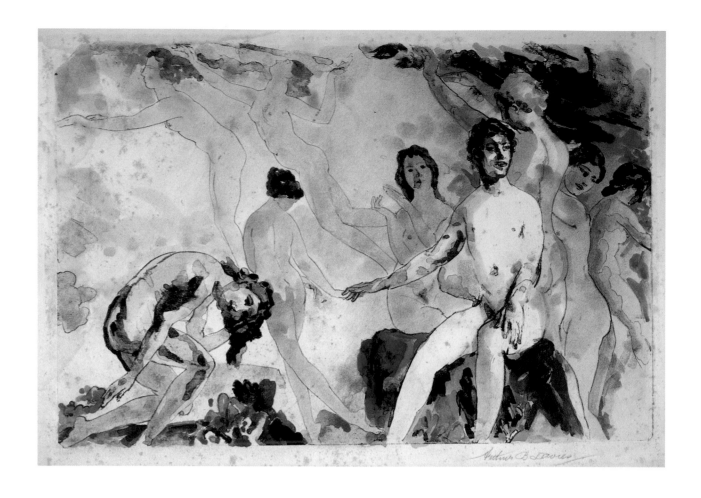

Arthur B. Davies
Release at the Gates, 1919–20
Lithograph with applied watercolor,
10 ¹⁵/₁₆ x 15 ¹³/₁₆ inches (27.8 x 40.2 cm) image

Private collection

PROVENANCE: Earl Horter, Philadelphia;
Elizabeth Lentz Keim, South Langhorne
(Penndel), Pennsylvania (later Elizabeth Lentz
Horter), June 25, 1936, to 1985; estate of
Elizabeth Lentz Horter, 1985.

PLATE 68

J. Wallace Kelly
(American, 1894–1976)
Clown, 1925
Stone, height 21½ inches (54.6 cm)

Grete Meilman Fine Art, New York

PROVENANCE: Earl Horter, Philadelphia;
Elizabeth Lentz Horter, Philadelphia, n.d.
to 1985; estate of Elizabeth Lentz Horter,
1985; Sotheby's, Arcade Auctions,
New York, "American Nineteenth- and
Twentieth-Century Paintings, Drawings,
and Sculpture," October 25, 1985, lot 246.

EXHIBITION: Philadelphia, 1934.

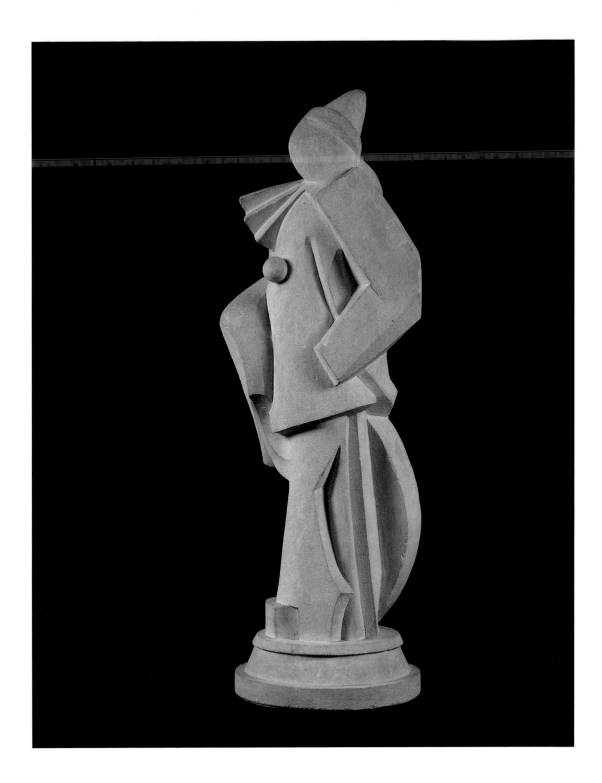

PLATE 69
J. Wallace Kelly
Abstract Figure

Location unknown

PROVENANCE: Earl Horter, Philadelphia.

EXHIBITION: Philadelphia, 1934.

Photograph of Earl Horter with *Abstract Figure*.

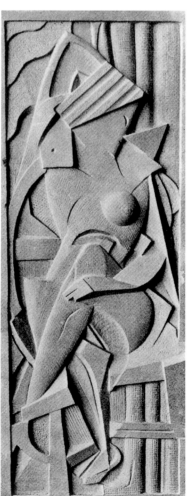

PLATE 70
J. Wallace Kelly
Seated Nude, c. 1929
Bas-relief (model for an exterior relief,
N. W. Ayer and Son Building, Philadelphia)

Location unknown

PROVENANCE: Earl Horter, Philadelphia.

EXHIBITION: Philadelphia, 1934.

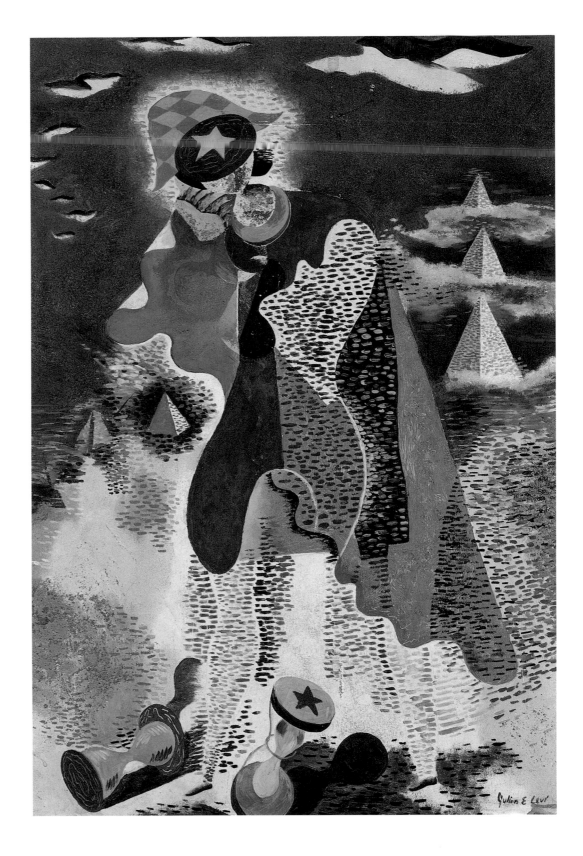

John Marin
(American, 1870–1953)
**On the Ledges, Small Point, Maine,*
1914
Watercolor on paper, 19¼ x 16¼ inches
(48.9 x 41.2 cm)

Bryn Mawr College, Bryn Mawr,
Pennsylvania. From the collection
of Mary La Boiteaux. Given by
Constance La Boiteaux Drake, class
of 1922

PROVENANCE: Earl Horter, Philadelphia;
Mary La Boiteaux; Constance La Boiteaux
Drake, Bryn Mawr, Pennsylvania; Bryn
Mawr College, 1950.

EXHIBITION: Philadelphia, 1934.

John Marin
Landscape in Maine, 1915
Watercolor over graphite on paper,
16½ x 19½ inches
(41.7 x 49.4 cm)

The Art Institute of Chicago. Samuel P.
Avery Fund, 1934

PROVENANCE: Earl Horter, Philadelphia,
to 1934; The Art Institute of Chicago, 1934.

EXHIBITIONS: Philadelphia, 1934; The Art
Institute of Chicago, *Thirteenth International
Watercolor Exhibition,* March 29–April 29, 1934,
no. 376; The Art Institute of Chicago, *A
Century of Progress: Exhibition of Paintings and
Sculpture,* June 1–November 1, 1934, no. 866.

PLATE 74
Sigmund Menkès
(American, born Poland, 1896–1986)
Flowers

Location unknown

PROVENANCE: Earl Horter, Philadelphia;
Elizabeth Lentz Horter, Philadelphia, 1940;
David David Gallery, Philadelphia,
May 7, 1971.

EXHIBITIONS: Philadelphia, 1934; Chicago,
1934, no. 33.

PLATE 75
Jules Pascin
(American, born Bulgaria, 1885–1930)
Seated Woman
Watercolor

Location unknown

PROVENANCE: Earl Horter, Philadelphia;
Elizabeth Lentz Keim, South Langhorne
(Penndel), Pennsylvania (later Elizabeth
Lentz Horter), June 25, 1936.

EXHIBITIONS: Philadelphia, 1934;
Chicago, 1934, no. 36 (as "Nude").

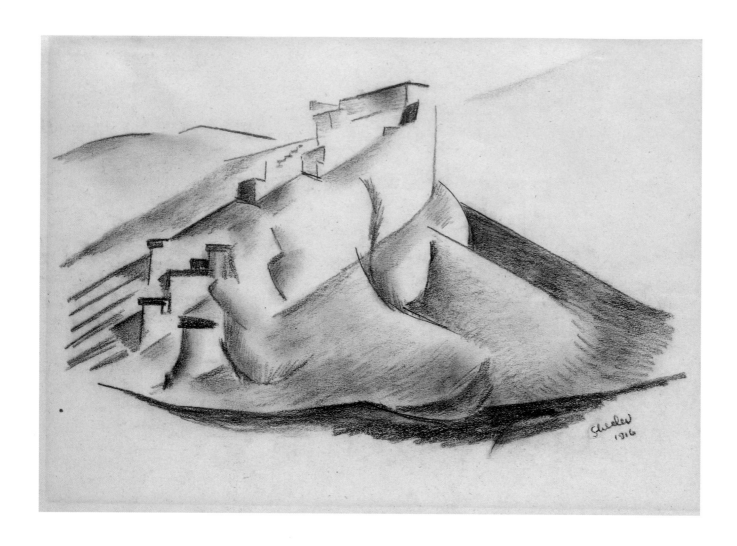

Charles Sheeler
(American, 1883–1965)
Lhasa (Landscape No. 3), 1916
Pencil and crayon on paper, 7 ³/₈ x 10 inches
(18.7 x 25.4 cm)

Private collection

PROVENANCE: Earl Horter, Philadelphia;
Elizabeth Lentz Keim, South Langhorne
(Penndel), Pennsylvania (later Elizabeth Lentz
Horter), June 25, 1936, to 1985; estate of
Elizabeth Lentz Horter, 1985.

PLATE *77*
Charles Sheeler
Flower Forms, 1917
Oil on canvas, 23¼ x 19¼ inches
(59 x 48.9 cm)

Terra Museum of American Art,
Chicago. Daniel J. Terra Collection

PROVENANCE: Acquired from the artist
by John Quinn, New York, March 1920;
estate of John Quinn, 1924 to 1927; The
American Art Association, New York,
"The John Quinn Collection: Paintings and
Sculptures of the Moderns," February 9–11,
1927, lot 68; Alexander Lieberman,
Philadelphia; Earl Horter, Philadelphia;
Elizabeth Lentz Keim, South Langhorne
(Penndel), Pennsylvania (later Elizabeth
Lentz Horter), June 25, 1936, to 1985; estate
of Elizabeth Lentz Horter, 1985; James
Maroney, Inc., New York; Terra Museum
of American Art, Chicago, 1987.

EXHIBITIONS: Philadelphia, 1934; Chicago,
1934, no. 58; Whitney Museum of American
Art, New York, *Abstract Painting in America*,
February 12–March 22, 1935, no. 104;
The Museum of Modern Art, New York,
*Charles Sheeler: Paintings, Drawings,
and Photographs*, October 2–November 1, 1939,
no. 9.

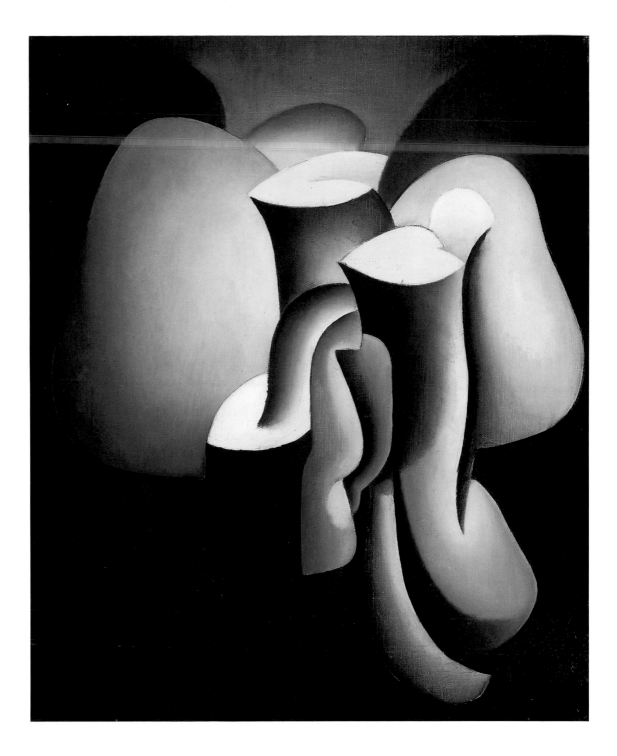

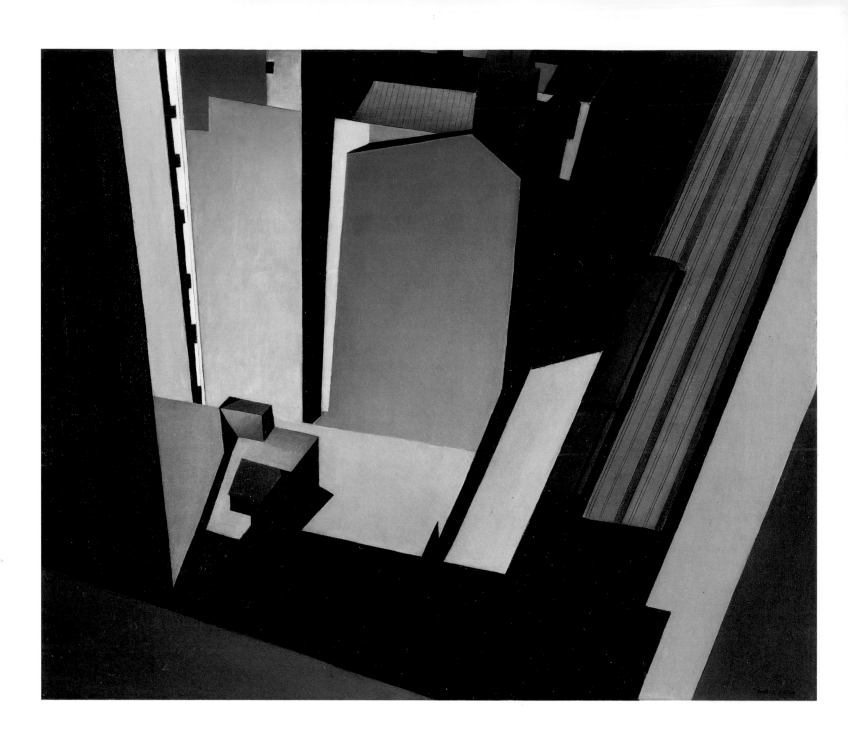

PLATE 78

Charles Sheeler
Church Street El, 1920
Oil on canvas, 16⅛ x 19⅛ inches
(41 x 48.6 cm)

The Cleveland Museum of Art. Mr. and Mrs.
William H. Marlatt Fund

PROVENANCE: Earl Horter, Philadelphia;
Elizabeth Lentz Keim, South Langhorne
(Penndel), Pennsylvania (later Elizabeth Lentz
Horter), June 25, 1936, to 1985; estate of
Elizabeth Lentz Horter, 1985; Harold Diamond,
New York; The Cleveland Museum of Art, 1977.

EXHIBITIONS: Whitney Studio Galleries, New York,
Exhibition of Selected Works by Charles Sheeler, March 1–31, 1924;
Philadelphia, 1934; Chicago, 1934, no. 57 (as "New York");
The Museum of Modern Art, New York, *Charles Sheeler:
Paintings, Drawings, and Photographs,* October 2–November 1,
1939, no. 11.

PLATE 79

Charles Sheeler
Calla Lily, c. 1920
Crayon, charcoal, and graphite on
paper, 13 ½ x 10 ¾ inches
(34.3 x 27.3 cm)

Private collection

PROVENANCE: Earl Horter, Philadelphia;
Elizabeth Lentz Keim, South Langhorne
(Penndel), Pennsylvania (later Elizabeth
Lentz Horter), June 25, 1936, to 1985; estate
of Elizabeth Lentz Horter, 1985; Richard
York Gallery, New York.

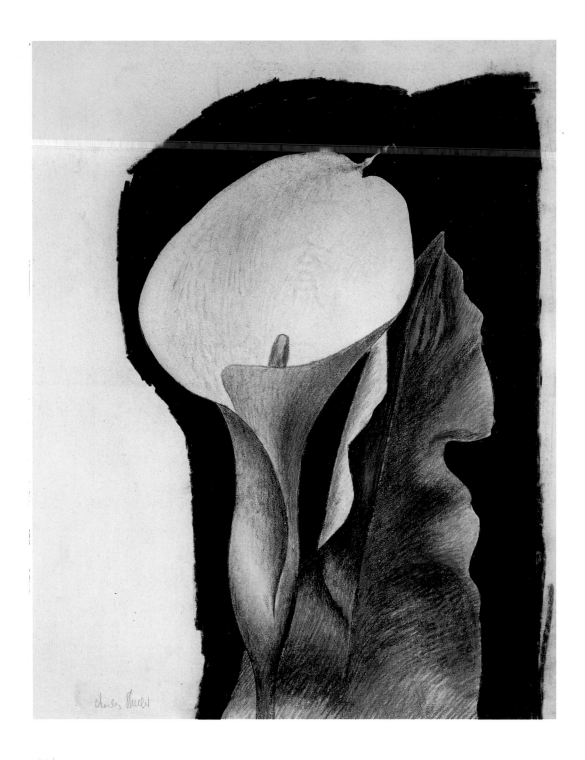

Charles Sheeler
Female Torso, 1920
Graphite on paper, 4⁹/₁₆ x 6 inches
(11.5 x 15.2 cm) sheet

Museum of Fine Arts, Boston.
M. and M. Karolik Fund

PROVENANCE: Earl Horter, Philadelphia;
Elizabeth Lentz Keim, South Langhorne
(Penndel), Pennsylvania (later Elizabeth
Lentz Horter), June 25, 1936, to 1985; estate
of Elizabeth Lentz Horter, 1985; James
Maroney, Inc., New York; Museum of Fine
Arts, Boston, 1986.

EXHIBITION: Philadelphia, 1934.

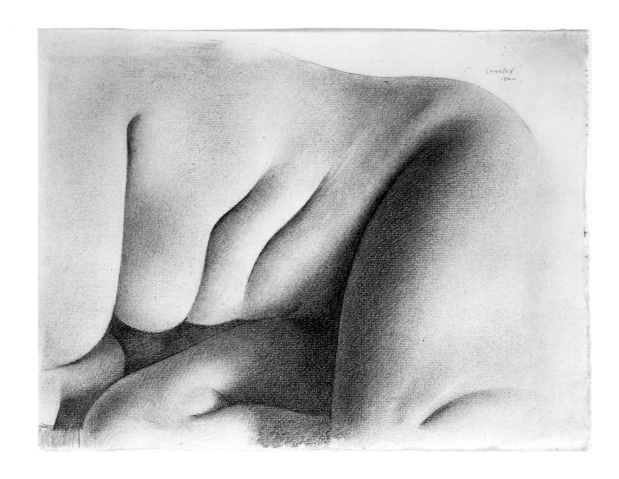

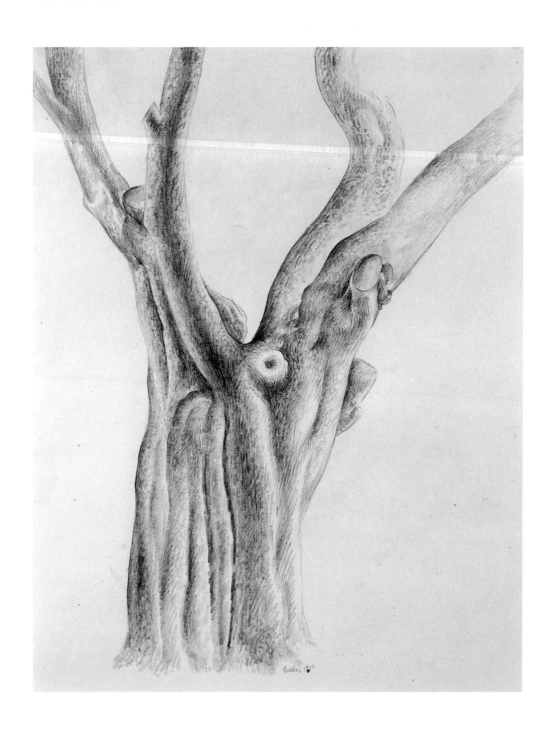

PLATE 81
Charles Sheeler
*Tree, 1920
Graphite on paper, 9½ x 7¼ inches
(24.2 x 18.4 cm)

Private collection

PROVENANCE: Earl Horter, Philadelphia;
Elizabeth Lentz Keim, South Langhorne
(Penndel), Pennsylvania (later Elizabeth Lentz
Horter), June 25, 1936, to 1985; estate of
Elizabeth Lentz Horter, 1985.

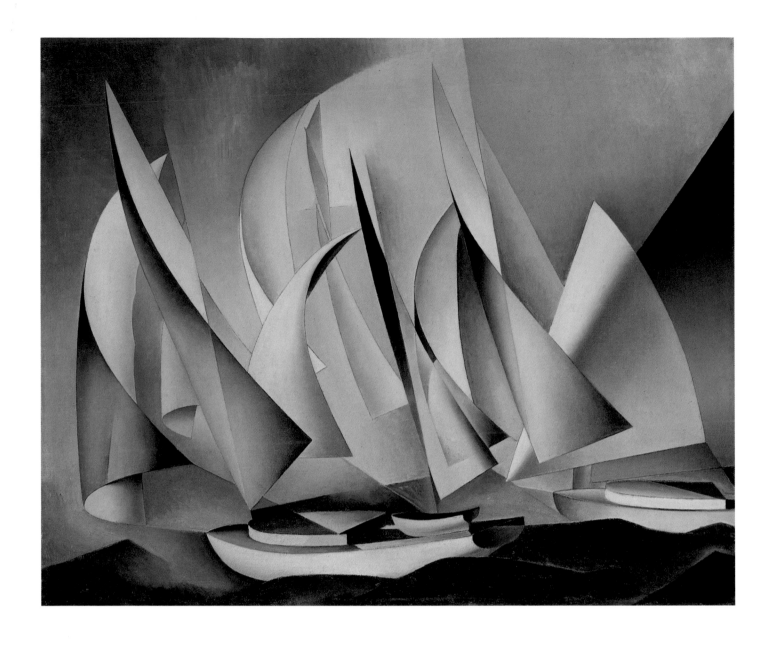

PLATE 82
Charles Sheeler
*Pertaining to Yachts and Yachting, 1922
Oil on canvas, 20 x 24¹/₁₆ inches
(50.8 x 61.1 cm)

Philadelphia Museum of Art. Bequest of
Margaretta S. Hinchman, 1955-96-9

PROVENANCE: Montross Gallery, New York,
January 1923; Earl Horter, Philadelphia, by April
1923; Margaretta S. Hinchman, Gladwyne,
Pennsylvania, by March 1934, to 1955; Philadelphia
Museum of Art, 1955.

EXHIBITIONS: Montross Gallery, New York, *Contemporary Art,* January
23–February 10, 1923; 1607 Walnut Street, Philadelphia, *31* [Exhibition],
April 3–14, 1923, no. 78; The American Art Association, New York, *Spring Salon,*
May 21–June 9, 1923; Whitney Studio Galleries, New York, *Exhibition of Selected
Works by Charles Sheeler,* March 1–31, 1924; The Museum of Modern Art, New York,
Painting and Sculpture by Living Americans, December 2, 1930–January 20, 1931, no. 77;
Pennsylvania (later Philadelphia) Museum of Art, Philadelphia, *Living Artists: An
Exhibition of Contemporary Painting and Sculpture,* November 20, 1931–
January 1, 1932; Philadelphia, 1934; Chicago, 1934, no. 55.

PLATE 83

Charles Sheeler
Stairway to the Studio, 1924
Conte crayon and tempera on paper,
25 3/8 x 19 11/16 inches (64.4 x 50 cm)

Philadelphia Museum of Art. Bequest
of Mrs. Earl Horter in memory of her
husband, 1985-59-1

PROVENANCE: Earl Horter, Philadelphia,
1930; Elizabeth Lentz Keim, South
Langhorne (Penndel), Pennsylvania (later
Elizabeth Lentz Horter), June 25, 1936, to
1985; Philadelphia Museum of Art, 1985.

EXHIBITIONS: Smith College Museum
of Art, Northampton, Massachusetts,
Contemporary Paintings of the Modern School, May
29–June 18, 1930, no. 3; Philadelphia, 1934;
Chicago, 1934, no. 56 (as "Staircase");
Whitney Museum of American Art,
New York, *Abstract Painting in America*,
February 12–March 22, 1935, no. 105; The
Museum of Modern Art, New York, *Charles
Sheeler: Paintings, Drawings, and Photographs*,
October 2–November 1, 1939, no. 62.

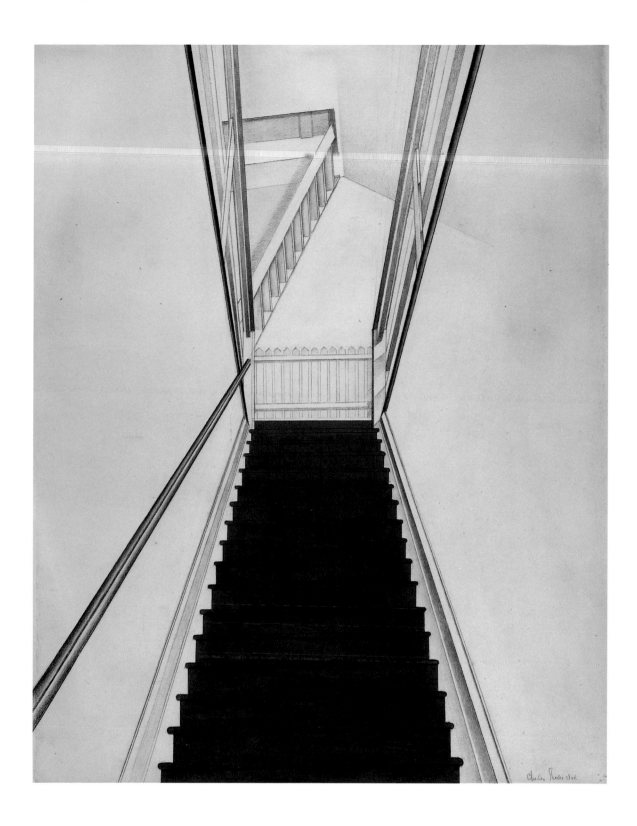

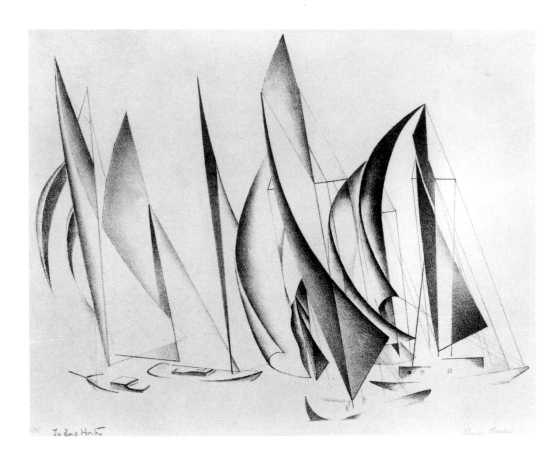

PLATE 84

Charles Sheeler
Yachts, 1924
Inscribed: *To Earl Horter*
Lithograph, 8 x 9¾ inches
(20.3 x 24.7 cm) image

Whitney Museum of American Art, New
York. Purchase, with funds from the
Lauder Foundation, Leonard and Evelyn
Lauder Fund, 96.68.246

PROVENANCE: Earl Horter, Philadelphia;
C. MacKenzie Lewis, Jr., by 1942 to 1979;
Philadelphia Museum of Art, 1979 to 1996;
Whitney Museum of American Art, 1996.

PLATE 85

Joseph Stella

(American, born Italy, 1880–1946)

Water Lilies, 1919–20

Oil on glass, 12½ x 7 inches
(31.8 x 17.8 cm)

Collection of Margaret L. Driscoll

PROVENANCE: Earl Horter, Philadelphia,
April 16, 1921; Elizabeth Lentz Horter,
Philadelphia, 1940; estate of Elizabeth
Lentz Horter, 1985.

EXHIBITIONS: The Pennsylvania Academy
of the Fine Arts, Philadelphia, *Exhibition
of Paintings and Drawings Showing the Later
Tendencies in Art,* April 16–May 15, 1921,
no. 35; Philadelphia, 1934.

PLATE 86
Franklin Watkins
(American, 1894–1972)
*Nude Reclining, 1929
Oil on canvas, 12¾ x 18⅛₆ inches
(32.4 x 45.8 cm)

Ackland Art Museum, The University of North Carolina at Chapel Hill. Gift of Claiborne T. Smith, Jr.

PROVENANCE: Earl Horter, Philadelphia, by April 1930; Elizabeth Lentz Keim, South Langhorne (Penndel), Pennsylvania (later Elizabeth Lentz Horter), June 25, 1936; Claiborne T. Smith, Jr., Ardmore, Pennsylvania; Ackland Art Museum, 1979.

EXHIBITIONS: The Pennsylvania Academy of the Fine Arts, Philadelphia, *The One-Hundred and Twenty-Fifth Exhibition of Painting and Sculpture*, January 26–March 16, 1930, no. 410; The Museum of Modern Art, New York, *An Exhibition of the Work of Forty-Six Painters and Sculptors Under Thirty-Five Years of Age*, April 12–26, 1930, no. 126; Philadelphia, 1934; Chicago, 1934, no. 60 (as "Nude").

M1
Georges Braque
(French, 1882–1963)
Still Life—Peaches

Location unknown

PROVENANCE: Earl Horter, Philadelphia;
Elizabeth Lentz Keim, South Langhorne
(Penndel), Pennsylvania (later Elizabeth Lentz
Horter), June 25, 1936.

EXHIBITIONS: Philadelphia, 1934; Chicago, 1934.

M2
Arthur B. Carles
(American, 1882–1952)
Two Nudes, 1915

Location unknown

PROVENANCE: Earl Horter, Philadelphia.

EXHIBITIONS: Philadelphia, 1934; Chicago, 1934,
no. 16.

M3
Eugene Higgins
(American, 1874–1958)
Drinkers

Location unknown

PROVENANCE: Earl Horter, Philadelphia,
Elizabeth Lentz Horter, Philadelphia, 1940.

EXHIBITIONS: Philadelphia, 1934; Chicago, 1934,
no. 25.

M4
J. Wallace Kelly
(American, 1894–1976)
Abstraction
Bas-relief

Location unknown

PROVENANCE: Earl Horter, Philadelphia.

EXHIBITION: Philadelphia, 1934.

M5
Moise Kisling
(French, born Poland, 1891–1953)
Head of a Girl

Location unknown

PROVENANCE: Earl Horter, Philadelphia.

EXHIBITIONS: Philadelphia, 1934; Chicago, 1934,
no. 26; Nebraska Art Association, Lincoln, *Forty-
Eighth Annual Exhibition of Painting*, March 6–April 3,
1938.

M6
Stanton MacDonald-Wright
(American, 1890–1973)
Still Life Synchromy, 1917

Location unknown

PROVENANCE: Samuel S. White, 3rd, and Vera
White, Ardmore, Pennsylvania; Earl Horter,
Philadelphia, by 1923.

EXHIBITIONS: Philadelphia, 1934; Chicago, 1934,
no. 61 (as "Synchronist [*sic*] painting").

M7
Louis Marcoussis
(Polish, active France, 1883–1941)
Still Life (Abstraction), 1921
Oil on glass

Location unknown

PROVENANCE: Earl Horter, Philadelphia; Helen
Lloyd Horter (later Helen Kelly, Harvey Cedars,
New Jersey), 1937; Paula K. Muller.

EXHIBITION: Philadelphia, 1934.

M8
Henri Matisse
(French, 1869–1954)
Nude
Lithograph

Location unknown

PROVENANCE: Earl Horter, Philadelphia.

EXHIBITION: Chicago, 1934, no. 28.

M9
Sarah Langley Mendenhall
(American, 1885–1953)
Abstraction, 1916

Location unknown

PROVENANCE: Earl Horter, Philadelphia.

EXHIBITION: Philadelphia, 1934 (as by Sarah
Langley).

M10
Amedeo Modigliani
(Italian, 1884–1920)
Nude (Caryatid)
Watercolor on paper

Location unknown

PROVENANCE: Earl Horter, Philadelphia, to 1934.

EXHIBITION: The Art Institute of Chicago,
Thirteenth International Watercolor Exhibition, March
29–April 29, 1934, no. 140.

M11
Amedeo Modigliani
Girl's Head
Oil

Location unknown

PROVENANCE: Earl Horter, Philadelphia.

EXHIBITIONS: Philadelphia, 1934; Chicago,
1934, no. 34.

M12
Amedeo Modigliani
Portrait of a Woman
Drawing

Location unknown

PROVENANCE: Earl Horter, Philadelphia,
to 1934.

EXHIBITIONS: Philadelphia, 1934; Chicago,
1934, no. 35 (as "Drawing").

M13
Jules Pascin
(American, born Bulgaria, 1885–1930)
Beach Scene
Watercolor

Location unknown

PROVENANCE: Earl Horter, Philadelphia.

EXHIBITIONS: The Print Club of Philadelphia,
*Contemporary French Drawings in Black and White and
Color*, November 10–27, 1930, no. 57(?)
(as "Figure Landscape"); Philadelphia, 1934;
Chicago, 1934, no. 37 (as "Watercolor").

M14
Pablo Picasso
(Spanish, 1881–1973)
Guitar, 1912
Charcoal and pencil on paper

Location unknown

PROVENANCE: Galerie Kahnweiler, Paris
(inv. no. 1055); Kahnweiler sale; Earl Horter,
Philadelphia; Galerie Berggruen, Paris; Douglas
Cooper, London, May 1955.

EXHIBITIONS: Philadelphia, 1934; Chicago,
1934, no. 38.

M15
Franklin Watkins
(American, 1894–1972)
Still Life (Fruit)

Location unknown

PROVENANCE: Earl Horter, Philadelphia.

EXHIBITIONS: Philadelphia, 1934; Chicago,
1934, no. 59.

In 1931 a reporter for Philadelphia's *Evening Public Ledger* visited the home of Earl Horter to view his extensive art collection. Ascending the stairs leading from the street-level drawing room to the formal living room on the second floor, the reporter unexpectedly came across a "forbidding parade" of African masks and figures prominently displayed on bookshelves and tables throughout the room (see figs. 1, 3, and 4).[1] "Mr. Horter," the paper later noted with some surprise, "is very enthusiastic over Negro sculpture."[2]

The amazement expressed at finding a selection of African sculpture amid the Picassos and Braques in Earl Horter's collection was, in some ways, still to be expected in 1931. Although objects from Africa entered American collections as early as 1810, not until the first decades of the twentieth century were African artifacts viewed in the West as art and valued for their formal qualities as sculpture.[3] Horter, who began acquiring African art in the mid-1920s, was himself clearly aware of his prescience as a collector. Indeed, in his 1931 interview he had observed that "until about ten years ago . . . Negro sculpture was regarded only as an archaeological find, but now it has been recognized as it should be, as an exquisite form of art."[4] As part of a small but significant contingent of collectors of African sculpture in the Philadelphia area, Horter helped foster a wider appreciation of its artistry among an American audience during the years between the world wars.

The collecting of African art in the United States was initially stimulated by the interest in objects from Africa on the part of the avant-garde in Europe, particularly in Paris. For it was Paris, as art historian Jean-Louis Paudrat has argued, that became "the point of convergence for the propagation of ideas and activities that bestowed on African art an essential role in the formation of Western sensibility."[5] Seeking new forms of artistic expression for inspiration, artists such as Pablo Picasso, André Derain, and Maurice Vlaminck began looking at and collecting African masks and figures as early as 1905. The abstract formal properties of African sculpture appealed to these early modernists, who desired to move beyond realism in representation in their own

work. Objects from Africa, along with those from Oceania and the Americas, inspired various art movements throughout Western Europe that have been collectively grouped under the term "Primitivism."[6]

A market for African art soon developed in Paris, established by enterprising dealers such as Joseph Brummer and Paul Guillaume.[7] These dealers rarely traveled to Africa themselves, instead relying on shipments from their correspondents in the colonies to provide an inventory. France's political and commercial relations with Africa therefore influenced the general availability of objects for purchase, with most African works deriving from the French colonies, especially those in the Western Sudan, the Ivory Coast, and Gabon. The content of early twentieth-century collections of African art was further influenced by the aesthetic preferences of dealers and collectors, most of whom selected masks and statuary in wood and metal, object types and mediums most easily assimilated into established categories of fine arts in the West.

Dealers in African art were able to capitalize on its growing popularity among the avant-garde in Paris during the years leading up to World War I. In addition to French collectors, there were a sizable number of American expatriates who began to acquire African art as a facet of their commitment to modernism. One of the first Americans to collect African art was the painter Max Weber. Weber frequented the ethnographic collections at the Musée d'Ethnographie du Trocadero while in Paris between 1905 and 1908.[8] By 1909 he had acquired a small Yaka figure from the Congo, which he used as a model in his work and brought with him upon his return to New York that year.[9] Another American expatriate artist, Patrick Henry Bruce, was also collecting African sculpture by 1910 and eventually assembled a diverse group of African objects that included mortars and pestles as well as a number of Akan gold weights.[10] Both artists were students of Henri Matisse around 1907–8 and likely became interested in African art through their teacher, who employed examples in his sculpture class to demonstrate characteristics of volume.[11]

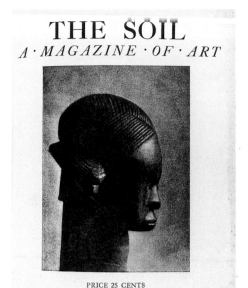

Fig. 58. *The Soil*, published in 1916 and 1917 by New York gallery owner Robert Coady, was one of the earliest American periodicals to promote the art of Africa. The cover of the July 1917 issue featured a profile view of a Congo figural sculpture. Horter subscribed to the magazine.

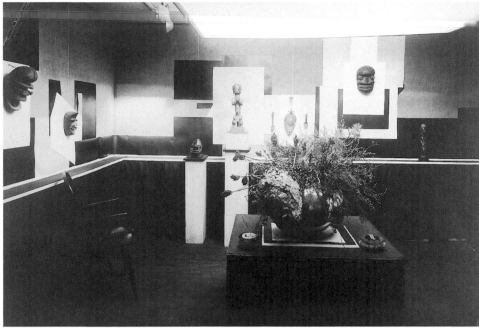

Fig. 59. View of *Statuary in Wood by African Savages: The Root of Modern Art*, an exhibition at 291 in New York, 1914, photographed by Alfred Stieglitz. Organized by Alfred Stieglitz and Marius de Zayas, the exhibition included eighteen works on loan from Paul Guillaume's Paris gallery. Photographer Edward Steichen installed the show, adopting a modernist framework that emphasized the formal properties of the objects.

American expatriates such as Weber and Bruce served as conduits through which the vogue for *l'art nègre* was transmitted from Paris to the United States. Through their associations with artists, critics, and gallery owners, mainly in New York, interest in the forms of African sculpture began to develop. The advent of World War I further fueled American collecting of African art by forcing many European dealers of non-Western art to seek additional markets, as well as by sending American artists home from Paris, some with a newfound taste for African sculpture. Thus, by 1914 the market for African art had expanded from France to the United States as New York galleries began promoting the "new" art form to American collectors.

Although Horter had not been part of the American expatriate community in Paris before the war, he did have ample opportunity to develop an interest in African art while living in New York between 1903 and 1916. The Washington Square Gallery, in New York's Greenwich Village, appears to

have been the first American gallery to display objects from Africa as art. Opened in the spring of 1914 by Robert Coady and his partner Michael Brenner, the gallery exhibited African sculpture as well as modernist and children's art.[12] Coady was a progressive thinker and an early champion of African art through his magazine, *The Soil*. While there is no direct evidence that Horter frequented the Washington Square Gallery, he did subscribe to Coady's magazine, which was published in only five issues from 1916 to 1917.[13] Illustrating *The Soil* with examples of African sculpture (fig. 58), Coady promoted the idea of an aesthetic relationship between the arts of Africa and modernism.

Horter was also a visitor to Alfred Stieglitz's gallery 291, where he would have had an opportunity to see the first gallery exhibition devoted solely to African art.[14] *Statuary in Wood by African Savages: The Root of Modern Art*, organized by Stieglitz and his associate, the caricaturist Marius de Zayas, was held from November 3 to December 8, 1914, and featured eighteen African masks and figures

on loan from Paul Guillaume's Paris gallery.[15] This exhibition was to be a defining moment in the history of Western appreciation of African art, as the selection of the works and their presentation in the gallery setting diverged sharply from the prevailing ethnographic approach to display. Whereas museum installations exhibited a broad range of African material culture arranged typologically, the exhibition at 291 emphasized the sculptural characteristics of a select number of masks and figures presented as unique objects (fig. 59).

The modernist framework underlying the presentation of African sculpture in a gallery setting was directly manifest through the installation itself, designed by photographer Edward Steichen. Steichen emphasized the planar elements of the objects by placing them against rectangular panels of yellow, orange, and black paper, a setting clearly suggestive of Cubism. This formal relationship would not have been lost on Horter, who later observed that "the background of cubism may be found in this

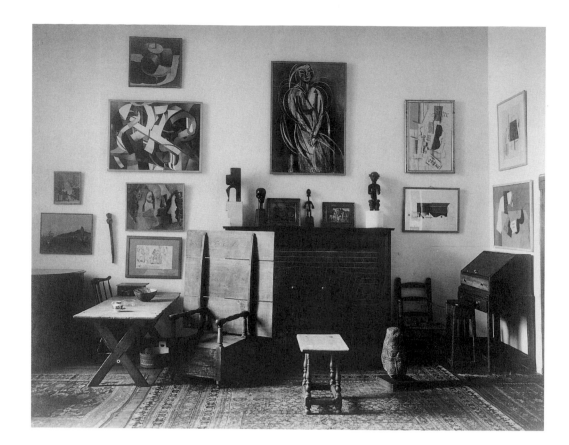

Fig. 60. Interior of Walter and Louise Arensberg's apartment in New York about 1918, photographed by Charles Sheeler. African objects from Gabon and Mali, on the mantelpiece, are interspersed with modernist works from their collection.

primitive sculpture, and in cubism lies the secret of modern art."[16]

After organizing the exhibition at 291, Stieglitz and de Zayas quickly capitalized on the interest in African art that had arisen in the United States. Both together and individually, they sponsored a number of exhibitions featuring this "new" art. At de Zayas's own Modern Gallery, for example, between 1915 and 1918 three exhibitions were devoted to African sculpture, and African pieces were included in a fourth.[17] De Zayas, in particular, was keenly aware of the commercial potential for his new gallery, realizing that the art market in Europe had been "eliminated by the war."[18]

By 1920 there were a number of small but significant American collections of African art acquired primarily from such dealers as Coady, Stieglitz, and de Zayas. In New York, Walter and Louise Arensberg owned a number of African sculptures that they displayed in their apartment along with modernist works from their collection (fig. 60).[19] John Quinn, a New York attorney who was involved in the organization of the Armory Show of 1913, also assembled a collection of African art, through both Coady and de Zayas.[20] Horter, however, though he had many opportunities to begin collecting

while in New York, apparently did not purchase African sculpture until the mid-1920s, well after he had moved to Philadelphia.

Although overshadowed by its northern neighbor, Philadelphia was, in fact, an important center for African art during the 1920s and 1930s. The city already had a well-established museum collection in the University of Pennsylvania's University Museum.[21] The early holdings of the museum, founded in 1887, were especially strong in Fang works from Gabon and Kongo pieces from the Congo, objects acquired from missionaries and explorers in Africa. Around 1911 the collection began to be developed in a systematic manner under the directorship of George Byron Gordon, who purchased a large group of works from Benin, Nigeria, through British dealer William O. Oldman, as well as a selection of nineteen sculptures from Paris dealer Charles Vignier.[22]

Although the University Museum had African works from its extensive ethnographic collection on public display, it was the well-known Philadelphia collector Dr. Albert C. Barnes who fostered Horter's appreciation of African sculpture. Barnes, a chemist by vocation, is best remembered as an ardent patron of modernist art, particu-

larly paintings by Renoir, Cézanne, and Matisse. He also acquired an important and influential collection of African sculpture.[23] Barnes began purchasing African art in 1922 through the Paris dealer Paul Guillaume, who became foreign secretary of the Barnes Foundation one year later. By December 1923, Barnes had assembled a collection of more than a hundred masks and figural works, primarily from the Western Sudan, the Ivory Coast, Gabon, and the Congo.

Barnes's collection of African art became more widely known in 1925 with the opening of the Barnes Foundation in Merion, just outside Philadelphia. Chartered as an educational institution, the foundation was specifically built to house Barnes's extensive collection of more than 2,500 works, which, in addition to African sculpture, included modern European art, medieval panel painting, and ceramics. The collection was actively used as a tool for teaching Barnes's systematic method of art appreciation to students enrolled in the foundation's classes. Barnes carefully arranged his works into "wall ensembles" designed to illustrate various aspects of his educational aesthetic theory. His exclusive focus on what he termed "plastic form"—color, line, light, and space—provided a critical framework that encompassed all visual material, regardless

Fig. 61. The south wall of gallery 22 in the Barnes Foundation, Merion, Pennsylvania. Masks and figures from West and Central Africa are interspersed with paintings by Picasso and Modigliani, among others. Through such arrangements, Barnes sought to demonstrate interrelationships between works of different cultures and periods by revealing their "universal attributes."

Fig. 62. African art from Horter's collection arranged on a mantel in his widow's house, 1940s or 1950s, in Chestnut Hill in Philadelphia. Many of these works feature finely crafted wood mounts by Paris-based woodworker Inagaki.

of cultural origin or subject matter. African art was therefore integrated with other works from the collection, primarily modernist paintings, to reveal shared formal properties and to challenge Western preconceptions of the fine arts (fig. 61).

Horter was among the first to take courses in art appreciation at the Barnes Foundation. In the spring of 1925 he was part of a group of about twenty painters who attended Barnes's Sunday lectures in the foundation's galleries.[24] He also audited a course in modern art taught by Barnes Foundation teacher Thomas Munro at the University of Pennsylvania. Both courses included the appreciation of African sculpture. Barnes himself would often lecture on the subject, advancing his aesthetic criteria for African art and situating it within a history of "great form." A typical lecture was described by Barnes in 1928:

Last Sunday we had a fine meeting at the gallery before a distinguished audience of painters, writers, musicians, etc. I talked on Negro sculpture, demonstrated its sculptural characteristics, and showed the difference between it and Greek, Chinese and Egyptian sculpture. I never had a more attentive and appreciative audience; many, many people thanked me and said that they could see why negro sculpture was important.[25]

Horter continued to attend classes at the Barnes Foundation intermittently through 1928. Through these courses, Horter was introduced to Barnes's ideological perspectives on and aesthetic criteria for African art, which were codified in the 1926 Barnes Foundation textbook *Primitive Negro Sculpture*, written by Paul Guillaume and Thomas Munro.[26] Barnes held that a contextual understanding was not necessary for artistic appreciation of African art, instead maintaining that it could be analyzed aesthetically for sculptural design. He particularly emphasized the restructuring of the human body in the interest of design and therefore defined as "art" objects such as figural statuary and masks but excluded textiles, utilitarian objects, and weapons. Further, Barnes proposed four "major" regional traditions exhibiting shared stylistic characteristics that he determined to be the most important artistically: the Western Sudan, the Ivory Coast, Gabon, and the Congo.

Barnes was to be a formative influence on Horter, who, inspired by his courses at the Barnes Foundation, began acquiring African art. Although non-Western arts were often viewed collectively as "primitive" art during this era, it appears that Horter distinguished his collecting of African sculpture from his interest in Native American artifacts. Horter

had an intensely romantic view of Native American arts, fueled by his boyhood visits to Buffalo Bill shows.[27] In contrast, Horter's appreciation of African art seems to have developed along purely formal lines, surely encouraged by the approach to African sculpture advocated at the Barnes Foundation. Horter considered Barnes to have "one of the finest collections of Negro sculpture in this country" and sought his guidance in forming his own collection.[28] For his part, Barnes, as a mentor to the younger collector, was clearly impressed by Horter's interest, deeming him "one of the most enthusiastic people about Negro art."[29]

There are no extant records of Horter's acquisitions of African art, but most purchases were through Barnes's Paris dealer, Paul Guillaume, probably in 1925.[30] Such works are distinguishable by their sleek and elegant wood mounts, which feature a characteristic chop mark on the base. These were made by the Paris-based woodworker Inagaki, whom Guillaume employed as a mount-maker. Many works from Horter's collection with an Inagaki mount—and therefore likely purchased from Guillaume—were photographed after Horter's death aligned on a mantel in his widow's house (fig. 62). They include, from left to right, a horned Guro mask (pl. 91), a Kota reliquary

guardian figure (pl. 94), a Bembe female figure, a Baule figural work, a Bamana mask (pl. 87), and two Dan masks (pls. 88 and 89).

That Barnes had a hand in the selection of the African sculpture in Horter's collection is evident in its content. Most of the works in Horter's collection derive from the four "style regions" Barnes found aesthetically significant and include specific types of objects that Barnes particularly valued. Both Horter and Barnes, for example, owned a sizable number of smoothly finished and relatively naturalistic Dan face masks from the Ivory Coast. In addition, many of Horter's African objects are strikingly similar to specific pieces in the Barnes Foundation collection. The Bamana *ntomo* mask and the small Bembe figure in Horter's collection are, in fact, works that appear to be by the same hand or workshop as their counterparts in Merion.[31]

By 1926 Horter had acquired thirteen works of African art for his collection. While Barnes advised Horter on many of his purchases, he was probably not the sole influence in the formation of the collection. Horter approached dealers other than Guillaume, including Stieglitz, regarding potential purchases. Inquiring in 1926 about an African work, Horter wrote to Stieglitz, "that wonderful piece of Negro sculp [sic] you have ought to be added to my 13 pieces—an unlucky number—how about it sometime."[32] Although it is unclear whether the work was actually acquired from Stieglitz, several objects in Horter's possession suggest influences other than Barnes for his collection. Horter owned two stools, one from Nigeria and one from Cameroon, and a Shona-Tsonga headrest (pl. 95), none of which reflect Barnes's aesthetic preference for figural sculpture.

The formal similarities Horter perceived between African art and modernism also differed from those advanced by Barnes. Horter related the often abstract properties of African sculpture to the planar distortions of the Cubist works in his collection, maintaining that the background of Cubism could be found in this primitive sculpture.[33] This aesthetic relationship was suggested most clearly in Horter's arrangement of his African art collection in his residence at 2219 Delancey Street. In the living room, a row of African figures and masks is carefully placed beneath Cubist paintings by Picasso and Braque (figs. 3 and 4). On the other side of the room (fig. 1), the Kota reliquary guardian figure from Gabon is situated directly below Picasso's *Nude*, 1909 (pl. 31), the angular forms of the African sculpture echoing the fractured planes of the painting above. A Cubist framework also underlies the display of a Dan mask (pl. 90) in Horter's fourth-floor studio (fig. 32). Complementing the Precisionist-influenced interior decor, the mask is placed against a wall of windows to emphasize the geometry of its form. Ironically, although Horter credited Barnes with opening his eyes to Cubism, Barnes himself was dismissive of the artistic movement, lamenting that some Cubist works of art were completely divorced from representation.[34]

Horter shared his interest in African sculpture through his friendships with other collectors, most of whom had first collected modern art. In the Philadelphia area, Horter's close friends Samuel and Vera White assembled a small collection of African sculpture, some of it acquired through Paul Guillaume's Paris gallery.[35] Philadelphia collector Carroll S. Tyson, Jr., also developed an interest in African art, purchasing a Guro face mask surmounted by a bird (figs. 66 and 67) from Horter in the early 1930s. Horter was acquainted as well with Frank Crowninshield, editor of *Vanity Fair* and a fellow collector of both African and modernist art.[36] It was probably through Horter that Crowninshield first visited the Barnes Foundation collection, sometime during the late 1920s.[37]

By the mid-1930s Horter's collection of African art began to be displayed publicly through his participation in a number of exhibitions. In February 1934, the Pennsylvania (now Philadelphia) Museum of Art opened a loan exhibition of selections from Horter's collection in its Gallery of Modern Art. In addition to works by Charles Sheeler, Braque, Picasso, and other modernists, the exhibition included nine "African wood carvings, negro masks and statuettes."[38] The inclusion of African art in this exhibition likely was designed to demonstrate the formal inspiration of the modernist works. In this, it was in keeping with a previous exhibition of the collection of Sam and Vera White, which included "two wooden negro masks [to] show the inspiration of Modigliani's portraits," which were also exhibited.[39]

One work from Horter's collection was canonized through its inclusion in the historic exhibition *African Negro Art*, organized in 1935 by curator James Johnson Sweeney for the Museum of Modern Art in New York. Sweeney and museum director Alfred H. Barr, Jr., set out to develop an exhibition of African "masterpieces," assembling the best pieces from major public and private collections in Europe and America.[40] Sweeney selected many of the works for the exhibition by perusing existing books and catalogues of African art that included photographic reproductions.[41] Horter's collection of African art, however, was already known to the museum, as he had previously lent to its Henri Matisse exhibition in 1931.

Barr wrote to Horter in the fall of 1934, initially inquiring about another mask in his collection. As it turned out, the object in question was the Guro mask he had sold to Carroll Tyson in the early 1930s.[42] In its place, Horter offered to lend any works from his collection and highlighted a particular mask, "a fairly large one," that he sketched in the margin of his note (fig. 63). This mask, a Bamana *ntomo* mask from Mali (pl. 87), was featured in the exhibition along with the Guro mask from the Ivory Coast previously sold to Tyson (figs. 66 and 67). Of the more than six hundred works included in the exhibition, these were the only African objects from the private collections of Philadelphians.[43]

African Negro Art, which opened March 18, 1935, at the Museum of Modern Art, was the first major art museum exhibition to display objects from Africa solely for their formal properties. During its run, Horter's Bamana mask was seen by a large audience, as attendance at the exhibition averaged a thousand visitors a day.[44] The mask was also selected to be photographed by Walker Evans for a portfolio based on the exhibition.[45] Evans photographed the mask in two closely cropped views, frontal and profile, emphasizing the angular lines and flat planes of the object (figs. 64 and 65).[46] The portfolio

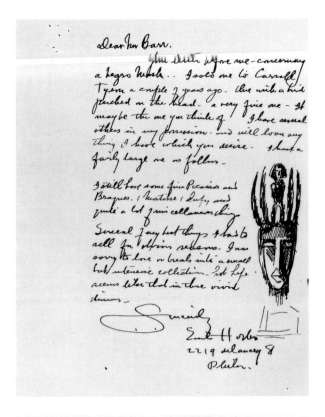

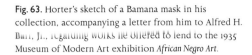

Fig. 63. Horter's sketch of a Bamana mask in his collection, accompanying a letter from him to Alfred H. Barr, Jr., regarding works he offered to lend to the 1935 Museum of Modern Art exhibition *African Negro Art.*

Fig. 64. Bamana mask from Horter's collection photographed by Walker Evans for the portfolio *African Negro Art* based on the 1935 exhibition of the same name at the Museum of Modern Art in New York.

Fig. 65. Profile view of the same Bamana mask photographed by Walker Evans. Evans employed certain photographic techniques such as tightly cropping the subject to emphasize the formal properties of African sculpture.

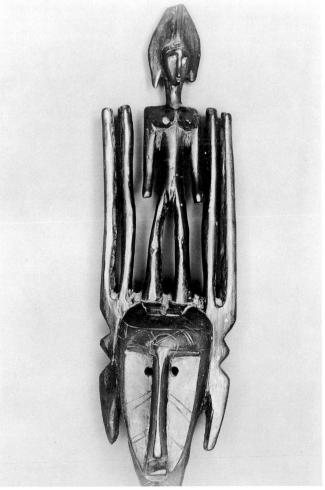

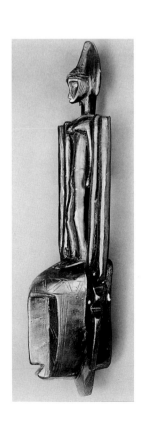

Fig. 66. Guro mask, formerly in Horter's collection and sold to Carroll S. Tyson, Jr., in the early 1930s. The mask was included in the 1935 exhibition *African Negro Art* and photographed by Walker Evans for the portfolio of the same name.

Fig. 67. Profile view of the same Guro mask photographed by Walker Evans.

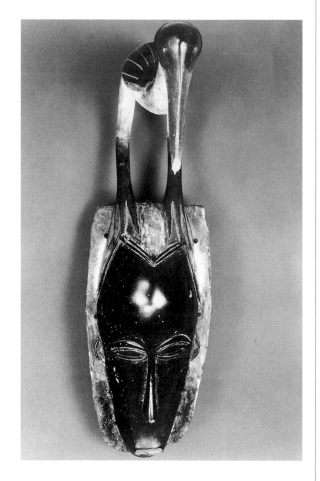

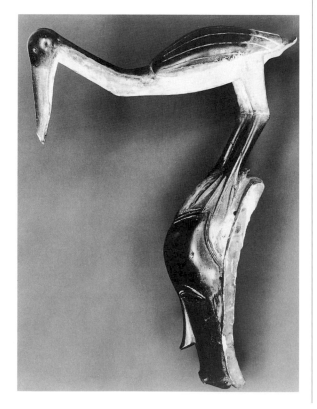

itself, produced in a limited edition of seventeen, became an exhibition, displayed at a number of museums and galleries throughout the United States.

Although *African Negro Art* would be the most important exhibition to include objects from his African collection, Horter continued to participate in other, smaller shows that helped to foster interest in African art outside the New York City region. Most of these exhibitions emphasized the relationship of African sculpture to modernist art. In 1936 in Philadelphia, for example, the Philadelphia Art Alliance held an exhibition entitled *African Art and Its Modern Derivatives*. Horter was a generous lender to the exhibition, though mostly of modern works from his collection; he included only one African mask. The majority of African works were lent by the University Museum, with additional objects from the collections of Sam and Vera White and Frank Crowninshield.[47] Just three months after this exhibition, Horter participated in a show at the Memorial Art Gallery of the University of Rochester, New York, lending objects from his collection to *The Art of the African Negro with Related Modern Paintings*.[48] Other collectors of African art participating in the Rochester exhibition included the composer George Gershwin and Edith Isaacs of *Theatre Arts* magazine. Later that year, Horter placed six works from his African collection on extended loan to the Pennsylvania Museum of Art; it is unclear whether the museum exhibited them.[49]

When Horter died in 1940, he left behind only eleven works of African art, a collection that he had characterized, quite accurately, as "small but intensive."[50] Although he never developed a collection on the scale of that of Barnes, Horter helped to cultivate in the Philadelphia area a wider appreciation of the artistic qualities of African art. By 1959 interest in African sculpture among area collectors had increased to the extent that the University Museum was able to mount *Ancient and Primitive Art in Philadelphia Collections*, an exhibition that featured African art from about a dozen Philadelphia collectors, including Horter's friends R. Sturgis Ingersoll and Carroll Tyson. The assemblage was described as offering "a pulse count of the

taste of [the] time."[51] Part of an influential contingent of Americans who collected African art during the period between the world wars, Horter certainly contributed to Western taste in African art. His collection of African art, reflecting the aesthetic interests of his era, allows us today to see African art through the eye of a modernist.

Notes

1. "Hobby Hunter Runs into Artist Who Thrills in Works of Others," *Evening Public Ledger* (Philadelphia), July 3, 1931.

2. "Hobby Hunter," 1931.

3. See Warren Robbins, "Collecting and Exhibiting in America: A Brief Sketch," in Warren M. Robbins and Nancy Ingram Nooter, *African Art in American Collections: Survey 1989* (Washington, D.C., and London: Smithsonian Institution Press, 1989). Warren states (p. 29), "The first objects of African art in an American public collection were recorded, circa 1810 to 1814, by the East India Marine Society in Salem, Massachusetts, now the Peabody Museum."

In Europe, African artifacts began to be collected as curiosities around the fifteenth century, but not in any great number; see Ezio Bassani and Malcolm McLeod, "African Material in Early Collections," in *The Origins of Museums: The Cabinet of Curiosities in Sixteenth- and Seventeenth-Century Europe*, ed. Oliver Impey and Arthur MacGregor (Oxford: Clarendon Press, 1985), pp. 245–50. Jean-Louis Paudrat provides the most comprehensive chronology of the collecting of African art in the West to date, though he focuses primarily on the development of French collections; see Paudrat, "[The Arrival of Tribal Objects] From Africa," in *"Primitivism" in Twentieth Century Art: Affinity of the Tribal and the Modern*, ed. William Rubin (New York: The Museum of Modern Art, 1984), pp. 125–75.

4. "Hobby Hunter," 1931.

5. Paudrat, "From Africa," 1984, p. 125.

6. Since the 1938 publication of Robert J. Goldwater's groundbreaking study *Primitivism in Modern Painting* (New York and London: Harper and Brothers, 1938), the subject of "Primitivism" has generated considerable interest and debate. Aspects of "Primitivism" in Western art were considered in the 1970s by Lucy Lippard, "Heroic Years from Humble Treasures: Notes on African and Modern Art," in Lippard, *Changing: Essays in Art Criticism* (New York: E. P. Dutton, 1971), pp. 35–47; Judith Zilczer, "Primitivism and New York Dada," *Arts Magazine*, vol. 51, no. 9 (May 1977), pp. 140–42; Jean Laude, *La Peinture française (1905–1914) et "l'art nègre"* (Paris: Editions Klincksieck, 1968); and J. Donne, "African Art and Paris Studios, 1905–20," in *Art in Society: Studies in Style, Culture, and Aesthetics*, ed. Michael Greenhalgh and Vincent Megaw (New York: St. Martin's Press, 1978), pp. 105–20.

In 1984 the highly controversial exhibition at the Museum of Modern Art in New York, *"Primitivism" in Twentieth-Century Art: Affinity of the Tribal and the Modern*, organized by William Rubin, spawned a host of rejoinders to what many saw as a Eurocentric approach to the subject. Among the most noteworthy of these for their trenchant criticisms are Thomas McEvilley, "Doctor Lawyer Indian Chief," *Artforum*, vol. 23, no. 3 (November 1984), pp. 54–60, and James Clifford, "Histories of the Tribal and Modern," *Art in America*, vol. 73, no. 4 (April 1985), pp. 164–77, 215. Since then, a number of studies have considered "Primitivism" as a cultural construct. Historically grounded examinations that are informed by this perspective include both Annie E. Coombes, *Reinventing Africa: Museums, Material Culture, and Popular Imagination in Late Victorian and Edwardian England* (New Haven and London: Yale University Press, 1994), and Frances S. Connelly, *The Sleep of Reason: Primitivism in Modern European Art and Aesthetics, 1725–1907* (University Park: Pennsylvania State University Press, 1995). Among the studies adopting a broader view of the phenomenon of "Primitivism" are Sally Price, *Primitive Art in Civilized Places* (Chicago and London: The University of Chicago Press, 1989); Marianna Torgovnick, *Gone Primitive: Savage Intellects, Modern Lives* (Chicago and London: The University of Chicago Press, 1990); and Susan Hiller, *The Myth of Primitivism: Perspectives on Art* (London and New York: Routledge, 1991).

7. Paudrat, "From Africa," 1984, pp. 143–44, has rightly emphasized the importance of Brummer's role in establishing a market for African art. Colette Giraudon's important studies on Guillaume include a discussion of his involvement in African art; see Giraudon, *Paul Guillaume et les peintres du XXᵉ siècle: De l'art nègre à l'avant-garde* (Paris: Bibliothèque des Arts, 1993), and Giraudon, *Les Arts à Paris chez Paul Guillaume* (Paris: Éditions de la Réunion des musées nationaux, 1993).

8. William Innes Homer, *Alfred Stieglitz and the American Avant-Garde* (Boston: New York Graphic Society, 1977), p. 74.

9. Weber included the Yaka figural work in a still life from 1910 entitled *Congo Statuette* (or *African Sculpture*); see Gail Levin, "American Art," in *"Primitivism" in Twentieth Century Art*, 1984, p. 454. The Yaka figure is probably the same object of which Weber wrote in *Camera Work*, no. 31 (July 1910), p. 25: "A Tanagra, Egyptian, or Congo statuette often gives the impression of a colossal statue, while a poor, mediocre piece of sculpture appears to be of the size of a pin-head, for it is devoid of this boundless sense of space or grandeur"; quoted in *Camera Work: A Critical Anthology*, ed. Jonathan Green (New York: Aperture, 1973), p. 202.

10. William C. Agee and Barbara Rose, *Patrick Henry Bruce: American Modernist; A Catalogue Raisonné* (New York: The Museum of Modern Art; and Houston: The Museum of Fine Arts, 1979), p. 12, fig. 17, and p. 223, under Documents, "Henri-Pierre Roché: Memories of P. Bruce."

11. Gail Levin has offered Matisse as a source of Weber's interest in African art in her essay "American Art," in *"Primitivism" in Twentieth-Century Art*, 1984, p. 453. Agee mentions Matisse's pedagogical use of African sculpture in Agee and Rose, *Patrick Henry Bruce*, 1979, p. 31 n. 53.

12. For an extensive discussion of Coady, see Judith K. Zilczer, "Robert J. Coady, Forgotten Spokesman for Avant-Garde Culture in America," *American Art Review*, vol. 2, no. 6 (November–December 1975), pp. 77–89.

13. Horter's library contained four of the five published issues of *The Soil*.

14. In a 1926 letter to Stieglitz, Horter expressed his fond memories of "the early days of 291," Horter to Stieglitz, January 18, 1926, Stieglitz Archives, Beinecke Rare Book and Manuscript Library, Yale University.

15. Marius de Zayas recounts the development of this historic exhibition in his memoir, begun in the 1940s, *How, When, and Why Modern Art Came to New York*, ed. Francis M. Naumann (Cambridge, Massachusetts, and London: The MIT Press, 1996), pp. 55–59.

16. "Hobby Hunter," 1931.

17. For the exhibition schedule during the brief life of the Modern Gallery, which opened in October 1915 and closed in April 1918, see "Appendix A: Exhibitions at the Modern and De Zayas Galleries," in *How, When and Why Modern Art Came to New York*, 1996, pp. 134–55.

18. Announcing his gallery's opening in *Camera Work*, no. 48 (October 1916), p. 64, de Zayas stated: "To foreign artists our plan comes as a timely opportunity. Their market in Europe has been eliminated by the war. Their connections here have not yet been established"; quoted in *Camera Work: A Critical Anthology*, 1973, p. 306. Although de Zayas refers here to modernist art, his sentiments undoubtedly would have extended to the market for African sculpture in Europe, which was similarly affected by the war.

19. Francis Naumann briefly discusses the Arensbergs' collecting of African art through de Zayas's gallery in "Walter Conrad Arensberg: Poet, Patron, and Participant in the New York Avant-Garde, 1915–20," *Philadelphia Museum of Art Bulletin*, vol. 76, no. 328 (Spring 1980), p. 10.

20. For an in-depth analysis of Quinn as a collector, though focusing primarily on his patronage of modernist art, see Judith Zilczer, *"The Noble Buyer": John Quinn, Patron of the Avant-Garde* (Washington, D.C.: Smithsonian Institution Press, 1978). Zilczer notes (p. 83) that Quinn purchased works from Coady's gallery. Quinn's collection of African art was dispersed after his death in 1924.

21. Allen Wardwell documents the development of this extensive collection in *African Sculpture from the University Museum, University of Pennsylvania* (Philadelphia: Philadelphia Museum of Art, 1986), pp. 15–28. The University Museum (now known as the University of Pennsylvania Museum of Archaeology and Anthropology) purchased eighteen African works from the collection of John Quinn after his death in 1924.

22. Wardwell identifies the dealer as H. Vignier, whom he describes as having run a gallery specializing in Asian art but dealing also in African and Oceanic objects; see *African Sculpture from the University Museum*, pp. 19–20. This is likely Charles Vignier, the Symbolist poet and, later, dealer in Asian art who collected and sold African and Oceanic sculptures in a shop on the rue Lamennais in Paris; see Paudrat, "From Africa," p. 152.

23. For a detailed study of Barnes's role as a patron of African art, see Christa Clarke, "Defining Taste: Albert C. Barnes and the Promotion of African Art in the United States during the 1920s" (Ph.D. diss., University of Maryland, College Park, 1998).

24. Barnes described Horter's class in a letter to his Paris dealer Paul Guillaume: "On Sundays I have been opening the gallery to painters and each Sunday there has been about twenty there," Barnes to Guillaume, February 27, 1925, Barnes Foundation Archives, Merion, Pennsylvania.

25. Barnes to Guillaume, February 23, 1928, Barnes Foundation Archives, Merion, Pennsylvania.

26. Although authorship of this influential book is credited to Paul Guillaume and Barnes Foundation teacher Thomas Munro, recent archival research at the foundation reveals that Barnes's aesthetic beliefs substantially informed the content of the book; see Clarke, "Defining Taste," 1998. Horter owned a copy of

Primitive Negro Sculpture, which was sold at auction in 1986 by his widow's estate.

27. See William Wierzbowski, "Horter's Native American Collection," pp. 148–57 in this volume.

28. "Hobby Hunter," 1931.

29. Barnes to Guillaume, February 27, 1925, Barnes Foundation Archives, Merion, Pennsylvania.

30. On February 27, 1925, Barnes wrote to Guillaume that Horter "has asked me to tell you that he will soon take the rest of the Negro pieces which he had you reserve for him"; Guillaume replied in a letter of March 11, 1925: "Pour Horter, c'est entendu; d'ailleurs vous m'aviez parlé de lui dans termes assez élogieux pour que je ne songe pas à le contrarier" (As for Horter, that's settled; moreover, you've spoken about him to me in terms so complimentary that I wouldn't dream of disappointing him). Barnes Foundation Archives, Merion, Pennsylvania.

31. Horter's Bamana mask is quite similar to one hanging on the south wall of gallery 22 at the Barnes Foundation (inventory no. A260). Likewise, Horter's Bembe female figure appears to be by the same hand as a number of Bembe figures in the Barnes Foundation collection, illustrated in plate 37 of Paul Guillaume and Thomas Monroe, *Primitive Negro Sculpture* (New York: Harcourt, Brace, 1926; reprint, New York: Hacker Art Books, 1968).

32. Horter to Stieglitz, January 18, 1926, Stieglitz Archives, Beinecke Rare Book and Manuscript Library, Yale University.

33. "Hobby Hunter," 1931.

34. Although Barnes found "considerable esthetic power" in the Cubist paintings of Picasso and Braque, he felt that "the idea of abstract form divorced from a clue, however vague, of its representative equivalent in the real world, is sheer nonsense"; Albert C. Barnes, *The Art in Painting*, 3rd ed. (Merion Station, Pennsylvania: The Barnes Foundation Press, 1976), p. 357. Barnes's discussion of Cubism in this text draws upon ideas expressed in his earlier article "Cubism: Requiescat in Pace," *Arts and Decoration*, vol. 6, no. 3 (January 1916), pp. 121–24.

35. African sculpture from the Samuel and Vera White collection is catalogued in "The Samuel S. White, 3rd, and Vera White Collection," *Philadelphia Museum of Art Bulletin*, vol. 63, nos. 296/97 (January–March/April–June 1968), cat. nos. 368–80. See especially cat. no. 369 (Lumbo mask, Gabon), cat. no. 374 ("Ancestor mask"), and cat. nos. 377–78 ("Dance masks") for objects purchased from Guillaume.

36. For Crowninshield's collection of African art, see Christa Clarke, "John Graham and the Crowninshield Collection of African Art," *Winterthur Portfolio*, vol. 30, no. 1 (Spring 1995), pp. 23–39.

37. Horter wrote to Barnes about "Mr. Crownenshield [*sic*], a friend and collector and distinct friend of all the gallery contains—I would like to bring," Horter to Barnes, undated, Barnes Foundation Archives, Merion, Pennsylvania.

38. Henry Clifford, "The Earl Horter Collection," press release for the exhibition, Pennsylvania Museum of Art (February 17–March 13, 1934), PMAA. Clifford states that eleven African pieces were included in the exhibition, but all other documentation indicates the

number was nine.

39. Henry Clifford, "The White Collection," *The Pennsylvania Museum Bulletin*, vol. 29, no. 159 (January 1934), p. 33.

40. In March 1934, Barr wrote to Sweeney about the proposed exhibition, asking, "Have you considered writing a list of masterpieces which we would almost certainly want in the exhibition?" Barr to Sweeney, March 20, 1934. Correspondence regarding *African Negro Art*, Registrar's Office, The Museum of Modern Art, New York.

41. Sweeney's requests for loans to the exhibition often made reference to a reproduction of the desired object in extant books or catalogues, most frequently referring to the catalogue of the 1930 exhibition at the Galerie Pigalle in Paris, *Exposition d'art africain et d'art océanien*, but also mentioning Nancy Cunard's *Negro* (London: Wishart & Company, 1934), and Eckart von Sydow's *Primitive Kunst und Psychoanalyse: Eine Studie über die sexuelle Grundlage der bildenden Künste der Naturvölker* (Leipzig, Vienna, and Zurich: Internationaler Psychoanalytischer Verlag, 1927). Correspondence regarding *African Negro Art*, 1935, Registrar's Office, The Museum of Modern Art, New York.

42. In an undated (1935) letter to Alfred Barr, Horter wrote: "Your letter before me—concerning a Negro mask . . . I sold one to Carroll Tyson a couple of years ago—one with a bird perched on the head—a very fine one. It may be the one you think of." Correspondence regarding *African Negro Art*, 1935, Registrar's Office, The Museum of Modern Art, New York.

43. See cat. no. 32, "Mask, Coll. Earl Horter," and cat. no. 33, "Mask, Coll. Carroll S. Tyson, Jr.," in James Johnson Sweeney, *African Negro Art* (New York: The Museum of Modern Art, 1935). Albert Barnes was one of the first collectors Sweeney contacted, but he refused to lend any African works from his collection to the exhibition. Although Horter and Tyson were the only private collectors from the Philadelphia area who lent works to the exhibition, the University Museum sent several works from its extensive collection.

44. "Attendance," *The Bulletin of the Museum of Modern Art*, vol. 2, nos. 6–7 (March–April 1935).

45. *African Negro Art*, a photographic portfolio by Walker Evans, 1935. For a discussion of the Evans portfolio, see Virginia-Lee Webb, "Art as Information: The African Portfolios of Charles Sheeler and Walker Evans," *African Arts*, vol. 24, no. 1 (January 1991), pp. 56–63.

46. *African Negro Art*, a photographic portfolio by Walker Evans, 1935. See plate 29, "Mask surmounted by figure (Catalog no. 32)," and plate 30, "Same as plate 29. Profile view." Tyson's mask was also photographed in two views; see plates 34 and 35. The plate numbers in the portfolio are indexed with the object numbers in the catalogue of the same title, by James Johnson Sweeney (see note 43 above).

47. For works exhibited, see *African Art and Its Modern Derivatives* (January 6–31, 1936, Philadelphia Art Alliance), records of the Philadelphia Art Alliance, Department of Special Collections, Van Pelt–Dietrich Library Center, University of Pennsylvania.

48. Horter lent three paintings by Picasso and two by Braque to this exhibition, but there is no documen-

tation showing that he also lent African art from his collection. Reviews of the exhibition include reproductions of African works from the collections of Edith Isaacs and George Gershwin but nothing from Horter's collection. See, for example, Isabel Herdle, "African Negro Art Opens Gallery's April Exhibit," *Democrat and Chronicle* (Rochester, New York), April 5, 1936; "African Negro Art," *Gallery Notes [Rochester Memorial Art Gallery]*, April 1936; and Isabel Herdle, "Study in Both Ethnology and Arts Offered at African Exhibition," *Democrat and Chronicle*, April 12, 1936.

49. Receipt no. 2050 from the Pennsylvania Museum of Art, dated August 6, 1936. Based on the descriptions on the receipt, I have identified the works as the Bamana mask, Kota reliquary guardian figure, Guro mask, Dan mask, Baule figure, and Shona-Tsonga headrest in Horter's collection.

50. Horter to Alfred Barr, undated correspondence regarding *African Negro Art*, 1935, Registrar's Office, The Museum of Modern Art, New York.

51. David Crownover, "Ancient and Primitive Art in Philadelphia Collections," *Expedition*, vol. 1, no. 4 (Summer 1959), pp. 19–21.

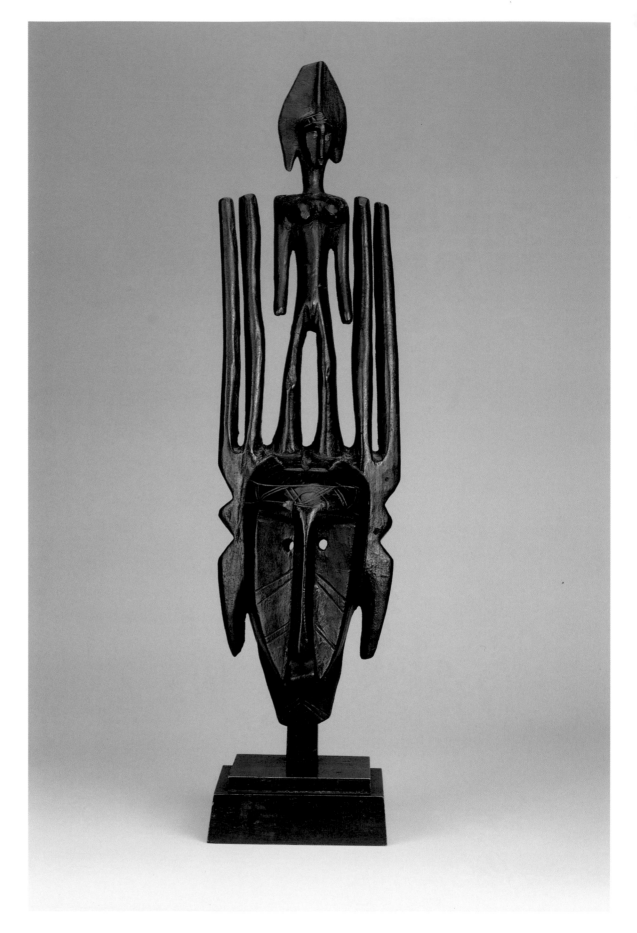

PLATE 87
Bamana peoples, Mali
**Face Mask*
Wood, height 25 inches (63.5 cm),
Inagaki base

Private collection

PROVENANCE: Paul Guillaume, Paris;
Earl Horter, Philadelphia, by 1929/30 to
1940; Elizabeth Lentz Horter, Philadelphia,
1940 to 1985; estate of Elizabeth Lentz
Horter, 1985; Sotheby's, Arcade Auctions,
New York, "Tribal Furniture, Utilitarian and
Decorative Objects, Oceanic, African,
American Indian, and Pre-Columbian
Works of Art," November 16, 1985, lot 381.

EXHIBITION: The Museum of Modern Art,
New York, *African Negro Art*, March 18–
May 19, 1935, no. 32.

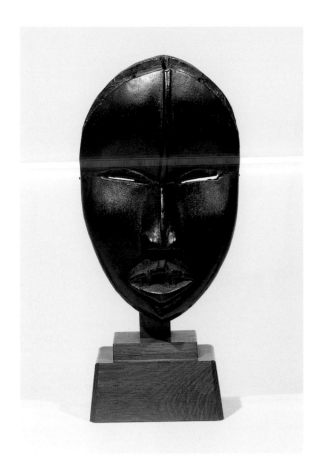

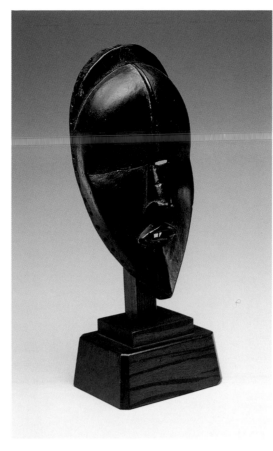

PLATE 88
**Dan peoples,
Liberia and Ivory Coast**
Face Mask
Wood and metal, height 9⅝ inches
(24.4 cm), Inagaki base

Collection of Arnold and Lucille
Alderman

PROVENANCE: Earl Horter, Philadelphia,
to 1940; Elizabeth Lentz Horter,
Philadelphia, 1940 to 1985; estate
of Elizabeth Lentz Horter, 1985; Sotheby's,
New York, "Important Tribal Art Including
African, Oceanic, and American Indian
Art," November 15–16, 1985, lot 64.

PLATE 89
**Dan peoples,
Liberia and Ivory Coast**
Face Mask
Wood, height 8½ inches (21.5 cm),
Inagaki base

Private collection

PROVENANCE: Paul Guillaume, Paris;
Earl Horter, Philadelphia, by 1929/30 to
1940; Elizabeth Lentz Horter, Philadelphia,
1940 to 1985; estate of Elizabeth Lentz
Horter, 1985; Sotheby's, New York,
"Important Tribal Art Including African,
Oceanic, and American Indian Art,"
November 15–16, 1985, lot 65.

PLATE 90
**Dan peoples,
Liberia and Ivory Coast**
Face Mask
Wood, height 9½ inches (23 cm),
Inagaki base

Collection of Paula K. Muller

PROVENANCE: Paul Guillaume, Paris;
Earl Horter, Philadelphia, by 1929/30 to
1937; Helen Lloyd Horter (later Helen
Kelly, Harvey Cedars, New Jersey), 1937.

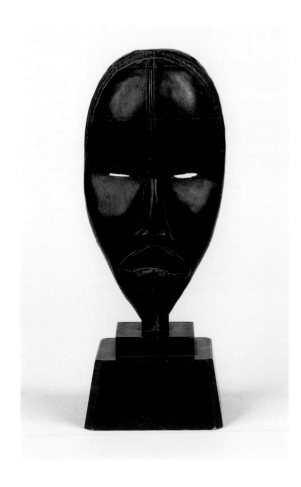

PLATE 91

Guro peoples, Ivory Coast
Face Mask
Wood, height 14⅛ inches (35.9 cm),
Inagaki base

Collection of Arnold and Lucille
Alderman

PROVENANCE: Paul Guillaume, Paris;
Earl Horter, Philadelphia, by 1929/30 to
1940; Elizabeth Lentz Horter, Philadelphia,
1940 to 1985; estate of Elizabeth Lentz
Horter, 1985; Sotheby's, New York,
"Important Tribal Art Including African,
Oceanic, and American Indian Art,"
November 15–16, 1985, lot 66.

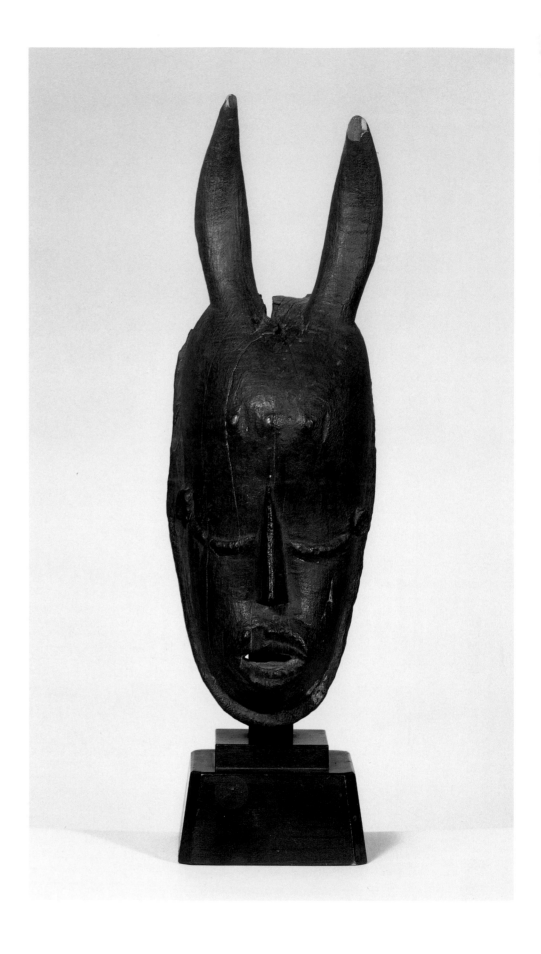

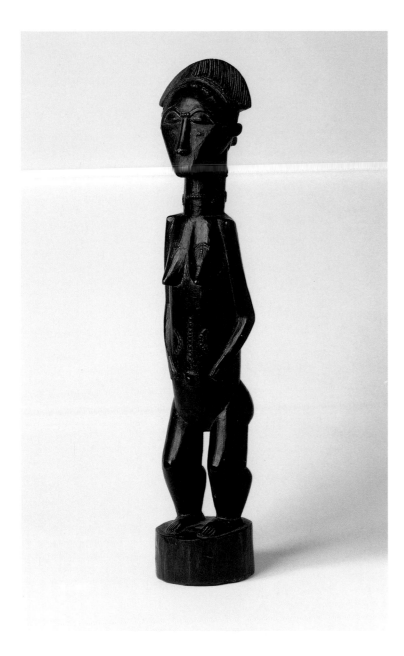

PLATE 92
Baule peoples, Ivory Coast
Female Figure
Wood, height 15 ¼ inches (38.8 cm)

Collection of Paula K. Muller

PROVENANCE: Earl Horter, Philadelphia,
to 1937; Helen Lloyd Horter (later Helen
Kelly Horter Coh...... 1......]i 1933.

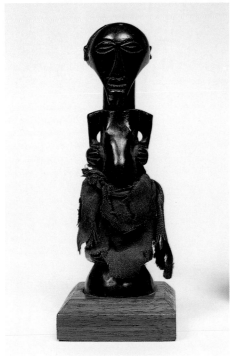

PLATE 93
**Songye peoples, Democratic
Republic of the Congo**
Male Figure
Wood and cloth, height 6 inches
(15.3 cm)

Collection of Charles and Blanche Derby

PROVENANCE: Earl Horter, Philadelphia,
1920s(?) to 1940; Elizabeth Lentz Horter,
Philadelphia, 1940 to 1985; estate of
Elizabeth Lentz Horter, 1985; Sotheby's,
Arcade Auctions, New York, "Tribal
Furniture, Utilitarian and Decorative
Objects, Oceanic, African, American
Indian, and Pre-Columbian Works of Art,"
November 16, 1985, lot 397.

PLATE 94
Kota peoples, Gabon
Reliquary Guardian Figure
Wood and brass, height 23¼ inches
(59.1 cm), Inagaki base

Collection of Robert C. Larson

PROVENANCE: Paul Guillaume, Paris; Earl
Horter, Philadelphia, by 1929/30 to 1940;
Elizabeth Lentz Horter, Philadelphia, 1940 to
1985; estate of Elizabeth Lentz Horter, 1985;
Sotheby's, New York, "Important Tribal Art,"
November 18, 1986, lot 67.

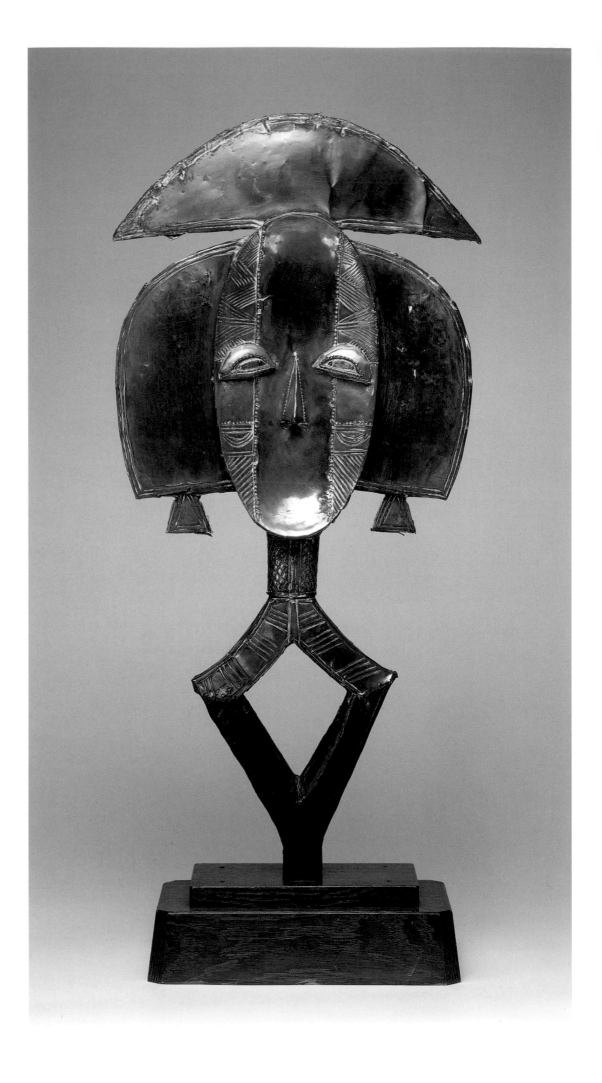

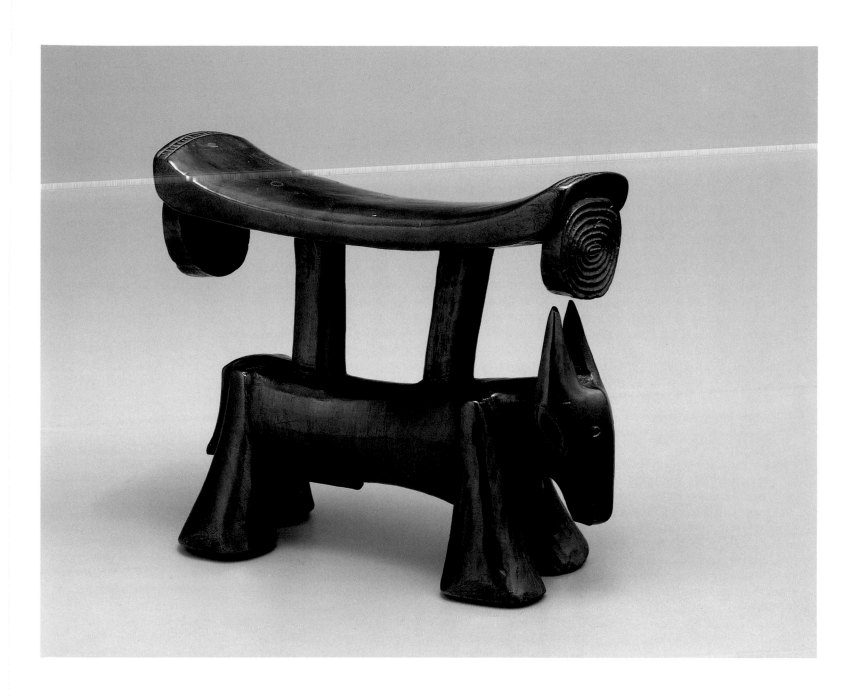

PLATE 95
**Southeastern Shona-Tsonga, Zimbabwe
and Mozambique**
Headrest
Wood, length 7½ inches (19.1 cm)

Collection of Pamela and Oliver E. Cobb

PROVENANCE: Earl Horter, Philadelphia, to
1940; Elizabeth Lentz Horter, Philadelphia, 1940
to 1985; estate of Elizabeth Lentz Horter, 1985;
Sotheby's, New York, "Important Tribal Art
Including African, Oceanic, and American Indian
Art," November 15–16, 1985, lot 128.

Fig. 70. The 1938 catalogue of Earl Horter's Native American collection: page 1 listing war bonnets and war shirts. Sixteen headdresses are described in this inventory, including two that belonged to Lakota Sioux chiefs Crazy Horse and Flatiron (war bonnets no. 3 and no. 14, respectively). Five war shirts, a dress, a vest, and a Ghost Dance shirt appear under the war shirt category. Values are listed to the right.

see live Indians. Former warriors—men who had fought the U.S. Army—were recruited from the reservations to reenact what they had actually done in the recent past. Even Sitting Bull joined *Buffalo Bill's Wild West* show for one season in 1885.

In the quotation by Horter above, he says that he was about eight years old when he saw the Buffalo Bill show. The show first came to Philadelphia in 1884, which is too early a date for Horter to have remembered it well (he would have been only four years old). The next time it was in the area was on July 19, 1888, in Bethlehem, Pennsylvania—moving on to Baltimore for its next engagement, possibly stopping in Philadelphia. It was not until 1895 that *Buffalo Bill's Wild West* revisited Philadelphia (the years 1889 to 1892 were spent in Europe), but between 1895 and 1899 the show played in Philadelphia every year

except 1897.[9] Horter could have seen *Buffalo Bill's Wild West* in 1888, or he may have seen it in the 1890s, when he would have been in his teens, not eight years old. Regardless of the age at which he saw it, the show's impact on Horter is important for understanding his collecting of Native American material.

If we follow the rest of Horter's statement—that after seeing *Buffalo Bill's Wild West* he began corresponding with traders, agents, and anyone who might have American Indian things—we must assume that he actively began searching Philadelphia for such material in the late 1890s, rummaging through curio shops, searching out collectors, and seeking out retired military men. In the late nineteenth century Philadelphia was home to a number of collectors and dealers of Native American material. Collections large and small had been assembled by adventur-

ers, travelers, and men who had served in the military or for various Indian-rights organizations that were based in Philadelphia. Probably the finest of these belonged to Charles H. Stephens, who was also an artist and an illustrator. His collection of about 1,500 Native American objects became part of the University Museum's collection and was meticulously catalogued by him on file cards with his own illustrations of the objects.[10]

The Collection

Earl Horter's widow commented on his American Indian collection in an interview in 1956, mentioning that "he'd been collecting these things since he was fourteen."[11] And according to an interview with Earl Horter late in his life, he "got himself a job as soon as he could ($3 a week on Arch st.) to buy a real war bonnet."[12]

The first Native American artifact Horter acquired that can be documented is a dance bustle, a feathered object worn on the lower back and tied around the waist that was a prominent feature of dancers participating in the Grass Dance, which, at the end of the nineteenth century, was performed by various Native American groups across the Plains. The bustle is listed in both the 1938 inventory and the 1939 inventory of Horter's collection. In the 1938 inventory the bustle is no. 40, described as "very old Sioux bustle—decorated feather ornamented pendent [sic]," bought in 1899 from "Benham Ind. T. Co." (presumably the Benham Indian Trading Company). The description matches no. 114 in the 1939 inventory of a "very old bustle—fine drab flap—bells + old bunches of hawk + prairie chicken pendents—obtained from Wm. Westover—1901—He was connected with Rodman Wanamaker and collected much for him 40 years ago—one of the best

bustles I've ever seen." Although the two numbers describe the same object, the differences in the descriptions, the two purchase dates given, and the mention of two of the participants in the Wanamaker expeditions[13] must be accounted for by the passage of nearly forty years before Horter wrote down his account.

To summarize, it can safely be said that shortly before he left Philadelphia for New York (around 1903), Horter bought a Native American object, a "Sioux dance bustle." Other than this, there is little that can be specified about the Native American artifacts collected by Horter in his early years in Philadelphia. The same can be said for his stay in New York, during which time Horter left no letters and no notations concerning his Native American collection or his collecting habits. It can be assumed that he kept up contacts with others who had Native

American material, both in and out of New York, but documentary evidence is lacking.

Horter returned to Philadelphia late in 1916 to begin working for N. W. Ayer and Son. Philadelphia had just lost George Heye's collection of Native American material (primarily Northeastern and Plains Indian), which had been on display at the University Museum since 1908. In 1917 the Museum of the American Indian, Heye Foundation (now the National Museum of the American Indian) was opened in New York.[14] The University Museum, however, had developed a major collection of Native American material (although with the removal of the Heye material a substantial gap was left in the Plains area), and the anthropology department of the University of Pennsylvania, under the direction of Frank Speck, also became a major force in the study of Native American cultures.

It is not known how Earl Horter became acquainted with Frank Speck, but he purchased at least one Native American artifact from him, a pipe bag (Speck financed most of his own fieldwork through the selling of such objects). It appears in the 1938 inventory as no. 66A, "All red quilled—very old—(Speck Col. Sioux)," and in the 1939 inventory as no. 269, "Sioux bag entirely quilled—very old piece—all red and yellow quills . . . (Speck Col.)."[15] Horter may also have purchased a Seneca corn-husk mask and turtle rattle from Speck.[16] These do not appear in either of the inventories, but they do appear in the lists of American Indian objects Elizabeth Lentz Horter made in her record book. Speck did a great deal of fieldwork among the Iroquois, of whom the Seneca are a part. The objects obtained from Frank Speck could have been purchased in either the 1920s or 1930s.

It was in the 1930s that Horter's Native American collection saw the greatest growth. At the outset of the decade Horter referred to his collection as "small," but that would soon change as he began contacting various museums to arrange exchanges, and dealers and collectors to purchase single pieces or whole collections.

The year 1932 may have been pivotal for Earl Horter's Native American collection. From January 5 through 24 the Philadelphia Art Alliance hosted the *Exposition of Indian Tribal Arts*, an exhibition devoted to Native American material in which the objects were selected, first and foremost, for their aesthetic qualities, the aim being to present them as *art*. The show included some 615 objects from museums and private collectors, both historic and contemporary pieces. John Sloan headed the private organization that sponsored the exhibition, which featured a veritable "who's who" of the art and anthropology worlds. The exposition opened in New York in November 1931, and response from the press was overwhelming. Horter served on the Philadelphia general committee for the exhibition. Following its New York run, when it opened at the Philadelphia Art Alliance, the entire gallery space was given over to its installation.

Contemporaneously with this exposition, in a gallery or galleries set apart, the Art Alliance . . . will dis-

play also, as a Memorial Exhibition, the extraordinary collection of Indian Arts, collected by the late Charles H. Stephens, of Rose Valley, Moylan.[17]

In one building was housed an incredible richness of Native American art, truly a feast for the eyes. To see great historic Native American pieces drawn from many museums together with the exquisite collection Stephens had been able to assemble must have been inspiring to Earl Horter. The seed of the idea for a museum of his own was probably planted at this time—an as yet only imagined museum for which he voraciously began to buy.

In April or early May of 1933, Horter, in a letter sent to the "curator of the department of the American Indian of the Natural History Museum" (the American Museum of Natural History, New York), does, in fact, refer to his collection as a museum: "My home is really a museum for students and artists." He writes: "Could you let me know if in the many donations you have of Indian curios you have duplicates that you would be willing *to sell me* [Horter's emphasis]—I want feathered work of Sioux and the Plains Indians—hed [sic] gears—shields—ornaments. . . . Already I have quite a good small collection."[18] The response came in a letter from Clark Wissler, the curator, dated May 8: "We have your request for duplicates of our American Indian collections, but it so happens that we have no material for sale, and so cannot assist you."[19]

After being turned down by Wissler, Horter changed his tactics. Rather than offering to buy duplicate material from museums, he began to suggest exchanges from his own collection. He initiated the first of these with the University Museum. Horter's connection to the museum is unclear. He does not appear on any of the member lists. He did, however, know people at the museum. Horace Jayne, the director, had served with Horter in 1932 on the committee for the Philadelphia showing of the *Exposition of Indian Tribal Arts*; J. Alden Mason, the curator of the American section, had attended grammar school with Horter in Germantown; and Horter's second wife, Elizabeth, was hired by Jayne in 1930 (the year she and Horter divorced) as a docent at the museum. In various letters that span the months from May

through September of 1934, Horter negotiated the exchange of an Early Roman head for Native American pieces. Discussions must have begun earlier, for in an undated letter (before May 8, 1934) to Horace Jayne, Horter wrote:

I would like to get the matter of A TRADE [Horter's emphasis] *settled as soon as possible and am leaving town for the Summer. If you are not interested in the Early Roman Head I will come and take it away—but I believe it is a fine one and if we do make a trade the Museum will eventually get my Indian material which contains some really extraordinary pieces.*[20]

A series of letters between Horter and Jayne ensued. Jayne makes excuses for the delay in the trade, and Horter appears at the museum one day to reclaim the head and presses to have the matter resolved. Horter must have left town for the summer, as he mentioned, and the matter of the trade was put on hold. When he returned in the fall, Horter again wrote to Jayne:

I am bothering you again—in hopes—I am going to New York in a week. If you can do nothing to effect the trade by then, allright, otherwise am taking the head to the Brooklyn Museum—they seem willing to negotiate. Hope you can do something about it.[21]

This tactic—not just to take the head back but to go to another museum—worked. The trade was effected September 22, 1934. For his Roman head Horter received a Lakota Sioux headdress and a Lakota Sioux ceremonial shield.[22] The headdress appears in the 1938 inventory as no. 4, "Tribe uncertain—horned bonnet . . . ," and on the 1939 inventory as no. 214, "old Sioux horned bonnet . . . a very fine piece." The shield is no. 35 in the 1938 inventory, "old ceremonial shield . . . dec red flannel small fea.—birds etc drawn on cover," and no. 11 in that of 1939, "Shield—thin hide—hoop around disk—moon stars birds etc painted on cover—remnants of red flannel." Again, the inconsistency between the 1938 and 1939 inventories is apparent. The information received from the University Museum regarding the two objects listed them both as "Sioux," a designation that does not appear on the 1938 inventory.

While the exchange between Earl Horter and the University Museum was being played

out over many months, Horter, in the course of a few days at the end of May 1934, completed two exchanges with George Heye at the Museum of the American Indian, Heye Foundation, in New York. Horter traded a Hunkpapa Lakota Ghost Dance shirt and a Tlingit pipe bowl (pl. 106) for an Osage roach, a headdress made of dyed porcupine hair that covers the head from the forehead to the nape of the neck (the effect is that of a "mohawk" haircut). The roach appears on the 1938 inventory (schedule 1) as no. 56, "purple roach (Heye Col)—very fine one," and, confusingly, in the 1939 inventory as no. 127, "one green + red hair roach obtained from Geo Heye in a trade."

The other exchange that Horter effected with George Heye that May was the trade of a group of fifteen artifacts, fourteen of them from the Spiro archaeological site in Oklahoma, for a shield. The shield appears in the 1938 inventory as no. 25, "very old shrunken hide shield—with human scalp suspended (Heye Col.)," and in the 1939 inventory as no. 1, "Dark shield of shrunken Buffalo Hide—very old—no decoration—shoulder strap—obtained from Mr. Heye of the Heye Foundation."[23]

Although Earl Horter never traveled farther west than Chicago, in his search for Native American material he was in touch with people around the country.[24] Frank Speck had put him in contact with at least two: David Rodnick, who was working among the Assiniboine in Montana and from whom Horter may have purchased a drum (Rodnick asked if Horter could wire money[25]), and M. Selleck of C and B Traders of Lincoln, Nebraska, who offered Horter two shields.[26] He purchased a least one of them. It appears as no. 37C in the 1938 inventory, "old buffalo hide shield covers." Horter also purchased two shields from R. B. Bernard in Oakland, California; these appear in the 1939 inventory as nos. 7 and 8.[27]

Horter was also buying Native American material from local sources. An especially beautiful object purchased sometime after 1931 is a Maliseet wampum belt (pl. 105). The belt had belonged to George Emlen Starr, the remainder of whose Native American collection was purchased by the University Museum.[28] Horter also bought the collec-

tions of John L. Craig and Col. Henry Paxson of Bucks County.[29] Paxson served with Horter in 1932 on the local committee for the *Exposition of Indian Tribal Arts*, and a number of Horter's artist and collector friends from the modern art scene served on the same committee, including Arthur B. Carles, Carroll S. Tyson, Jr., George Howe, Paul Cret, Adolphe Borie, Maurice Speiser, Samuel and Vera White, and R. Sturgis Ingersoll. The artists Thornton Oakley, Henry McCarter, N. C. Wyeth, and Charles Demuth were also members. With the exception of his close friend Carles, from whom Horter received at least two objects (a Cheyenne shield, no. 36 on the 1938 inventory, and a bear-claw necklace, no. 196 on the 1939 inventory), whether any of the others owned Native American material is not known. If so, they probably owned only a few objects—certainly nothing on the scale of Horter's collection.[30]

Conspicuously missing from the committee was Robert Riggs, another artist and illustrator who had a large collection of Native American artifacts. Horter may have encouraged Riggs to begin collecting such objects during their early days working together at N. W. Ayer and Son. They were friends but also competitors when it came to American Indian material ("collector-enemies," as it were).[31] Riggs's name does not appear on either of Horter's inventories as someone with whom he traded.

The last few years of the 1930s continued to be prolific buying years for Horter. With money generally tight during that decade, many institutions could not afford to purchase individual items, nor collections. The reminiscences of E. K. Burnett of the Heye Foundation recount:

As far as important auction sales in the East were concerned, it was never too difficult for Joe Spinden at Brooklyn, Clark Wissler at the American Museum, Alden Mason at the University Museum in Philadelphia, and Heye's representative to get together before the sale and arrange not to bid against each other on certain objects which each respectively wanted to acquire. But some time late in the Thirties a strange fish began to ruffle the placid waters of this friendly pond, and the museum representatives began to look at each other in agonized horror. The stranger was Earl Horter. Now, Earl was a swell

chap. . . . Earl became interested in making an Indian collection, and in his early days Heye sold him several pieces of one type of Plains material or another. Horter turned out to be an auctioneer's delight: one of those enthusiastic individuals, who had means, and who simply would not be outbid for any piece which had struck his fancy. Horter used to get so excited at sales that he'd raise his own bids. I remember one sale in Philadelphia where he had three representatives buying material for him, and he was bidding against them![32]

It is known that in 1938 Horter purchased a number of objects from the M. William Bradley collection, which went on the auction block in Philadelphia on November 21, 1938.[33] This may be the auction described in the quotation above. The Bradley collection consisted primarily of Plains Indian artifacts—shields, headdresses, war shirts, tomahawks, and clubs—in addition to other arms and armor from around the world (not an unusual grouping for collections at this time, especially those made by military men). The items purchased from the Bradley sale appear in Horter's 1939 inventory and include two shields (fig. 72 shows one of them; it is listed in the 1939 inventory as no. 9, "Apache shield").[34]

Another collection that became available in 1938 was that assembled by Amos Gottschall, who traveled extensively in the North American West between 1871 and 1902. He divided his collection into three parts. Parts one and two were given to the Academy of Natural Sciences, Philadelphia, and came to the University Museum in 1937. Part three remained in storage in Harrisburg until 1938, when it was sold by Gottschall's widow to Ira Reed, a dealer from Perkasie, Pennsylvania.[35] Whether Horter bought any material from this collection is not known, but probably he did. This was a large body of material that entered the market when Horter was collecting avidly, and Ira Reed no doubt knew Earl Horter.

Horter apparently added significantly to his Native American collection in 1939, the year before his death. Between the 1938 and 1939 inventories there is a marked increase, for example, in the number of shields and war bonnets: fourteen new shields and six new bonnets. At $150 to $250 dollars apiece, the total price of his new acquisitions is

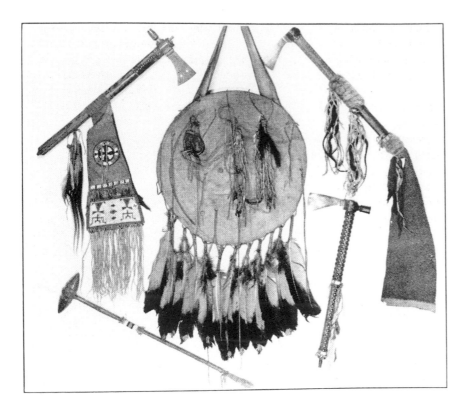

substantial for this time period. Horter also purchased at least one more war shirt and a bustle.

Horter was so interested in shields that he again wrote about them to Clark Wissler at the American Museum of Natural History sometime in July of 1939. In the letter Horter asks specifically for information about Plains shields and mentions the ones that he owns (see pls. 100 and 101).

There seems to be little written on this fascinating subject. . . . There are about eight fine buffalo hide shields in my col. . . . I want to cover this subject completely. I have sources—always on the lookout for a good old shield but they are getting very scarce.[36]

This extravagant buying was set against the backdrop of Horter's perpetual lack of funds. As Horter admitted to Wissler in 1939, "collecting Indian material has long been a real obsession."[37] His obsession lead Horter to purchase material even if he did not have the funds. This became most apparent in his dealings with the San Diego dealer Madge Hardin Walters, from whom Horter purchased a number of objects.[38] Over the course of 1939 Horter bought a shield (no. 5

on the 1939 inventory), four tomahawks (nos. 242, 243, 247, 248), and four headdresses (nos. 223—26). He paid for these in installments over the course of that year, straining their relationship. Walters wrote to Horter:

I am so glad you will have these things. I have entirely exhausted my [her emphasis] savings account, but you will understand, I know, why I cannot refuse anything. . . . Am very grateful to you for your help and anything you can send will fly to Canada, whether we have food or not.[39]

And later:

As I wrote you, I have not been able to pay for either of the headdresses you have, and it is now entirely too late to return them. Besides, the credit I have made such sacrifices to establish, is rapidly melting.[40]

Considering that Horter purchased fourteen shields in 1939 alone (only one of those from Walters), it is easy to understand why he could send Walters only $25, $40, or $60 at a time. In a later, more conciliatory letter she wrote:

I understand too well the difficulty of juggling a dozen

balls in the air at a time; of wanting things irresistibly and then doing an amazing balancing act to add one more to obligations. I know about it so well that I have a calm assurance that you'll do it. . . . Doubtless that sounds very mixed, but I mean that I appreciate your difficulties and know that you are doing the very best you can. I have the constant experience of many urgent demands on a too-small income.[41]

The most interesting aspect of these letters is the philosophical discussion between Horter and Walters about the reasons for collecting. The collector's "need" to acquire, which Horter no doubt expressed in his letters, is captured beautifully in Walters's responses to Horter.

Beginning with the last remark of your delightful letter about the insatiable "wants" of an Indian collector, I think it is at least partly due to the breathless feeling of haste we have, knowing that the source and background of the old articles is gone and it is only the occasional bit, like leaves in an eddy, that one can snatch and rescue.[42]

And later:

Of course, I'm immensely interested in the things you want, for "wants" are the breath of life to a collector,

and when I stop longing to collect, I may as well be
dead. Your wants interests me in many ways.[43]

The "need" to collect and Horter's specific
"wants" were beginning to crystallize into a
plan for a museum. The idea planted in
Horter's mind years earlier was now devel-
oping. In a number of letters Walters men-
tions that she is very interested in the
projected museum and offers to help Horter
in any way she can by providing objects,
including some Northwest Coast pieces she
purchased in Vancouver, "but didn't know if
you were interested in any but Plains."[44]
None of this came to pass, as Horter died on
March 29, 1940, two months after he
received his last letter from Walters.

The Collection Dispersed

In May 1940, Earl Horter's widow, Elizabeth
Lentz Horter, decided to put the Native
American collection on the market. Unfor-
tunately, she decided to do so privately
rather than publicly at auction, which gener-
ated fewer records for posterity. In at least
two instances she contacted museum cura-
tors announcing the sale. The first to be con-
tacted was Clark Wissler at the American
Museum of Natural History in New York. The
second was J. Alden Mason at the University
Museum in Philadelphia. Wissler replied that
he was in no position to purchase anything.
Mason's reply stated that he would send H.
Newell Wardle, the keeper of the American
section at the University Museum, to see the
collection on the appointed Saturday. No
purchases were made.

It is not known how many other people
were contacted about the sale of the collec-
tion. E. K. Burnett of the Heye Foundation
reports that he was ordered by George
Heye, who had just heard of Earl Horter's
death, to go to Philadelphia: "Now I want
you to drop everything, Ken, get over to
Germantown, see Mrs. Horter, give her
Treatment 19 with all the fringes, and let's
see what we can make out of this."

*Some two or three weeks after the funeral, Mrs.
Horter . . . wrote us saying that her late husband had
been so fond of Dr. Heye and Mr. Burnett that she
wanted to give them first opportunity to look over his
collection before she allowed other people to see it.*[45]

According to Burnett, he and George Heye
drove to Philadelphia with a list and loaded
up the back of the car, purchasing Horter's
tent back sheet, pipe tomahawk, club,
another tomahawk, and more (pls. 96, 97,
99, and 104, respectively).[46]

Locally, private collectors and dealers were
probably contacted by Mrs. Horter. Robert
Riggs purchased some Native American
material.[47] At this time George Green, Jr., of
New Jersey, may have purchased at least one
piece, a Plains Indian scalp lock.[48] The
Perkasie dealer Ira Reed also may have pur-
chased pieces from the Horter collection.

New York art dealer Pierre Matisse saw
Horter's Native American collection in the
summer of 1941 and wrote to Mrs. Horter:

*I . . . want to thank you for the trouble you took to
explain the Indian things to me. I am still enchanted
with the Deer Mane headdress and will try to do
something with them.*[49]

How many objects were sold during this ini-
tial dispersal of the collection is not known.
A substantial number of pieces must have
remained, however, for in 1956 the follow-
ing interview with Elizabeth Lentz Horter in
the *Germantown Courier* stated:

*The Horter collection, which is extensive enough to
start a small museum, is held in rather light regard
by Mrs. Horter. Few of the treasures are on display.
Most of them are stuffed away in bureaus and chests
in the attic. "They're great dust collectors," says Mrs.
Horter. "I keep them largely because my husband was
so fond of them."*[50]

The eight photographs accompanying the
article show some of the types of objects
the collection included: pipe bags, shields,
clubs, moccasins, necklaces, and a war shirt
and war bonnet.

The record book belonging to Elizabeth
Lentz Horter indicates that in 1964 she sold
a number of objects (at least sixty-three) to
individuals: about thirty-nine objects to
William Guthman, a dealer, in three
batches; eleven objects to M. Richard Miller;
at least eight objects to C. Haushauer; four
objects to Jolyon Sprowles; and three
objects to Landis Smith.[51] She also sold eight
objects to the State Museum of Pennsylvania

in Harrisburg that same year (see pls. 102,
103, and 105).[52] In addition, a medicine
pouch passed from Mrs. Horter to Shirley
Woodward, who in turn gave it to the
Smithsonian Institution (it appears to
have been a Crow Tobacco Society bag).

The same record book contains two differ-
ent lists of objects, one of 48 pieces, and the
other of 111 pieces. More pieces must have
been sold between 1964 and 1985, when
Elizabeth Lentz Horter died, for those that
passed to her family do not approach the
total of 159 objects contained in the record-
book lists. After her death, sixteen objects
were sold at Sotheby's in New York in
November 1985.[53] Another group of artifacts
was sold to private dealers.

Had Earl Horter diligently kept records of his
collection, or had Mrs. Horter sold the col-
lection publicly at auction, we would know
its size and extent and perhaps would be able
to trace the pieces. Only a handful of objects
are traceable, primarily those in public col-
lections. Most of Earl Horter's Native
American collection has vanished—vanished
so completely that only fifty-five years after
Horter's death John Ewers, the authority on
Plains Indian art and its collectors for the last
half of this century, remarked that he had
never heard of a Horter collection. The
thoughts about collecting that Madge Hardin
Walters expressed to Earl Horter in a letter in
1939 can be applied just as readily to Horter's
collection: ". . . and it is only the occasional
bit, like leaves in an eddy, that one can
snatch and rescue."[54]

Notes

1. Objects are listed with the name Madge Hardin Walters, a California dealer, as the source in the undated inventory, and it is known that Horter purchased objects from her in 1939. The two inventories are part of the Earl Horter papers, PMAA.

2. A note on the 1938 inventory states that the number assigned each object was written on that object in black ink. This is borne out by a shield that appears as no. 35 on the inventory and that carries such a number; this shield was part of an exchange with the University Museum in 1934 and has returned to the collections of the museum (now known as the University of Pennsylvania Museum of Archaeology and Anthropology).

3. Elizabeth Lentz Horter record book, private collection.

4. Earl Horter papers, PMAA. Horter's letters to Walters have not been located.

5. R. Sturgis Ingersoll, *Recollections of a Philadelphian at Eighty* (Philadelphia: National Publishing Company, 1971), p. 91.

6. "Picasso—And Sitting Bull," *Philadelphia Record*, April 9, 1938.

7. "Lakota" is the name by which the Teton or Western Sioux refer to themselves. It means "allies" or "friends" and encompasses the seven divisions that comprise the Western Sioux: Oglala, Sicangu, Hunkpapa, Miniconjou, Sihasapa, Oohenonpa, and Itazipco. William Cody got the name Buffalo Bill in 1867–68 when he was under contract to supply buffalo meat for the construction workers on the Union Pacific Railroad.

8. See Don Russell, *The Wild West: or A History of the Wild West Shows* (Fort Worth, Texas: Amon Carter Museum of Western Art, 1970), p. 100. As Buffalo Bill began touring his *Wild West* show around the country, a series of dime novels with Buffalo Bill as the hero began to be published (1,700 issues containing some 557 original stories). The novels, in fact, prepared the way for the appearance of Buffalo Bill and his *Wild West* cast—the dime novel hero come to life.

9. The show came through Philadelphia on the following dates: April 22–May 4, 1895; April 18–25, 1896; May 2–7, 1898; and May 29–June 3, 1899.

10. The Stephens collection, formed over the course of four decades (1890–1930), was purchased in 1945 after being on loan for a number of years. Whether Horter knew Stephens is not known, but it seems likely that he did. Both Horter and Stephens were artists and probably moved in the same circles. Stephens lent material from his collection to his friends Howard Pyle, Frederic Remington, and N. C. Wyeth to use as "props" in their paintings, and he was married to another Philadelphia artist, Alice Barber.

11. Blanche Day, "Heap Big Indian Collection," *Germantown Courier* (Philadelphia), vol. 20, no. 48 (November 1, 1956).

12. "Picasso—And Sitting Bull," 1938.

13. Both John Wanamaker and his son Rodman were involved in Native American affairs. John Wanamaker provided funds to the University Museum for the purchase of American Indian collections such as the Thomas Donaldson collection in 1901. He was also the financial backer for Stewart Culin's collecting expeditions in the West for the museum in 1900 and 1901. Both Benham and Westover were involved in these expeditions. Rodman Wanamaker financed three expeditions to the West in 1908, 1909, and 1913, led by Joseph K. Dixon, which documented native peoples of the Great Plains in photographs and in film. The photographs were published in 1914 by Dixon under the title *The Vanishing Race* (Philadelphia, 1914). Both Wanamakers also collected Native American material, displaying it in the executive offices of the John Wanamaker department store.

14. For a history of the Heye collection in Philadelphia, see Eleanor King and Bryce Little, "George Byron Gordon and the Early Development of The University Museum," in the exhibition catalogue *Raven's Journey* (Philadelphia: The University of Pennsylvania Museum, 1986). When George Heye's collection was located in Philadelphia it was known simply as the "The Heye Collection." After his museum was incorporated and opened in New York in 1917, its official title became the Museum of the American Indian, Heye Foundation, and since that time it has been referred to by the whole title or by one part of the title: "Museum of the American Indian" or "Heye Foundation." The collections of the foundation were transferred to the Smithsonian Institution in November 1989, becoming the National Museum of the American Indian, which will open on the Mall in Washington, D.C., in 2002, with parts of the collection still housed in the George Gustav Heye Center in New York.

15. The original label in Speck's handwriting is extant and states that the bag was obtained from a collection made before 1870, courtesy of Paula Kelly Muller.

16. The turtle rattle is probably one located at the State Museum of Pennsylvania in Harrisburg (inv. no. E64.1.4). The objects were used in the curing rites of the False Face Society of the Iroquois.

17. Philadelphia Art Alliance, *Exposition of Indian Tribal Arts*, January 5–24, 1932.

18. Horter to Clark Wissler, undated, Clark Wissler papers, Anthropology Department, American Museum of Natural History, New York. Horter's characterization of his collection as small is confirmed by the recollections of Albert Gold, a student of his who saw the collection in Horter's Delancey Street house (letter from Albert Gold to the author, May 1, 1998).

19. Wissler to Horter, May 8, 1933, Clark Wissler papers, Anthropology Department, American Museum of Natural History, New York.

20. Horter to Jayne, undated, University of Pennsylvania Museum Archives, Philadelphia, Office of the Director.

21. Horter to Jayne, September 11, 1934, University of Pennsylvania Museum Archives, Philadelphia, Office of the Director. A search of the Brooklyn Museum's archives revealed no letters from Horter proposing any exchanges.

22. The Roman head has since been identified as Cypriot (first century B.C.), University of Pennsylvania Museum (34-23-1). The shield is also now at the University Museum (NA 5446), but it is not known how or when it was returned.

23. Two receipts, dated May 1934, Archives of the National Museum of the American Indian, New York, Records of Gifts, Loans and Exchanges. In the 1938 inventory (schedule 1) no. 62 is a "Sioux hair ornament (Heye)—beaded strip mirror feathered quill medallion." The inclusion of Heye's name suggests that other transactions occurred between Horter and Heye; this is borne out by a comment in reminiscences recorded by E. K. Burnett, an associate of Heye and former director of the Museum of the American Indian, Heye Foundation, to the effect that in his early days Heye sold several pieces of Plains material to Horter (E. K. Burnett transcript, Archives of the National Museum of the American Indian, New York). However, there are no records at the National Museum of the American Indian to substantiate this.

24. According to Elizabeth Lentz Horter in her interview with Blanche Day, "Heap Big Indian Collection," 1956.

25. Rodnick to Horter, June 27, 1935, courtesy of Paula Kelly Muller.

26. Selleck to Horter, undated, courtesy of Paula Kelly Muller.

27. Bernard to Horter, June 24, 1935, courtesy of Paula Kelly Muller.

28. Starr's collection was on deposit at the University Museum from 1897 until 1911, when it was removed by the owner after the museum refused to purchase it. In 1931 Starr was approached by the museum and asked if he would lend the collection to the museum, possibly to be purchased. The collection was lent in June and purchased in July. The wampum belt, however, was treated separately, and the museum did not buy it. The correspondence relating to these transactions is in the University of Pennsylvania Museum Archives, Philadelphia, Administrative Records, Curatorial, American Section.

29. Paxson's collection was labeled with rectangular red labels stamped "Col. Henry D Paxson Collection," and each object was numbered. Some of these labels contain information that was never included in Horter's inventories, such as the collector from whom Paxson received the object. It is nearly impossible to match the labels to their respective objects. Courtesy of Paula Kelly Muller.

30. N. C. Wyeth had a few pieces of beadwork that he obtained on various trips.

31. As stated in correspondence from Albert Gold (a student of Horter's) to the author, May 1, 1998.

32. E. K. Burnett transcript, Archives of the National Museum of the American Indian, New York.

33. Samuel T. Freeman and Company, Philadelphia, *Catalogue of the M. William Bradley Collection*, November 21, 1938. A copy of the catalogue with margin check marks and comments such as "good" and "bid" and the name "Riggs" written next to some objects—all in Horter's handwriting—is in a private collection.

34. The shield is listed in the Bradley sales catalogue (see note 33 above) as lot 143, "Comanche shield, very rare and fine."

35. University of Pennsylvania Museum Archives, Philadelphia, Administrative Records, Curatorial, American Section, Gottschall Collection. Reed proba-

bly purchased the collection together with another person named Morley. The collection became known as the "Morley Reed Gottschall Collection."

36. Horter to Wissler, Clark Wissler papers, Anthropology Department, American Museum of Natural History, New York.

37. Horter to Wissler, Clark Wissler papers, Anthropology Department, American Museum of Natural History, New York.

38. Walters had connections with George Heye, the Denver Art Museum, and the Southwest Museum in Los Angeles. Her material came primarily from the Blackfeet in Alberta, Canada.

39. Walters to Horter, March 14, 1939, Earl Horter papers, PMAA.

40. Walters to Horter, June 15, 1939, Earl Horter papers, PMAA.

41. Walters to Horter, January 29, 1940, Earl Horter papers, PMAA.

42. Walters to Horter, February 7, 1939, Earl Horter papers, PMAA.

43. Walters to Horter, August 12, 1939, Earl Horter papers, PMAA.

44. Walters to Horter, September 16, 1939, Earl Horter papers, PMAA.

45. E. K. Burnett transcript, Archives of the National Museum of the American Indian, New York.

46. The accessioned pieces from Horter's collection that entered the Heye collection in 1940 number eleven (nos. 20/1983–88 and 20/1990–94). The account by Burnett, however, seems to suggest that many more pieces were obtained. Records at the National Museum of the American Indian, New York, do not substantiate this.

47. Isa Burnett, Philadelphia artist and friend of Riggs, said that part of Horter's collection went to Riggs. Two duplicate lists of objects exist in the Horter papers at the Philadelphia Museum of Art. At the bottom of one is written "Mr. R. Riggs," and at the bottom of the other, after listing three shields, is the note "taken on approval." These are probably pieces Riggs purchased after Horter's death. Given Horter's obsession with shields, he probably did not part with them during his lifetime.

48. The scalp lock appears as lot 178 in the catalogue of the sale of the Green collection at the Parke-Bernet Galleries, New York, November 19, 1971. The Green collection was begun by George Green, Jr.'s father, Col. George Green, about 1870. Three generations of the family owned the collection in turn, including George Green, Jr.'s children. The catalogue of the sale of the collection lists twelve pieces that had been in Earl Horter's collection: one piece that came directly from the collection, and eleven pieces that came from Horter via the collection of Walter Chattin, a Philadelphia dealer. Green also bought at Freeman's auction house in 1938 from both the Bradley (Plains material) and Peirson (basketry) collections.

49. Pierre Matisse to Elizabeth Lentz Horter, November 8, 1941, Earl Horter papers, PMAA. The headdress in question appears on schedule 1 of the 1938 inventory, where it is listed as a piece from the Southwest. The archives of the Pierre Matisse Foundation contain no record of this piece being sold through the Matisse Gallery.

50. Day, "Heap Big Indian Collection," 1956.

51. Elizabeth Lentz Horter record book, private collection.

52. The objects bear the accession numbers E64.23.1–8.

53. Auction catalogues, Sotheby's, New York, November 11, 1985, lots 141 and 142; November 15 and 16, 1985, lots 164 and 188. The other objects sold at Sotheby's, Arcade Auction, November 16, 1985, lot 445.

54. Walters to Horter, February 7, 1939, Earl Horter papers, PMAA.

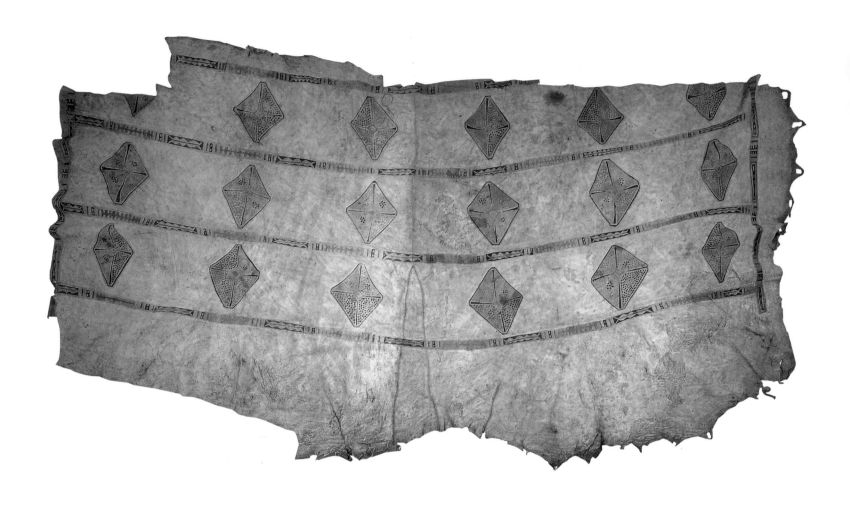

PLATE 96
Blackfeet, Blood sub-group,
Great Plains, Alberta, Canada
Tent Back Sheet
Late nineteenth century
Elk hide, mineral pigments, 73 x 133 inches
(186 x 338 cm)

National Museum of the American Indian,
Smithsonian Institution, Washington, D.C.,
20-1944

PROVENANCE: Probably Madge Hardin Walters,
San Diego, California, to 1939; Earl Horter,
Philadelphia, 1939 to 1940; National Museum
of the American Indian, Smithsonian Institution,
1940.

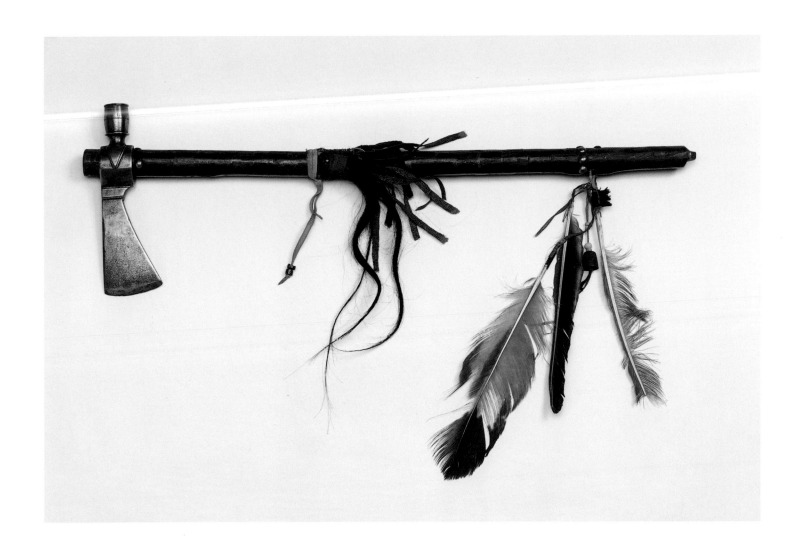

PLATE 97
Blackfeet, Blood sub-group,
Great Plains, Alberta, Canada
Pipe Tomahawk
Late nineteenth century
Wood, metal, cloth, feathers, hair,
and beads, length 25 3/16 inches (64 cm)

National Museum of the American Indian,
Smithsonian Institution, Washington, D.C.,
20-1991

PROVENANCE: Probably Madge Hardin Walters,
San Diego, California, to 1939; Earl Horter,
Philadelphia, 1939 to 1940; National Museum of
the American Indian, Smithsonian Institution,
1940.

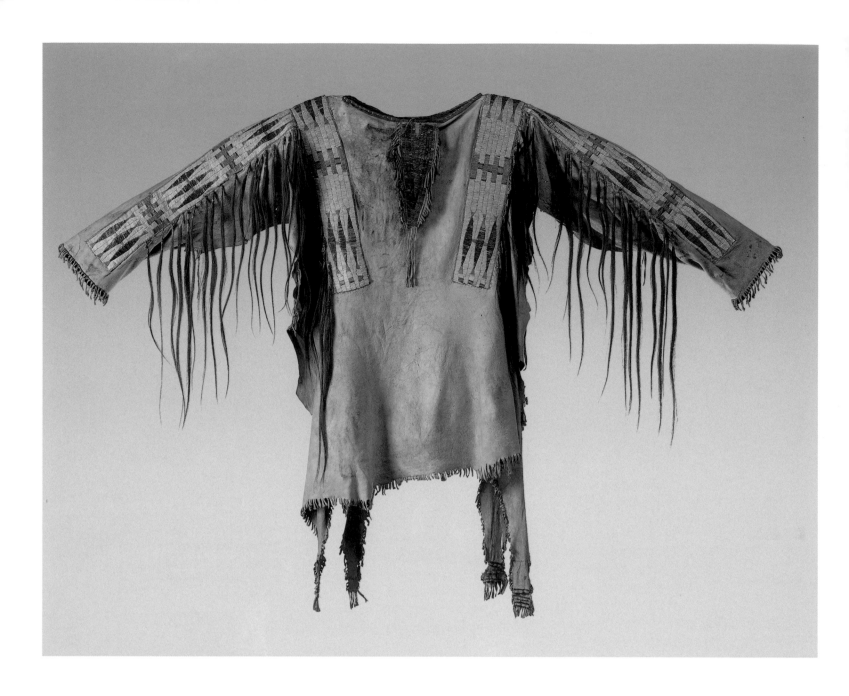

PLATE 98

Lakota (Sioux), Great Plains, South
Dakota (Rosebud Reservation)
War Shirt, c. 1880
Deer hide, cloth, porcupine quills, mineral
pigments, and human hair, length 38 inches
(96.5 cm)

Private collection

PROVENANCE: Earl Horter, Philadelphia,
to 1940; Elizabeth Lentz Horter, Philadelphia,
1940 to 1985; Barry May, Dublin, Pennsylvania,
1985; Morning Star Gallery, Santa Fe, New Mexico.

PLATE 99
Sisseton (Sioux), Great Plains
Gunstock Club
Late nineteenth century
Wood and metal, length 27^{15}/$_{16}$ inches
(70.9 cm)

National Museum of the American Indian,
Smithsonian Institution, Washington, D.C.,
20-1987

PROVENANCE: Earl Horter, Philadelphia, to
1940; National Museum of the American Indian,
Smithsonian Institution, 1940.

PLATE 100
Arapaho, Great Plains
Shield, before 1850

Buffalo hide, feathers, mineral pigments, and
antelope strap, diameter 19½ inches (49.5 cm)

Private collection

PROVENANCE: Earl Horter, Philadelphia, to
1940; Elizabeth Lentz Horter, Philadelphia, 1940
to 1985; Barry May, Dublin, Pennsylvania, 1985;
Morning Star Gallery, Santa Fe, New Mexico.

PLATE 101
Comanche, Great Plains
Shield, c. 1850
Buffalo hide, feathers, brass dangles,
mineral pigments, quilled fringe, and
antelope strap (with Pueblo overpainting),
diameter 21½ inches (55 cm)

Private collection

Provenance: Earl Horter, Philadelphia, to
1940; Elizabeth Lentz Horter, Philadelphia,
1940 to 1985; Barry May, Dublin,
Pennsylvania, 1985; Morning Star Gallery,
Santa Fe, New Mexico.

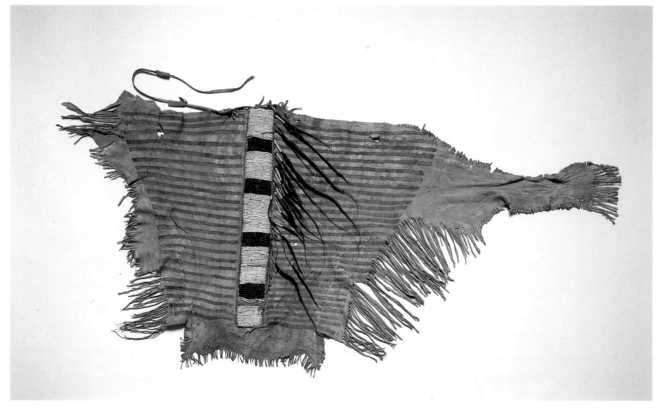

PLATE 102

Great Plains

**Pair of Leggings*

Late nineteenth century

Animal hide, beads, horsehair, and

mineral pigments

52 x 22½ inches (132 x 57.2 cm), top

48 x 23 inches (122 x 58.4 cm), bottom

The State Museum of Pennsylvania,

Harrisburg, E64.1.3.a–b

PROVENANCE: Earl Horter,

Philadelphia, to 1940; Elizabeth Lentz

Horter, Philadelphia, 1940 to 1964; The

State Museum of Pennsylvania, 1964.

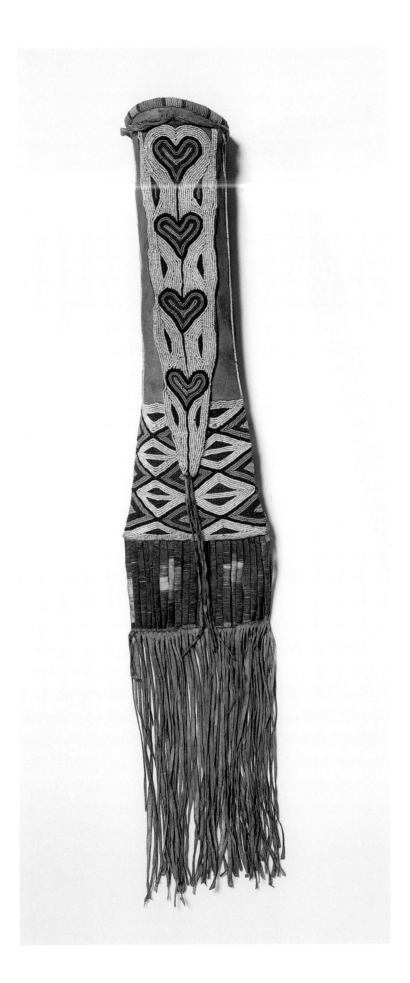

PLATE 103
Great Plains
Pipe Bag
Late nineteenth century
Animal hide, metal wire, and beads,
length 32½ inches (82.6 cm)

The State Museum of Pennsylvania,
Harrisburg, E64.1.1

PROVENANCE: Earl Horter, Philadelphia, to
1940; Elizabeth Lentz Horter, Philadelphia, 1940
to 1964; The State Museum of Pennsylvania, 1964.

PLATE 104
Iroquois, Northeast, New York
Tomahawk
Early nineteenth century
Wood and metal, length 14¹/₁₆ inches
(35.7 cm)

National Museum of the American Indian,
Smithsonian Institution, Washington, D.C.,
20-1993

PROVENANCE: Earl Horter, Philadelphia, to
1940; National Museum of the American Indian,
Smithsonian Institution, 1940.

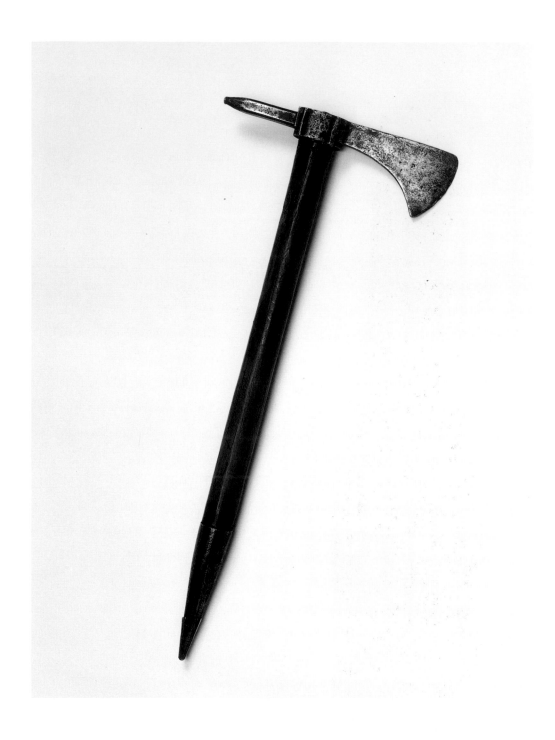

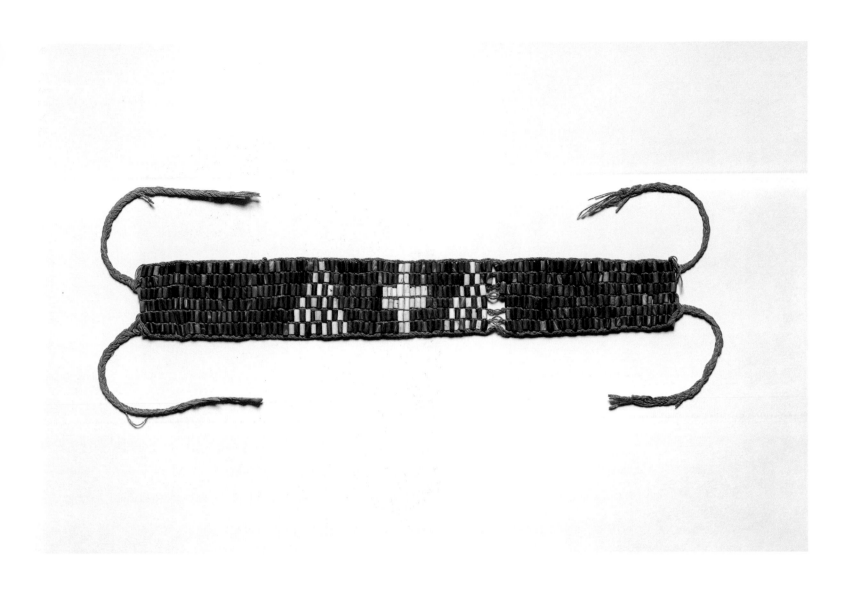

PLATE 105

**Maliseet, Tobique Band, Northeast,
New Brunswick, Canada**
Wampum Belt
Early nineteenth century
Shell bead and native hemp,
length 21 inches (53.3 cm)

The State Museum of Pennsylvania, Harrisburg,
E64.1.8

PROVENANCE: George Starr, 1897 to after 1931;
Earl Horter, Philadelphia, after 1931 to 1940;
Elizabeth Lentz Horter, Philadelphia, 1940
to 1964; The State Museum of Pennsylvania, 1964.

PLATE 106
Tlingit, Northwest Coast, Alaska
Pipe Bowl
Late nineteenth century
Wood and abalone shell,
3⅛ x 6⅜ x 2½ inches (8 x 16.2 x 6.3 cm)

National Museum of the American Indian,
Smithsonian Institution, Washington, D.C.,
18-6514

PROVENANCE: Earl Horter, Philadelphia, to
1934; National Museum of the American Indian,
Smithsonian Institution, 1934.

1880

Earl Horter is born in December to Jacob Horter and Jeannette Blumner Horter, Philadelphia.

1900

Lives at 617 Chelten Avenue in the Germantown section of Philadelphia with his widowed mother and grandmother (and two aunts and uncles and four cousins). He is listed as a "landscape artist" in the 1900 U.S. census.

1903–4

Leaving his job as a designer of price tickets for the John Wanamaker store in Philadelphia, moves to New York City to join the first art department of the advertising agency Calkins and Holden.

1908

Exhibits in the *Exhibition of Advertising Art*, National Arts Club, New York (February 19–28).

Makes his first etching.

Studies etching at night school from about 1908 to 1916. Among his teachers are George Senseney and Troy Kinney.

1909

Lives at 135th Street, New York.

Exhibits in the *Second Annual Exhibition of Advertising Art*, National Arts Club, New York (February).

Marries Elin Magnusson on September 13. They live at 87 Hamilton Place, New York.

Birth of Donald, son of Horter and Elin Magnusson, on December 7.

1910

Exhibits in the *Third Annual Exhibition of Advertising Art*, National Arts Club, New York (October–November).

1911

Collaborates with Jerome Myers and Joseph Pennell to illustrate urban landscapes and vignettes of city life for *Glimpses of New York: An Illustrated Handbook of the City*, published in two editions by the New York Edison

Company: first edition, 1911, and second edition, 1912.

The Horters move to 168th Street and Broadway, New York.

1912

The Horters move to 181st Street and Broadway, New York.

Carl Zigrosser is hired as a research librarian at Frederick Keppel and Company, New York, which would eventually show Horter's work. Zigrosser works at Keppel until early 1918.

1913

The *International Exhibition of Modern Art* (The Armory Show) opens at the 69th Infantry Regiment Armory, New York (February 17–March 15). The Armory Show also travels to the Art Institute of Chicago (March 24–April 16) and to Copley Hall, Boston (April 28–May 19).

Buys *Paysages et Intérieurs* ("Landscapes and Interiors"), a series of twelve lithographs and a title page by Édouard Vuillard, at the Armory Show on March 9; also purchases an (unidentified) "picture," according to correspondence.

Makes a series of advertisements for Packard automobiles.

1914

Shows five etchings at *New York Society of Etchers: First Annual Exhibition at the Galleries of the Berlin Photographic Company* (January 6–31). He is listed as a founding member and secretary of the Society of Etchers.

Separates from Elin Horter.

Moves to 11 East 36th Street, New York.

Has five etchings published in the *Yearbook of American Etching 1914* (New York: John Lane Company, 1914), Association of American Etchers; introduction by Forbes Watson.

1915

Wins a silver medal for four etchings submitted by the Brown-Robertson Company at the *Panama-Pacific International Exposition*,

Fig. 73. Earl Horter (on the left) with two colleagues at work, probably in New York, about 1905–15.

Fig. 74. Earl Horter, *Coal Pockets and Viaduct, New York*, c. 1911, ink and gouache on paper, 8⅛ x 10¼ inches (20.7 x 26.1 cm). Private collection. Although this drawing shows the same site as one of Horter's etchings (fig. 10), it is not necessarily a preparatory drawing for the print.

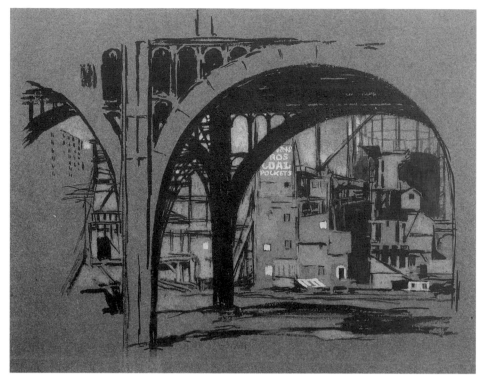

Department of Fine Arts, San Francisco (February 20–December 4).

Exhibits one etching in the *Thirteenth Annual Philadelphia Water Color Exhibition*, Pennsylvania Academy of the Fine Arts, Philadelphia (November 7–December 12).

1916
His drawings depicting the changing architecture of New York City commissioned by the New York Edison Company are published in *The Sun*, January 2, 1916.

Exhibits thirty etchings and thirty-three drawings in his first one-man show, *An Exhibition of Etchings and Drawings by Earl Horter*, organized by Carl Zigrosser for Frederick Keppel and Company, New York (September 26–October 14).

Exhibits five etchings in *Exhibition: New York Society of Etchers*, Montross Gallery, New York (October 31–November 18).

Exhibits four etchings in the *First Annual Exhibition, The Brooklyn Society of Etchers*, Brooklyn Museum (November 28–December 31).

The James McClees Gallery, Philadelphia, holds the *First Exhibition of Advanced Modern Art*, thirty-one works drawn mainly from the Armory Show, chosen by Philadelphia artists Morton Schamberg and H. Lyman Säyen.

Accepts a position at the advertising agency N. W. Ayer and Son, 300 Chestnut Street, Philadelphia.

Moves to 4920 Parkside Avenue, Philadelphia.

1917
Arthur B. Carles joins the faculty of the Pennsylvania Academy of the Fine Arts, Philadelphia.

The United States enters World War I on April 6.

The James McClees Gallery holds an exhibition of modern art called *Thirty-One Philadelphia Artists*, an association of Philadelphia modernists in protest of academic art (April 11–18). Artist-exhibitors include Arthur B. Carles, Charles Demuth, Hugh H. Breckenridge, Henry McCarter, Franklin Watkins, and Charles Sheeler.

Begins a series of advertisements for the Atlantic Refining Company and Vermont Slate Manufacturers, clients of N. W. Ayer and Son.

Robert Riggs begins to work as a sketch artist at N. W. Ayer and Son.

Purchases Whistler's etching *La Vieille aux Loques* from Frederick Keppel and Company.

Visits the *Fifteenth Annual Philadelphia Water Color Exhibition* at the Pennsylvania Academy of the Fine Arts and writes to Carl Zigrosser that it was "the worst watercolour show I ever saw. . . . Pennell . . . was much in evidence with about 100 munitions lithographs . . . by far the most enthusiastic work there."

1918
Exhibits ten etchings in *An Exhibition of New York in the Graphic Arts*, Frederick Keppel and Company, New York, organized by Carl Zigrosser (February 14–March 2).

Charles Sheeler organizes *Objects from the Museum Collection* at the University Museum, University of Pennsylvania, Philadelphia

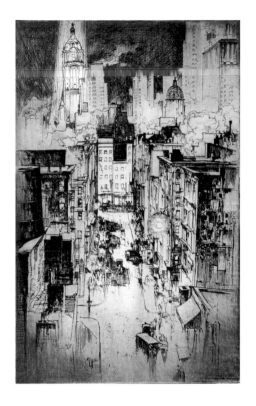

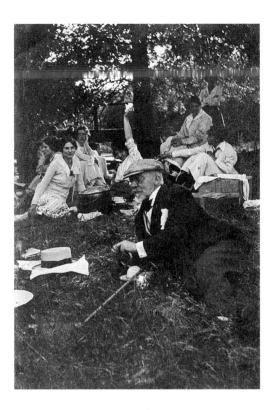

(February 26–April 9). Included are wooden statues from the Congo, bronzes from Benin, and Kuba textiles.

Exhibits four works in the *Sixteenth Annual Philadelphia Water Color Exhibition*, Pennsylvania Academy of the Fine Arts (November 10–December 15).

World War I ends on November 11.

Franklin Watkins joins the art department at N. W. Ayer and Son.

Through Franklin Watkins, meets Arthur B. Carles and Henry McCarter. Writes to Carl Zigrosser, "Do you know Henry McCarter? a teacher at the Academy and a really artistic personality."

1919
Attempts a reconciliation with Elin Horter. She moves to Philadelphia about March 5.

Has seven etchings published in an insert in the magazine *The Century* (New York), vol. 98, no. 1 (May).

Horter's etching *The Dark Tower* (fig. 17) is

included in *Twelve Prints by Contemporary Artists*, a portfolio selected by Carl Zigrosser, the newly appointed head of the print department at the Weyhe Gallery, New York, and published by the gallery. Other artists in the portfolio are Rockwell Kent, William Auerbach Levy, Kenneth Hayes Miller, Jerome Myers, Walter Pach, Boardman Robinson, Rudolph Ruzicka, John Sloan, Maurice Stern, Albert Sterner, and Mahonri Young.

Attempt at reconciliation fails and Elin Horter leaves Horter on July 10.

Charles Sheeler moves to New York by September, living at 160 East 25th Street.

Shows eight drawings and nine etchings in the *Seventeenth Annual Philadelphia Water Color Exhibition*, Pennsylvania Academy of the Fine Arts (November 9–December 14). Writes to Carl Zigrosser, "The Academy here gave me a wall in the Ex and seemed to like it very well."

Begins to work on drawings advertising the Eldorado pencil for the Joseph Dixon

Crucible Company, a client of N. W. Ayer and Son.

Begins a series of advertisements for the Blaw Knox Company, a client of N. W. Ayer and Son.

1920
Participates in *An Exhibition of Work by Artist Members of the Stowaways* at the Weyhe Gallery, New York (January 20–February 14). The Stowaways is a New York club founded in 1907 for artists involved in illustration, graphic design, and the book arts.

Exhibits six etchings at the *Fourth Annual Exhibition of the Painter-Gravers of America*, The Anderson Galleries, New York (April 1–17). He is listed as a charter member.

Lends a Toulouse-Lautrec lithograph and six Vuillard lithographs to the *Exhibition of Paintings and Drawings by Representative Modern Masters*, Pennsylvania Academy of the Fine Arts (April 17–May 9). The exhibition is organized by William H. Yarrow, Arthur B. Carles, and Carroll S. Tyson, Jr.

Fig. 77. Earl Horter, *Walt Whitman's House in Camden, New Jersey*, 1919, ink over traces of graphite on paper, 5 9/16 x 6 5/16 inches (14.1 x 16.1 cm). Philadelphia Museum of Art. Purchased: Lola Downin Peck Fund from the Carl and Laura Zigrosser Collection, 1973-12-415. Drawing commissioned by Carl Zigrosser for the Walt Whitman issue of *The Modern School: A Monthly Magazine Devoted to Libertarian Ideas in Education*, April–May 1919.

Fig. 78. Front and back covers of the *31* exhibition brochure, 1923.

Exhibits five drawings and eight etchings in the *Eighteenth Annual Philadelphia Water Color Exhibition*, Pennsylvania Academy of the Fine Arts (November 7–December 12).

Lives at 1826 Spruce Street, Philadelphia, until 1923.

1921
Included in the *Annual of Advertising Art in the United States in 1921*, a catalogue for the first annual exhibition of advertising paintings and drawings held by the Art Directors Club, Galleries of the National Arts Club, New York (March 2–31); his work is submitted by N. W. Ayer and Son (Joseph Dixon Crucible Company) and by the Lincoln Motor Company.

The *Exhibition of Paintings and Drawings Showing the Later Tendencies in Art* opens at the Pennsylvania Academy of the Fine Arts (April 16–May 15), organized by a committee composed of seven modernist artists: Thomas Hart Benton, Paul Burlin, Arthur B. Carles, Bernard Gussow, Joseph Stella, Alfred Stieglitz, and William Yarrow. Horter buys Joseph Stella's *Water Lilies* (pl. 85) for $80 on the first day of the show.

Travels to Europe on a commission to draw European monuments for the Joseph Dixon Crucible Company.

First auction of the holdings of Daniel-Henry Kahnweiler's gallery at the Hôtel Drouot, Paris (June 13–14). Picasso's *Portrait of Daniel-Henry Kahnweiler* (pl. 38) is purchased by Isaac Grünewald, a Swedish artist living in Paris.

Arthur B. Carles travels to France with his family. They stay at Edward Steichen's house in Voulangis from July 9 to February of the next year.

Serves on the jury of selection and exhibits fourteen works in the *Nineteenth Annual Philadelphia Water Color Exhibition*, Pennsylvania Academy of the Fine Arts (November 6–December 11).

Exhibits six works and wins the Kate W. Arms Memorial Prize (the best print by a member of the society) for *The Yittish* [sic] *Junk Shop* at the *Sixth Annual Exhibition*, *The Brooklyn Society of Etchers*, Brooklyn Museum (December 5–January 2, 1922).

1922
Exhibits one etching in the *Third International Print Makers Exhibition*, Los Angeles Museum Exposition Park (March 21–April 16).

In April Arthur B. Carles makes a list of seven of his paintings in Horter's residence at 1826 Spruce Street.

Makes sketches of Brancusi sculptures (fig. 31) at *Contemporary French Art*, The Sculptor's Gallery, New York (March 24–April 10).

Exhibits seven of his nudes in the *Twentieth Annual Philadelphia Water Color Exhibition*, Pennsylvania Academy of the Fine Arts (November 5–December 10).

On December 4 the Commonwealth of Pennsylvania grants Dr. Albert C. Barnes a charter for an educational institution to be called the Barnes Foundation in Merion, Pennsylvania.

1923
Purchases Charles Sheeler's *Pertaining to Yachts and Yachting* (pl. 82), which was exhibited in

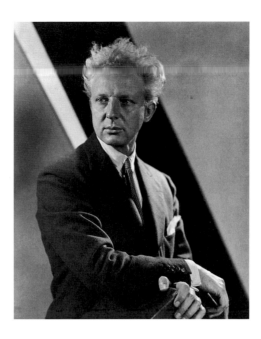

the show *Contemporary Art*, Montross Gallery, New York (January 23–February 10)

Anna Warren Ingersoll writes in her diary (February 10), "met Carles at Horter's where we had tea and looked at his pictures Lovely Carleses, a Picasso, a Braque etc."

Exhibits the watercolor *Nude* (fig. 21) at the *Third International Watercolor Exhibition*, The Art Institute of Chicago (March 20–April 22); it is purchased by the Art Institute.

Serves with Arthur B. Carles, Henry McCarter, Anna Warren Ingersoll, and Christine Chambers on the organizing committee for the exhibition *31, 1607 Walnut Street, Philadelphia* (April 3–14). Exhibits eight of his own drawings and watercolors and lends Carles's *Girl with Red Hair (Angele)* (pl. 59) and Sheeler's *Pertaining to Yachts and Yachting* (pl. 82).

Marius de Zayas organizes *Picasso 1919–1923* at the Whitney Studio Galleries, New York (April–May). *Still Life with Bottle of Port (Oporto)* (pl. 47), which Horter owned by 1929/30, is shown in this exhibition.

The exhibition *Contemporary European Paintings and Sculpture* opens at the Pennsylvania Academy of the Fine Arts (April 11–May 9). Dr. Albert C. Barnes lends seventy-five works by contemporary European artists from his collection while his gallery in Merion, designed by Philadelphia architect Paul Cret, is under construction.

The *Exhibition of Etchings and Dry-Points by Earl Horter*, Brown-Robertson Gallery, New York, includes thirty-three works (April 30–May 17).

Exhibits one of his own works and lends Sheeler's *Pertaining to Yachts and Yachting* (pl. 82) to the *Spring Salon*, The Galleries of the American Art Association, New York (May 21–June 9).

Owns a vacation house in Barnegat, on the New Jersey seashore, where he entertains his friends, including Arthur B. Carles and his daughter Mercedes.

Leaves the staff of N. W. Ayer and Son on October 5 but continues to work freelance for Ayer clients.

Buys Stanton MacDonald-Wright's *Still Life Synchromy* (missing, M6) from Samuel S. White, 3rd, and Vera White.

Sails for Europe with the young artist Sophie Victor on the *Paris* to draw European sites for advertisements for the Joseph Dixon Crucible Company. The couple arrive in Paris and then travel through southern France, Spain, and Italy (November 1923–Spring 1924).

1924
Exhibits for the first time in the annual painting exhibition of the Pennsylvania Academy of the Fine Arts, the *One-Hundred-and-Nineteenth Annual Exhibition* (February 3–March 23), to which he also lends Carles's *Composition of Flowers* (pl. 60).

Lends *Pertaining to Yachts and Yachting* (pl. 82) and *Church Street El* (pl. 78) to the *Exhibition of Selected Work by Charles Sheeler* at the Whitney Studio Galleries, New York (March 1–31).

Lives at 2038 Spruce Street, Philadelphia.

Arthur B. Carles takes a studio at 4920 Parkside Avenue, Philadelphia.

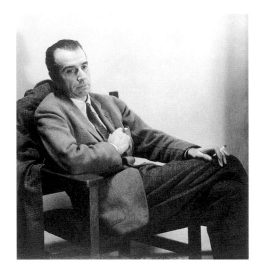

Fig. 81. Franklin Watkins about 1935.

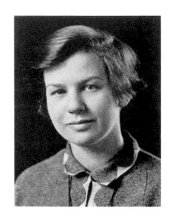

Fig. 82. Horter's second wife, Elizabeth Reynolds Sadler, in her University of Pennsylvania yearbook, 1927. They were married from about 1928 to 1930.

Fig. 83. Exterior of 2219 Delancey Street, Philadelphia.

Interviewed in "An Interesting Correspondence with the Eldorado Pencil Artist," for the magazine *Graphite* (Jersey City, New Jersey), vol. 26 (September–October).

Exhibits six works in the *Twenty-Second Annual Philadelphia Water Color Exhibition*, Pennsylvania Academy of the Fine Arts (November 9–December 14).

In the November issue of *Printers' Ink Monthly*, Stanford Briggs, Inc., New York, announces that "Mr. Horter's work in the field of advertising may be had through our organization."

1925
In February, with other Philadelphia artists, including Arthur B. Carles, Sara Carles, Franklin Watkins, Christine Chambers, Raphael Sabatini, Anna Warren Ingersoll, Leon Kelly, and Julian Levi, begins Sunday classes at the Barnes Foundation taught by Dr. Albert C. Barnes and Dr. Thomas Munro.

Exhibits two paintings in the *One-Hundred-and-Twentieth Annual Exhibition*, Pennsylvania Academy of the Fine Arts (February 8–March 29).

Dr. Barnes writes to Paris dealer Paul Guillaume (February 27) that Horter would like to purchase the "Negro pieces" Guillaume has reserved for him.

Arthur B. Carles is dismissed from the faculty of the Pennsylvania Academy of the Fine Arts.

Anna Warren Ingersoll writes in her diary (November 13) of meeting Horter at the *George Bellows Memorial Exhibition* at the Metropolitan Museum of Art: "[Horter] said the best he could say for B.[ellows] was he would rather have gone to [Daniel] Garber's funeral than his!"

Purchases the Picasso drawing *The Violin* (pl. 42) and a Braque still-life collage (pl. 7) from the auction "Tableaux modernes: Aquarelles, gouaches, pastels, et dessins," Hôtel Drouot, Paris (December 12).

Anna Warren Ingersoll writes in her diary (November 22) of spending a Sunday morning at the Barnes Foundation: "Lots of people—professors etc. . . . produced a negro quartette who sang "Nearer my God to Thee" & others. It was funny but all somehow nice—as long as one could look at the

Matisses. Then much talk about education & answers from the professors. I can't imagine or understand what they are driving at."

Georges Braque's *Still Life with Glass and Newspaper (Le Gueridon)* (pl. 8) is published in Léonce Rosenberg's *Bulletin de l'Effort Moderne* (November).

Begins a series of portraits based upon photographs of famous composers and musicians for Steinway and Sons, a client of N. W. Ayer; many are published in the *Saturday Evening Post*.

The French artist Jacques Mauny makes his first trip to the United States but visits only New York.

1926
Writes to Alfred Stieglitz (January 18) that he has ten Picassos and thirteen African sculptures.

On various days, purchases six works from the private sales of the estate of the collector John Quinn, organized by the Brummer Gallery: Brancusi's *Mademoiselle Pogany I* (pl. 1); Duchamp's *Nude Descending a Staircase, No. 1* (pl. 16); Matisse's *Italian Woman* (pl. 21); an

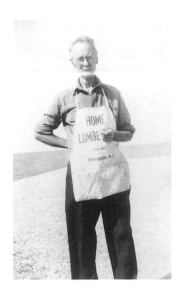

Fig. 84. Horter's handyman Fred Helsengren, seen in a later photograph.

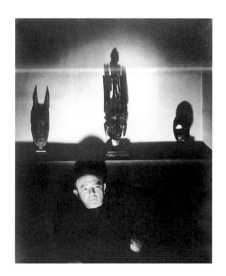

Fig. 85. Horter with three African sculptures from his collection at 2219 Delancey Street, Philadelphia.

Fig. 86. Horter pictured with one of his drawings for Salem Roofs, 1931, an indication of how well known he had become in the field of advertising.

unidentified work by Georges Braque; Brancusi's *Muse* (pl. 3); and an unidentified work by Charles Sheeler.

Included in the *Fifth Annual of Advertising Art from Advertisements Shown at the Exhibition of the Art Directors Club*, Art Center, New York (May 5–29); his work is submitted by N. W. Ayer and Son (Joseph Dixon Crucible Company) and the George Batten Company (Electric Storage Battery Company).

Purchases Brancusi's *Cock* (pl. 4) from the exhibition *Brancusi*, Brummer Gallery, New York (November 17–December 15). The exhibition is installed by Marcel Duchamp and includes Brancusi sculptures purchased by Duchamp and Henri-Pierre Roché from the Quinn estate and from private American collections, as well as new sculptures and drawings.

1927
On February 3 divorces Elin on charge of desertion.

Helps to organize an exhibition of prints by Walt Kuhn at the Philadelphia Art Alliance (April 1–16).

Included in the *Sixth Annual of Advertising Art from Advertisements Shown at the Exhibition of the Art Directors Club*, Art Center, New York (May 4–31); his work is submitted by Barton, Durstine, and Osborn, Inc. (Creo-Dipt Company, Inc.).

Juan Gris's *Pipe and Newspaper* (Fantômas) (pl. 18) is published in Léonce Rosenberg's *Bulletin de l'Effort Moderne* (June). It is possible that Horter acquired it from Rosenberg in this year.

Writes to Dr. Albert C. Barnes that he has twenty Picassos.

Jacques Mauny visits the United States again. Horter commissions him to make a replica of his painting *White Oxen* (pl. 25).

Exhibits eleven works, including the drawing *City Hall: Philadelphia*, in the *Exhibition of Paintings by Seven Philadelphia Painters*, Wildenstein Galleries, New York (October–November). Other participating artists are Adolphe Borie, Hugh H. Breckenridge, Arthur B. Carles, Henry McCarter, Carroll S. Tyson, Jr., and Franklin Watkins. The exhibition travels to the Cincinnati Museum of Art, the Columbus Gallery of Fine Arts, Ohio, and the Art Institute, Milwaukee.

Jacques Mauny writes to A. E. Gallatin (November 13) that Horter is "anxious to buy all the sculptures by Picasso."

1928
Marries Elizabeth Reynolds Sadler by fall.

Exhibits eight etchings in the *First Annual Exhibition of the Philadelphia Society of Etchers*, The Print Club of Philadelphia (January 16–28).

Exhibits his painting *Senlis* (location unknown) in an exhibition of painting and sculpture by Philadelphia modernist artists at the McClees Gallery, Philadelphia (February 20–March 20).

Lends Brancusi's *Mademoiselle Pogany I* (pl. 1) to the *Inaugural Exhibition of the New Museum of Art, Fairmount: European and American Sections*, Pennsylvania (later Philadelphia) Museum of Art (March).

Exhibits in a non-juried modernist art exhibition at the New Students' League, Philadelphia (March 26–April 4).

Included in the *Seventh Annual of Advertising Art from Advertisements Shown at the Exhibition of the*

Fig. 87. Earl Horter's watercolor for an advertisement for the 1933 Pierce Arrow. Collection of Ollie James.

Fig. 88. Edward C. Smith, *Caricature of Earl Horter*, 1932, etching, 6½ x 4¾ inches (16.5 x 12.4 cm) plate. Philadelphia Museum of Art. The Samuel S. White, 3rd, and Vera White Collection, 1967-30-233.

Art Directors Club, Art Center, New York (May 5–29); his work *Rhapsody in Blue* (see figs. 28–30), for Steinway and Sons, is submitted by N. W. Ayer. He also serves on the exhibition committee.

Jacques Mauny writes to Picasso (May 31) about an "American painter" (probably Horter) who is in Paris and would like to visit his studio. Mauny adds that this artist already has seven Picassos in his collection and would like to purchase an important work during his visit.

Georges Braque's *Glass, Bottle, Playing Card, BAR* (pl. 6), which Horter owned by 1929/30, is sold at the auction "Tableaux modernes: Collection de Docteur Soubies," Hôtel Drouot, Paris, lot 27, to the Paris dealer Van Leer.

With his wife Elizabeth, purchases 2219 Delancey Street, Philadelphia, on September 10.

Recent Paintings by Giorgio de Chirico opens at the Valentine Gallery, New York (December 31–January 6, 1929). Horter probably acquires *The Invincible Cohort* (pl. 13) from this exhibition.

1929
Paul Cret redesigns the top floor of 2219 Delancey Street, including a large studio for Horter.

Serves with R. Sturgis Ingersoll, Adolphe Borie, Henry McCarter, Maurice Speiser, and Carroll S. Tyson, Jr., on the exhibition committee for the *Exhibition of Drawings and Lithographs by Henri de Toulouse-Lautrec*, The Print Club of Philadelphia (April 1–13).

Included in the *Eighth Annual of Advertising Art from Advertisements Shown at the Exhibition of the Art Directors Club*, Art Center, New York (May 4–29); his work is submitted by the Blackman Company (Vacuum Oil Company) and Young and Rubicam, Inc. (International Silver Company).

The stock market crashes on October 29.

Serves as a faculty member in printmaking at the Graphic Sketch Club (now the Samuel S. Fleisher Art Memorial).

Horter writes to Barnes (late 1929), "I bought a Picasso + a fine large Chirico this year."

Photographed by William Shewell Ellis posed with Brancusi's *Muse* (frontispiece).

W. Vivian Chappel photographs Horter's collection installed at 2219 Delancey Street (figs. 1–4).

1930
Listed in *Advertising Arts* (January 8, p. 4) as one of the seventeen artists whose work is sold exclusively through the advertising firm of Byron Musser, Inc., New York: "The modern trend in advertising leans more and more toward a frankly pictorial appeal."

Fig. 89. Earl Horter, *Steamship*, c. 1930, watercolor on paper, 10¼ x 11 inches (26.1 x 28 cm). Collection of Mr. and Mrs. Peter Paone. Using a style and a technique similar to the advertisement for Pierce Arrow (fig. 87), Horter may also have made this watercolor to advertise a steamship.

Fig. 90. Earl Horter, *Manhattan Night*, c. 1932, aquatint, 14½ x 11⅛ inches (36.9 x 29.2 cm) plate. Philadelphia Museum of Art. Gift of Hortense Ferne, 1969-300-13.

Lends a view of Palermo and the painting *Scene in Palermo* (pl. 24) to the *First Exhibition in America of Paintings and Gouaches by Jacques Mauny*, De Hauke and Company, New York (January 6–25).

Exhibits in the *One-Hundred-and-Twenty-Fifth Annual Exhibition of Paintings and Sculpture*, Pennsylvania Academy of the Fine Arts (January 26–March 16). Horter and Franklin Watkins exhibit for the first time since 1926; Arthur B. Carles exhibits for the first time since 1925.

Lends Franklin Watkins's *Nude Reclining* (pl. 86) to *An Exhibition of the Work of Forty-Six Painters and Sculptors Under Thirty-Five Years of Age*, The Museum of Modern Art, New York (April 12–26).

Included in the *Ninth Annual of Advertising Art from Advertisements Shown at the Exhibition of the Art Directors Club*, Art Center, New York (May 6–29); his work is submitted by the

Blackman Company (The Parke Davis Company) and the McLain Simpers Organization (Horace E. Dodge Boat and Plane Corporation).

Organizes the commencement exhibition *Contemporary Paintings of the Modern School*, Tryon Gallery, Smith College Museum of Art, Northampton, Massachusetts (May 29–June 18). Buys Charles Sheeler's *Stairway to the Studio* (pl. 83) from this exhibition.

In June joins a group of twenty-five subscribers to purchase Arthur B. Carles's *The Marseillaise* for the Pennsylvania (later Philadelphia) Museum of Art.

A Committee on Modern Art is established at the Pennsylvania Museum of Art for the "devoting of adequate space . . . to the work of contemporary artists, and especially American contemporaries of creative power" (Fiske Kimball, director of the museum, to Horter, June 12).

Divorced from Elizabeth Sadler Horter on August 15.

Marries Helen Sharpless Lloyd later in August.

Jacques Mauny writes to Leon Kelly (October 4) that Horter wants to sell his collection for $100,000, payable over ten years.

Exhibits four watercolors in the *Twenty-Eighth Annual Philadelphia Water Color Exhibition*, Pennsylvania Academy of the Fine Arts (November 2–December 7).

Serves on the exhibition committee for *Contemporary French Drawings in Black and White and Color*, The Print Club of Philadelphia (November 10–27); lends the Derain *Nude* (pl. 14), the Pascin *Beach Scene* (missing, M13), and two Picasso "abstractions."

Lends Sheeler's *Pertaining to Yachts and Yachting* (pl. 82) to *Painting and Sculpture by Living*

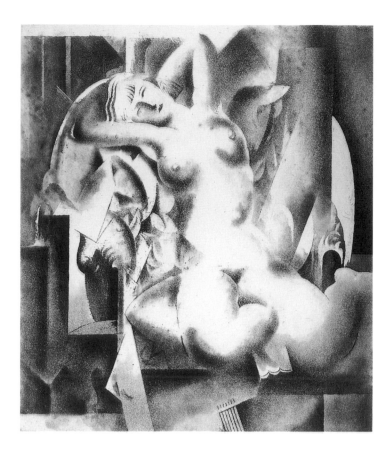

Fig. 91. Edward C. Smith's etching *The Art of Illuminating, Engrossing, and Lettering,* in a book of the same title assembled for Earl Horter by "The Esoteric Etchers," August 20, 1931. Private collection.

Fig. 92. Earl Horter, *Nude,* c. 1933, aquatint, 12¼ x 10⁹⁄₁₆ inches (31.1 x 26.8 cm) plate. Philadelphia Museum of Art. Gift of Dr. Samuel B. Sturgis, 1973-268-163.

Americans, The Museum of Modern Art, New York (December 2–January 20, 1931).

1931
In February asks Henri Marceau, curator of painting at the Pennsylvania (later Philadelphia) Museum of Art, to suggest an appraiser for his collection.

Carl Zigrosser writes in his diary (February 10) of visiting Horter: ". . . saw his marvelous collection of 22 Picassos, 14 Braques, and many other treasures, paintings, negro sculptures, etc."

An Exhibition of All the Etchings by Earl Horter opens at the Art Center, New York (February).

Included in the *Tenth Annual of Advertising Art from Advertisements Shown at the Exhibition of the Art Directors Club,* Art Center, New York (April 18–May 18); his work is submitted by Kenyon and Eckhardt, Inc. (Bergdorf Goodman).

The Pennsylvania (later Philadelphia) Museum of Art acquires Picasso's *Woman with Loaves* as a gift of Charles E. Ingersoll, the father of R. Sturgis and Anna Warren Ingersoll.

By May 15 Horter has sold the Picasso *Portrait of Braque* (pl. 34) to Frank Crowninshield, editor of *Vanity Fair.*

Tells a reporter for the *Evening Public Ledger* (Philadelphia), July 3, that he has twenty-two Picassos.

On August 20 is presented with *The Art of Illuminating, Engrossing, and Lettering,* a book of etchings (fig. 91) by "The Esoteric Etchers," fifteen of his fellow etchers, friends, and students.

Shows four watercolors and two pastels in the *Twenty-Ninth Annual Philadelphia Water Color Exhibition,* Pennsylvania Academy of the Fine Arts (November 1–December 6).

Exhibits the aquatint *Manhattan Night* (fig. 90) in the *Sixteenth Annual Exhibition of the Society of Etchers,* National Arts Club, New York (November–December).

Exhibits his painting *Spring in Pennsylvania* and lends the Sheeler *Pertaining to Yachts and Yachting* (pl. 82), Jacques Mauny *Scene in Palermo* (pl. 24), and Brancusi *Muse* (pl. 3) to *Living Artists: An Exhibition of Contemporary Painting and Sculpture,* Pennsylvania Museum of Art (November 20–January 1, 1932).

Lends *Italian Woman* (pl. 21) to the *Henri Matisse Retrospective Exhibition,* The Museum of Modern Art, New York (November 3–December 6).

1932
Serves on the Philadelphia General Committee for the *Exposition of Indian Tribal Arts,* Philadelphia Art Alliance (January 6–24).

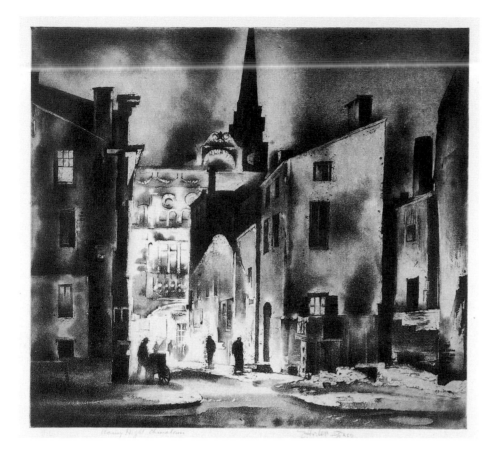

Fig. 93. Earl Horter, *Rainy Night, Chinatown*, c. 1934, aquatint, 12⅞ x 13⅝ inches (32.7 x 34.6 cm) plate. Philadelphia Museum of Art. Purchased. Lola Downin Peck Fund from the Carl and Laura Zigrosser Collection, 1973-12-423.

Exhibits three aquatints and wins the Mr. and Mrs. Frank G. Logan Prize, third place, for *Junk Shop* in the *First International Exhibition of Etching and Engraving*, The Art Institute of Chicago (March 24–May 15).

Sends paintings from his collection to the Pierre Matisse Gallery, New York, to sell.

Is visited in May by a representative of the Marie Harriman Gallery, New York, who is making a survey of public and private collections of modern art in Philadelphia.

Vacations in Rockport, near Gloucester, Massachusetts.

Wins an honorable mention for his aquatint *The Kitchen, New Orleans* (fig. 37) in the *Fourth Annual Exhibition of Prints Made During the Year by Philadelphia Artists*, The Print Club of Philadelphia (October).

Exhibits seven watercolors in the *Thirtieth Annual Philadelphia Water Color Exhibition*, Pennsylvania Academy of the Fine Arts (November 6–December 11).

Exhibits in *Some Living Pennsylvania Artists*, the first exhibition held in the Gallery of Modern Art of the Pennsylvania Museum of Art (December 17–January 18, 1933).

Wins the Charles M. Lea prize for his aquatint *Light and Shadow* (fig. 38) in the *First National Salon of Etchings, Lithographs, and Block Prints*, The Print Club of Philadelphia (December).

1933

Exhibits one work in the *One-Hundred-and-Twenty-Eighth Annual Exhibition*, Pennsylvania Academy of the Fine Arts (January 29–March 19).

Exhibits in *Pictures by Seven Philadelphia Artists*, Beagary House, Plymouth Meeting, Pennsylvania (February 13–March 5). Also participating are Adolphe Borie, Hugh H. Breckenridge, Arthur B. Carles, Leon Kelly, Carroll S. Tyson, Jr., and Franklin Watkins.

Earl Horter: Studies of Nudes opens at the Crillon Galleries, Philadelphia (March 15–28).

On April 28 sells the Brancusi *Mademoiselle Pogany I* (pl. 1) to the Pennsylvania Museum of Art for $2,000.

Horter's *Gloucester* (lent by the Whitney Museum of American Art, New York) and *Nude Reclining* (lent by the Art Institute of Chicago) are exhibited in *A Century of Progress: Exhibition of Painting and Sculpture Lent from American Collections*, The Art Institute of Chicago (June 1–November 1).

Vacations in Rockport, Massachusetts. Arthur B. Carles visits his daughter Mercedes, who is studying with Hans Hofmann in Eastern Point, Gloucester.

Begins teaching "Pictorial Expression" at the Pennsylvania Museum School of Industrial Art.

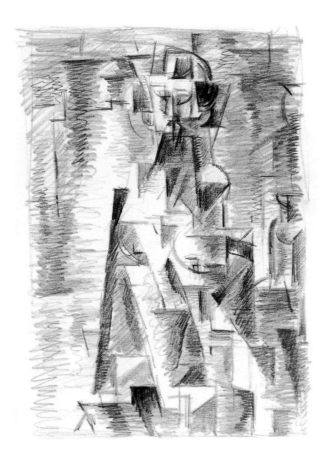

Nude Descending the Staircase—Marcel Duchamp

Loaned by
MR. EARL HORTER

APRIL THIRD TO APRIL TWENTY-SIXTH
NINETEEN HUNDRED THIRTY-FOUR

Fig. 94. Earl Horter, *Cubist Study of a Woman*, 1930s, graphite on paper, 13³/₄ x 10³/₁₆ inches (35 x 26 cm). Private collection.

Fig. 95. Cover of *Modern Paintings from the Collection of Mr. Earl Horter of Philadelphia*, The Arts Club of Chicago, April 3–26, 1934, the only checklist of Horter's modern art collection ever published.

The Collections of Miss Anna Warren Ingersoll and Mr. and Mrs. R. Sturgis Ingersoll, shown in the Pennsylvania Museum of Art's Gallery of Modern Art, is the first in the museum's series of exhibitions of Philadelphia private collections of modern art (November 4–December 6).

Exhibits six works and wins a watercolor prize in the *Thirty-First Annual Philadelphia Water Color Exhibition*, Pennsylvania Academy of the Fine Arts (November 5–December 10).

Marcel Duchamp writes to Constantin Brancusi (November 9) that he saw Horter in Philadelphia "qui me rend les 2 choses sans payer naturellement" (who took 2 things from me without paying, of course).

Lends *Cock* (pl. 4) to the exhibition *Brancusi*, Brummer Gallery, New York (November 17–January 13, 1934). Duchamp is curator of the exhibition, which includes fifty-seven new sculptures brought from Brancusi's studio in Paris and six loans from American collections, representing the artist's earlier work.

The Collection of Samuel S. White, 3rd, and Vera White, Pennsylvania Museum of Art (December 9–January 10, 1934), is the second in the museum's series of exhibitions of Philadelphia private collections of modern art.

1934
The Collection of Maurice J. Speiser, Pennsylvania Museum of Art (January 13–February 14), is the third in the museum's series of exhibitions of Philadelphia private collections of modern art.

Exhibits one work in the *One-Hundred-and-Twenty-Ninth Annual Exhibition*, Pennsylvania Academy of the Fine Arts (January 28–February 25).

The Collection of Earl Horter, Pennsylvania Museum of Art (February 17–March 13), the fourth in the museum's series of exhibitions of Philadelphia private collections of modern art, includes forty-three paintings, eigh-teen watercolors and drawings, and fifteen sculptures.

The Collection of Bernard Davis, Pennsylvania Museum of Art (March 17–April 28), is the fifth in the museum's series of exhibitions of Philadelphia private collections of modern art.

Writes "Abstract Painting—A Visit to Braque," *Pennsylvania Museum Bulletin*, vol. 29, no. 161 (March 1929), p. 63.

In March sells Sheeler's *Pertaining to Yachts and Yachting* (pl. 82) to Philadelphia artist Margaretta S. Hinchman.

Exhibits his own work and lends a Modigliani watercolor, *Nude (Caryatid)* (missing, M10), and John Marin's *Landscape in Maine* (pl. 73) to the *Thirteenth International Watercolors Exhibition*, The Art Institute of Chicago (March 29–April 29). His *Chinatown at Night* wins the Watson F. Blair Award and is purchased by the institute, as is the Marin.

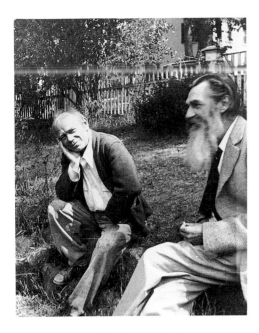

Fig. 96. Earl Horter and Arthur B. Carles about 1935.

Fig. 97. Horter and friends sailing at Fortesque, New Jersey, in the 1930s (left to right): Ed Smith, Wyn Lambdin, Horter (at the tiller), Frank Ewing, and Hubert Foster.

Exhibits in *Contemporary American Painting*, Pennsylvania Museum of Art (March 31–April 30).

Sells Marcel Duchamp's *Nude Descending a Staircase, No. 1* (pl. 16) to Walter and Louise Arensberg; Duchamp acts as the intermediary for the sale.

Sells the Picasso *Still Life with Cards, Glasses, and Bottle of Rum: Vive la [France]* (pl. 46) to Sidney Janowitz (later Janis) through Pierre Matisse.

Lends sixty-one works from his collection to *Modern Paintings from the Collection of Mr. Earl Horter of Philadelphia*, The Arts Club of Chicago (April 3–26).

From the Arts Club exhibition, sells the Gris *Guitar and Glass* (pl. 19), Braque *Still Life* (pl. 7), and Picasso *Portrait of a Woman* (pl. 37) and *Portrait of Daniel-Henry Kahnweiler* (pl. 38) to Mrs. Charles B. Goodspeed (later Mrs. Gilbert W. Chapman); he also sells a Modigliani drawing to an unknown buyer.

Exhibits four watercolors and two aquatints in the *Thirty-Second Annual Philadelphia Water Color Exhibition*, Pennsylvania Academy of the Fine Arts (November 4–December 9).

1935
Exhibits two works in the *One-Hundred-and-Thirtieth Annual Exhibition*, Pennsylvania Academy of the Fine Arts (January 27–March 3).

On February 10 lends twenty-six paintings from his collection to the Pennsylvania Museum of Art.

Lends Sheeler's *Flower Forms* (pl. 77) and *Staircase to the Studio* (pl. 83) and exhibits two of his own watercolors in *Abstract Painting in America*, The Whitney Museum of American Art, New York (February 12–March 22).

Lends a Bamana mask (pl. 87) from Mali to the exhibition *African Negro Art*, The Museum of Modern Art, New York (March 18–May 19).

Horter's students at the Graphic Sketch Club exhibit their work. A reviewer in the *Evening Bulletin* (Philadelphia), May 11, 1935, reports, "Although the influence of the teacher is easily apparent, the display is nevertheless one of the finest exhibitions of black and whites seen in the city this season."

Takes a group of students and art teachers to Rockport, Massachusetts, for a summer painting class.

Hired by the sculptor Boris Blai to join the first faculty of the Stella Elkins Tyler School of Fine Arts of Temple University, Philadelphia, where he teaches printmaking and watercolor, remaining on the faculty for five years.

Teaches "Pictorial Expression" at the Pennsylvania Museum School of Industrial Art.

Exhibits eight works in the *Thirty-Third Annual Philadelphia Water Color Exhibition*, Pennsylvania Academy of the Fine Arts (November 3–December 8).

Fig. 98. Fiske Kimball with R. Sturgis Ingersoll in the galleries of the Philadelphia Museum of Art, 1946.

Fig. 99. Earl Horter (right) at Gimbel Galleries, Philadelphia, about 1935.

1936

Serves on the exhibition committee and is a lender to *African Art and Its Modern Derivatives*, Philadelphia Art Alliance (January 6–31).

Exhibits two works in the *One-Hundred-and-Thirty-First Annual Exhibition*, Pennsylvania Academy of the Fine Arts (January 26–March 1).

Watercolors by Paul L. Gill, Earl Horter, Eliot O'Hara, and Thornton Oakley are shown in the galleries of the Philadelphia Art Alliance (February 4–15).

Pierre Matisse purchases Henri Matisse's *Italian Woman* (pl. 21) from Horter sometime before February 14.

Lends two Braques and three Picassos to *The Art of the African Negro with Related Modern Paintings*, The Memorial Art Gallery of the University of Rochester, New York (April).

Exhibits one work in the *Exhibition of Paintings, Sculpture, and Graphic Arts*, Texas Centennial Exposition, Department of Fine Arts, Dallas Museum of Fine Arts (June 6–November 29).

On June 25 sells a group of works from his collection to Elizabeth Lentz Keim (later Elizabeth Lentz Horter) for $5,000.

Teaches "Illustration and Decoration" at the Pennsylvania Museum School of Industrial Art.

Exhibits six watercolors in the *Thirty-Fourth Annual Philadelphia Water Color Exhibition*, Pennsylvania Academy of the Fine Arts (November 1–December 6).

On November 5 is asked by Fiske Kimball, director of the Pennsylvania Museum of Art, to "write a line to one of the newspapers saying how an artist feels about the acquisition of this Cézanne [*The Large Bathers*] for Philadelphia."

With Yarnall Abbott, director of the Philadelphia Art Alliance, organizes Andrew Wyeth's first one-man show, *Water Colors by Andrew Wyeth*, Philadelphia Art Alliance (November 16–December 6).

Sells the Brancusi *Muse* (pl. 3) to Philadelphia artist Ray F. Spreter.

The C. Howard Hunt Pen Company, Camden, New Jersey, publishes the brochure

"Principles of Pen Drawing by Earl Horter" to advertise its products.

1937

Lends Japanese books, a "Japanese fish," a "Negro stand," Native American stone carvings and a pipe, and a print by the Japanese artist Ogata Korin to *Animals in Art*, Philadelphia Art Alliance (January 18–February 7).

Exhibits one work in the *One-Hundred-and-Thirty-Second Annual Exhibition*, Pennsylvania Academy of the Fine Arts (January 24–February 28).

Is divorced by Helen Horter on February 23 on charges of adultery.

On March 30 sells the Braque *Still Life with Fruit* (pl. 12) to Anna Warren Ingersoll.

Pierre Matisse purchases Picasso's *Woman with a Book* (pl. 30) on April 22.

Suffers a heart attack while in New York City in July.

Sells the Picasso *Nude* (pl. 31) and *Still Life with Bottle, Cup, and Newspaper* (pl. 41), as well as the Braque *Still Life with Glass and Newspaper* (*Le*

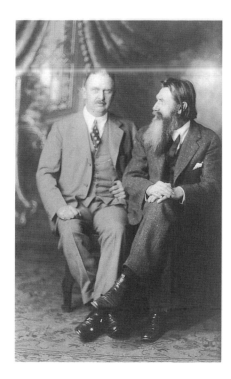

Fig. 100. Earl Horter, *The PSFS Building*, c. 1932, etching, aquatint, and drypoint, 16 ¹¹/₁₆ x 9 ⁷/₈ inches (42.4 x 25.1 cm) plate. Philadelphia Museum of Art. Gift of Dr. Samuel B. Sturgis, 1962-82-63. Horter's rendition of the PSFS Building, designed by George Howe and William Lescaze, which opened in 1932.

Ackland Art Museum, The University
 of North Carolina at Chapel Hill
Albright-Knox Art Gallery, Buffalo
Arnold and Lucille Alderman
The Art Institute of Chicago
Bryn Mawr College, Bryn Mawr,
 Pennsylvania
The Cleveland Museum of Art
Pamela and Oliver E. Cobb
Charles and Blanche Derby
Hester Diamond
Dixon Ticonderoga Company Collection,
 Heathrow, Florida
Margaret L. Driscoll
Mrs. Robert B. Eichholz
Hirshhorn Museum and Sculpture Garden,
 Smithsonian Institution, Washington, D.C.
Ollie James
Jane and Philip Jamison
Robert C. Larson
Hilary Dixon Lewis
Grete Meilman Fine Art, New York
The Menil Collection, Houston
Paula K. Muller
Museum Folkwang, Essen
Museum of Fine Arts, Boston
The Museum of Modern Art, New York
National Gallery of Art, Washington, D.C.
National Museum of the American Indian,
 Smithsonian Institution, Washington,
 D.C., and New York
Dr. and Mrs. Perry Ottenberg
Mr. and Mrs. Peter Paone
Pennsylvania Academy of the Fine Arts,
 Philadelphia
The Schwarz Gallery, Philadelphia
Staatliche Museen zu Berlin,
 Nationalgalerie. Leihgabe der Sammlung
 Berggruen
The State Museum of Pennsylvania,
 Harrisburg
Solomon R. Guggenheim Museum, New York
Charles K. Williams II
Yale University Art Gallery, New Haven
Private collections (thirteen)

Writings by Earl Horter

Horter, Earl. "A Note on the Exhibition." In Smith College Museum of Art, Northampton, Massachusetts, *Contemporary Painting of the Modern School.* May 29–June 18, 1930.

——. *Picasso, Matisse, Derain, Modigliani.* Philadelphia: H. C. Perleberg, 1930.

——. *Pencil Drawing.* Philadelphia: H. C. Perleberg, 1931.

——. "Abstract Painting—A Visit to Braque." *Pennsylvania Museum Bulletin,* vol. 29, no. 161 (March 1934), p. 63.

——. "A Word to the Student." *The Sketchbook* (The Pennsylvania Museum School of Industrial Art, Philadelphia), January 1936, n p

——. "Drawing in Pencil." *American Artist* (New York), vol. 20, no. 4 (April 1956), pp. 67–68.

Selected Exhibitions of Earl Horter's Work and Collections

Berlin Photographic Company, New York. *New York Society of Etchers: First Annual Exhibition at the Galleries of the Berlin Photographic Company.* January 6–31, 1914.

Department of Fine Arts, San Francisco. *The Panama-Pacific International Exposition.* February 20–December 4, 1915.

Montross Gallery, New York. *Exhibition: New York Society of Etchers.* Introduction by Carl Zigrosser. October 31–November 18, 1916.

Frederick Keppel and Company, New York. *Catalogue of an Exhibition of Etchings and Drawings by Earl Horter.* Introduction by Carl Zigrosser. September 26–October 14, 1916.

Frederick Keppel and Company, New York. *Catalogue of an Exhibition of New York in the Graphic Arts.* Introduction by Carl Zigrosser. February 14–March 2, 1918.

National Arts Club, New York. *First Annual Exhibition of Advertising Paintings and Drawings Held by the Art Directors Club.* March 2–31, 1921.

Brown-Robertson Gallery, New York. *Exhibition of Etchings and Dry-Points by Earl Horter.* April 30–May 17, 1923.

1607 Walnut Street, Philadelphia. *31 [Exhibition].* April 3–14, 1923.

Wildenstein Galleries, New York. *Exhibition of Paintings by Seven Philadelphia Painters.* October–November 1927.

Art Center, New York. *An Exhibition of All the Etchings by Earl Horter.* February 1931.

Crillon Galleries, Philadelphia. *Earl Horter: Studies of Nudes.* March 15–28, 1933.

Pennsylvania (later Philadelphia) Museum of Art, Philadelphia. *The Collection of Earl Horter.* February 17–March 13, 1934 (cited as Philadelphia, 1934).

The Arts Club of Chicago. *Modern Paintings from the Collection of Mr. Earl Horter of Philadelphia.* April 3–26, 1934 (cited as Chicago, 1934).

Philadelphia Art Alliance. *African Art and Its Modern Derivatives.* January 6–31, 1936.

Palace of Fine and Decorative Arts, San Francisco. *Golden Gate International Exposition.* February 1–December 2, 1939.

Philadelphia Art Alliance. *Earl Horter Memorial Exhibition.* November 8–30, 1940.

Philadelphia Art Alliance. *Earle Horter: Oils, Watercolors, Drawings, Prints.* December 2, 1954–January 2, 1955.

Philadelphia Museum of Art. *Philadelphia: Three Centuries of American Art.* Catalogue by Darrel Sewell et al. April 11–October 10, 1976.

Allen Memorial Art Museum, Oberlin College, Ohio. *The Stamp of Whistler.* Catalogue by Robert H. Getscher. October 2–November 6, 1977.

Yale University Art Gallery, New Haven. *American Prints, 1900–1950: An Exhibition in Honor of the Donation of John P. Axelrod.* Catalogue by Richard S. Field et al. May 10–August 31, 1983.

Museum of Fine Arts, Boston. *Awash in Color: Homer, Sargent, and the Great American Watercolor.* Catalogue by Sue Welsh Reed and Carol Troyen. April 28–August 15, 1993.

Jersey City Museum, New Jersey. *Pencil Points: Selections from the Dixon Ticonderoga Company Collection.* Organized by Francine Corcione. August 31–November 12, 1994.

The Montclair Art Museum, New Jersey. *Precisionism in America, 1915–1940: Reordering Reality.* Catalogue by Gail Stavitsky. November 20, 1994–January 22, 1995.

Selected Books and Articles: Earl Horter

Haase, Albert E. "Pencil Drawings Which Give Effect of Etchings." *Printers' Ink Monthly,* vol. 1, no. 6 (May 1920), pp. 41–42.

White, K. B. "To Make the Factory Picture Reflect Your Product." *Printers' Ink Monthly,* vol. 3, no. 4 (September 1921), pp. 40–41, 84.

"Horter Etchings Have Varied Appeal." *Art News,* vol. 21, no. 30 (May 5, 1923), p. 2.

"An Interesting Correspondence with the Eldorado Pencil Artist." *Graphite* (Jersey City, New Jersey), vol. 26, no. 5 (September–October 1924), pp. 1, 102.

Parker, Robert Allerton. "Earl Horter's Achievement in Pencil." *International Studio* (New York), vol. 84 (July 1926), pp. 25–32.

Lewis, Paul. "Earl Horter: An Artist's Artist." *Advertising Arts* (New York), January 8, 1930, section 2, pp. 65–69.

"Hobby Hunter Runs into Artist Who Thrills in Works of Others." *Evening Public Ledger* (Philadelphia), July 3, 1931.

"The Art of the Lead-Pencil." *The Literary Digest* (New York), July 17, 1926, pp. 21–22.

"Painter Viewpoint in Horter Art: Cubism Traced in Europe and American." *Public Ledger* (Philadelphia), February 18, 1934.

Grafly, Dorothy. "The Horter Collection." *Christian Science Monitor* (Boston), February 24, 1934.

Jewett, Eleanor. "Art Exhibits Range from Old Masters at Johnson Galleries to Earl Horter's Collection of Moderns." *Chicago Sunday Tribune,* April 15, 1934.

Morrow, B. F. *The Art of Aquatint.* New York: G. P. Putnam's Sons, 1935.

"Picasso—And Sitting Bull." *Philadelphia Record,* April 9, 1938.

Levi, Julian E. "Earl Horter." *Living American Art Bulletin* (New York), July 1939, pp. 4–5.

"Earl Horter Dies, Noted Artist." *The Evening Bulletin* (Philadelphia), March 29, 1940.

"Earl Horter Dies; Prominent Artist." *Evening Public Ledger* (Philadelphia), March 29, 1940.

"Earle Horter Dies; Noted Art Teacher." *Philadelphia Inquirer,* March 30, 1940.

"Picture Finished, Earl Horter Dies." *Philadelphia Record,* March 30, 1940.

Grafly, Dorothy. "Horter's Built Up $20,000 Income: His Story More Colorful Than His Work." *Philadelphia Record,* April 21, 1940.

White, Samuel S., 3rd. "Earl Horter." *The Art Alliance Bulletin* (Philadelphia), November 1940, n.p.

Being an Exhibition of the Work of Earl Horter's Gang . . . This Show Is One Way of Saying "Thank You, Bill" . . . We Hope He Will Understand. Philadelphia: Philadelphia Sketch Club, 1940.

Calkins, Earnest Elmo. *"And Hearing Not—" Annals of an Adman.* New York: Charles Scribner's Sons, 1946.

Pitz, Henry C. "Earl Horter: The Man and His Work." *American Artist* (New York), vol. 20, no. 4 (April 1956), pp. 20–26, 66.

Day, Blanche. "Heap Big Indian Collection." *Germantown Courier* (Philadelphia), vol. 20, no. 48 (November 1, 1956).

Ingersoll, R. Sturgis. *Recollections of a Philadelphian at Eighty.* Philadelphia: National Publishing Company, 1971.

Gold, Albert. "Earl Horter: Pioneer of Modernism." *Step-by-Step Graphics* (Peoria, Illinios), July/August 1991, pp. 114–20.

Selected Books and Articles: General

Gallatin, A. E. *Museum of Living Art: A. E. Gallatin Collection.* New York: New York University, 1940.

Gardiner, Henry G. "The Samuel S. White, 3rd, and Vera White Collection." *Philadelphia Museum of Art Bulletin,* vol. 63, nos. 296/97 (January–March/April–June 1968), pp. 76–79.

d'Harnoncourt, Anne. "A. E. Gallatin and the Arensbergs: Pioneer Collectors of Twentieth-Century Art." *Apollo,* vol. 100, no. 149 (July 1974), pp. 52–61.

Zilczer, Judith. *"The Noble Buyer": John Quinn, Patron of the Avant-Garde.* Washington, D.C.: Smithsonian Institution Press, 1978.

Gee, Malcolm. *Dealers, Critics, and Collectors of Modern Painting: Aspects of the Parisian Art Market Between 1910 and 1930.* New York and London: Garland Publishing, 1981.

Rishel, Joseph J. *Cézanne in Philadelphia Collections.* Philadelphia: Philadelphia Museum of Art, 1983.

Scott, Wilford Wildes. "The Artistic Vanguard in Philadelphia, 1905–1920." Ph.D. diss., University of Delaware, 1983.

Wolanin, Barbara A. *Arthur B. Carles (1882–1952): Painting with Color.* Philadelphia: Pennsylvania Academy of the Fine Arts, 1983.

Paudrat, Jean-Louis. "[The Arrival of Tribal Objects] From Africa." In *"Primitivism" in Twentieth-Century Art: Affinity of the Tribal and the Modern,* ed. William Rubin. New York: The Museum of Modern Art, 1984, pp. 125–75.

Brown, Milton W. *The Story of the Armory Show,* 2nd ed. New York: Abbeville Press, 1988.

Kosinski, Dorothy M. *Picasso, Braque, Gris, Léger: Douglas Cooper Collecting Cubism.* Houston: Museum of Fine Arts, [1990].

Bach, Friedrich Teja, Margit Rowell, and Ann Temkin. *Constantin Brancusi, 1876–1957.* Philadelphia: Philadelphia Museum of Art, 1995.

Bogart, Michele H. *Advertising, Artists, and the Borders of Art.* Chicago and London: The University of Chicago Press, 1995.

Fitzgerald, Michael C. *Making Modernism: Picasso and the Creation of the Market for Twentieth-Century Art.* New York: Farrer, Straus and Giroux, 1995.

De Zayas, Marius. *How, When, and Why Modern Art Came to New York,* ed. Francis M. Naumann. Cambridge, Massachusetts, and London: MIT Press, 1996.

Yount, Sylvia. *To Be Modern: American Encounters with Cézanne and Company.* Philadelphia: Museum of American Art of the Pennsylvania Academy of the Fine Arts, 1996.

Illustrated Works by Earl Horter

Index of Names

Photographs supplied by the owners and/or the following:

Archives of American Art, Smithsonian Institution, Washington, D.C.: figs. 16, 96

Artists Rights Society (ARS), New York/ADAGP, Paris: Estate Constantin Brancusi, pls. 1–4; Estate Georges Braque, pls. 5–12; Estate André Derain, pls. 14, 15; Estate Marcel Duchamp, pl. 16; Estate Raoul Dufy, pl. 17; Estate Jacques Mauny, pls. 23–29; Estate Pablo Picasso, pls. 30–50; Estate Jules Pascin, pl. 75

Dirk Bakker: pl. 94

The Barnes Foundation, Merion, Pennsylvania, all rights reserved: fig. 61

Courtesy Doris Helsengren Black: fig. 84

Courtesy William Campbell: figs. 33, 46, 47, 97

Courtesy Christie's, New York: pls. 13, 57

Courtesy David David Gallery, Philadelphia: pl. 29

Katherine Fogden: pls. 96, 97, 99, 104, 106

© Foundation Giorgio de Chirico/Licensed by VAGA, New York, NY: pl. 13

Courtesy Galerie Rosengart, Lucerne: pl. 6

Courtesy George Eastman House, The International Museum of Photography and Film, Rochester, New York, reprinted with the permission of Johanna T. Steichen: fig. 80

David Heald: pl. 21

Paul Hester: pl. 40

Courtesy Eric Horter: fig. 5

Courtesy Robert Ingersoll III: fig. 78

Carl Kaufman: pl. 19

Robert Lifson: pl. 87

Herbert Lotz: pls. 100, 101

Paul Macapia: pl. 95

Martinot Photo Studio, Inc., Altamonte Springs, Florida: fig. 14

Courtesy George H. McNeely IV: fig. 22

The Metropolitan Museum of Art, New York: figs. 64, 65, 66, 67

Courtesy Paula K. Muller: pl. 69

Musée National Picasso Archives, Paris (Béatrice Hatala): figs. 1, 3

The Museum of Modern Art, New York: pl. 4, figs. 29, 63

National Gallery of Art, Washington, D.C.: pl. 18; (Richard Carafelli) pl. 31

Pennsylvania Academy of the Fine Arts, Philadelphia: figs. 26, 34, 76

Stephen Petegorsky: pl. 93

Philadelphia Museum of Art: pls. 17, 65, 84; figs. 32, 35, 48, 57, 59, 75, 90, 92, 99, 106, 108; (Andrew Harkins) fig. 93; (Eric Mitchell) pls. 2, 82; (Lynn Rosenthal) pls. 15, 16, 24, 28, 39, 48, 49, 67, 83, 98; figs. 2, 4, 6, 9, 13, 15, 17, 23, 24, 25, 27, 30, 31, 37, 38, 39, 49, 52, 56, 70, 71, 72, 73, 79, 86, 88, 89, 91, 95, 100, 101, 102, 103, 104, 105, 107; (Graydon Wood) pls. 1, 12, 14, 27, 42, 43, 55, 59, 60, 63, 66, 71, 72, 76, 81, 90, 92, 102, 103, 105; figs. 11, 28, 41, 42, 44, 50, 55, 74, 83, 87; The Alfred Stieglitz Collection, fig. 18; Samuel S. White, 3rd, and Vera White Archives, figs. 19, 20

Private collections: pls. 9, 10, 32, 42, 44, 45, 89; figs. 85, 94

Courtesy Richard York Gallery, New York: pls. 53, 56, 61, 79; fig. 40

Courtesy The Schwarz Gallery, Philadelphia: fig. 45, 53, 54

Courtesy Silva-Casa Foundation, Bern: pl. 47

Courtesy Sotheby's, New York: pls. 20, 22, 50, 62, 64

Joe Szaszfai: pls. 88, 91

Courtesy University of Pennsylvania, Philadelphia: pl. 70; figs. 12, 82

Courtesy University of Pennsylvania Museum of Archaeology and Anthropology, Philadelphia: fig. 69

Courtesy Thomas DuPuy Watkins and Jane Watkins: fig. 81

Courtesy Barbara Wolanin: pl. 52

Courtesy Elin Young: fig. 7

Dorothy Zeidman: pls. 11, 30, 46